Trade Paper
Press

Turner Publishing Company
200 4th Avenue North • Suite 950
Nashville, Tennessee 37219
(615) 255-2665

www.turnerpublishing.com

Fighting Colors: The Creation of Military Aircraft Nose Art

Library of Congress Control Number: 2010931324
ISBN: 978-1-59652-758-4

10 11 12 13 14 15 16 17—0 9 8 7 6 5 4 3 2 1

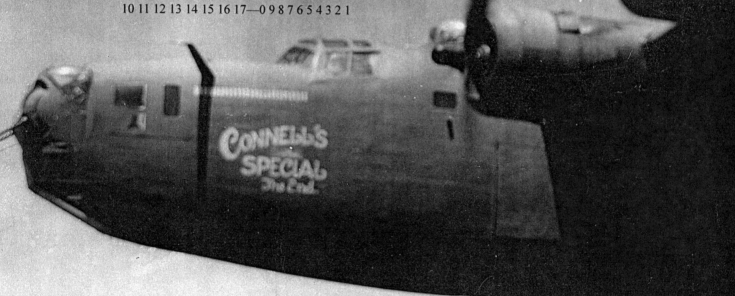

B-24J-15-CO s/n 41-24289 **CONNELL'S SPECIAL THE 2ND**
flew with the 90th Bomb Group, 400th Bomb Squadron.

NOTE ON COLOR:
This book was originally printed in hardback with color. This version
is black and white so references to color may not apply. To see color
versions of nose art restoration, visit fighting colors.com.

Fighting Colors

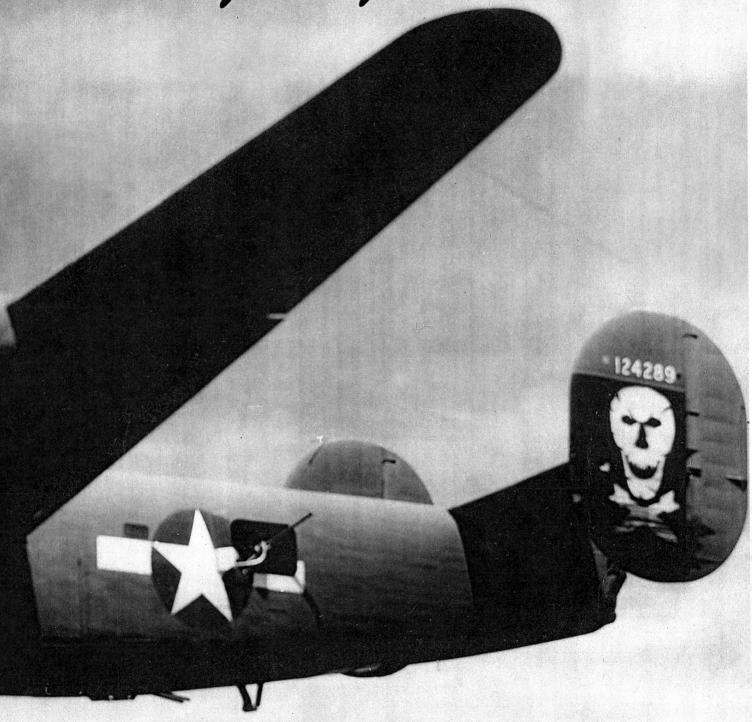

The Creation of Military Aircraft Nose Art
Gary Velasco

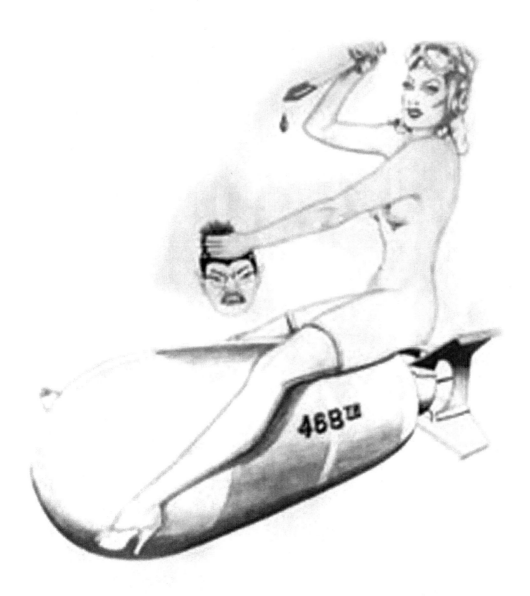

Contents

Acknowledgements

I never have imagined that my career would lead me to becoming an author. So much has happened since I returned to the field of aviation and the path seems to widen the further I explore the possibilities. I cannot fully explain why, only that it is a passion that drives me the more I learn about this subject.

The biggest benefit from what I do is meeting the valiant brave veterans that created history. While painting their creations on aircraft, the nose artists inadvertently forever marked and aided in the identification of the thousands of aircraft that participated in action that otherwise would have gone unnoticed, and perhaps only survived in a documented form filed away in a government vault. I am honored and proud to have met and collaborated with individuals from this great generation.

As part of my work, I feel obligated and enjoy the fact that my company is returning the favor by continuing the legacy left behind by unknown and very talented artists. My goal is to bring this lost art back into the mainstream by producing examples of this type of American folk art. In doing research for my nose art panel products, I have amassed a couple of thousand nose art photos and decided that, as part of promoting the subject of nose art, it would be fitting to publish them. The bulk of this volume is from this collection. I plan in the future to continue releasing new material as public record.

In compiling this first volume, I must thank the many individuals that contributed resources, services and information for this project. First and foremost is my wife Diane whose patience, understanding and graphic experience made this book possible. For my Daughter Ariel, who helped tap the "Apple" keyboard on some of these pages. Fashaya Crigler for her assistance in scanning all those photos. Adam Dintenfass for his mutual interest and loaning me his collection...you're a great 'scout'. Todd Bottorff and Randy Baumgardner from Turner Publishing Company for the confidence in letting me design this book. Bob and Linda Morgan for their enduring friendship and support.

John Campbell, Popper photo England, Janet Pack and the 388th Bomb Group (H) Assn., Louis Lane Collection, Shad Shaddox, Jerry Starcer, John Bruning's Reddie Archives, Owen Hughes, Hal Olsen and 'Agent', Gene Townsend, Phylis Brinkman Craig, Bruce Gamble, Carroll Haugh, Charles Harper, Darrell Crosby, Sam Sox, Jr. and the 352nd FG Assn, 308th BG pilots and veterans; Gene Boyars, Carroll Glines and Walt Kastner, Dwight Orman, Jeff Wolford, Anne LaMorge, Mike Speciale and Col. Dennis Savage from the New England Air Museum, The Collings Foundation, David Tallichet, Marge Bong Drucker, Henry Bourgeois, Jim Hill, USAF, NARA and last but not least, Jim Paidas.

For more info and contact on the artist/author and nose art products please visit;

www.fightingcolors.com

email: fightingcolors@hotmail.com

Foreword
By
B/Gen. THOMAS L. "TOMMY" HAYES

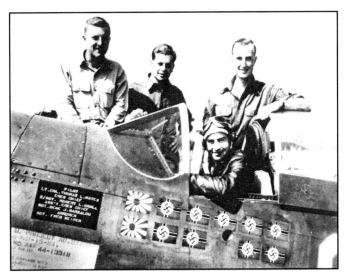

Capt. Thomas L. "Tommy" Hayes and crew in his second P-51
(P-51D-15-NA 44-13318), **FRENESI**.

Reading Fighting Colors has brought back many memories from my time in the service more than a half-century ago. I was 10 years old when Charles Lindbergh made his historic solo flight from New York to Paris in 1927, and this event filled me with dreams of becoming an aviator. My other childhood passion was painting, and I knew that one day I would be doing one or the other as an adult. Later, as a fighter pilot in WW II, I did both … flying P-39s, P-40s and P-51s, and painting nose art on fighters in both the Pacific and European theatres.

In *Fighting Colors*, Gary Velasco presents a unique insight into military aircraft nose art. In addition to authentic photographs of the period, this book provides detailed descriptions of how the artwork was applied and also captures the personality of the pilots and artists who gave each war bird its own unique character.

As an artist, I painted the nose art on my favorite P-51 fighter, FRENESI. When Gary contacted me a few years back about doing a Limited Edition replica panel of my nose art, I was surprised to know that a product like this existed. To this day, my panel hangs on the wall with all my other memorabilia and I prize it the most. I was impressed with the detail Gary provided to painting application techniques of the WW II years, the background provided on the artists of that time, and his insightful look at modern and traditional reproduction techniques used in this book and for his restoration projects. As a veteran, I enjoyed the wide variety of the fighters and bombers pictured; this book brought to memory hundreds of aircraft from long ago as well as their pilots and aircrew—we will always be remembered by the "ladies" we flew.

I have read many other books on military nose art, but none come close to the depth and historical perspective of *Fighting Colors*.

Tommy Hayes

USAF, Ret.

Tommy Hayes, a Portland, Oregon native, flew P-39s and P-40s with the 35th Pursuit Group in New Guinea, and survived being shot down by a Zero in Java. After recovering, Hayes trained pilots and was promoted to Captain. He was then transferred, in August 1943, to the 357th Fighter Group in command of the 346th Fighter Squadron in Europe, where he flew P-51s. He scored his last victory as a Lt. Col. on 14 July 1944 when he led a "Ramrod" mission to Paris and downed a Me-109. Hayes retired from the Air Force as a Brigadier General in 1970. In total, he flew 143 combat missions and was credited with 10.5 confirmed victories (8.5 in Germany and 2 in the Pacific) and one probable.

Introduction

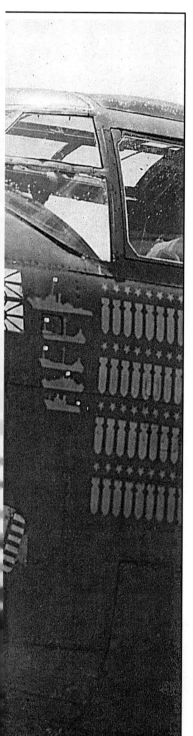

Throughout our human history of warfare, man has always in some manner adorned his weaponry with some sort of personal markings, from notches etched in bone, Roman chariots gilded with gold emblem, feathers tied to a spears, tattoos, "skull and crossbones" flags, ships with great shapely figureheads and the great fighting machines of WWI, to today's modern day multi-million dollar aircraft. In all instances, its purpose was always to serve as a morale booster and to strike fear in ones opponents, as well as to mark ones personal identity.

What we know today as aircraft nose art began in the early years of flight, soon after the Wright brothers developed their Wright Flyer to the then U.S. Army. Squadrons began painting emblem and insignia to tell them apart from other squadrons. This practice led to more personal insignias and colorful camouflage schemes so much so that during WWI, fighting aircraft were so brightly painted you could not miss them in the sky. With the likes of Baron Manfred Von Ricthofen's bright red Fokker Dr 1 Tri-plane and Eddie Rickenbacker's Nieuport 28, flying with the 94th Aero "Hat-in-the-ring" squadron, the life of nose art began to take shape although the term did not come in to use until the peak of the phenomenon in WWII.

In all combat theaters during WWII, there was some form of nose art applied to virtually every type of aircraft flown. Aircraft like the Boeing B-29 and the Consolidated B-24 Liberator had the amount of space available for artists to practice and hone their craft. They were literally flying billboards. I wonder what the enemy might have thought when making a pass at the scantily clad pin-ups painted on the noses of their formidable foe.

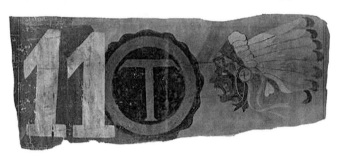

In this volume we will cover and focus mainly on the Pacific Theater (PTO) and China-Burma-India (CBI), where nose art flourished without boundaries. Restrictions there were relaxed and sometimes ignored due to an absence of top brass, meaning little regulated the artwork being applied. The study and technical aspects will be revealed on how this form of folk art was, and is still, being done today.

Left: B-25 **MITCH THE WITCH** from the 17th Recon Squadron scoreboard markings.

Right top: A piece of Spad VII fabric from the Lafayette Esquadrille.

Right bottom: 103rd squadron a/c #5301 flown by Sgt. George E. Turnure Jr.,1917.

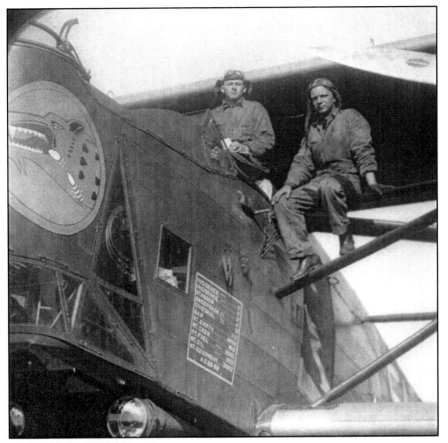

A Keystone LB-6 bomber s/n 29-25 from the 2nd Bomb Group, 49th Bombardment Squadron. One of only 17 built in this model, the insignia is painted on its nose. The colors are; orange circle with Grey border. The Wolf is Grey also with white teeth and tongue and gums red. All lines are black.

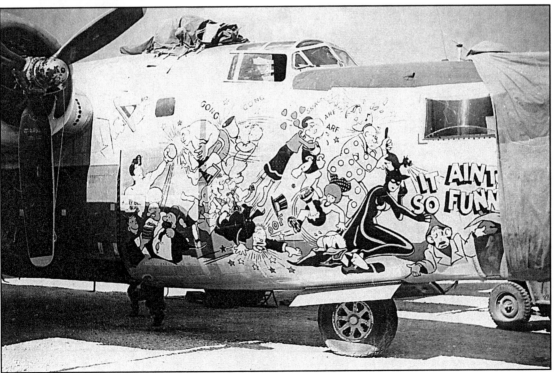

This B-24 **IT AINT SO FUNNY** from the 43rd Bomb Group, 64th Bomb Squadron s/n 44-49853 is a prime example of how large some of the designs got to be.

The Origin of Nose Art

Squadron insignias and unit emblem were some of the first signs of art to appear on aircraft just prior to WWI. Of course there were the national insignias on wings and fuselages along with country flag colors on the tails, but as for personal badges and insignia, there is no definitive date as to when the first designs appeared. Every imaginable type of fierce animal was used to depict the personality of the pilot and or squadron.

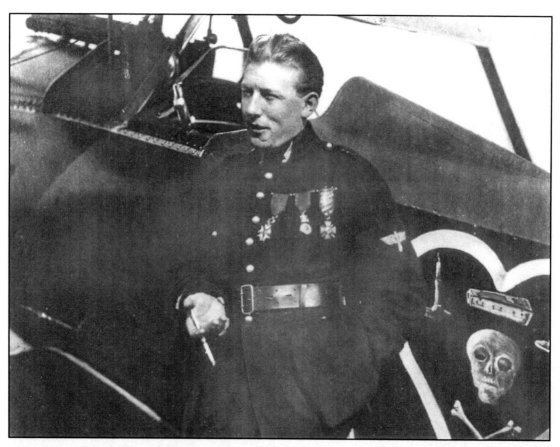

Perhaps one of the most universal of these designs used to rouse fear among the enemy was the "Skull and Crossbones". A battle flag designed by pirates better known as the "Jolly Roger" was a common emblem. Variants of the design were used by the likes of French ace Charles Nungesser. His rendition encompassed a black heart outlined in white. In the heart were two candlesticks and a coffin between them, all above the skull and crossbones.

In all theaters of all wars, both axis and allied, there have been all sorts of references to death used as nose and fuselage art. In contrast, there were also very humorous examples of art usually poking fun at the opponent or taunting the enemy and in instances, at oneself.

Opposite page: Unit insignia from the 1930s. 1. 13th Attack Group. 2. 8th Attack Squadron. 3. 20th Bomb Squadron. 4. Langley Field Technical School. 5. 3rd Attack Group. 6. 49th Bomb Squadron.

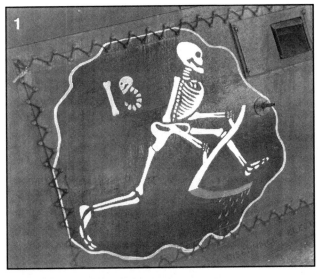

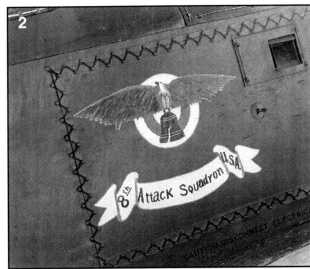

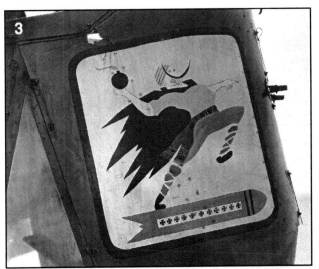

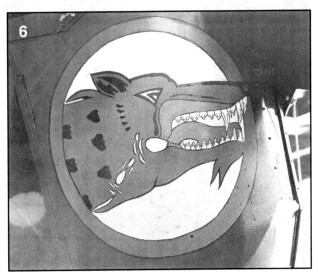

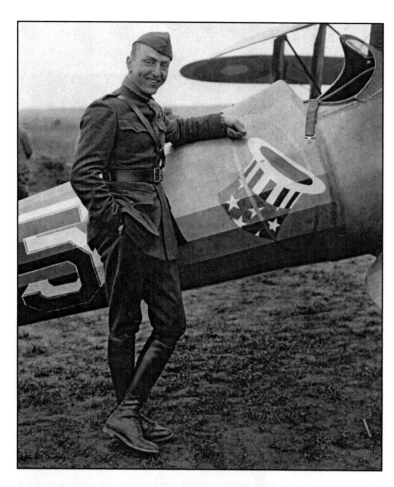

Capt. Eddie Rickenbacker poses by a 94th Aero Squadron Nieuport 28. His personal a/c was number 1 in red with a white shadow and blue outline. Rickenbacker shot down 26 enemy aircraft in a relatively short six months of combat.

The painting of unit insignias became a common practice on early aircraft. The paint available at the time were lead based alkyd which contained solvents like Toulene, Zylene and Acetone. They covered very well but in addition to the doping process over the fabric, contributed to weight. As hard as it may be to believe, even the amount of the crew's clothing could make a difference in the performance of the plane. Remember, up until the late 1930s, all aircraft were open cockpit.

Above: Spad. insignia from R. Brooks, 22nd aero Squadron.

Above right: Fokker D-VII fabric

Left: An excellent example of original printed Lozenge fabric with German national insignia

A Martin B-12 bears the insignia of the 31st Bombardment Squadron.

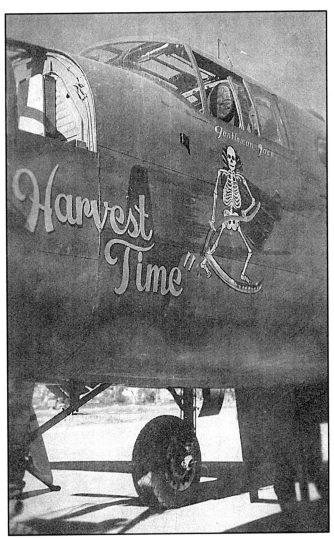

Left: **HARVEST TIME**, a B-25 shares the common "Death" theme.

Bottom: An A-20C s/n 42-86715 with the 13th Bomb Group (M).

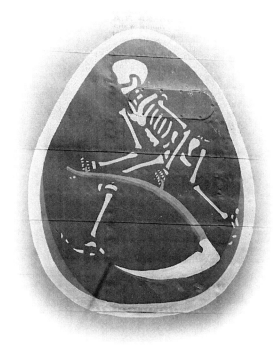

World War I aircraft wore a myriad of color schemes, some practical camouflaged and others extremely outlandish which defeated its purpose. The German *Reichsluftfahrt ministerium* (RLM) experimented and tried just about every conceivable color scheme imaginable. For the most part, camouflaging aircraft proved to be relatively easy when seen on the ground, compared to rendering it invisible when looking at it from the ground up. The trick was to try and reduce the dark silhouette of the plane in the sky. Today, we still have not been able to mask the visible shadow of aircraft when viewed from the ground up.

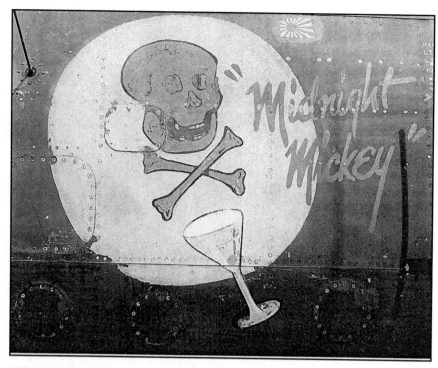

MIDNIGHT MICKEY is a P-61A s/n 42-5523 from the 6th Night Fighter Squadron. All early, P-61's. were painted in the usual OD/Grey camouflage.

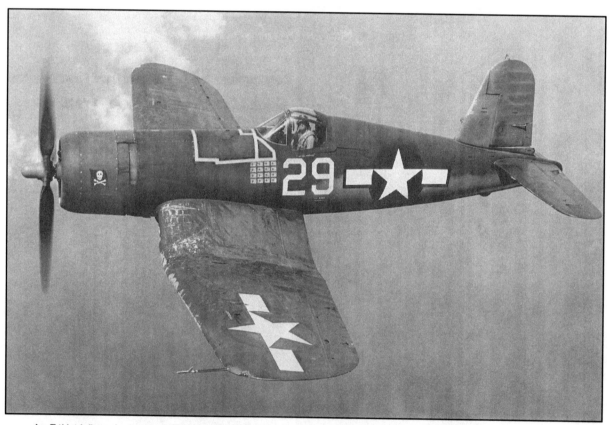

An F4U-1A flown by leading VF-17 ace Lt. (jg) Ira C. Kepford. This group used the JOLLY ROGER flag insignia on all their Corsairs. Note the white tape used to seal the gas fumes and leaks from the center fuel tank. *U.S. Navy Photo.*

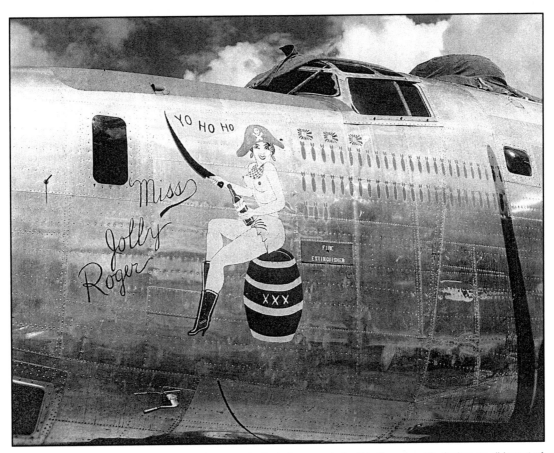

The 90th BG, 321st BS B-24 s/n 44-41190 had its insignia incorporated within the artwork's design, as did most of the group's aircraft.

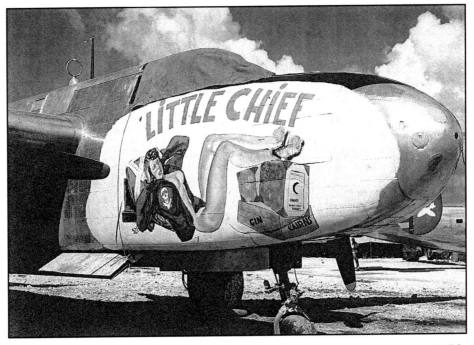

LITTLE CHIEF is a Douglas Havoc A-20G-45-DO s/n 42-54084 used as a "Hack" by the 90th BG. The artist used every bit of nose for this design. Note the group's insignia on the jacket.

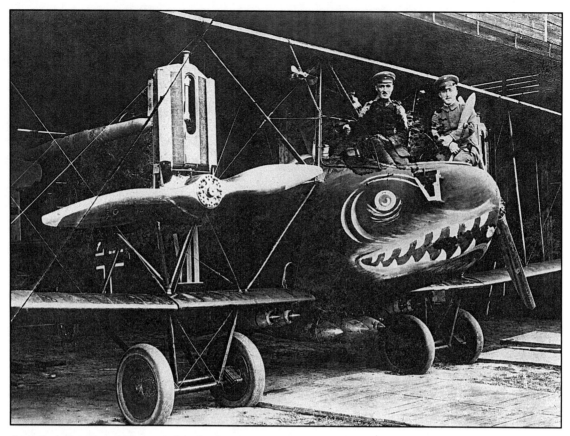

An early design of what appears to be a bat head on the nose of this German A.E.G. GIV. It might also be interpreted as a shark mouth.

This practice continued on through the war until WWII. Everyone experimented and started to figure out the combination of painting the underside of aircraft a light shade of Grey or blue to match the sky and various earth toned greens painted topside worked very well. The American equivalent to the German RLM color system was the Army-Navy Aeronautical (ANA), more commonly known as the Federal Standard system (FS). By the late 1930s, the standard camo scheme for U.S. Army aircraft was Olive Drab (OD) for fuselage sides and top surfaces. Neutral gray for all under-surfaces. Sherwin-Williams was the dominant paint manufacturer for the military and still is to this day.

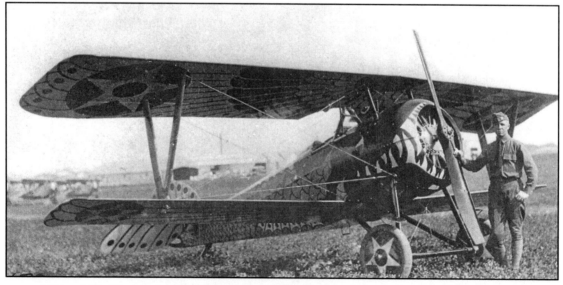

A Nieuport 28 of the American Expeditionary Force, 1918. The overall a/c is painted in a stylized fish motif.

As for unit insignias, the common applique were decalcomania transfers *Spec.24,101* dated August 9, 1917. The name was eventually shortened to decal. They were basically water decal transfers commonly used for models today, only thicker and larger. These proved to be difficult to apply and often cracked, bubbled, ripped and or damaged lending itself to touching up with paint. A coat or two of Dope was applied to protect the finish. There was no shortage of these decals and was economical as opposed to painting each by hand.

Prior to WWII, the term "Nose Art" and pin-up was not yet in use mostly because in the late thirties, the airbrush creators of the lavish girls, were just about to make the mainstream scene by way of print media and advertising.

Often with every new decade comes new fashions and with the forties approaching, hems got shorter and bathing suits became skimpier. Pulp fiction novels also became racier and *Esquire* magazine started to print the pin-up creations of Alberto Varga, Gil Elvgren and George Petty. These images became the mainstream, used in all print media and saturated a variety of advertisements. They soon began to appear on aircraft although it is not known when, what or who did the actual first pin-up on a plane. The artists did not foresee the value or impact his creation would make until decades later when the fascination of plane identification became important to historians as recorded history. It took on a new life and meaning on its own and has continued today as a tradition but will never be as flamboyant as in WWII due to (once again) top brass intervention and political correctness. Today's airshows with flyable warbirds is virtually the only place where admirers of this forgotten craft can be seen in its traditional glory.

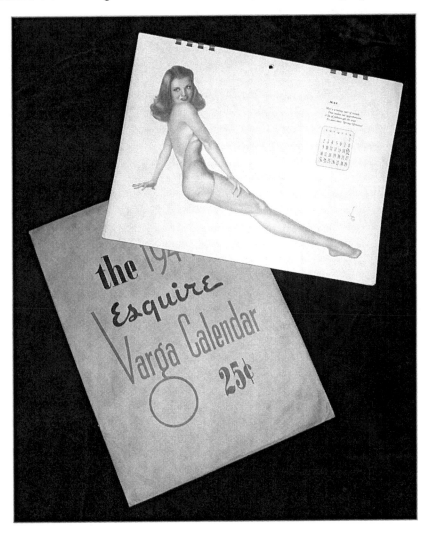

The Glamour Years

Between the great wars, Americans recovered from the depression and started to indulge in the finer things that life had to offer. Spending more time on nights-on-the-town and generally living it up. The entertainment business thrived and the original "Gibson Girl" evolved into calendar Pin-up girls. Among the prolific artists during the mid to late 1930's were Alberto Varga, Zoë Mozert, Earl Moran, George Petty and Gil Elvegren whose works of provocative semi-nude renderings brought attention throughout the print and advertising world. The tool primarily used in these renderings was mainly the airbrush whereby compressed air can be

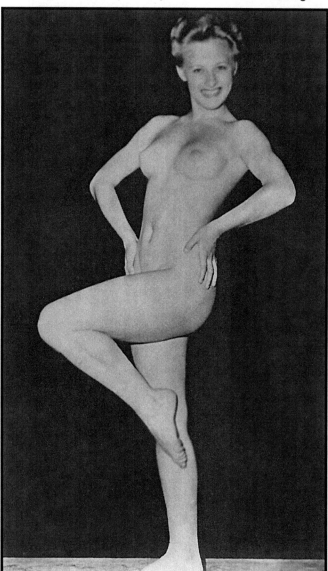

controlled through a small nozzle mixed with paint fed through a hose or a small reservoir cup attachment. The airbrush was held in the hand much like a pen. It took some time to get used to the bulky object and afforded the artist the ability to make blends and soft shading possible. Small details and lines where still done with brushes. Not all Pin-up artists used the airbrush. Some were determined to set themselves apart by using different mediums like colored pencil, fine oils or charcoal.

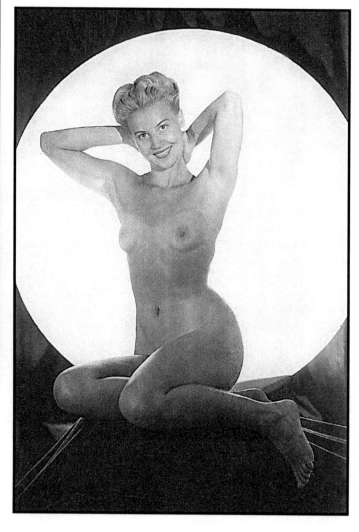

Artists alike needed "inspiration" to envision his paintings. Enter the models. Beautiful, voluptuous women models were hired to pose for the artist. In many cases photographers were also hired to produce poses the artist can also use as 2-D references. There was no shortage of these models as the pay was good and like today, hopes of being discovered as a starlett was in every girl's mind. In the case of George Petty, his daughter, Marjorie was employed by "dad" exclusively to model for his paintings. Only upon request or private commissions, would another model be used. Often, the completed piece would result in exaggerated forms to emphasize the voluptuous features of the female form.

The forum for pin-ups mainly graced the pages of calendars and men's magazines where these "cheese cake" pin-ups would inspire many service men during WWII to copy and paint these beauties onto the sides and forward fuselages or noses of their aircraft, hence the term "nose art". These designs were accompanied with messages, names and slogans that cleverly contained double meanings that were often perverse.

Anyone able to draw, sketch or paint was sought after to apply a design on ones aircraft. The fortunate few artists with talent were in most cases compensated for their services. There were exceptions where the artists modesty would not prevail and would do the work for free. This also led to nose art not being signed, forever unknowingly identifying who its creator was.

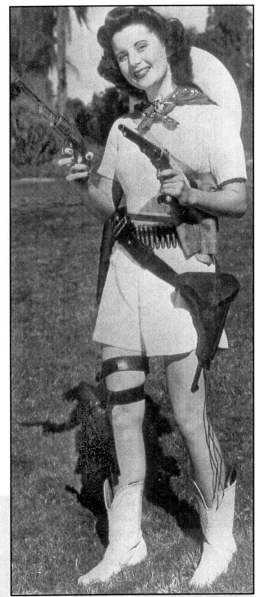

The name *"Pistol Packin' Mama"* became a popular slogan among soldiers and crew when hearing the song sung by the likes of June Courson (pictured) in her appropriate outfit. Other tunes intended to boost morale were written by Big Band and Jazz greats like Glenn Miller - *"In the Mood", "Tail End Charlie", "Jeep Jockey Jump" and "Peggy, the Pin-Up Girl".* Listening to music on local radio broadcasts was therapeutic as entertaining one's soul- A relaxing way to unwind and perhaps write to a loved one from home.

The trials and tribulations of war were about to commence as our history records brave young men barely out of high school pursuing their destinies. The art of war known as "nose art", also ensued and helped fight their battles despite the arrogance of the enemy. Many sign painters and artists soon put their skills to work and created thousands of notable examples of nose art paintings on aircraft, unbeknownst that in future generations would help record in identifying the individual role of the aircraft's history.

In all the hundreds of thousands of aircraft produced in WW II, 90 percent had some form of nose art, in some cases just a simple name to the elaborate whole side of the plane painted. The following is just but a few examples that have been re-discovered and for the record, published in this venue. It is the author's intention that this form of American folk art live on and enlighten a new class of artists, to demonstrate that in our time of political correctness when our voices are overshadowed by statesmen, simple and creative *fighting colors* can be very effective.

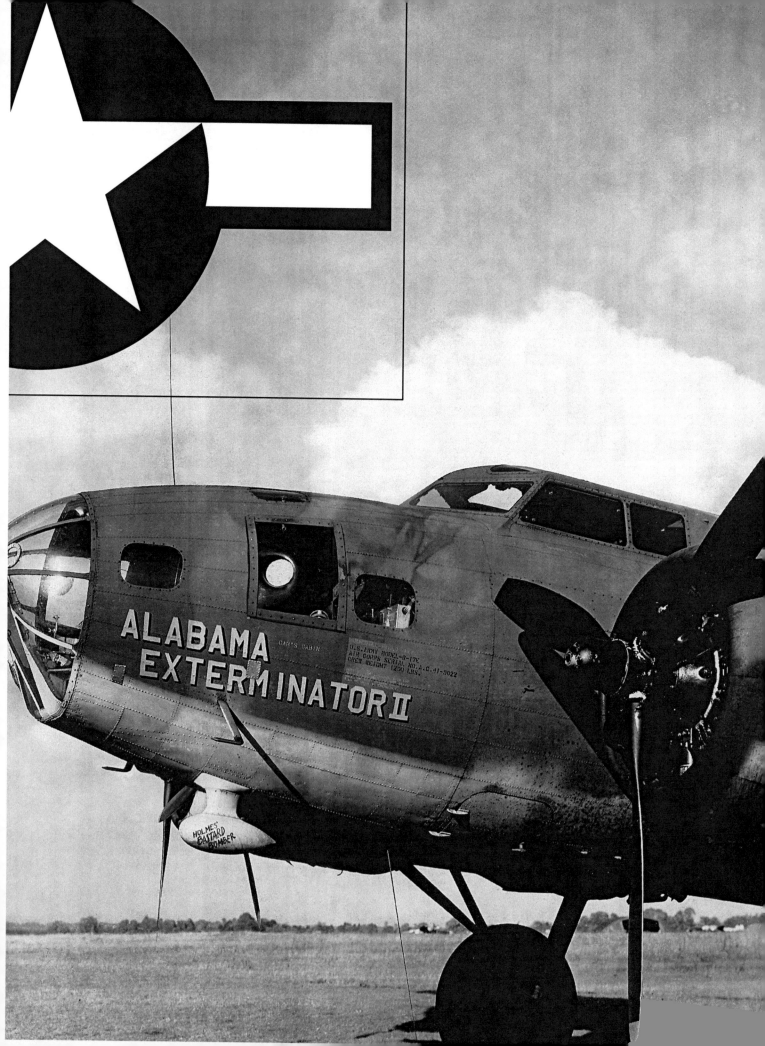

The Art of War
ETO and MTO Aircraft

The first year when freshly camouflaged painted B-17's arrived in England, crews simply began naming their planes. Amidst a field of bombers and fighters that all were identical, it was easier to identify and call their own by name than by its serial number. No one at the top seemed to object to the monikers until scantily clad female figures were incorporated with titles that insinuated more than met the eye. Eventually this practice was done stateside as crews were being trained and readied to be shipped overseas in their assigned aircraft.

The media began its Public Relation campaigns when fighter and bomber pilots began telling their heroic stories to news reporters. When photos of their planes with somewhat risque figures hit the newspapers, it led to censorship. The name "**MEMPHIS BELLE**" became synonymous with WWII when its pilot, then Capt. Robert K. Morgan, along with his crew became the first to complete the required 25 missions in the 91st Bomb Group, 8th Air Force. Upon returning to the States, they began a whirlwind War Bond tour that lasted three months. Upon request by Capt. Morgan, the pin-up girl was designed by George Petty and painted on B-17 serial no. 41-24485 by Cpl. Anthony Starcer. His nose art with the 91st BG was inspiring to other artists throughout the ETO and so the creative juices emerged as did the nose art throughout the war.

Many of these artists were by trade sign painters. This trade at the time was as common as a computer artist of today and a skilled brush in hand got you a job painting planes, A-2 jackets and squadron patches.

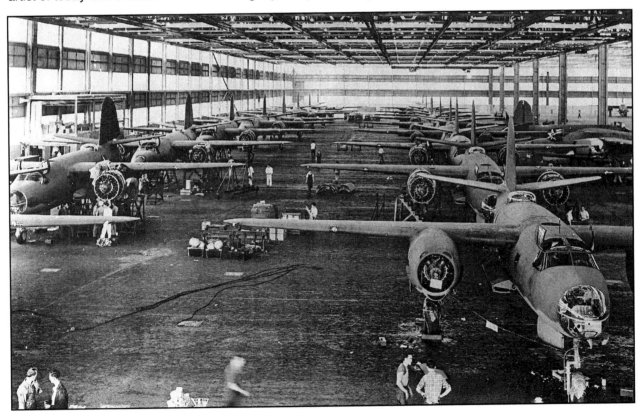

Above: B-26s near completion at the Baltimore, MD. Glen L. Martin plant 12/27-1941.

Opposite page: ALABAMA EXTERMINATOR II B-17E 41-9022 from the 97th Bomb Group, 341st Bomb Squadron and the 384BG, 546BS.

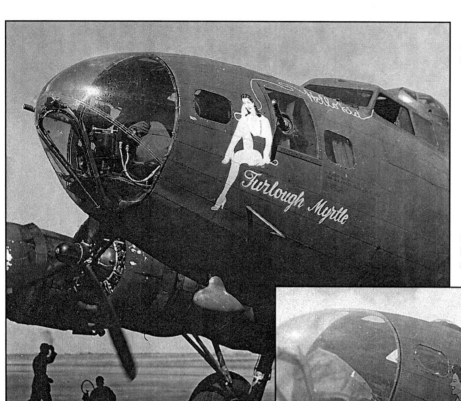

Left: B-17F **FURLOUGH MYRTLE** from the 385the BG.

Below: **TONDELAYO**, another B-17F possibly from the 95the BG and later 91st BG.

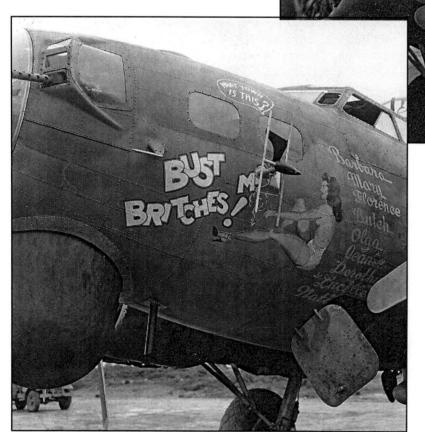

Left: **BUST MAH BRITCHES!**, a B-17G converted to an early H fitted with radar. The B-17H model was later used as air-sea rescue with a 27 foot long lifeboat attached to the belly.

24

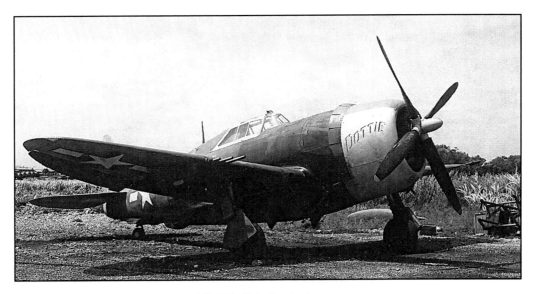

A P-47B with just a simple name.

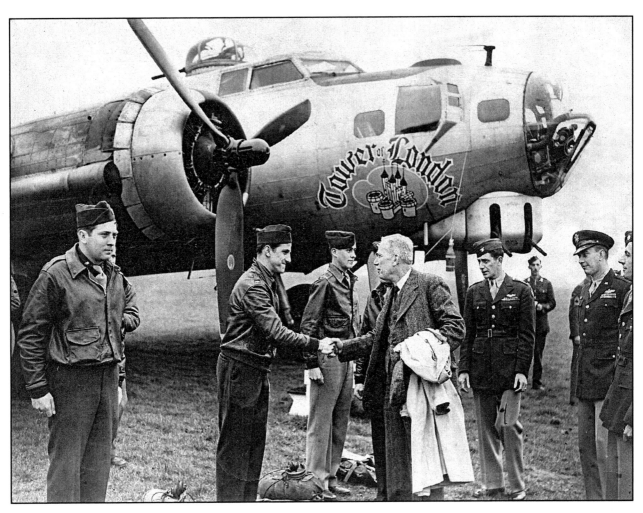

TOWER OF LONDON B-17G s/n 44- 8471 from the 91st BG is being christened by Lord Mayor of London Sir Frank Alexander and congratulates crew with Col. Terry, Gen. Gross and Lt. Col. Cahill 25th March 1945. The art applied by Tony Starcer appeared on both sides. It completed 26 missions and was transferred to the 306th BG in May.

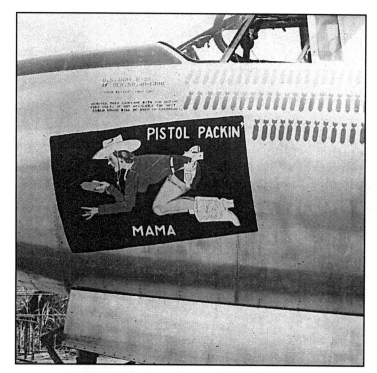

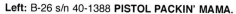

Left: B-26 s/n 40-1388 **PISTOL PACKIN' MAMA.**

Below: B-26-G-20 394BG, 585BS from the ninth Air Force **SURE GO FOR NO DOUGH** painted over its armor plating.

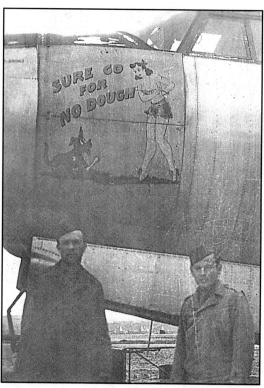

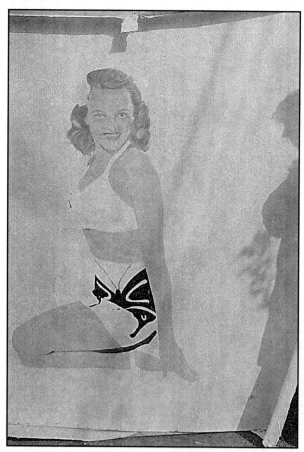

Above: Artists found that painting their designs onto linen or sheets prior to doping the finished art to the skin proved to be more manageable. This practice is often difficult to detect from photos.

Right: B-26 **MINNEAPOLIS** was most likely done by the same artist and this pin-up may have been doped on.

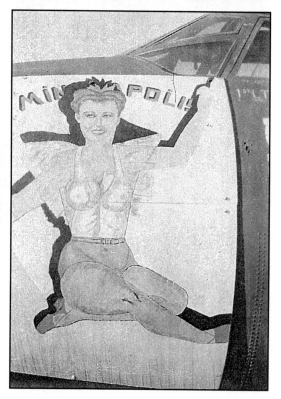

Owen Hughes - 10th Air Depot

The Eighth Air Force based in England would become the first and largest to enter WWII. Artists and anyone capable of using a paint brush was sought after to personalize aircraft for pilots and crew. One such artist was Owen Hughes. A 21 year old sign painter by trade was assigned to the 10th Air Depot in England and his task in the Dope and Fabric shop was to paint signage for the base. His first nose art design was on a B-17 that had come in for modifications. After completing his work duties for the day, the crew approached him and asked for a design which included a pin-up girl. A fee of $10.00 was forfeited in exchange for a ride in the bomber when the art was completed. "There wasn't a whole lotta design thought involved. I just painted what came natural". Hughes began on the pin-up on the pilot side and had completed it that night. Photos of

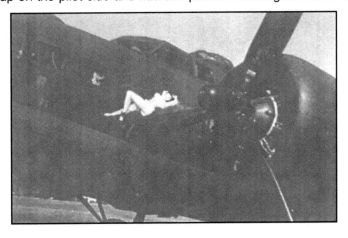

aircraft were forbidden and there happened to be an MP standing guard. During the MP's "rounds", Hughes had managed to time the guard's walk. As the sentinel proceeded to the opposite rear, double checked by looking for his feet under the fuselage confirming his position, Hughes whipped out his trusty folding bellows Kodak 620 and snapped a shot. For fear of confiscation, the film was not processed until his return to the states. This was the one and only time he took a photo of his nose art. The name **VIRGIN ON THE VERGE** was to be painted the next day but upon arriving, he learned that it had been flown back to its base. Disappointed, Hughes continued his duties

and went on to paint some 50 B-17s including **TEXAS LONGHORN** and **DON'T LENA ON ME**, 25 P-47s and 25 C-47s prior to returning home. Unfortunately there was not a log kept to record a list of planes done by Hughes. Not uncommon since it seemed to be a trivial task at the time.

Research for this book and 60 years later, Hughes learned that his first design was completed by someone else! Not only was the name done, but it was all copied, reversed and painted on the right side.

In this instance, Sherwin-Williams sign painter's paint was supplied by special order and made available for signage. When not available, one would simply go into town to the nearest hardware store and buy house paint or whatever was suitable. Lettering brushes were also supplied by "Uncle Sam" and made by Grumbacher. The quality of these were not the best and were trimmed down, shaped to suit the needs of the individual artist. Hughes has regained notoriety once again by recently painting a restored B-29 with the nose art **DOC**, a character from the Walt Disney Sleeping Beauty series.

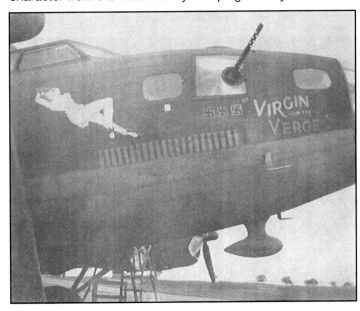

As artist work today, many sketches are done prior to settling on a design that would look aesthetically pleasing to the eye and approved by the commissioning party. This procedure was generally waived by most and trust in the artist's capabilities was the norm. The naming or christening of aircraft became a tradition and soon every plane captain wanted to have a **LUCKY LADY** on the nose. A type of lucky charm of sorts along with personal rituals before, during and after a mission was incorporated in the mix to ensure a feeling of comfort.

Top: Left side of B-17 42-5900 from the 388BG, 561BS completed 33 missions and was consequently declared war weary. *Owen Huges*

Bottom: The right side of **VIRGIN ON THE VERGE**. The bomber was salvaged on August 1, 1944.

27

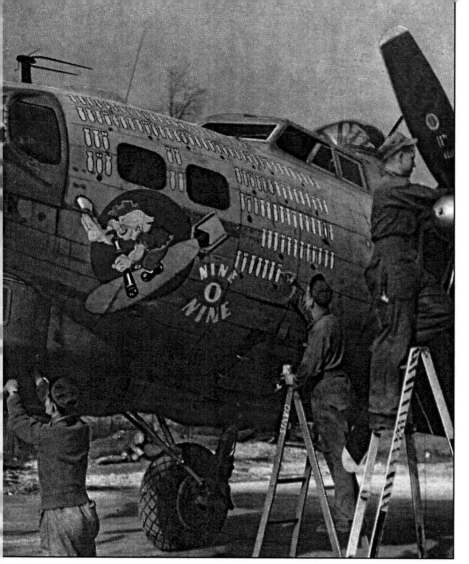

91st
Bomb Group

Anthony Starcer and the **MEMPHIS BELLE**, the first B-17 and crew to complete the required 25 missions in the 8AF, are synonymous with the 91st with the fact that Starcer painted the **MEMPHIS BELLE** and many others which made him one of the most noted nose artist in the ETO. His style and designs inspired others to follow suit in the prolific form of nose art. Starcer painted upwards of 130 B-17s and many A-2s. Its a wonder how he got any of his assigned duties done.

The first few nose art designs were **DAME SATAN, CAREFUL VIRGIN** and **MEMPHIS BELLE**. The paints used for these were usually house paint or whatever the military had lying around. He would drain off the oil that accumulated at the top and replace it with linseed oil which worked best for slowing down the drying process in high heat. This also helped the flow or consistency in the cold with the draw back of a longer drying time. The average time to do a nose art design was about half a day and

(continued. on page 34)

Above: B-17G-30-BO "NINE O NINE" 42-31909 91BG, 323BS OR·R. Named and designed by radio man Jack Grosh depicts Columbus riding a bomb thumbing his nose at the enemy. The name derives from the last three digits of the serial number. Tony Starcer painted the art and all other markings applied by the ground crew chief M/Sgt. Davis as illustrated in the photo.

After 21 engines, 18 replacement Tokyo Tanks and 15 main fuel tanks **NINE O NINE** survived the war with 140 completed missions, 126 without an abort due to mechanical problems. *USAF*

At right: B-17G-25-DL **MAN O WAR II HORSEPOWER LTD** 42-38083 322BS is the second B-17 assigned to Lt. Burtt after a belly landing in the first **MAN O WAR.** The design is the same only the title was rearranged in the scroll slightly changed. *Starcer Archives*

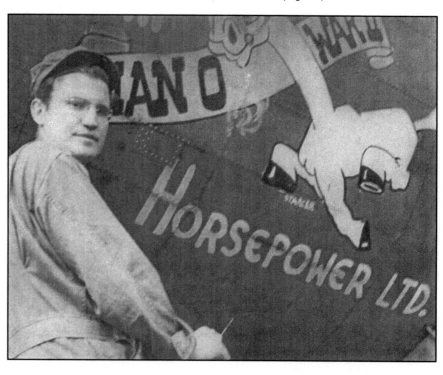

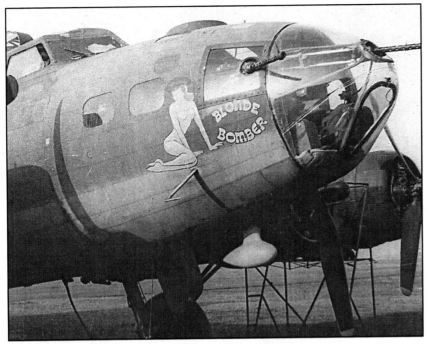

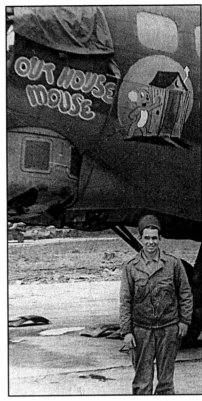

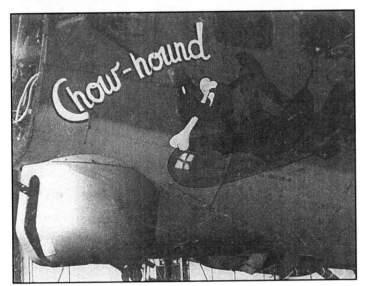

Top left: **BLONDE BOMBER** B-17F-20-DL 42-3057, 322BS LG·N

Top right: **OUT HOUSE MOUSE** B-17G-25-BO4 2-31636, 323BS OR·N

Middle: **CHOW-HOUND** B-17G-15-BO 42-31367, 322BS LG·R

Bottom left: **THE VILLAGE FLIRT** B-17F-70-B 42-29739, 323BS 0R·M

Bottom right: **DEMO DARLING** B-17G-1-VE 42-39774, 323BS OR·R/O *photos courtesy of Adam Dintenfass*

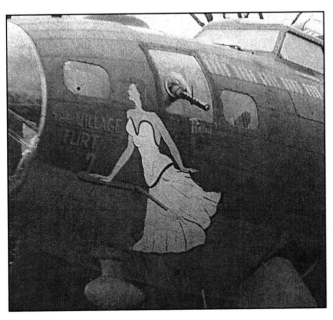

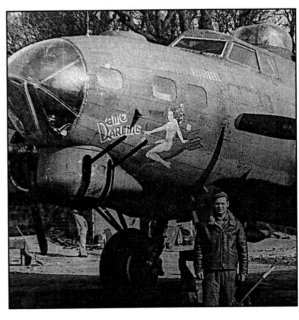

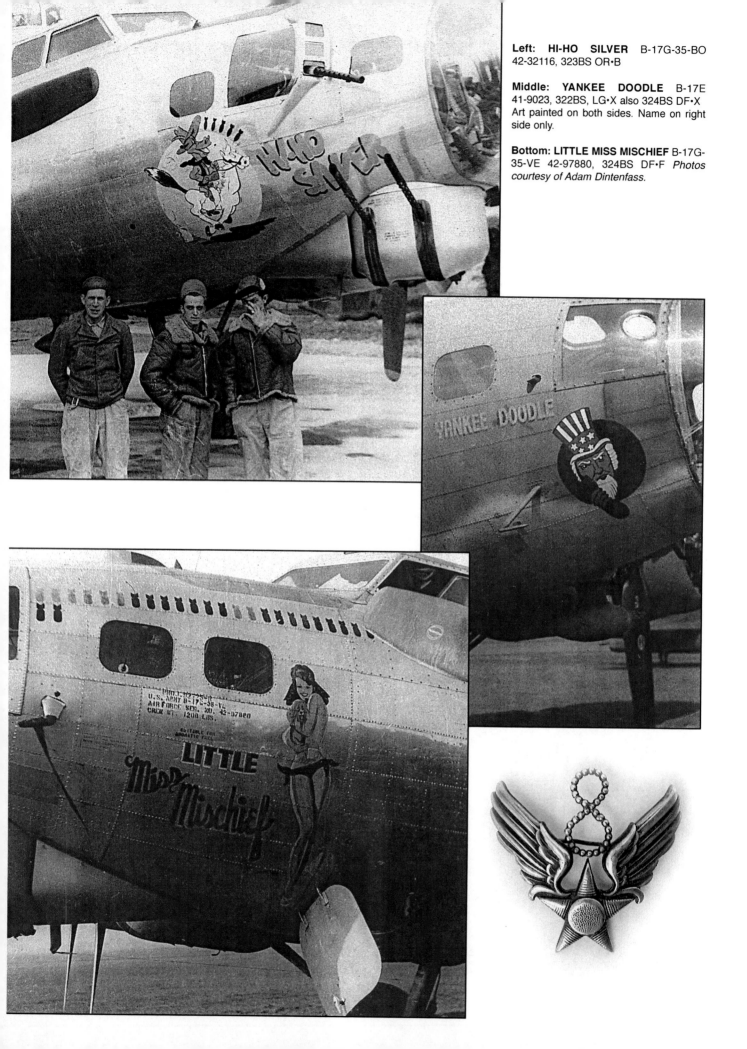

Left: HI-HO SILVER B-17G-35-BO 42-32116, 323BS OR·B

Middle: YANKEE DOODLE B-17E 41-9023, 322BS, LG·X also 324BS DF·X Art painted on both sides. Name on right side only.

Bottom: LITTLE MISS MISCHIEF B-17G-35-VE 42-97880, 324BS DF·F *Photos courtesy of Adam Dintenfass.*

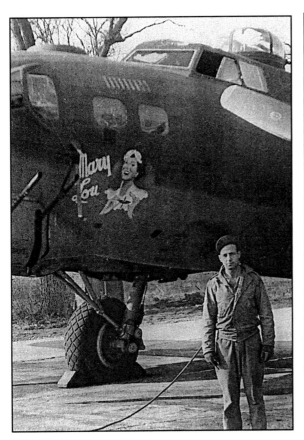

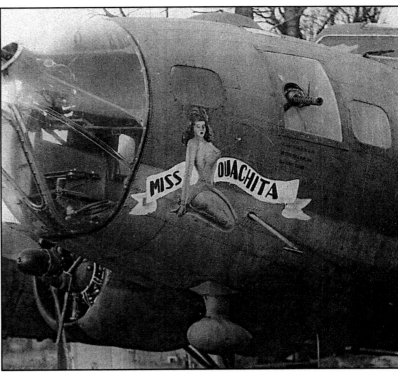

Left: MARY LOU B-17G-15-VE 42-97504, 323BS OR·P

Above: MISS OUACHITA B-17F-20-DL 42-3040, 323BS OR·Q

Below: SHIRLEY JEAN B-17G-35-DL 42-107040, 324BS DF·D also 323BS OR·K *Photos courtesy of Adam Dindenfass.*

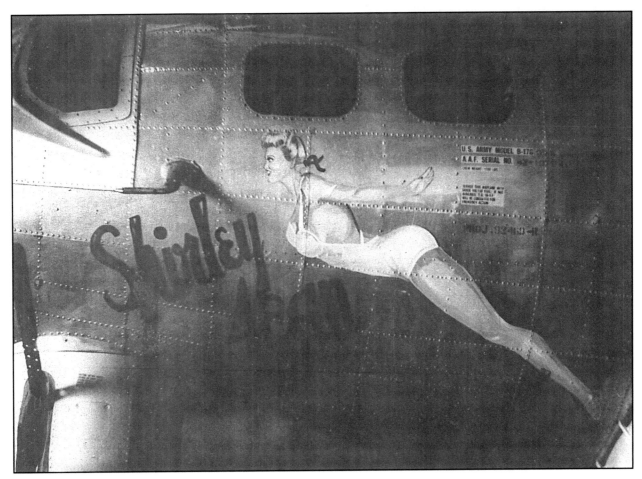

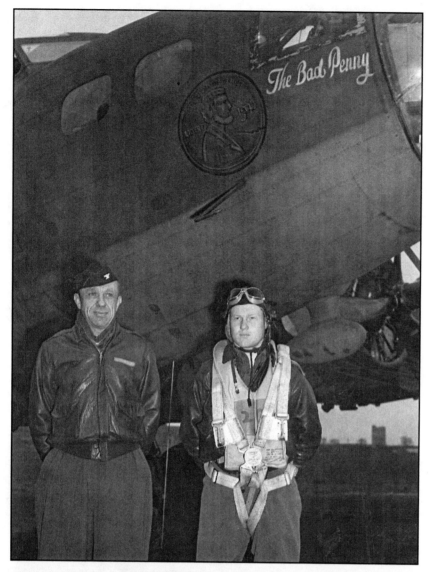

B17F-10-BO **THE BAD PENNY** 41-24480 324BS and 322BS. Col. A. A. Kessler with Capt. Charles "Red" Cliburn who is considered the most decorated pilot in the Eighth Air Force, flew this plane as a camera platform for the William Wyler's movie documentary "**The Memphis Belle**" during the winter of 1942-43.

Starcer painted the right side but the left side art was different and could have been done by another person since it was much simpler in design. The penny was replaced by a circle with the name within it and 21 bomb missions score added. One swastika painted above the bombs records the kill.

Opposite top: Starcer works on detailing this unidentified B-17G. *Starcer Archives*

Opposite middle right: B-17G-35-BO **ACK-ACK ANNIE** 322BS named after the British term "Ack-Ack" to describe Anti-Aircraft fire which most likely caused damage to the nose as can be seen by the patches. This led to Starcer touching up the art in the second photo opposite lower right. *Starcer Archives*

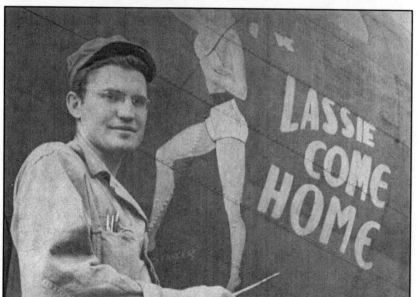

Left: B-17G-25-BO **LASSIE COME HOME** 42-31673 322BS is signed off by Starcer. This B-17 was lost on a mission near Eisenach 16 August, 1944. *Starcer Archives*

Other notable 91st BG nose artists were:

Charles Busa
Jack Gaffney
David Hettema

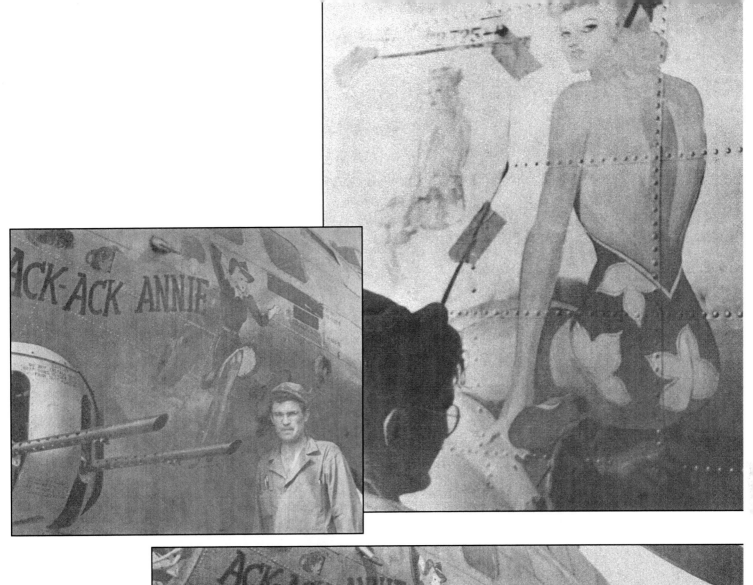

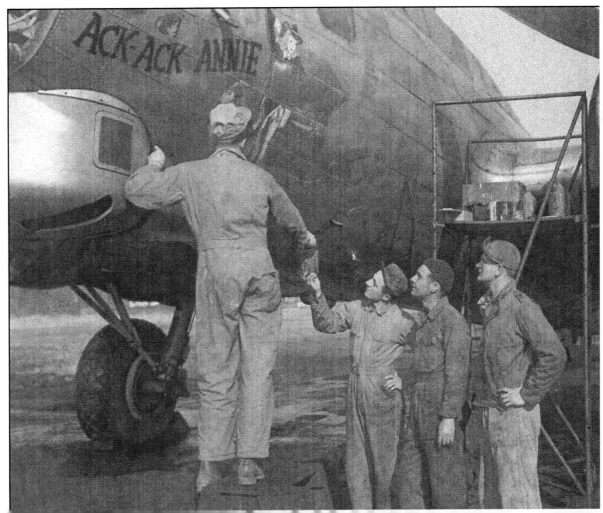

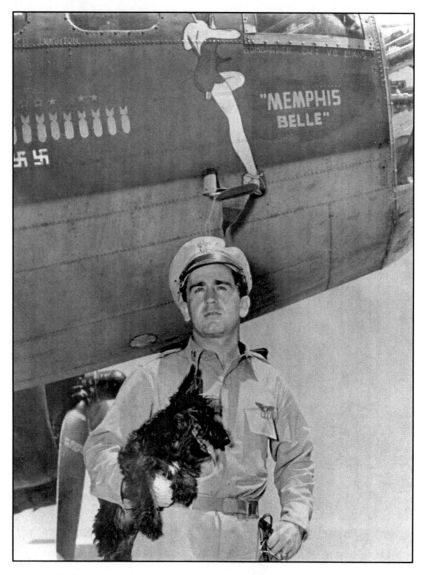

Co-pilot Jim Verinis with mascot Stuka during a stop on the war bond tour. Verinis later was given his own B-17 and named it **CONNECTICUT YANKEE**, which was his native state. *Photo courtesy of Linda Morgan.*

longer for A-2 or B-3 jackets. In many instances, the owner of the jackets would not show up to re-claim their wares so Starcer would store them and give them to the next of kin when he returned to the states.

The obvious recognizable design was the **MEMPHIS BELLE**, first 8th AF crew to complete 25 missions. Painted on both sides was a George Petty design requested by pilot Robert Morgan. Prior to being shipped out the B-17 was to be named **LITTLE ONE**, Morgan's pet nickname for his then fiancée Margaret Polk but after the crew seeing the movie Lady for a Night, they changed their mind. In the film, John Wayne who played Jack Morgan, was in love with Joan Blondell's character, Jenny Blake, aka Memphis Belle and steamboat gambling ship name. As fate would have it the crew settled on the revised name. Morgan then wrote to Esquire requesting that Petty send a design for the nose art. The result was the April 1941 gatefold painted by Starcer in Bassingbourn, England. The reason for the two color nighties on the pin-up was simply running out of one color. Being an earlier work, the shading detail in flesh tones was not as defined as other artists of today have depicted. It is more 2-D as opposed to latter. Another question I get asked a lot is the stars above the bomb mission symbols. A yellow star denotes the 91st Group as lead ship while a red star outlined in yellow was for flying wing lead B-17. Today, the **BELLE** is once again undergoing restoration while a permanent facility is being worked out by the USAF and Memphis Belle Association.

Starcer gave up painting after the war as abruptly as getting into it. He got married and and realizing the strong competitiveness in the graphics business, opted to move up the ladder in the May Company. The only other post WWII nose art Starcer did was when the original **SHOO SHOO BABY** was restored in 1981. Unfortunately Starcer passed before the original **BELLE** was restored, so the art was done by his nephew Tom Starcer.

Sgt. Eugene Townsend
301st Bomb Group, 32nd Bomb Squadron, England, North Africa and Italy

As a youngster, Townsend first explored art by a mail order correspondence art course. Later he worked as an apprentice for a local sign shop. Enlisting in December 1941 and assigned to the 32nd BG, Townsend painted crates, signs and A-2 jackets. At Westover AAB, Massachusetts, prior to being shipped overseas, he began painting names on aircraft. Soon after completing his first B-17 nose art, **BAD PENNY**, the squadron soon had him painting others including **LEADFOOT**, **PLAYBOY**, **PLUTOCRAT(E)**, **HUN-PECKER** and **THE GREMLIN**. The group moved from England to North Africa and finally Italy. His designs would be derived from the crews, then sketched out in chaulk and painted. The paints would be obtained from a variety of sources. The brushes, lettering quills and artists brushes were requisitioned. Some 40 B-17s of the 301st BG nose art were painted by Townsend.

After the war, he continued to work in the advertising trade industry until settlement back to his native state of Maine. Today at age 83, Townsend occasionally does pencil sketches and unfortunately can not use oil based paints due to prolonged use and contact of lead paints.

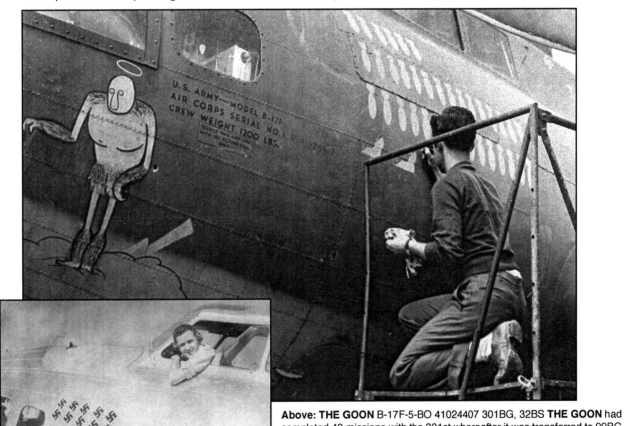

Above: THE GOON B-17F-5-BO 41024407 301BG, 32BS **THE GOON** had completed 48 missions with the 301st whereafter it was transferred to 99BG and completed a further 34 missions before being declared war weary in March 1944. The Fortress was ultimately scrapped at Walnut Ridge in December 1945.

The nose art was painted on both sides of the nose as a mirrored image but the mission tally (in three rows) was applied to the left side only.
Courtesy of Eugene Townsend

Left: MISS TALLAHASSEE LASSEE 42-97906.
Courtesy of Eugene Townsend

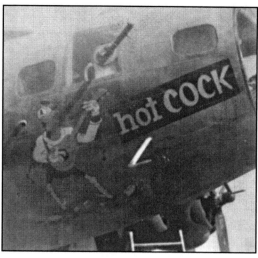

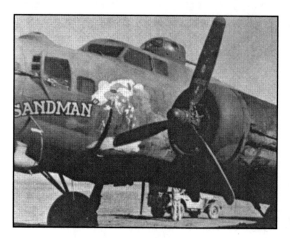

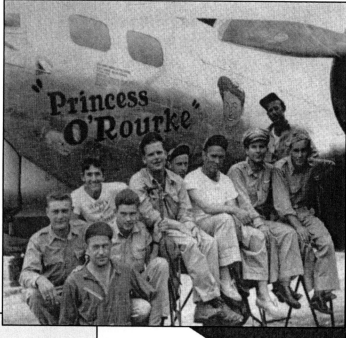

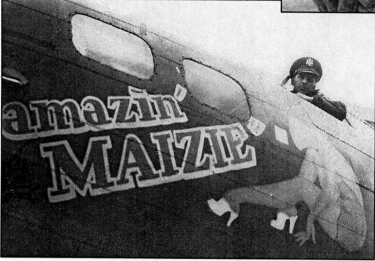

Upper left: Two examples of sketches from Townsend's war time sketch book.

Upper right: B-17 42-5836 **HOT COCK**

Middle left: B-17 42-30333 **SANDMAN**

Middle right: B-17 44-6347 **PRINCESS O'ROURKE**

Left: B-17 42-31886 **AMAZIN' MAIZIE**
All photos courtesy of Eugene Townsend.

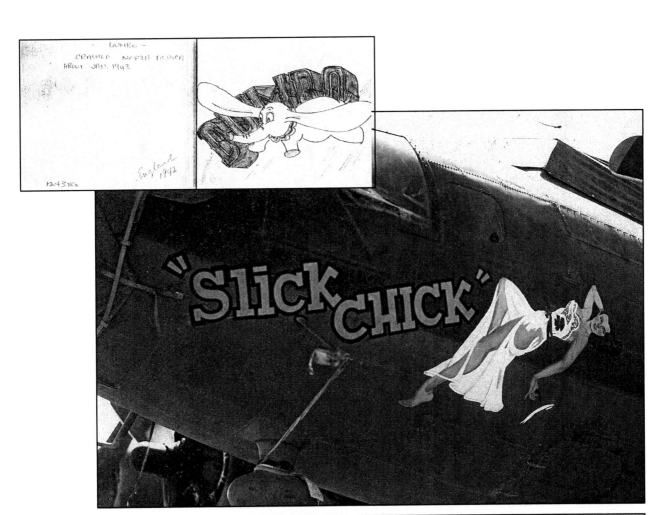

Top: Another example of Townsend's sketch designs for nose art. The flying elephant is a from Disney's "**DUMBO**" and appeared on the 32nd BS B-17 41-24350.

Above right: B-17F **SLICK CHICK** 42-3343 is another 32nd BS B-17.

Right: B-17G **SHOO-SHOO BABY** is presumably from the 32nd BS but no further info has been found and is considered an unknown.

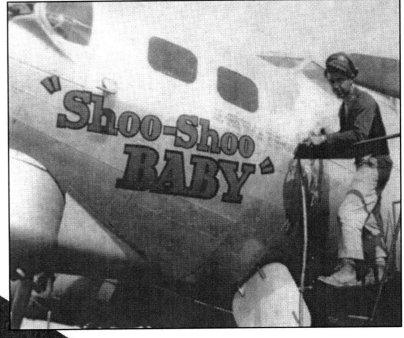

B-17 **HITLER'S HEADACHE**, B-17 **MISS CONDUCT** 43-38525 100BG, 418BS, B-17F **KNOCK-OUT DROPPER** 41-24605 303BG, 359BS, was the first B-17 in the 8th Air force to complete 50 missions on 16 November 1943. After a total 75 missions, it returned to the States on 10 May 1944.

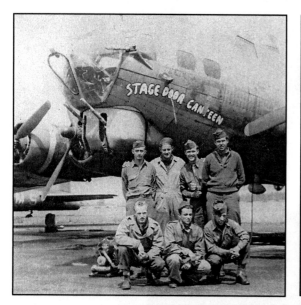

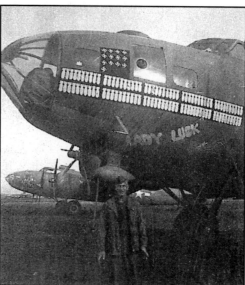

Left: B-17G **STAGE DOOR CANTEEN** 42-31990 381BG, 535BS

Right: B-17F **LADY LUCK** - Unknown

Opposite page bottom left: B-17F **SNOOZIN' SUZAN** 42-2981 97BG, 414BS

Opposite page bottom right: B-17F **NAPOLIS EXPRESS** - Unknown

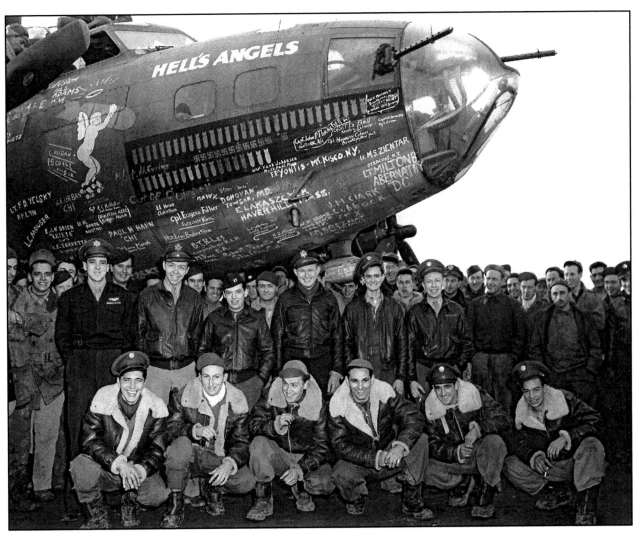

HELL'S ANGELS
B-17F 41-24577 303BG, 358BS

HELL'S ANGELS officially became the first B-17 in the 8th Air Force to complete the required 25 missions on 13 May 1943. Flown by its primary pilot Capt. Ira E. Baldwin, the bomber completed its first mission to St. Navarrone on 17 November 1942. After its fourth mission, the crew decided to name the B-17 after the 1930s Howard Hughes movie. The nose art was applied by S/Sgt. Harold Goldwin. **HELL'S ANGELS** went on to fly a total of 48 missions before being flown back to the USA on 20 January 1944 piloted by Capt. John B. Johnston where the original crew was reunited with the B-17 on War Bond tours.

Pictured left to right, front kneeling: M/Sgt. Fabian S. Folmer, T/Sgt. Edward A. West Jr., S/Sgt. Kasmer Wegrzyn, Sgt. John R. Kosilla, Sgt. Wilson F. Fairfield and S/Sgt. Ernest H. Touhey. Standing L to R: Capt. John B. Johnston, Capt. Donald F. Decamp, Capt. Richard E. McElwain, Lt. Lawrence E. McCord, T/Sgt. Wayne E. Briggs and M/Sgt. Cayrl C. Zeller.

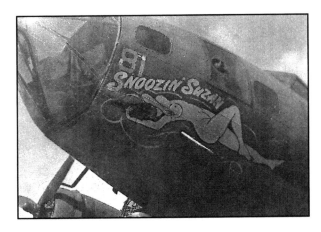

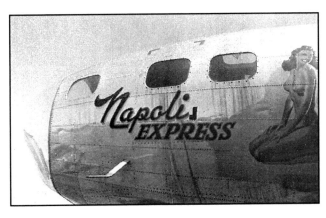

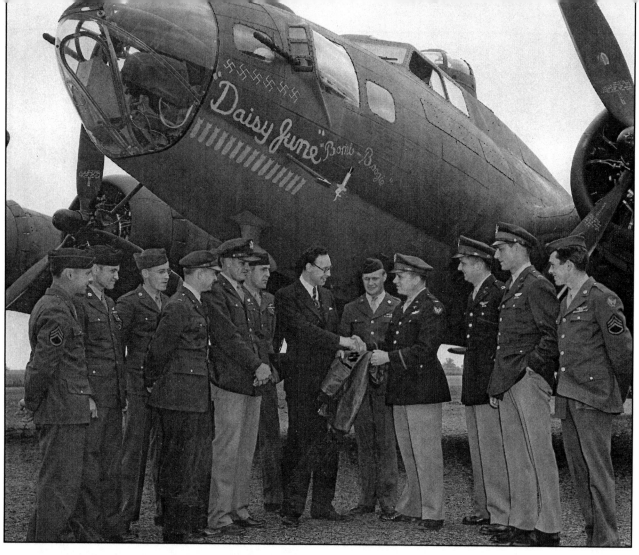

Above: B-17F **DAISY JUNE "BOMB BOOGIE"** 42-30369 96BG, 339BS. Peter Masefield, correspondent for the "Sunday Times" was presented with an A-2 jacket by CO T.S. Old, Jr. replete with insignia (censored) and autographed by the crew. Masefield flew on a mission over France and is seen on his return to the states. 24 July, 1943.

Below: B-17F-75-BO **OKLAHOMA OKIE** 42-29921 91BG, 324BS. The crew dons flak armor suits prior to a mission. It appears that the name has been recently applied. The fresh paint clearly shows the difference from the faded paint. June, 1943.

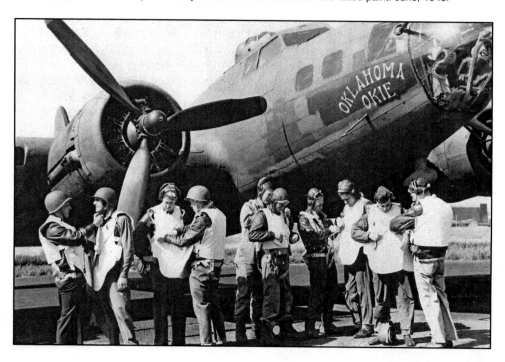

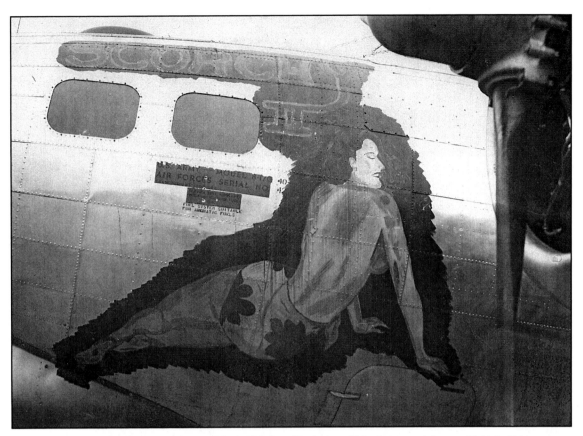

B-17G **SCORCHY II** 42-97058 303BG, 359BS flew 37 missions. This photo was taken on 22 April, 1944.

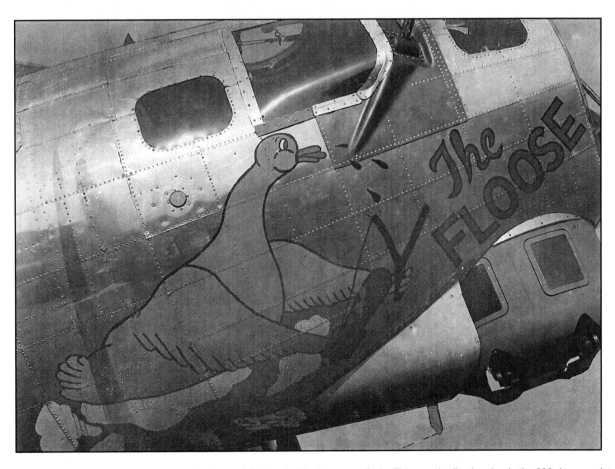

B-17G-45-BO **THE FLOOSE** 42-97298 303BG, 358BS flown by 2Lt. Lawrence Stein. This was the first bomber in the 303rd to complete 100 missions. It was later transfered to the 96BG on 22 April, 1944 when this photo was taken.

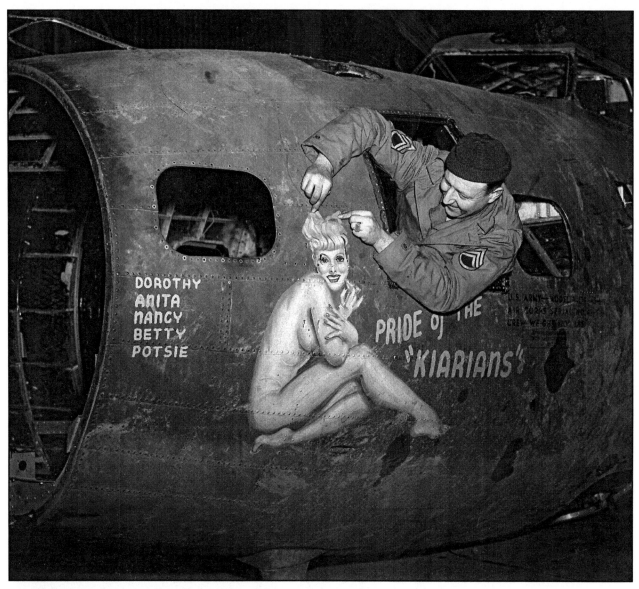

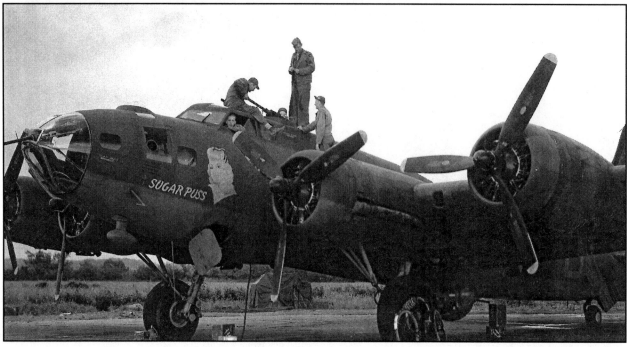

388TH BOMB GROUP
560·561·562·563 BS
KNETTISHALL

 Twenty eight year-old Col. William B. David took official command of Station 136 on June 23, 1943 and the first 17 of some 300 Flying Fortresses arrived.

 The first mission for the 388th was flown by Col. David in the lead plane on July 17. One of 306 combat missions the group would carry out including leading the 8th AF air support on D-Day.

 The 388th was the only group in the 8th Air Force that did not have squadron identity code markings on its B-17s.

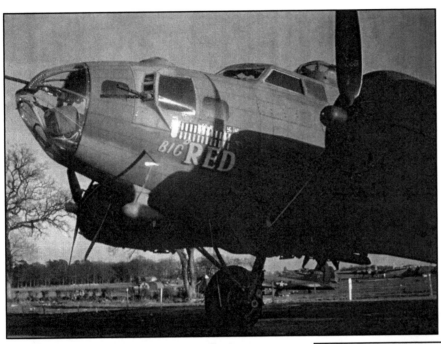

Opposite page top: B-17 **PRIDE OF KIARIANS** 42-5251 306BG, 368BS.

Opposite page bottom: B-17F **SUGARPUSS** 42-3088 384BG, 544BS. Lost to enemy fighters over Hamburg 7/25-43.

Above: **BIG RED** 42-30207 561BS

Middle right: **CAPTAIN JOE** 42-31153 562BS

Below: **BLIND DATE** 42-30195 560BS.
Photos Louis Lane via 388th BG (H) Assn.

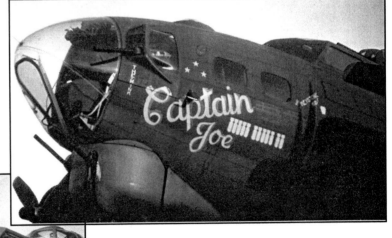

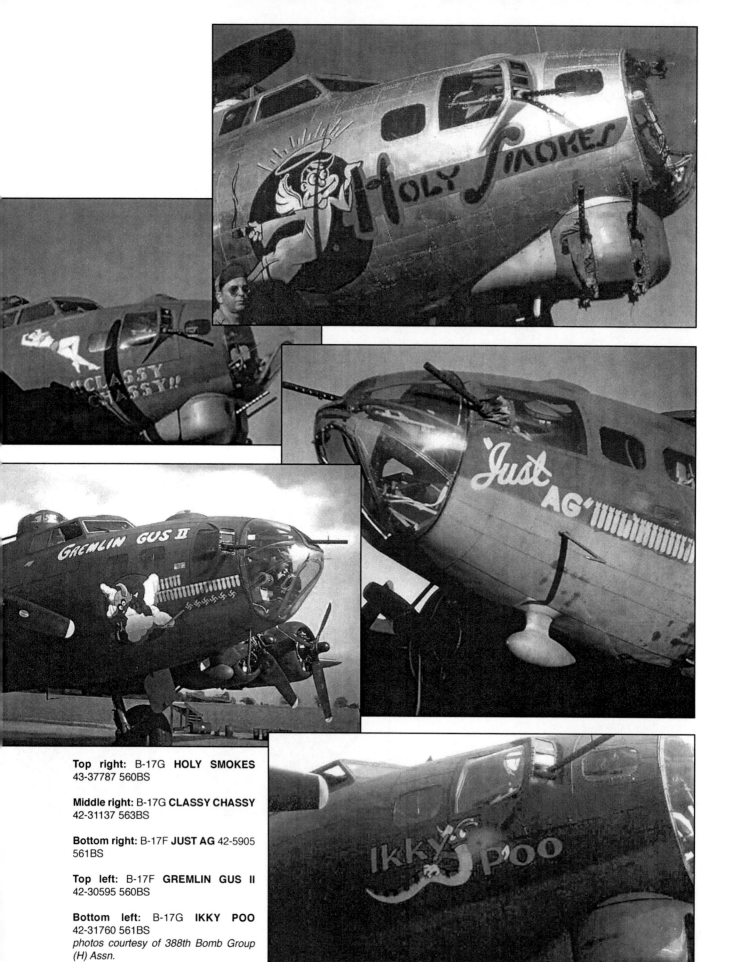

Top right: B-17G **HOLY SMOKES** 43-37787 560BS

Middle right: B-17G **CLASSY CHASSY** 42-31137 563BS

Bottom right: B-17F **JUST AG** 42-5905 561BS

Top left: B-17F **GREMLIN GUS II** 42-30595 560BS

Bottom left: B-17G **IKKY POO** 42-31760 561BS
photos courtesy of 388th Bomb Group (H) Assn.

44

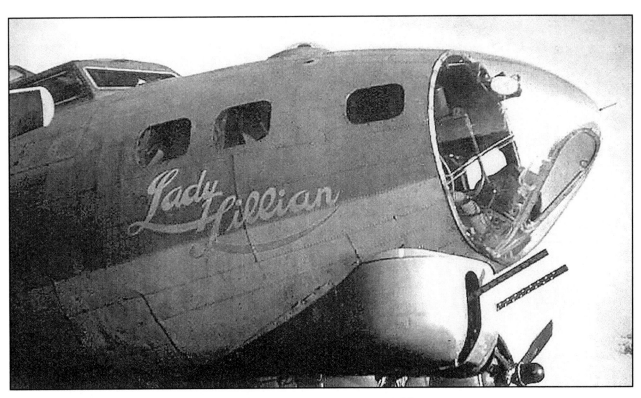

B-17G **LADY LILLIAN** 42-31996 561BS

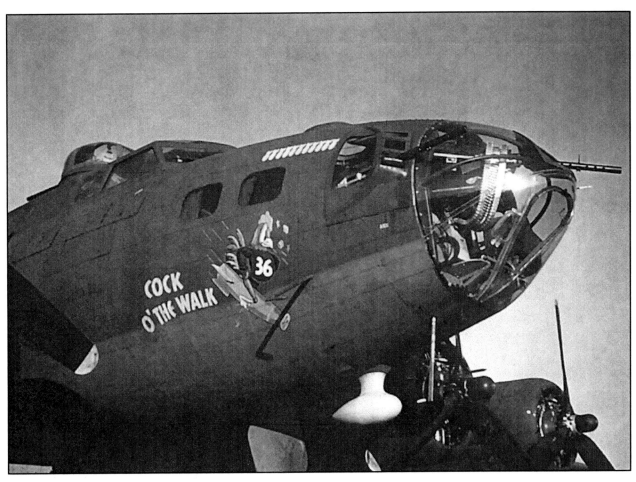

B-17F **COCK O' THE WALK** 42-30800 563BS *photos 388th Bomb Group (H) assn.*

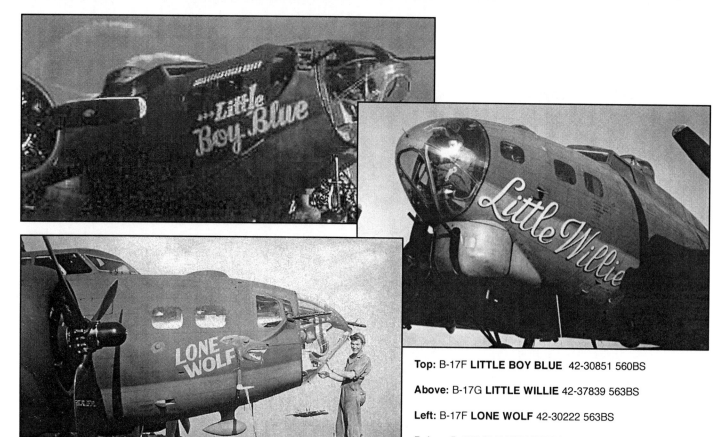

Top: B-17F **LITTLE BOY BLUE** 42-30851 560BS

Above: B-17G **LITTLE WILLIE** 42-37839 563BS

Left: B-17F **LONE WOLF** 42-30222 563BS

Below: B-17F **OLD IRONSIDES** 42-30030 560BS
photos 388th Bomb Group (H) assn.

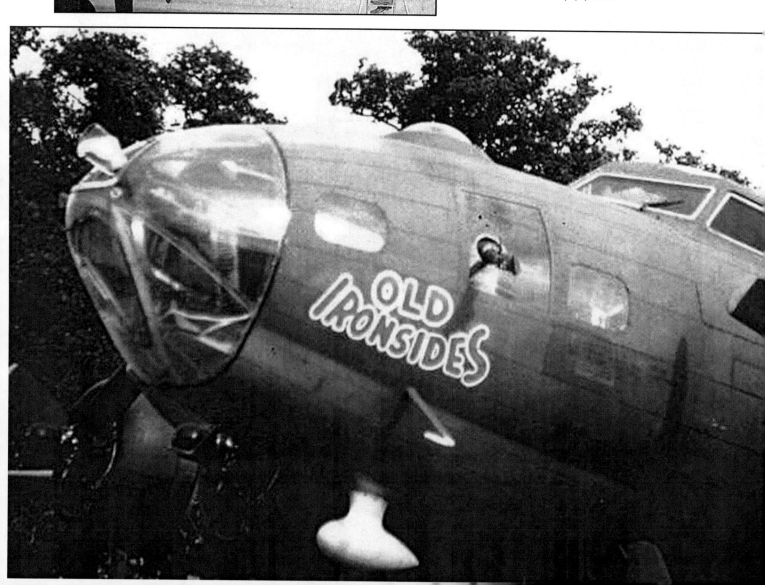

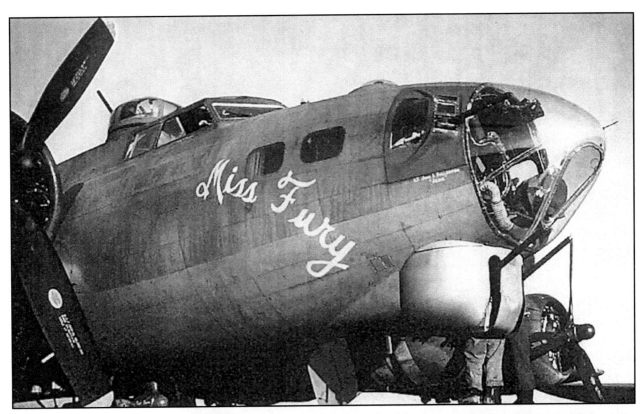

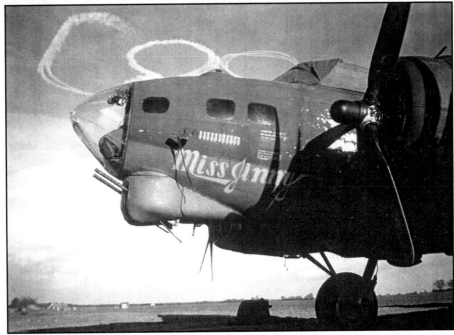

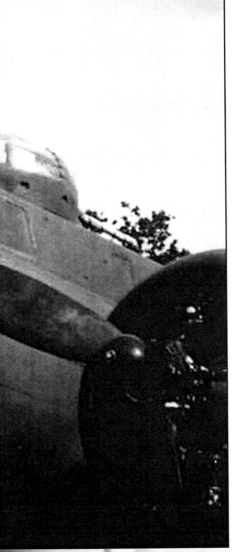

Top: B-17G **MISS FURY 4**

Above: B-17G **MISS JINNY 4** 560BS.
Note the contrail sky writing depicting 388.

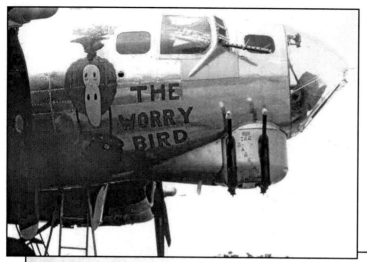

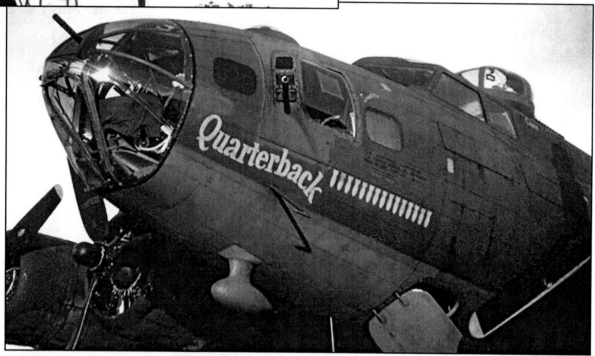

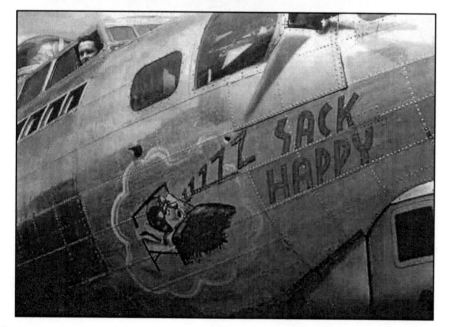

Top: B-17G **THE WORRY BIRD**
42-107062 562BS

Middle: B-17F **QUARTERBACK**
42-30212 562BS

Bottom: B-17G **SACK HAPPY**
42-97873 563BS

Photos 388th Bomb Group (H) assn.

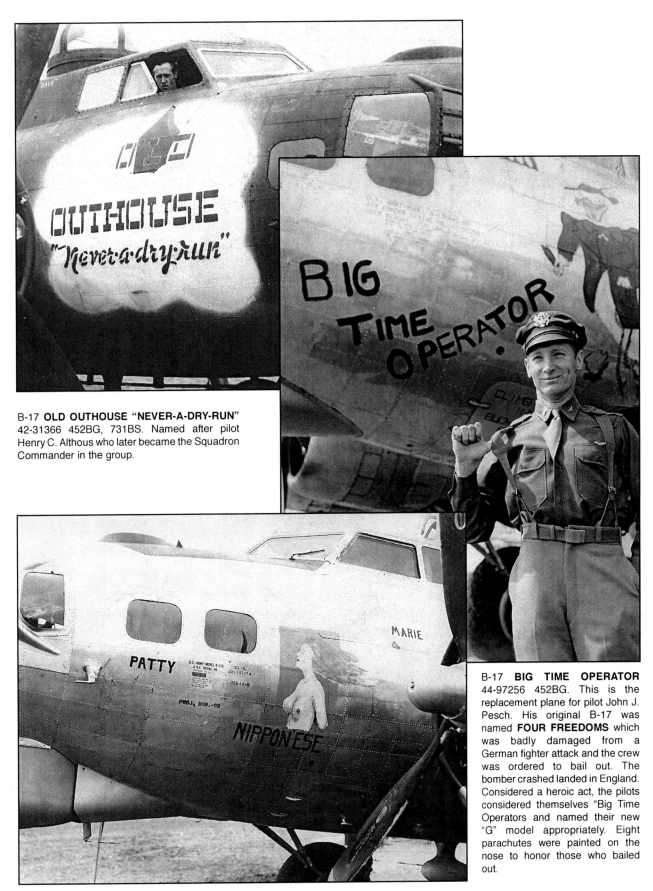

B-17 **OLD OUTHOUSE "NEVER-A-DRY-RUN"**
42-31366 452BG, 731BS. Named after pilot
Henry C. Althous who later became the Squadron
Commander in the group.

B-17 **BIG TIME OPERATOR**
44-97256 452BG. This is the
replacement plane for pilot John J.
Pesch. His original B-17 was
named **FOUR FREEDOMS** which
was badly damaged from a
German fighter attack and the crew
was ordered to bail out. The
bomber crashed landed in England.
Considered a heroic act, the pilots
considered themselves "Big Time
Operators and named their new
"G" model appropriately. Eight
parachutes were painted on the
nose to honor those who bailed
out.

B-17G **NIPPON'ESE** 42-107174 452BG.

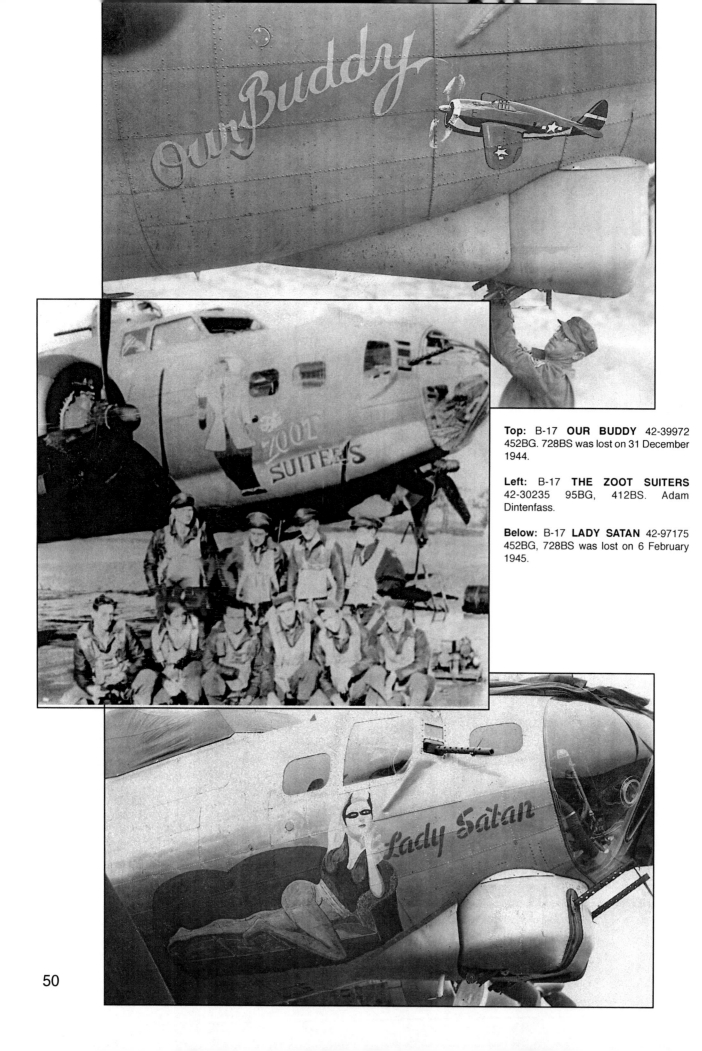

Top: B-17 **OUR BUDDY** 42-39972 452BG. 728BS was lost on 31 December 1944.

Left: B-17 **THE ZOOT SUITERS** 42-30235 95BG, 412BS. Adam Dintenfass.

Below: B-17 **LADY SATAN** 42-97175 452BG, 728BS was lost on 6 February 1945.

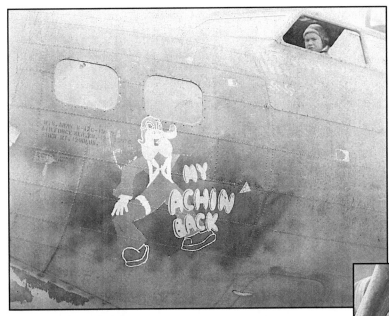

Top: B-17 **MY ACHIN' BACK** 42-39976 452BG, 731BS. Pilot Eugene Lohman named this B-17 while training at Walla Walla when a crew member complained about his back upon learning of another boring formation flight the next day.

Middle left: B-17 **IDIOTS' DELIGHT** 42-30301 94BG, 332BS painted bomb missions being applied after another successful mission. *USAF*

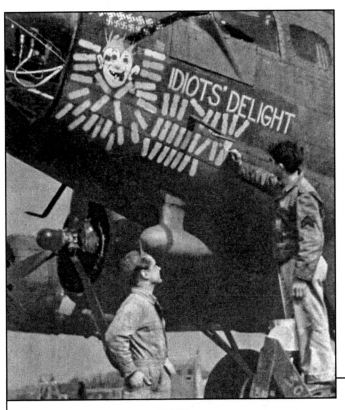

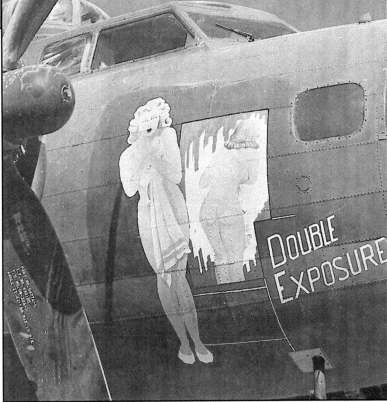

Middle right: B-17 **DOUBLE EXPOSURE.**

Left: B-17 **ROSALIE ANN II** 42-38145 452BG, 730BS was a replacement for the crew's fist B-17 named after the pilot and co-pilots's wives.

51

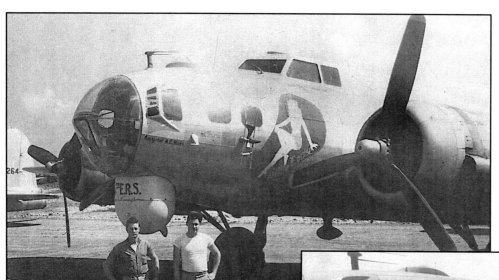

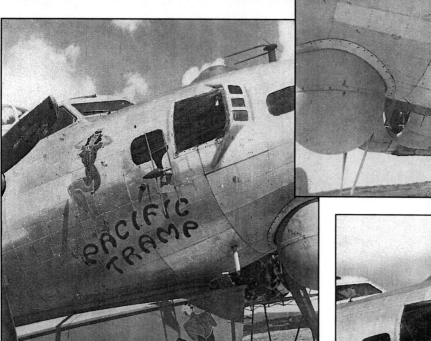

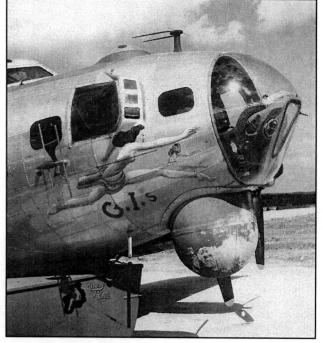

Top left: B-17G **BILLIE LOUISE** 43-39264 is a conversion with radar and Air/Sea Rescue (Dumbo).

Below: B-17G -105-BO 43-39272.

Above: B-17G **PACIFIC TRAMP** another conversion with the droppable life raft also adorns nose art.

Right: B-17G **G.I.s** with matching art named **CINDY 7TH ERS**. The aluminum skin is so shiny that the artist incorporated the pin-up with a reflection image as if it were mirror.

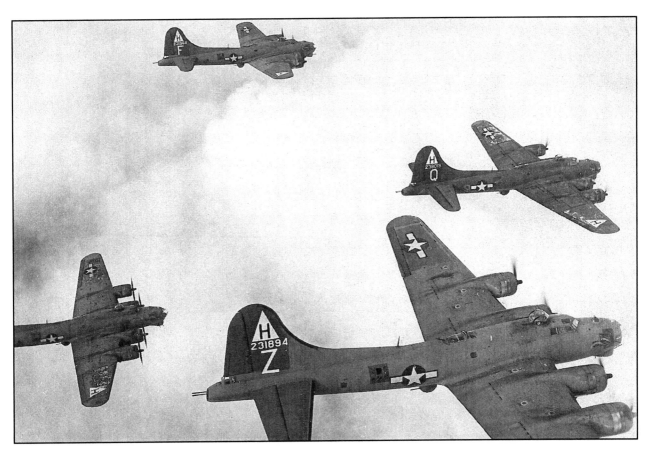

B-17s of the 306th Bomb Group en route to target.

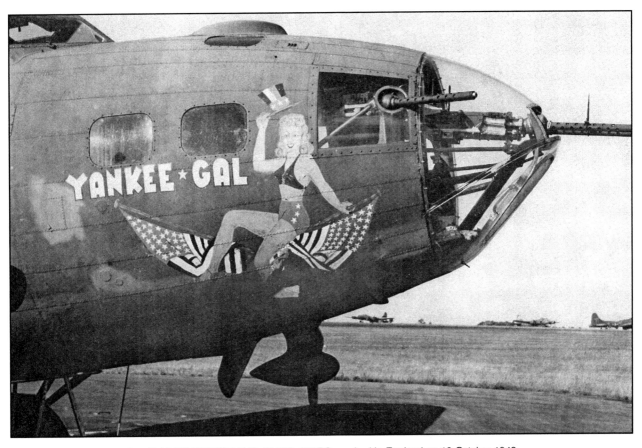

B-17F-60-BO **YANKEE GAL** 384BG, 547BS crashed in England on 10 October 1943.

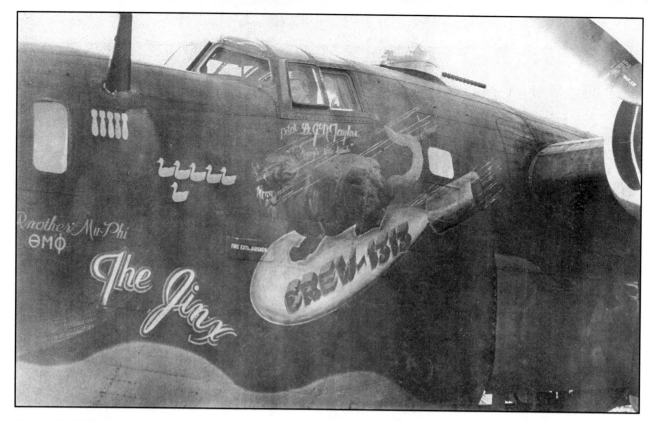

B-24H-1-FO **THE JINX** 44BG, 68BS transferred from the 392BG and ultimately lived up to its name. After a crash landing, battle damaged repaired, it crashed again and burned killing all on board 13 Jan '44 at Letton Hall, Cranworth, Norfolk.

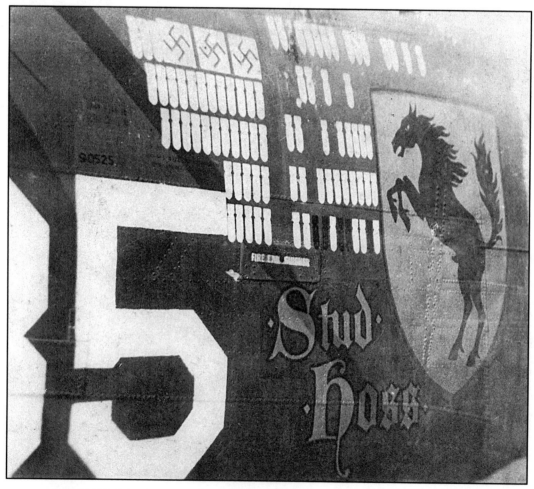

B-24 **STUD HOSS** 42-52658 borrowed the Ferrari logo from the 484BG or 461BG 15AF Italy.

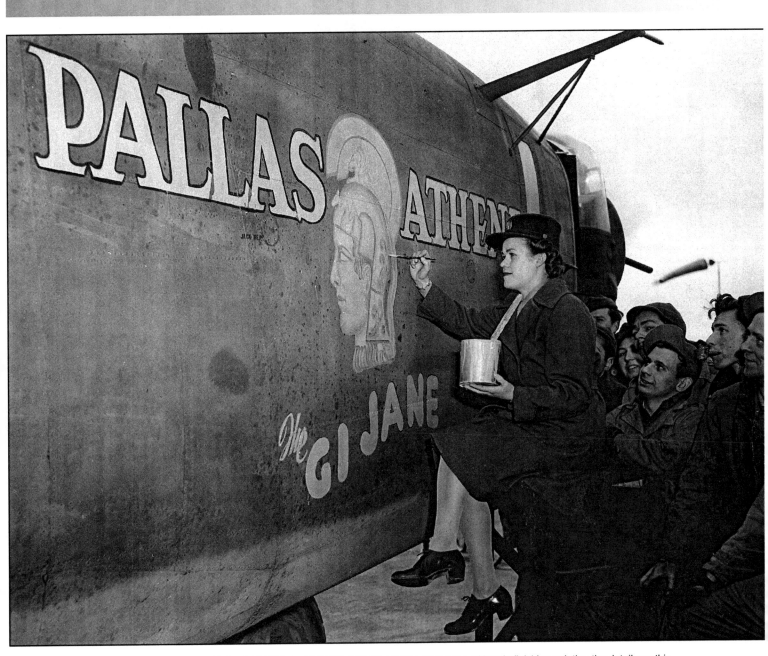

B-24J-80-C0 **PALLAS ATHENE the GI JANE** s/n 44-50505 392BG, 578BS. PFC Emma Utter is finishing painting the details on this battle hardened B-24. It took 16 hours to complete this piece and was the first bomber named in honor of the WAC 12 Feb. 1944.

LIBERATOR

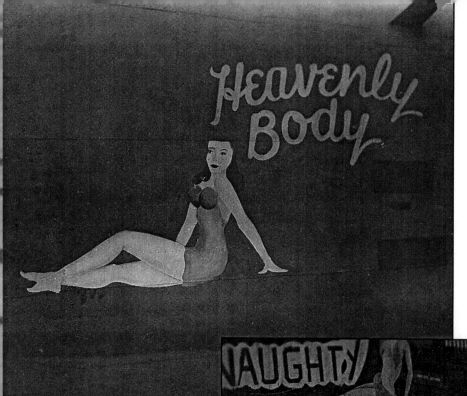

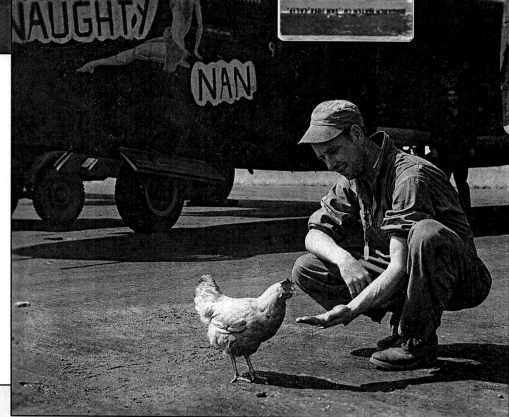

Above: HEAVENLY BODY B-24H-15-DT 41-28878 from the 34th Bomb Group, 18th Bomb Squadron was transferred to the 450th Bomb Group (MTO) and eventually returned to the USA.

Right: NAUGHTY NAN B-24H-15-FO 42-51581 446BG, 705BS. This a/c was forced to make a crash landing when its left main gear would not come down. The name is in blue surrounded in stylized white clouds. A blue scarf covers the pin-up and the hair is a pink/purple mix!

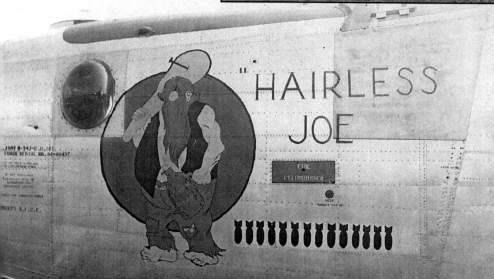

Left: HAIRLESS JOE B-24J-161-CO 44-40437 44BG, 506BS transferred from the 493BG in October 1944. A character from the popular comic strip Li'L Abner was the maker of the libation "Kickapoo Joy Juice".

The series of characters from this strip was widely used as nose art on a variety of aircraft. *Adam Dintenfass.*

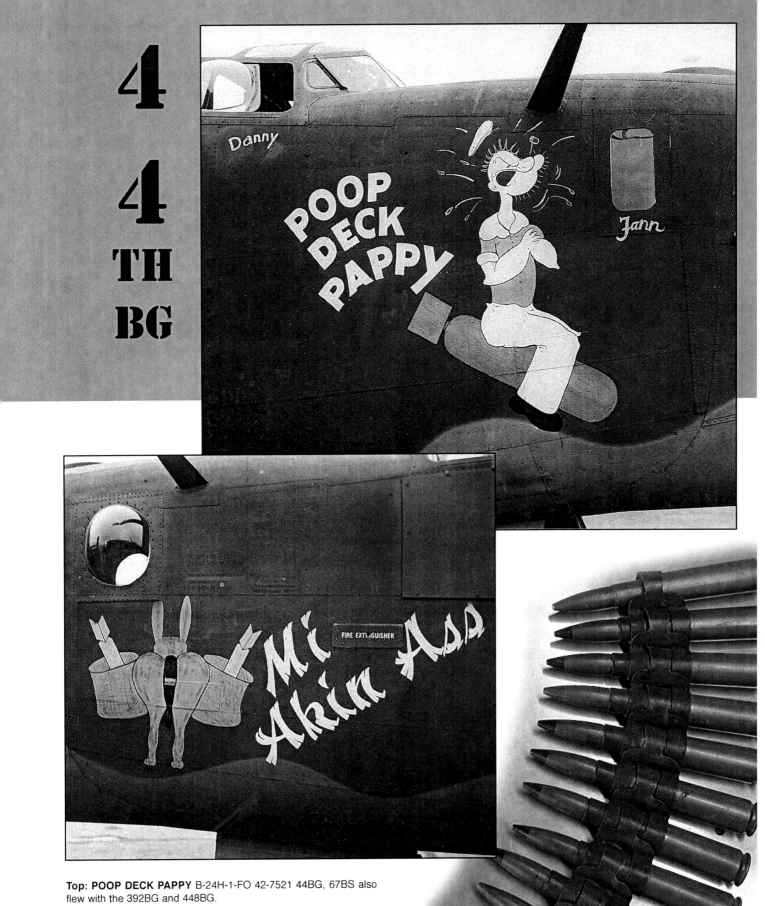

4 4 TH BG

Top: **POOP DECK PAPPY** B-24H-1-FO 42-7521 44BG, 67BS also flew with the 392BG and 448BG.

Bottom: **MI AKIN ASS** B-24H-20-FO 42-94846 44BS, 67BS ended the war with 127 missions and returned to the states 22 May 1945. Bomb mission markings were later added on the armor plating.

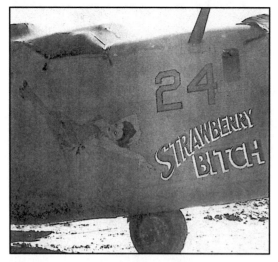

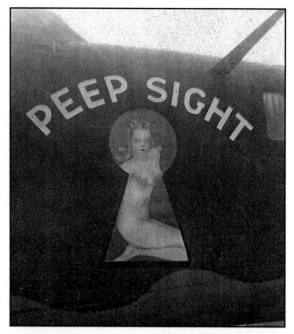

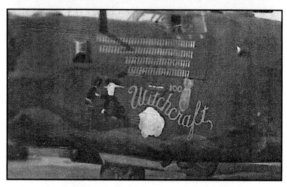

Top left: B-24D-160-CO **STRAWBERRY BITCH** 42-72843 376BG, 512BS. Lettering is red, black outline and white shadow. Pinup hair is orange/red and outfit is blue. The a/c # is yellow with a black outline.

Top left: B-24H-1-FO **PEEP SIGHT** 42-7535U 44BG, 506BS 3 B-24s from the 44BG.

Above right: B-24 H-15-FO **WITCHCRAFT** 42-52534 467BG, 790BS flew 130 combat missions without an abort or casualties.

Above right: B-24 J-1-FO **RAMP ROOSTER** 42-50671 482BG, 36BS later had **RED ROOSTER** painted below the name. Red lightning bolts through clouds were used as missions

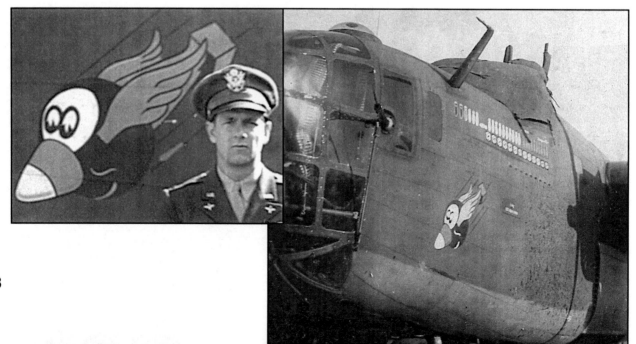

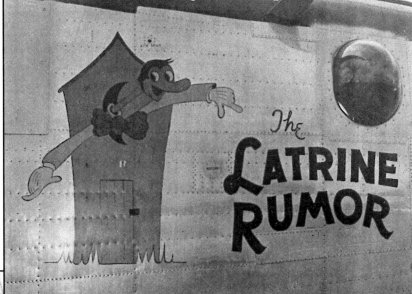

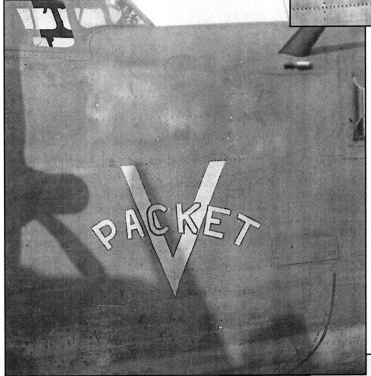

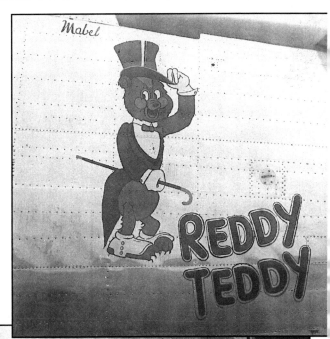

Top: an unidentified B-24 from the 93BG.

Middle left: B-24H-1-CF **V PACKET** 41-29156 44BG, 68BS. *Adam Dintenfass.*

Top right: B-24 **LATRINE RUMOR** 44-40271 491BG, 854BS *Adam Dintenfass.*

Middle right: B-24 **REDDY TEDDY** 41-23721 93BG, 330BS. *Adam Dintenfass.*

Bottom: B24 J-5-FO **SLEEPING DYNAMITE** 42-50839 93BG. *Adam Dintenfass.*

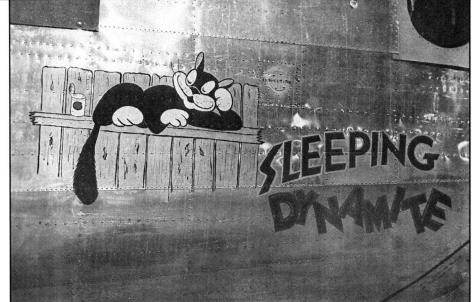

59

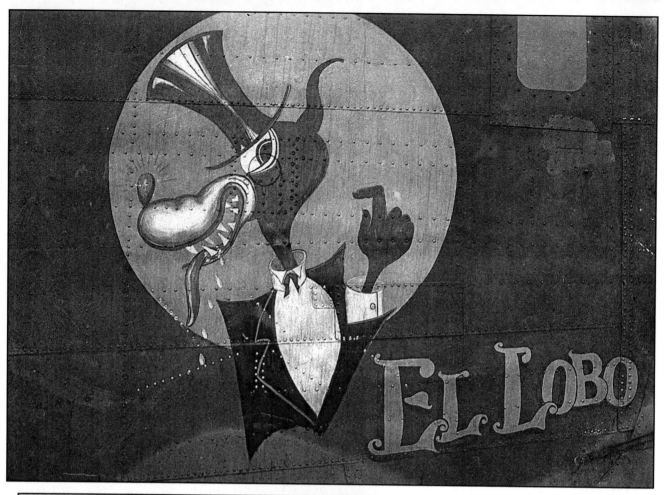

Above: EL LOBO B-24H-1-FO 42-7510 392BG, 579BS. The artist was waist gunner John S. Walters.

Left: SHOO SHOO BABY! B-24H-15-FO 42-52747 446BG, 707BS crashed in Belgium on 27 Dec. 1944. Bomb mission symbols were later added to armor plate.

Below: OUR HONEY B24 H-20-CF 42-50302 448BG, 713BS.

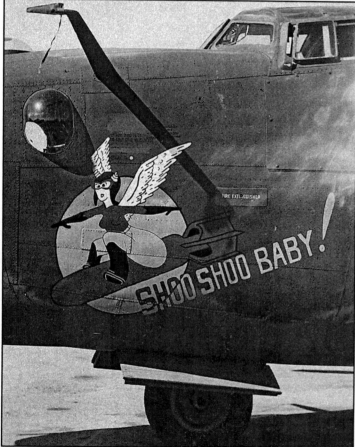

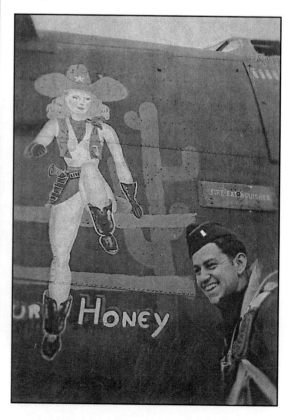

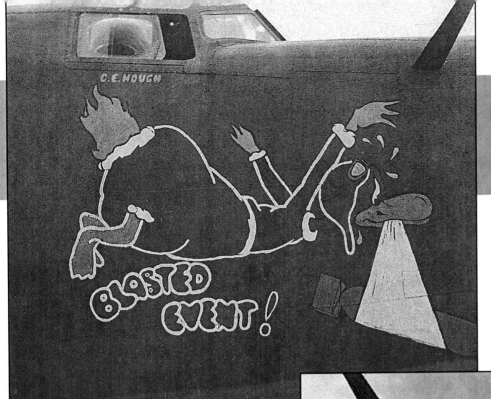

Top: BLASTED EVENT! B-24H-15-CF 42-52487 445BG, 700BS first flew with the 487BG, 837BS Harrington by its then aircraft commander, Lewis Houston. It was declared war weary on 29, May 1945. Note the lettering similarity to the now famous B-29 **BOCKS CAR**.

Right: The left side was a virtual mirror image with slight differences in the tail, hands and feet. *Adam Dintenfass*

Below: B-24H-25-FO **HARE FORCE** 445BG, 700BS was lost September, 1944 on a Kassel mission. *Adam Dintenfass*

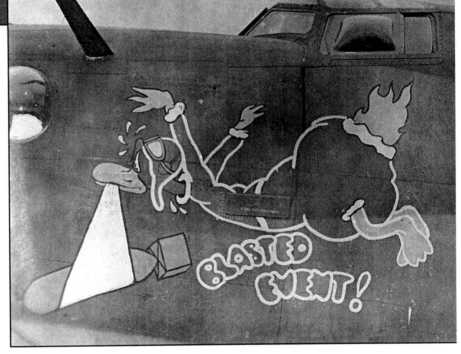

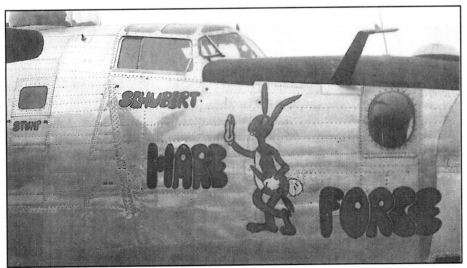

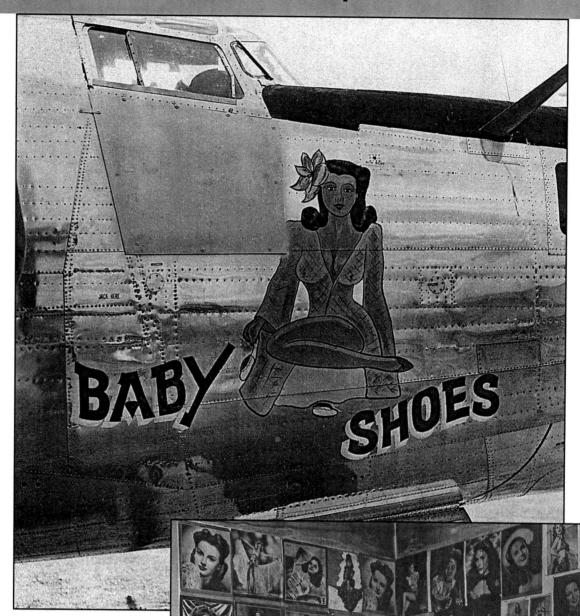

Above: BABY SHOES B24 J-1-FO 42-50555 753BS also flew eight missions with the 492BG.

Right: Regular Army office with walls lined like wallpaper was a common practice and must have been a distraction at times.

BRINEY MARLIN B24 H-25-FO
42-95183 753BS was lost in a
mid-air collision 27 May 1944.
The art appeared on both sides.

BIG CHIEF lil' BEAVER
B24 J 42-51514.

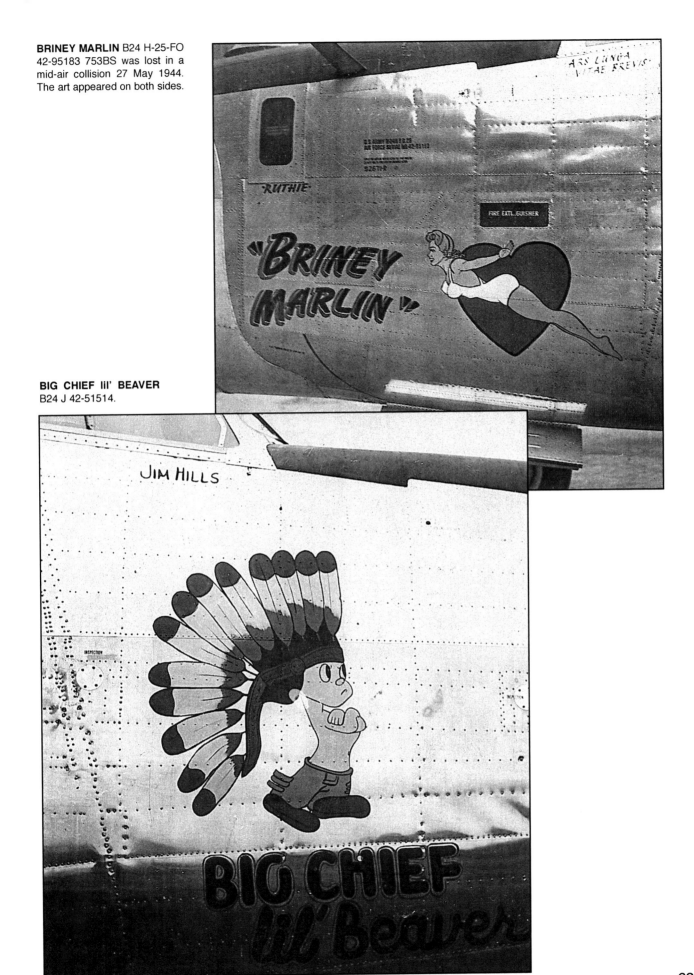

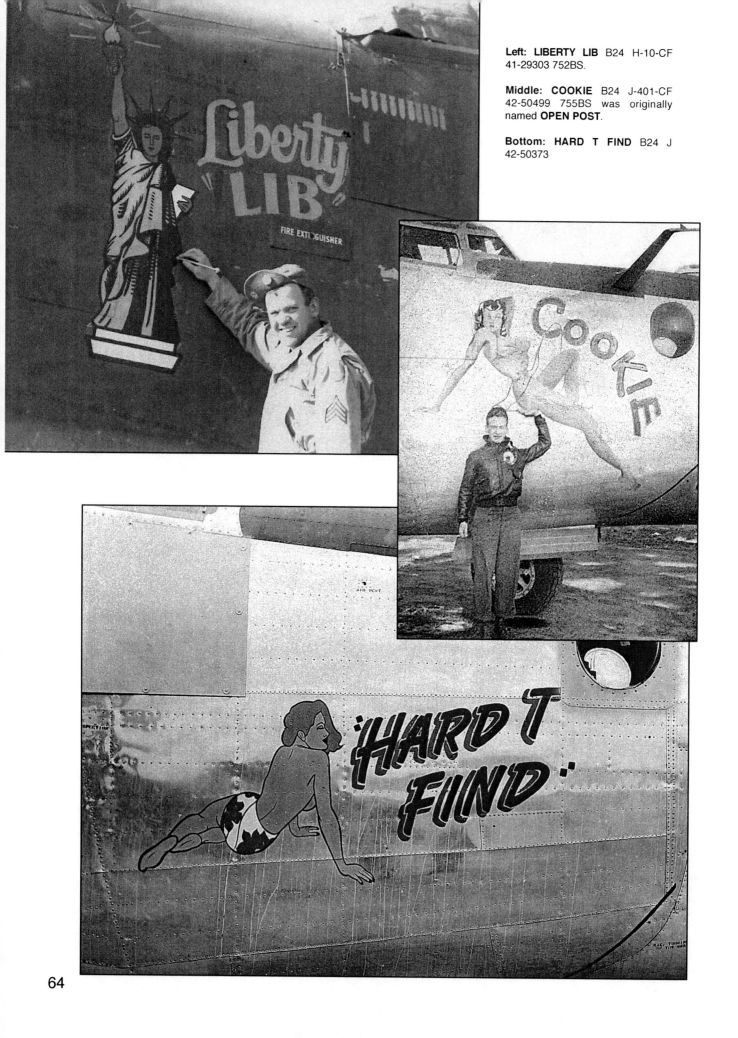

Left: **LIBERTY LIB** B24 H-10-CF 41-29303 752BS.

Middle: **COOKIE** B24 J-401-CF 42-50499 755BS was originally named **OPEN POST**.

Bottom: **HARD T FIND** B24 J 42-50373

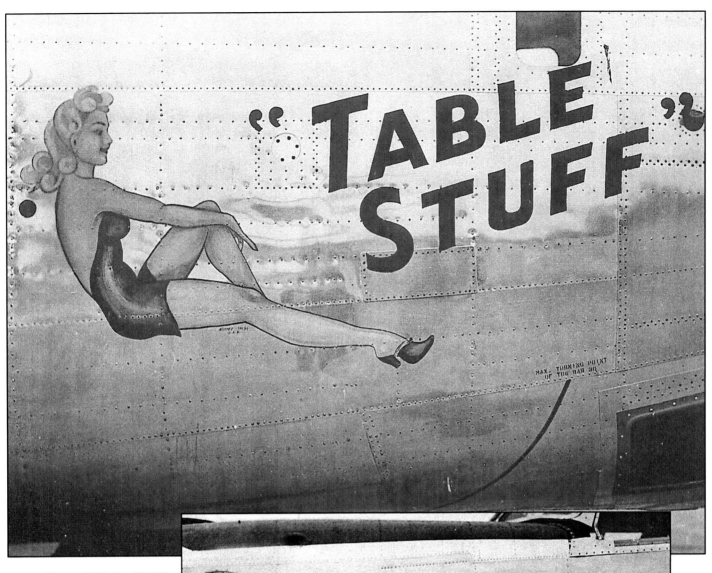

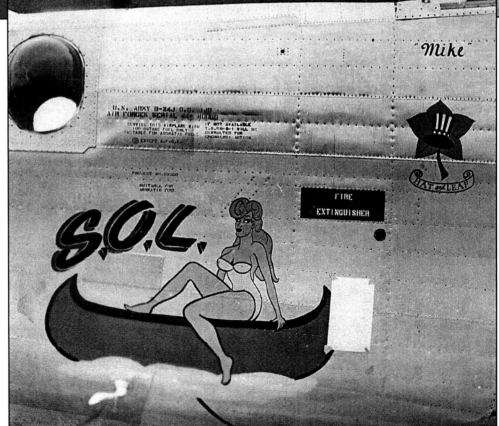

Top: TABLE STUFF B-24J-155-CO 44-40285 755BS.

Right: S.O.L. B24 J-145-CO 44-40066 753BS originally assigned to the 492BG and flew three missions before being transferred to the 458BG. The art appeared on both sides. It is obvious that the artist had a preference to a lettering style.

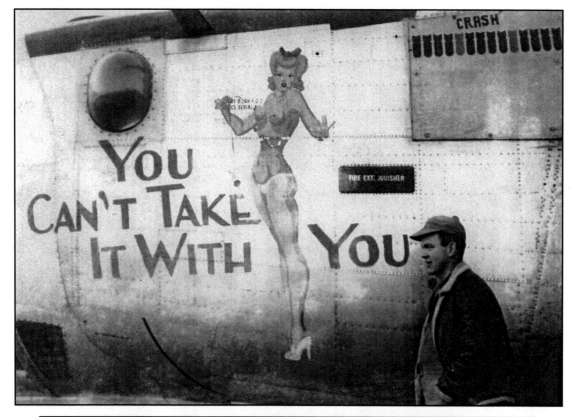

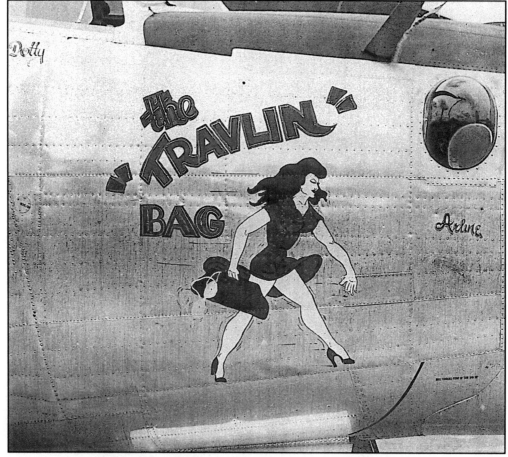

Top: **YOU CAN'T TAKE IT WITH YOU** B-24 H-25-FO 42-95117 752BS

Bottom: **THE "TRAVLIN" BAG** B-24 J-5-FO 42-50912 753BS

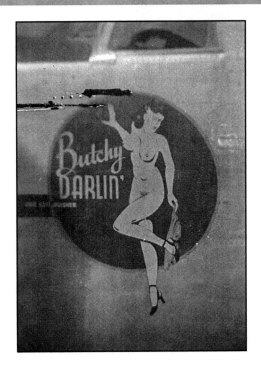

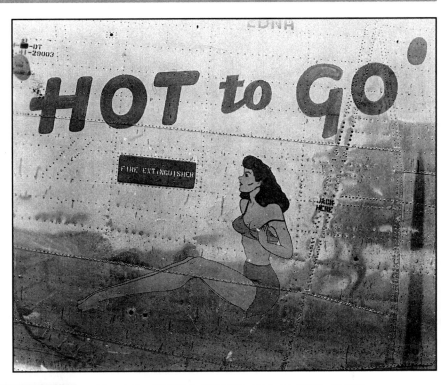

Top left: BUTCHY DARLIN' B24 44-41049 716BS. Replacement ship and salvaged on 11 August 1945.

Top right: HOT TO GO B-24H-20-DT 41-29003 719BS. The same art appeared on the right side. Reassigned to another bomb group after depot repair.

Left: LOS LOBOS B-24 42-07761 719BS. The Co-pilot painted the nose art on this a/c. The right side had similar art but no name. With drawn form combat and used for parts.

Below: B-24 J-15-CF **DRAGGIN' WAGGIN'** 42-99770 449BG, 716BS.

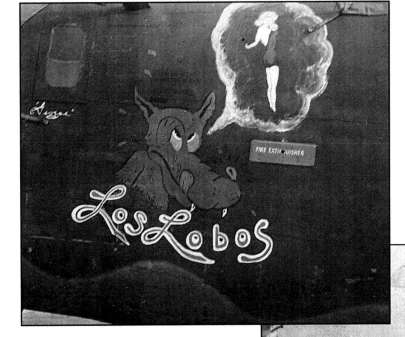

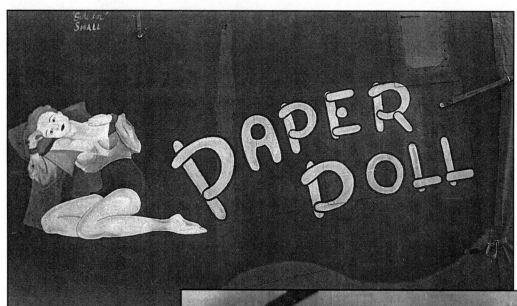

Top: **PAPER DOLL** B-24 42-07691 719BS was lost on 4 April, 1944.

Middle: **THE BUZZER** B-24H-10-CF 41-29307 719BS was a replacement ship and named by the C/C who when upon its arrival, buzzed the field. It was declared war weary and removed in September 1944. Stripped of its turrets and guns, it was converted to ferry personnel where later it disappeared on a ferrying flight in December 1944.

Bottom: **PISTOL PACKIN MAMA** B24 H-10-FO 42-52146 716BS. Shot down on a Regensburg mission 22 February 1944

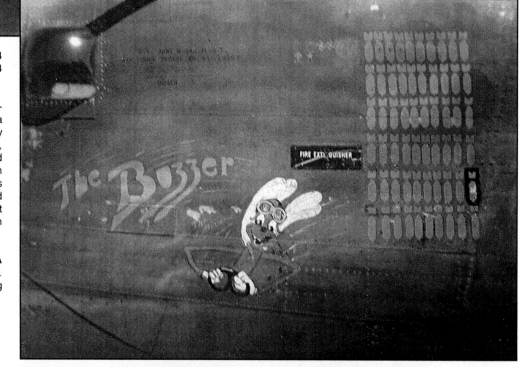

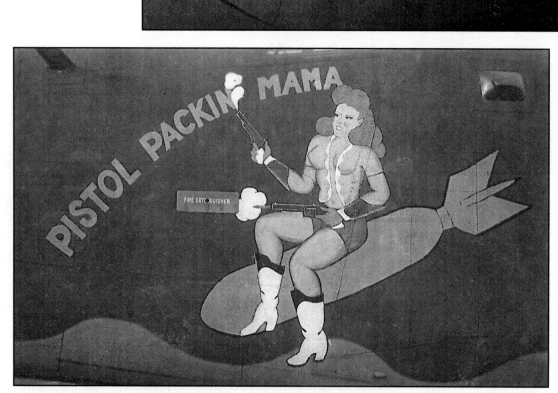

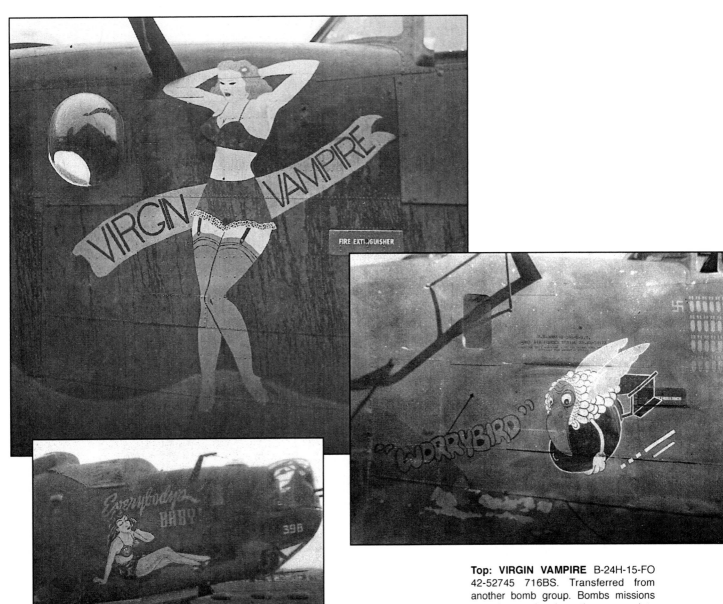

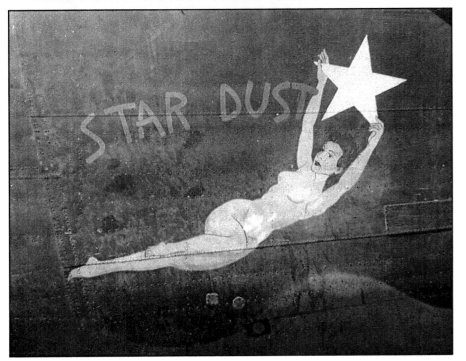

Top: VIRGIN VAMPIRE B-24H-15-FO 42-52745 716BS. Transferred from another bomb group. Bombs missions were later painted on the armor plate under the cockpit window.

Right: WORRY BIRD B-24G-10-NT 719BS. Note the dot-dot-dot-dash, morse code the letter V - victory. Another way to remember this is the first 4 notes of Bethoven's Fifth.

Middle: EVERYBODY'S BABY B-25H-5-FO 42-07756 from the 718BS. The nose artist was Tom Pacette, a 718th mechanic who copied the image and name from a Franklin Aircraft Magazine engine advertisement. This a/c was damaged in a taxiing accident and was a/c salvaged for its parts.

Bottom: STAR DUST B-24H-10-FO 42-52188 718BS became **HANGAR QUEEN** in the summer of 1944 for instructional use due to war weariness. The art work, bomb missions and a swastika scoreboard was added to the left side. The aircraft #26 also appeared along with the group insignia. This B-24 survived the war.

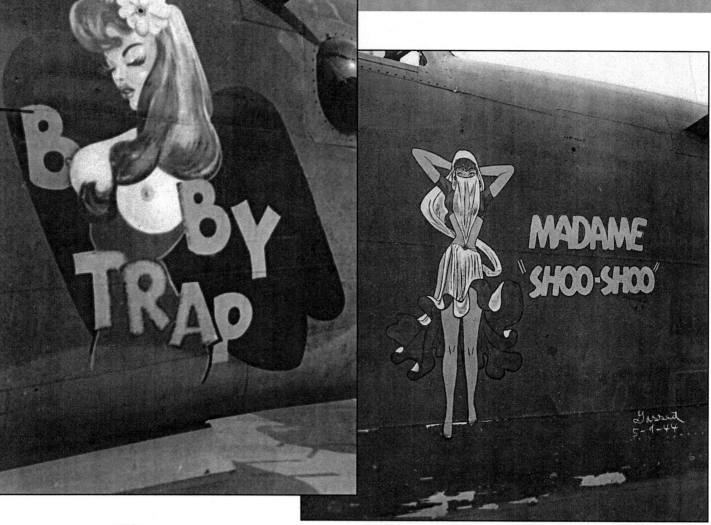

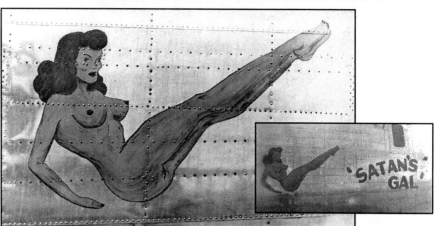

Top left: B-24 **BOOBY TRAP** 41-29332 722BS had different art work on the left side.

Top right: **MADAME SHOO-SHOO** B-24 42-99805 722BS. One of the more popular names painted on a/c, this B-24 had the name on both sides but painted by two artists. The left side *(opposite page)* was done by Sgt. D. Pasko who had done many designs on various aircraft.

Above: B-24G-10-NT **SATAN'S GAL** 42-78231 450BG, 720BS.

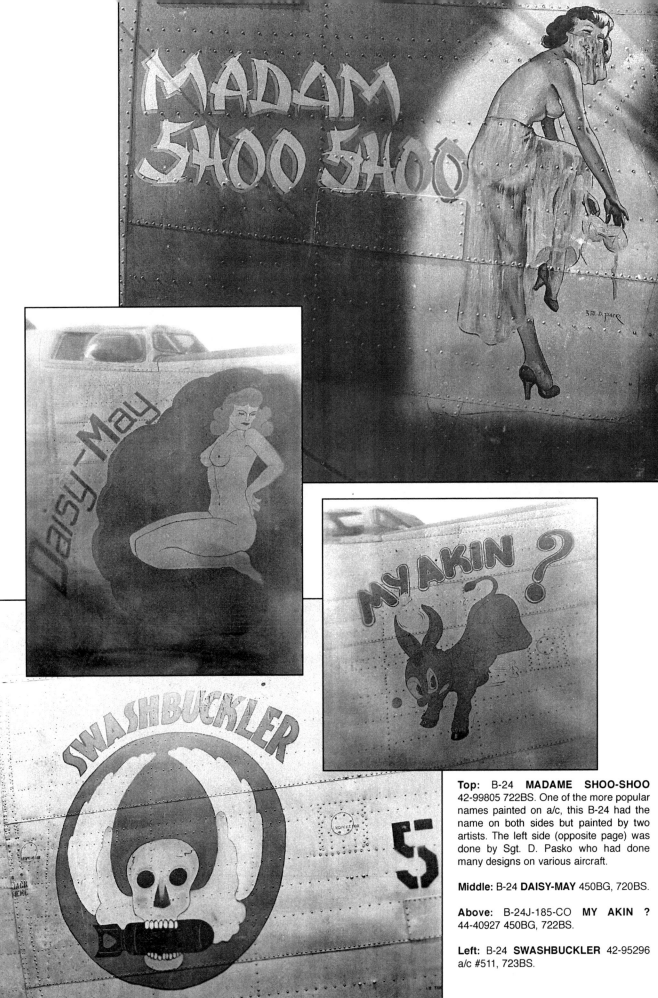

Top: B-24 **MADAME SHOO-SHOO** 42-99805 722BS. One of the more popular names painted on a/c, this B-24 had the name on both sides but painted by two artists. The left side (opposite page) was done by Sgt. D. Pasko who had done many designs on various aircraft.

Middle: B-24 **DAISY-MAY** 450BG, 720BS.

Above: B-24J-185-CO **MY AKIN ?** 44-40927 450BG, 722BS.

Left: B-24 **SWASHBUCKLER** 42-95296 a/c #511, 723BS.

71

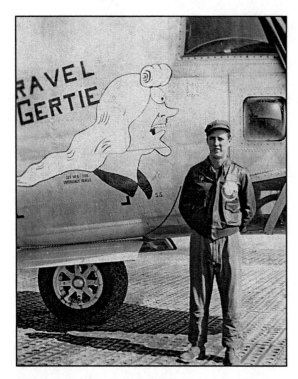

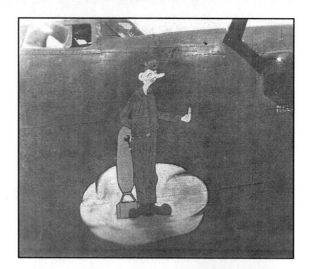

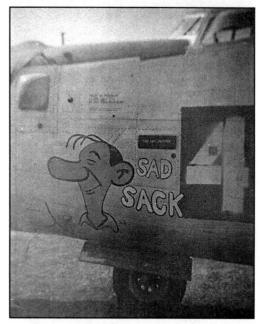

Top left: B-24 **GRAVEL GERTIE** 451BG, 454BS.

Top right: B-24 from the 450BG with the Sad Sack character.

Above: B-24 L-5-FO **SAD SACK** 44-49456 451BG, 726BS.

Left: B-24 from the 451BG status unknown.

Below: B-24 H-10-DT **SPOTTED ASS APE** 41-28697 458BG, 754BS. This is what happened to war weary planes. They were painted with outlandish color schemes and served as formation ships.

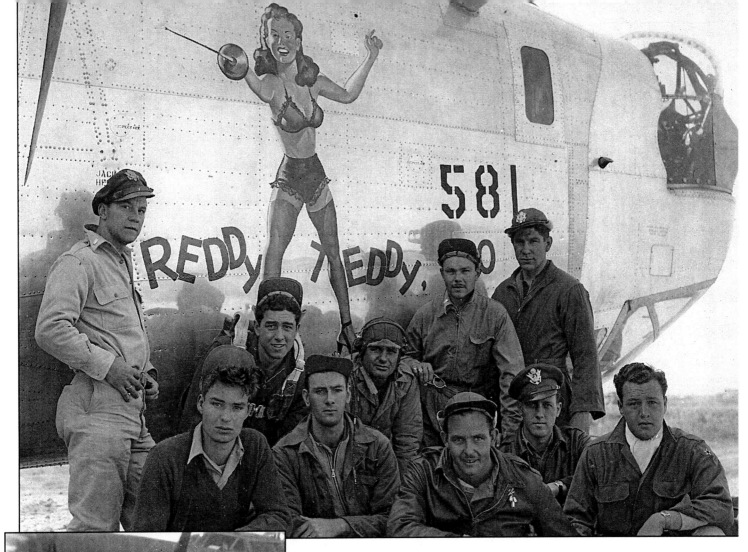

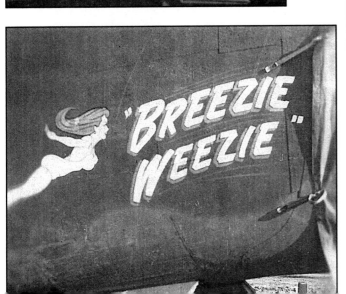

Top: B-24 **REDDY TEDDY**, **TOO** 41-28989 455BG, 742BS 12 April, 1944.

Left: B-24H-10-FO **PISTOL PACKIN' MAMA** 42-52124 450BG, 720BS. Right side had the same name but different art.

Below left: B-24 **BREEZIE WEEZIE** 451BG, 727BS. The artist may be from the 458BG since the lettering is similar.

Below right: B-24 H -25-FO **BIRD DOG** 42-95084 466BG, 784BS.

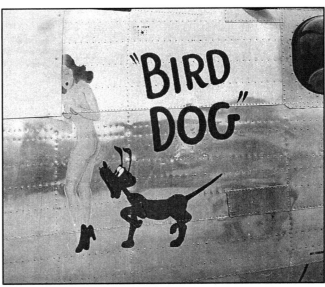

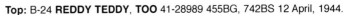

73

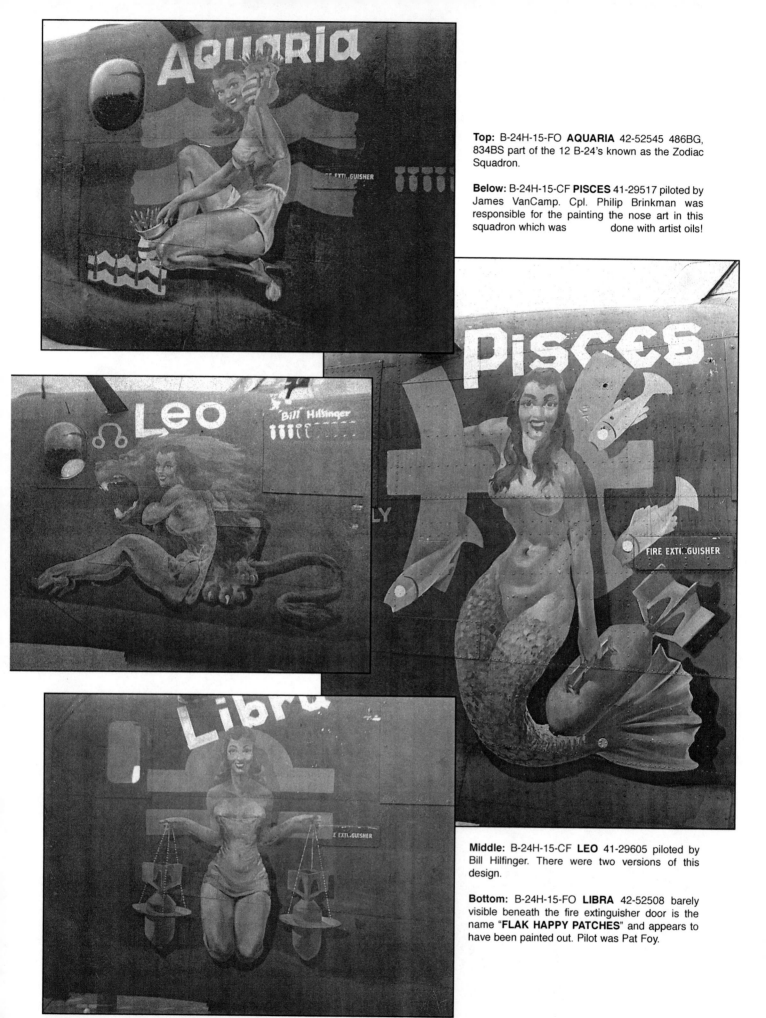

Top: B-24H-15-FO **AQUARIA** 42-52545 486BG, 834BS part of the 12 B-24's known as the Zodiac Squadron.

Below: B-24H-15-CF **PISCES** 41-29517 piloted by James VanCamp. Cpl. Philip Brinkman was responsible for the painting the nose art in this squadron which was done with artist oils!

Middle: B-24H-15-CF **LEO** 41-29605 piloted by Bill Hilfinger. There were two versions of this design.

Bottom: B-24H-15-FO **LIBRA** 42-52508 barely visible beneath the fire extinguisher door is the name "**FLAK HAPPY PATCHES**" and appears to have been painted out. Pilot was Pat Foy.

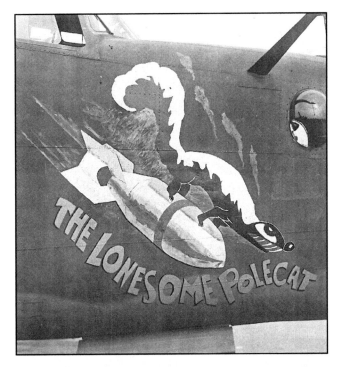

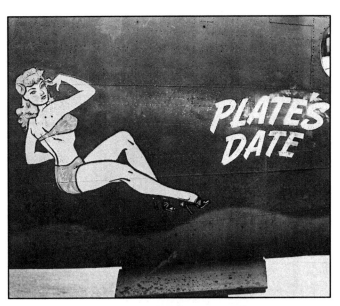

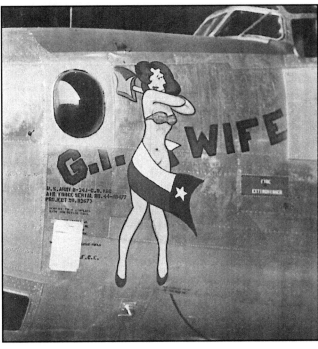

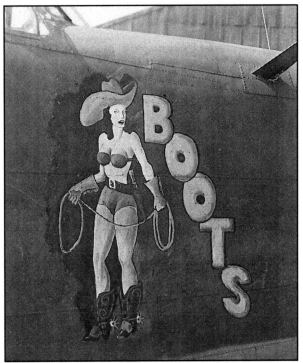

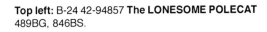

Top left: B-24 42-94857 The **LONESOME POLECAT** 489BG, 846BS.

Top right: B-24H-20-FO **PLATE'S DATE** 42-94830 489BG, 847BS which later transferred to the 389BG.

Bottom left: B-24 **G.I. WIFE** 44-40477 493BG.

Middle right: B-24H-15-CF **BOOTS** 41-29599 490BG, 850BS.

Bottom right: B-24 **YANKEE MAID** 41-29537 487BG. 838BS.

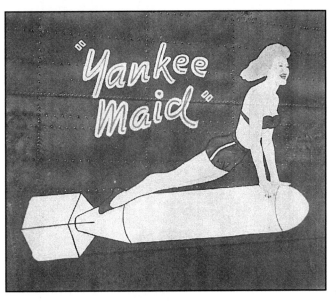

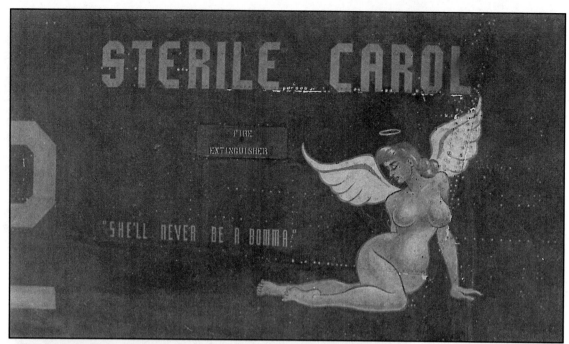

Top: B-24 **STERILE CAROL**
490BG replaced the 470BG

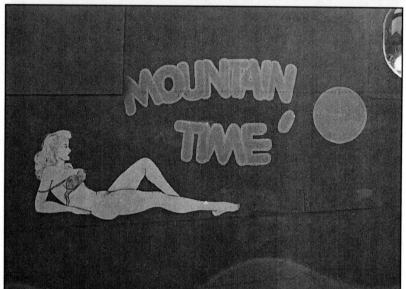

Middle: B-24 **MOUNTAIN TIME**
42-52619 487BG.

Bottom: B-24 **DORTY TREEK**
491BG, 852BS. *Adam Dintenfass.*

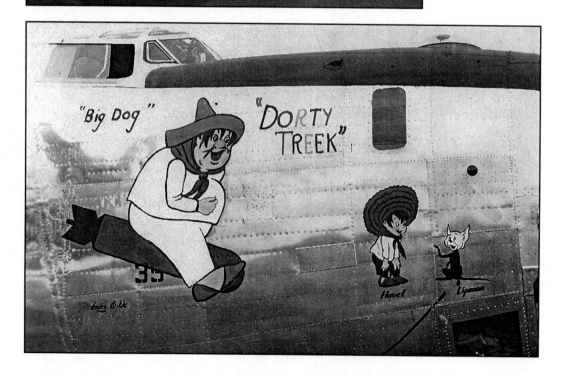

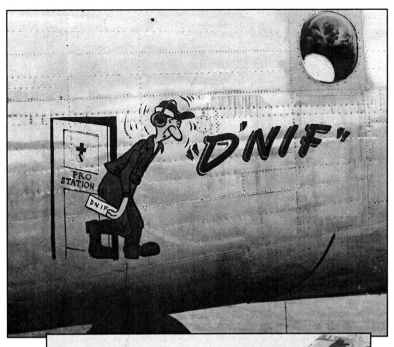

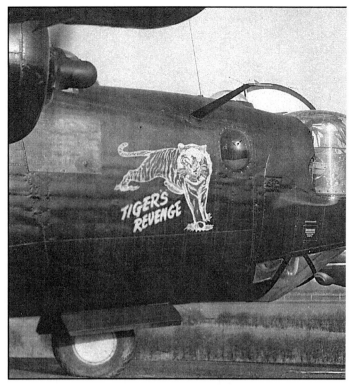

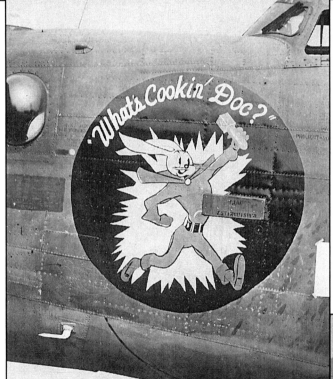

Top left: B-24J-145-CO "**D'NIFF**" 44-40100, 491BG, 852BS. The name was derived from a standard entry on an AAF form "Duty Not Including Flight." The artist and D'NIFF crew member was Angelo Pizzo. Pizzo did numerous nose art designs for the group.

Bottom left: B-24H **TIGER'S REVENGE** 42-94816 492BG, 858BS. Named after Bob Mitchell's brother "Tiger" Mitchell, a fighter pilot lost in combat, was painted black and the ball turrets were removed for supply drops to underground forces in Europe. This ship was shot down on 21 April, 1945, by an Me-110 and flak.

Top right: B-24 **WHAT'S COOKIN' DOC?** 42-110157 491BG, 855BS was later transferred to the 466BG.

Bottom right: B-24 **PONDEROUS PACHYDERM** 491BG, 853BS.

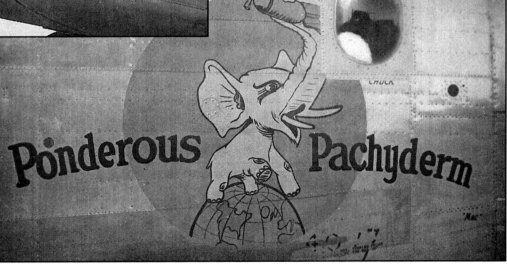

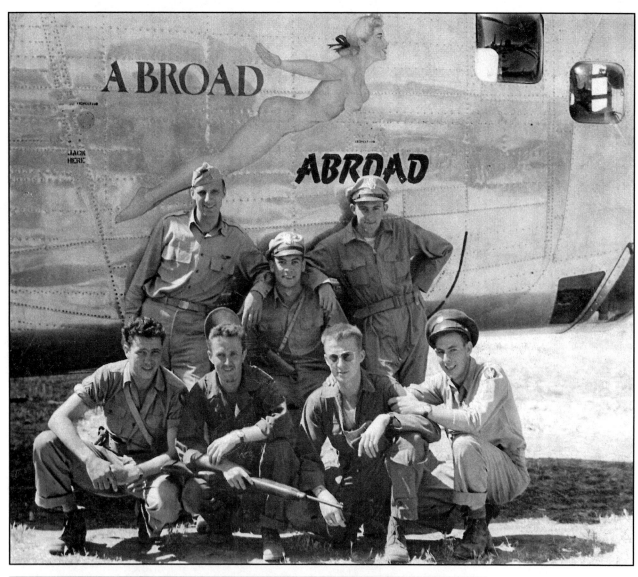

Above: B-24J-15-FO **A BROAD ABROAD** 42-51993 484BG, 827BS, 15AF.

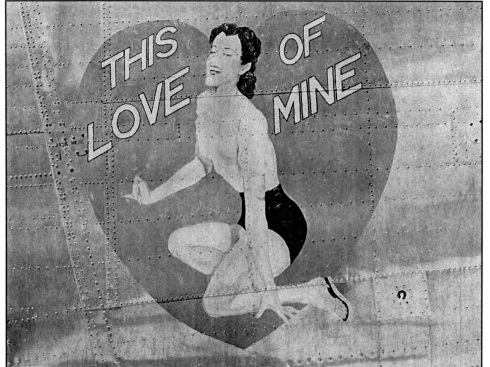

Bottom: B-24 **THIS LOVE OF MINE** 42-78071 460BG, 760BS, 15AF.

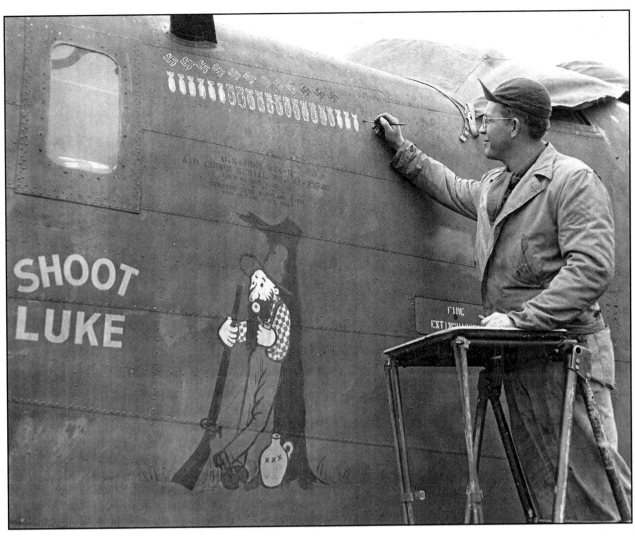

B-24D **SHOOT LUKE** 41-23729 93BG, 328BS In a posed shot, Arthur F. Kasch adds bomb #22 to the score along with12 enemy a/c downed. *12 April, 1943*

James Cagney visits the 452BG in the Officers Club.

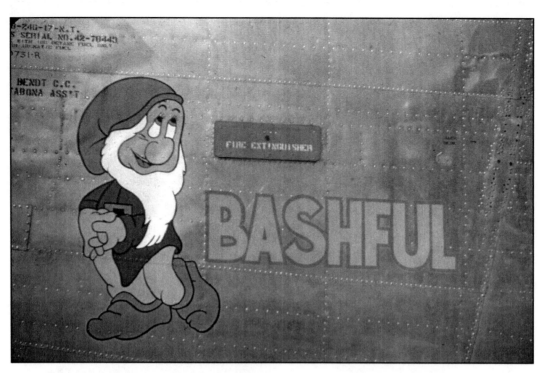

98BG

The "Pyramidiers" under the 15th Air Force beginning on 1 November 1943, the 98BG began the bulk of their operations.

One of their most famous missions was the Low Level raid to Ploesti on 1 August, 1943. On this raid, of the 47 B-24s launched, only 21 returned safely. One crashed on takeoff with the loss of all crewmembers except for two. Six aborted before reaching the target. Seventeen went down in enemy territory. Two went down at sea. Group Commander, Col. John R. "Killer" Kane was awarded the Medal of Honor for his leadership.

At wars end the 98th had Flown a total of 417 missions and earned 15 battle streamers as well as two Presidential Unit Citations.

The 98th had a variety of camo schemes and the latter of the three assigned bases is Lecce, Italy - January 1944 - April 1945. These photos were taken at this location.

B-24J-15-CO **BASHFUL** 42-51994 343BS nose art by Sgt. Gerald Viola who was an airplane electrician.

B-24 **BLONDE BOMBER** 343BS

98TH BOMB GROUP

98BG
98BG
98BG
98BG
98BG
98BG
98BG
98BG
98BG
98BG
98BG
98BG
98BG
98BG
98BG
98BG

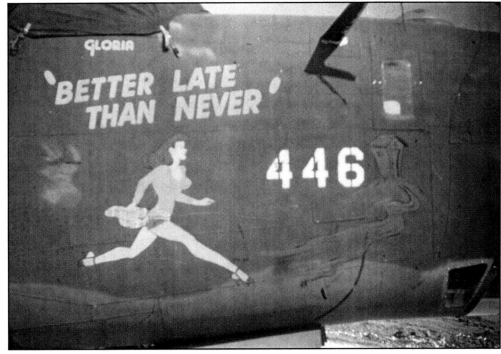

B-24 **BETTER LATE THAN NEVER** 42-51364 from the 343BS.

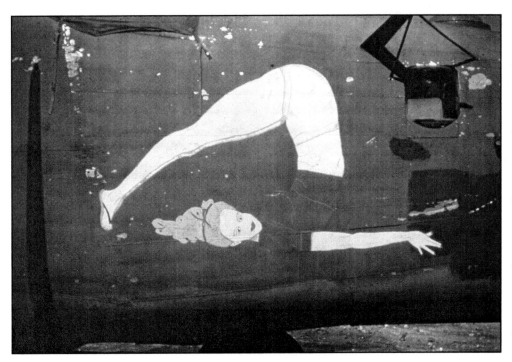

B-24 from the 450BG

81

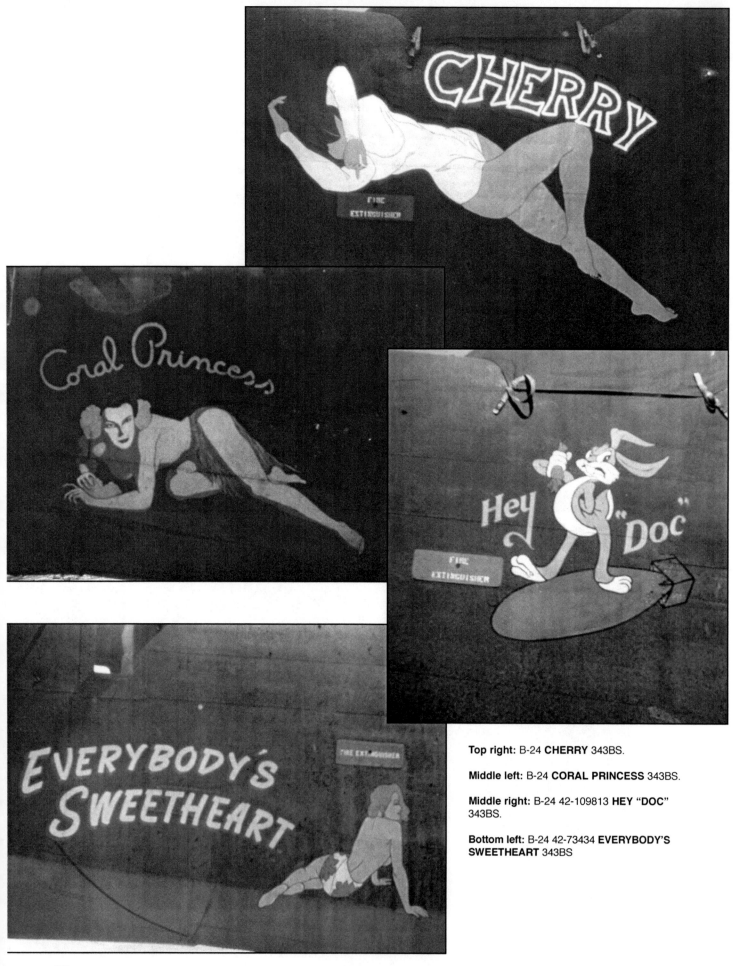

Top right: B-24 **CHERRY** 343BS.

Middle left: B-24 **CORAL PRINCESS** 343BS.

Middle right: B-24 42-109813 **HEY "DOC"** 343BS.

Bottom left: B-24 42-73434 **EVERYBODY'S SWEETHEART** 343BS

98BG
98BG
98BG
98BG
98BG
98BG

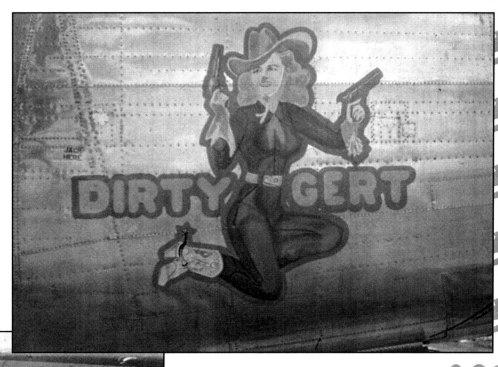

Top: B-24 **DIRTY GERT** from the 343BS.

Middle: B-24 J-15-CO **MISS PLEASE!** is the right side of **BASHFUL** 98BG, 343BS.

Bottom: B-24 H-30-FO 42-95352 **IRISH LASSIE** 348BS.

98BG

98BG

98BG

98BG

98BG

98BG

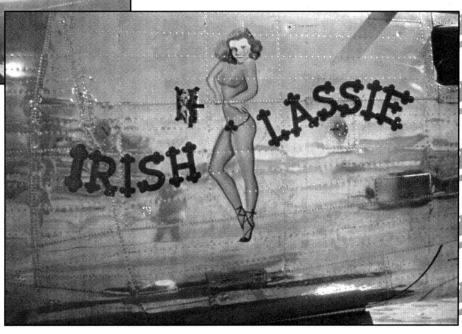

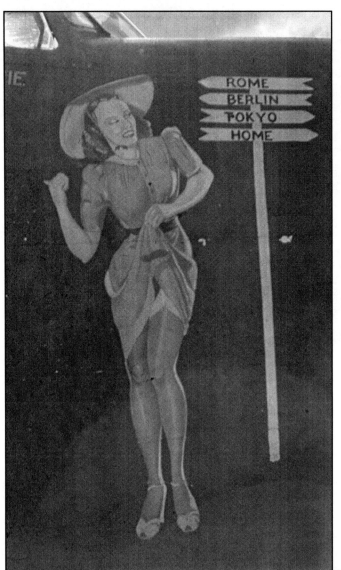

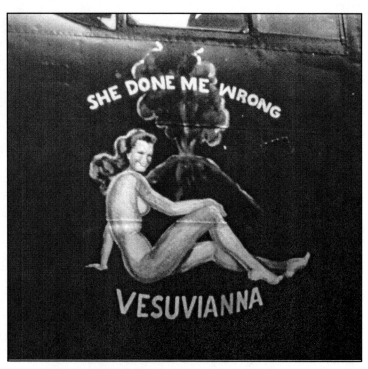

Left: B-24 from the 343 BS possibly **BELCHIN' BERTHA** on the left side.

Above: B-25C 340BG **VESUVIANNA, SHE DONE ME WRONG** in memory of the eruption at that time.

Bottom: B-24 44-48784 **UGLY BUT TOUGH** 343BS

Opposite: B-24 **TUFF SHIP** from the 450BG.
B-24 **THE DAUNTLESS DUCHESS** from the 450BG.
B-24 Unknown

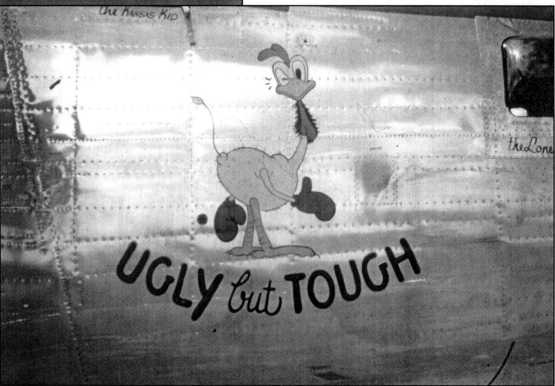

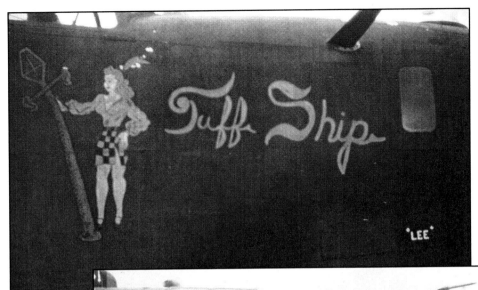

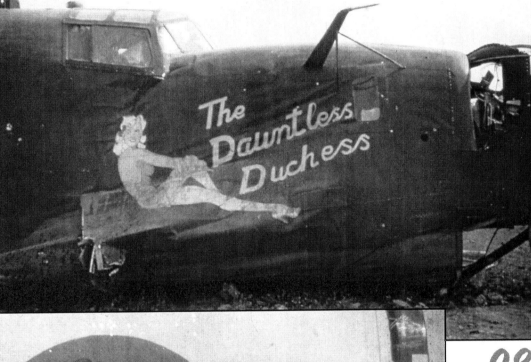

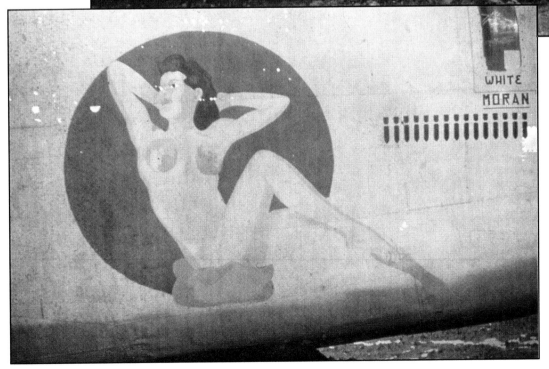

98BG
98BG
98BG
98BG
98BG
98BG
98BG
98BG
98BG
98BG
98BG
98BG
98BG
98BG
98BG
98BG

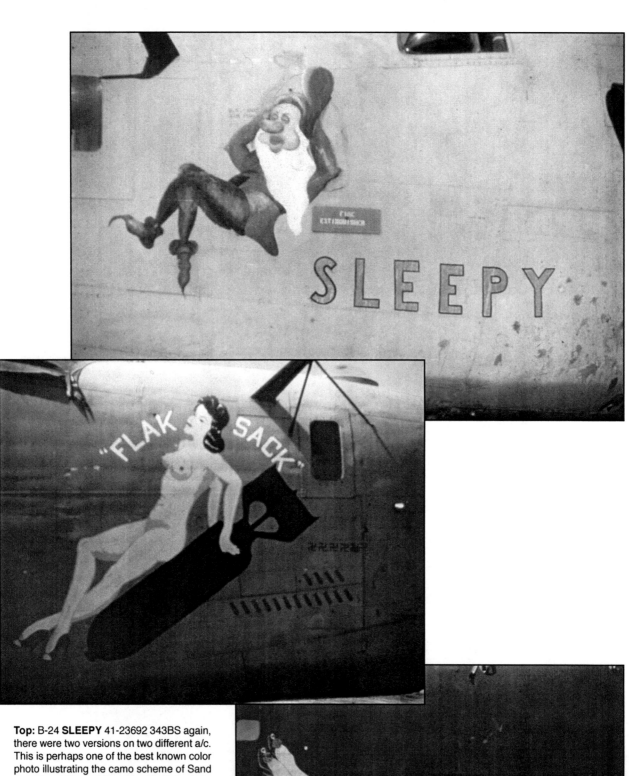

Top: B-24 **SLEEPY** 41-23692 343BS again, there were two versions on two different a/c. This is perhaps one of the best known color photo illustrating the camo scheme of Sand No. 49 and Neutral Gray No. 42. Note; *Take into consideration that at the time this photo was taken, at sunset.*

The right side art was **FLAK SACK** (middle photo).

Bottom: An un-named B-24 not yet identified.

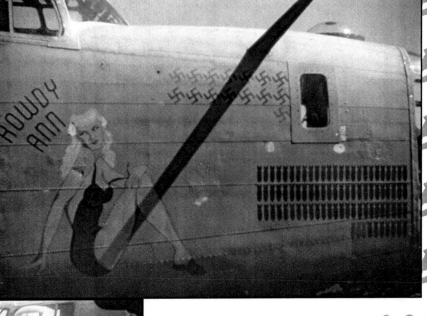

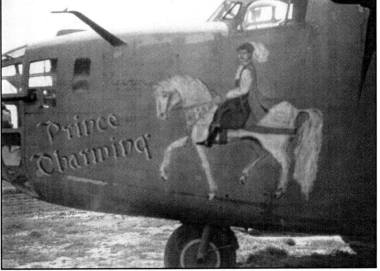

98BG
98BG
98BG
98BG
98BG
98BG
98BG
98BG
98BG
98BG
98BG
98BG
98BG
98BG
98BG
98BG
98BG

Top: B-24 unknown

Middle: B-24D **ROWDY ANN** 42-40082 343BG right side of **PRINCE CHARMING.**

Bottom: B-24D **PRINCE CHARMING** 42-40082 343BG left side second version. Group artist Amos Nicholson did the first version with same name and art.

87

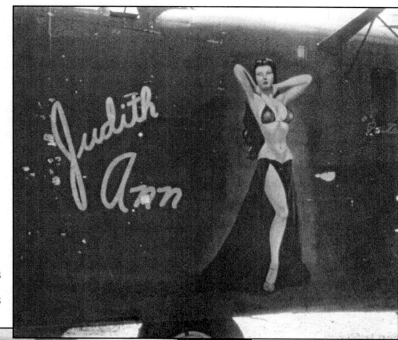

B-24J-15-CF **JUDITH ANN** 42-64343 345BS

B-24 **SHUFTI** 44-40494 343BS

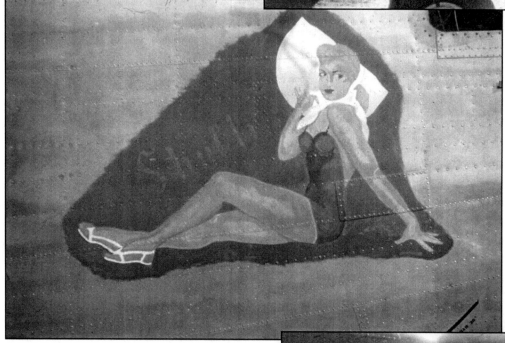

An unidentified B-24

88

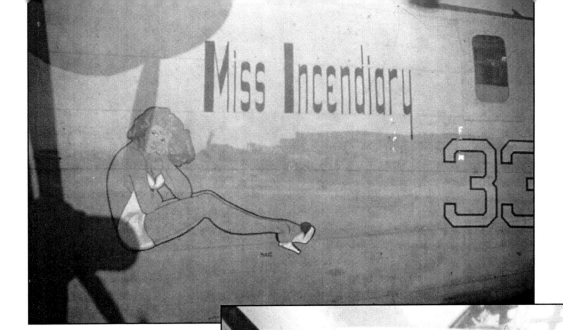

Top: A 376BG B-24 **MISS INCENDIARY** declared war weary and used as a Zig-Zag ship in Maison Blanche, Algeria April, 1944. This aircraft appears to be wet from rain hence the reflection.

Middle: Left side of **MISS INCENDIARY**.

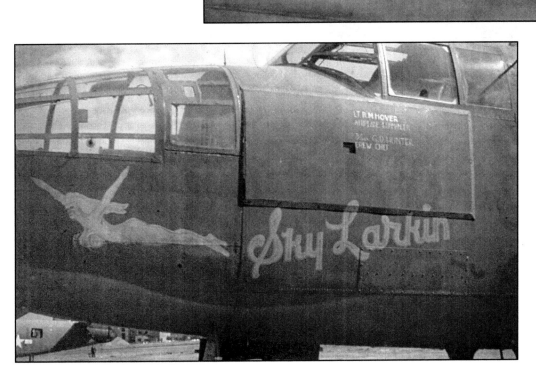

B-25 **SKY LARKIN** from the 340BG, one of 88 damaged from the Mt. Vesuvius eruption.

Corsica

As part of the 12th Air Force and Operation Torch, the five bomb groups that utilized the B-25 were the 12th, 310th, 319th, 321st and the 340th. The push from North Africa into Italy to root out the Nazis began on 8 November 1942. Of these groups the 310th, 321st and 340th were at some point based in Corsica where these following rare color photos were taken. The artists like Durley Bratton that created the nose art were very skilled in that the quality and composition of the works are the best I've seen on B-25s or any other in the MTO. These photos are evident that someone had the insight to meticulously record the works on film, and in color! These are but half of what exists from the aforementioned bomb groups.

On 22 March 1944, Mt Vesuvius erupted and the surrounding airfields were blanketed with ash and brimstone. Some of the aircraft were ferried out to safety, but most of the 321st and all (88) of the 340th BG's B-25s were literary buried and subsequently destroyed from the hot debris. They were eventually replaced with shiny new B-25Js. Some of the planes were only painted in OD on the top sides only and others stock with just the anti-glare panels painted. *Photos via Jeff Wolford.*

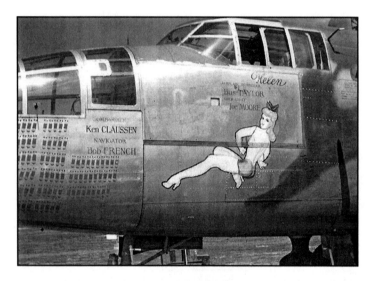

B-25J **BRIEFING TIME** 43-27638 340BG, 489BS. The name was removed at the end of the war and re-named Quitting Time. The artist was Crew Chief Joe Moore and may have done the others in this group.

B-25J-25-NA 44-30142 did not have a name at the time these photos were taken. Artist and crew chief Durley Bratton at work below painting one of the pin-ups.

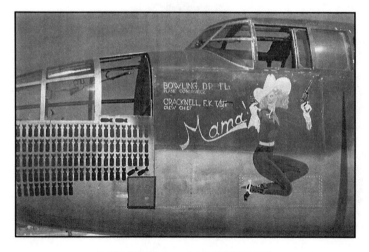

B-25J **MAMA** from the 340BG, 321BS.

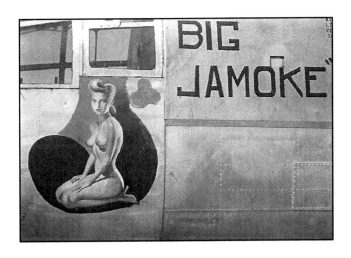

B-25J **BIG JAMOKE** flown by Lt. Gies.

This B-25 may be with the Air Transport Command.

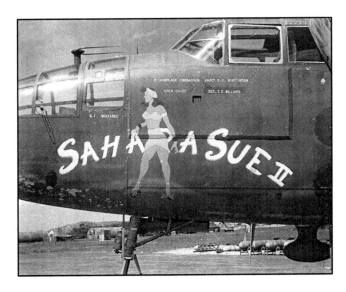

B-25J **SAHARA SUE II** 340BG, 486BS

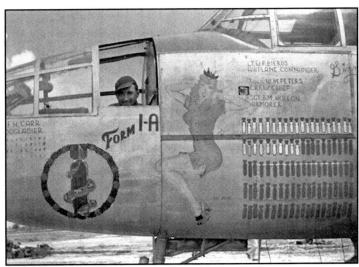

B-25 **FORM 1-A** 310BG, 381BS

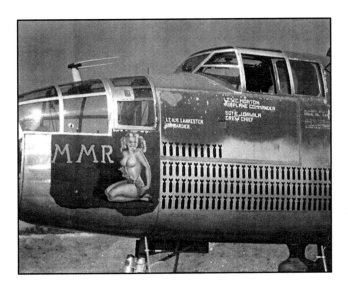

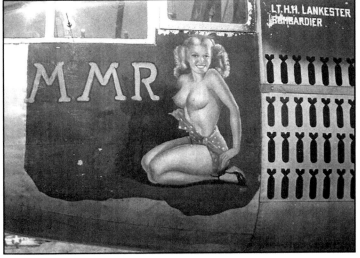

B-25J **MMR** 43-277 321BG, 447BS. Pilot Lt. W.C. Morton named the a/c after his girlfriend Mary Margaret Rustin.

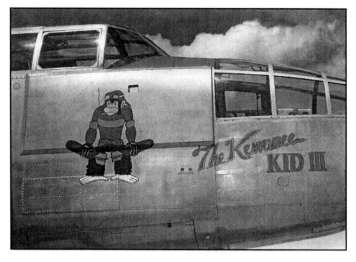

B-25J **THE KEWANEE KID** from the 310BG, 381BS.

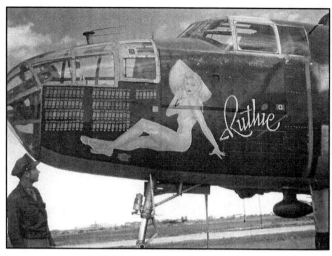

B-25J **RUTHIE** 43-27653 340BG, 489BS.

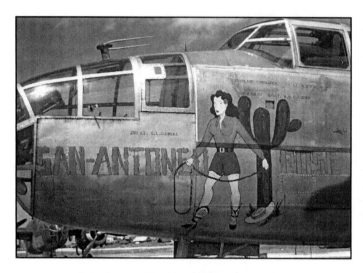

B-25 **SAN ANTONEO ROSE** from the 321BG.

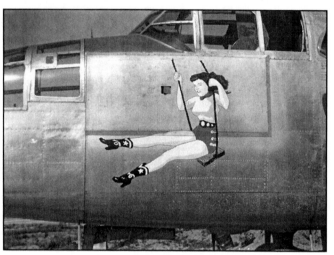

An unnamed B-25J

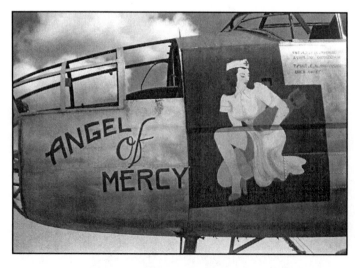

B-25J **ANGEL OF MERCY** from the 310BG, 428BS.

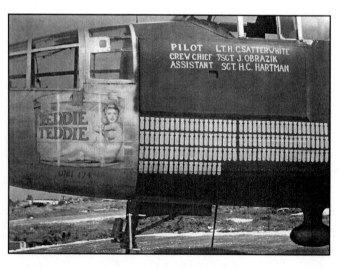

B-25J **REDDIE TEDDIE**.

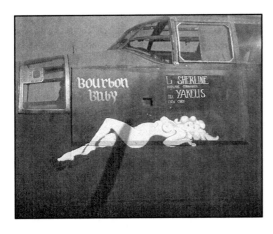

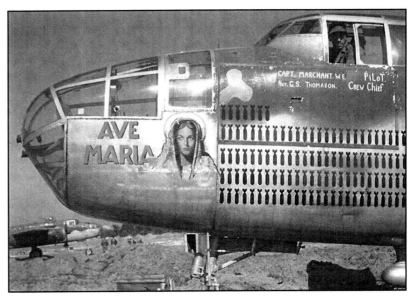

Top: B-25J **BOURBON BABY.**

Right: B-25J **AVE MARIA** from the 321BG, 447BS.

Right: B-25J **BIG NOISE** from the 310BG, 428BS.

Bottom left: B-25J **MISSION EM SEMPER PERFECIMUS.**

Bottom right: B-25J **SHADY LADY.**

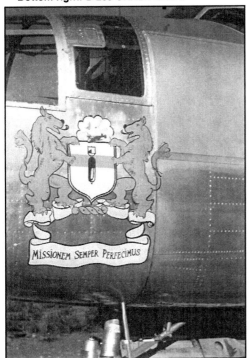

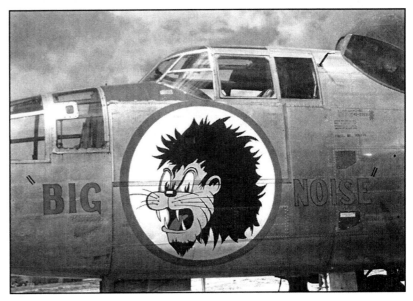

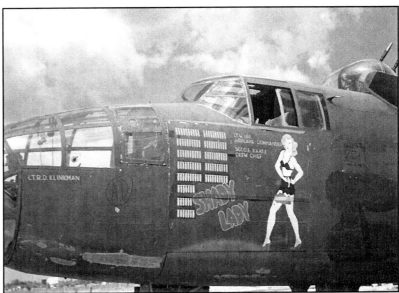

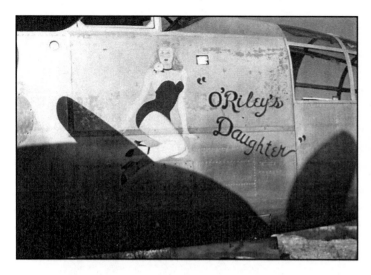

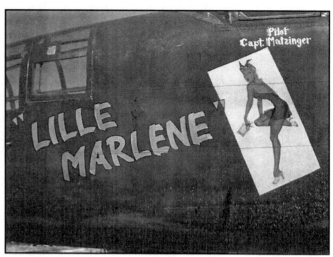

B-25J **O'RILEY'S DAUGHTER** at some point had the pin-up modified from black to red and the hair blonde to brunette.

B-25J **LILLE MARLENE.**

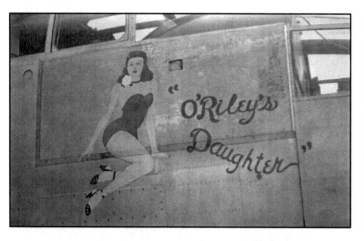

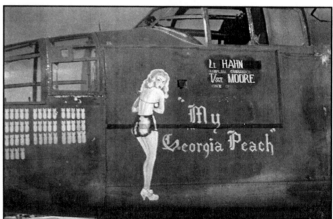

The third photo below is most likely the left side of the same a/c.

B-25J **MY GEORGIA PEACH.**

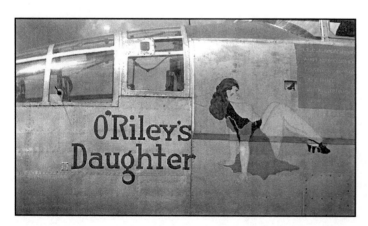

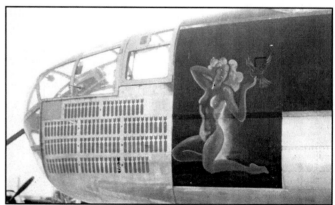

B-25J Unnamed.

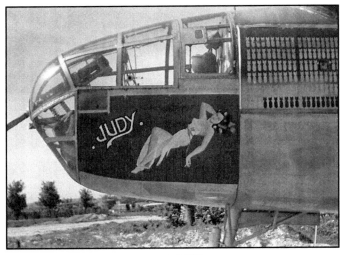

B-25J **JUDY.**

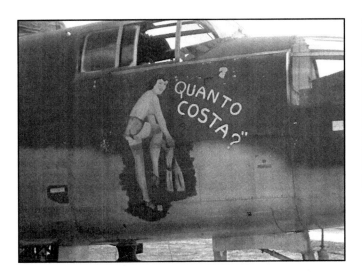

B-25J **QUANTO COSTA?**

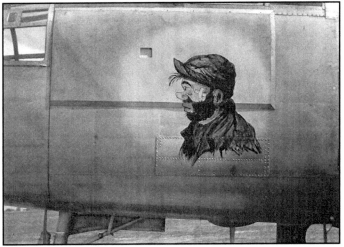

B-25J 43-4065 **G.I. JOES** of Capt. Joseph P. Turner, 340BG, 487BS was one of thirteen B-25s that featured 'Dogface' characters created by cartoonist Bill Mauldin. Turner copied them onto the B-25s as a tribute to the ground troops.

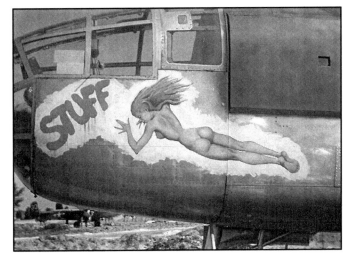

B-25J **STUFF**

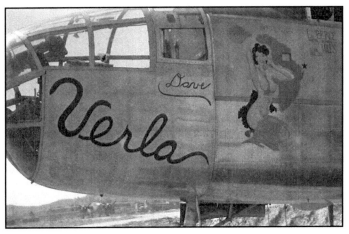

B-25J **VERLA**

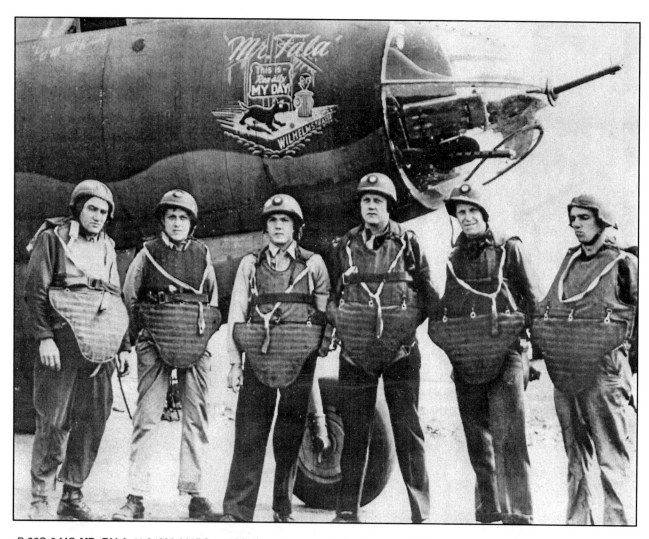

B-26C-6-MO **MR. FALA** 41-34692 323BG, 455BS. While the crew don their Flak vests, the nose art depicts President Roosevelt's pet Scottie running up to a fire hydrant with Hitler's head atop it. The title reads; "This is really my day". *26 August, 1943*

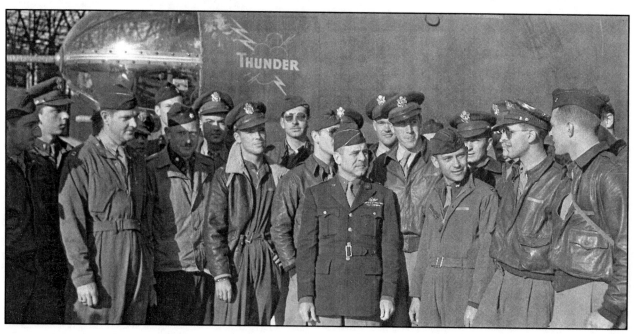

Above: B-26 **THUNDER** 41-178668 17BG, 37BS. Maj. Gen. Doolittle visits with squadron members 29 January, 1943 in French North Africa. **THUNDER** was lost the next month on 24 February. This was the only combat group to fight all three axis powers, Japan, Italy and Germany.

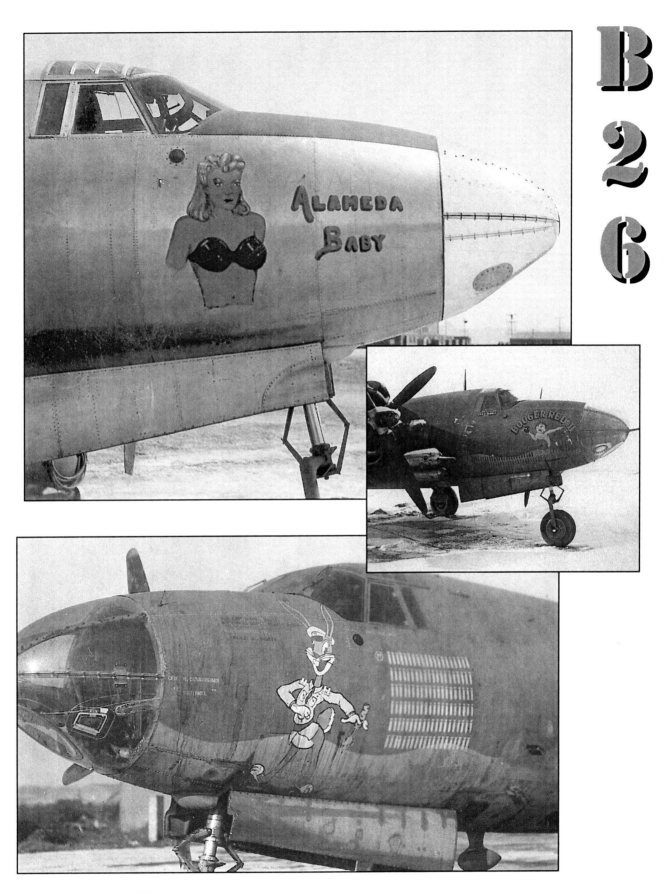

Top: B-26 **ALAMEDA BABY**.

Middle: B-26B-30-MA 41-31874 **BOOGER RED II** 387BG, 559BS.

Above: B-26 **BUGS BUNNY** 41-3190 319BG, 440BS completed 125 missions and was flown by Capt. W.C. Wood. This was the first unit to transfer to the PTO 7th AF and re-equipped with Douglas A-26s.

97

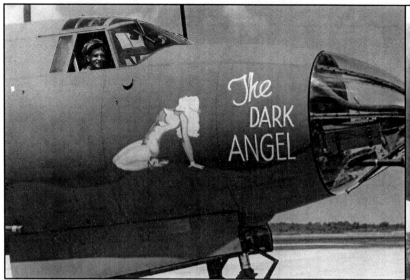

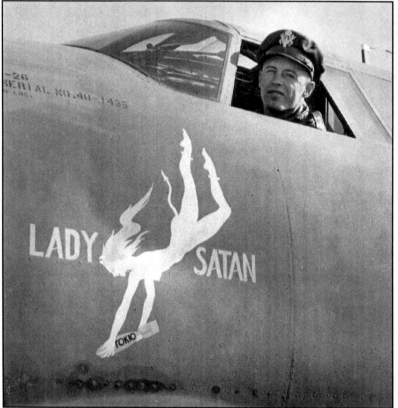

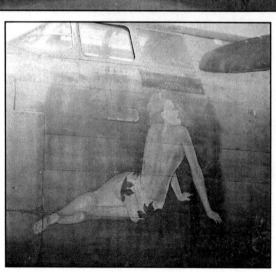

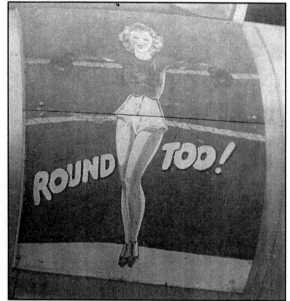

Top left: B-26 **THE DARK ANGEL** 17BG, 34BS.

Top right: B-26B-10-MA **PICKLED-DILLY** 41-18276 322BG, 451BS completed 100 missions on 21 June, 1944 and went missing on its 104th mission a month later 8 July.

Middle left: B-26 **LADY SATAN** 40-1435 22BG shown here at Tarrant Field, Texas with an instructor. 27 November, 1942.

Above: B-26B-10-MA **ROUND TOO!** 43-34571 394BG, 585BS.

Left: A-20G-25-DO 43-9100 312BG.

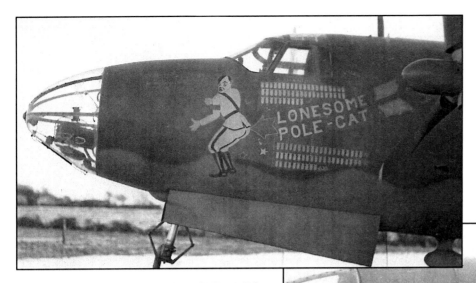

Top: B-26 **LONESOME POLE-CAT** 323BG, 455BS completed 101 missions.

Right: B-26 **MISS LAID** 391BG, 575BS.

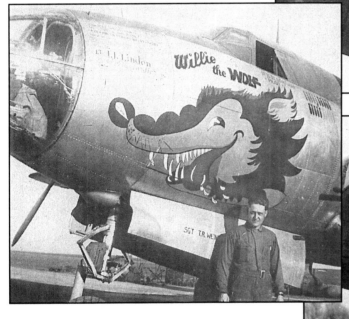

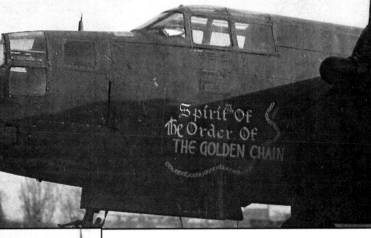

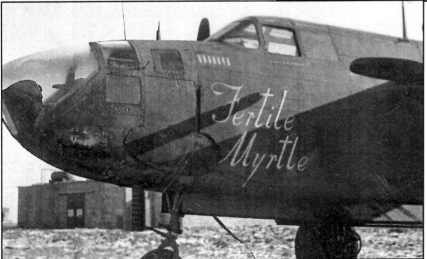

Middle left: B-26 **WILLIE THE WOLF** 43-34351 386BG, 558BS may also have served with the 387BG, 555BS and was eventually shot down by AAA.

Above right: A-20J **SPIRIT OF THE ORDER OF THE GOLDEN CHAIN** 416BG.

Left: A-20J **FERTILE MYRTLE** 416BG flown by Capt. Prentise.

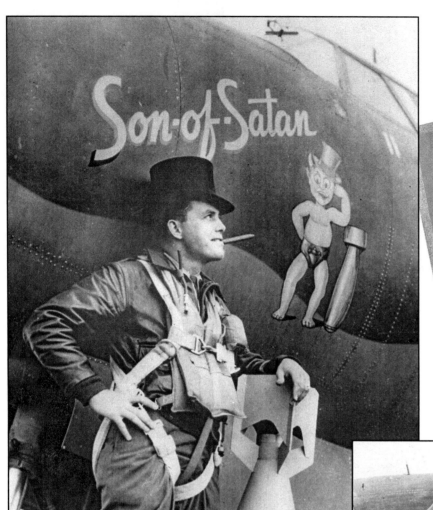

Top: B-26B-15 41-31613 **SON-OF-SATAN** from the 386BG, 555BS. Squadron Commander, Major Sherman R. Beaty is the inspiration for the art on his a/c. Notice the black test shadow on the letter "S". The shadow was later painted from red to black.1 September, 1944.

Right: B-26 **VICTORY READ** 394BG, 584 is named after its pilot, Lt. Reeder.

L-R Top: Lt. George Domblazer - Co-pilot, Lt. Owen Reeder - Pilot, Lt. Every Crouser - Bombardier

L-R Bottom: T/Sgt. Rex Merriman - Crew chief, Sgt. James Ray - Tail gunner, Unidentified ground crewman. Jim Diffee

Below: B-26 **LI'L LASS** from the 322BG flown by A.R. Danner.

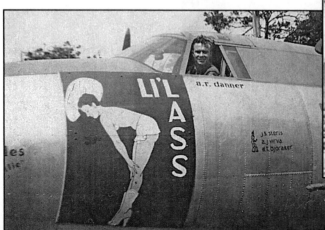

100

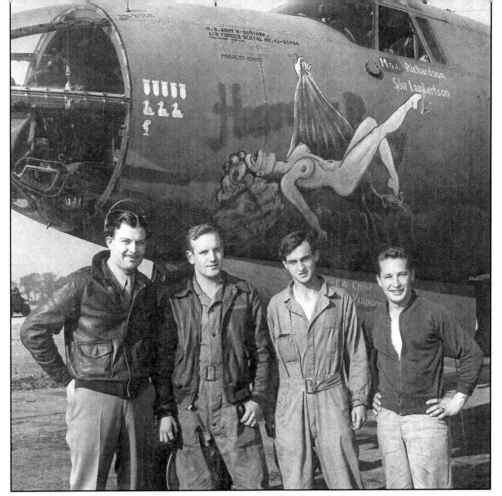

B-26 **HEAVENLY BODY** 41-31664 387BG, 558BS apparently had its name removed. On 8 June, 1944. This a/c went down after being hit by AAA.

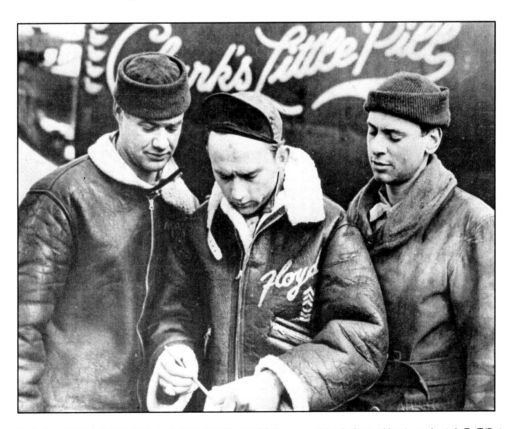

B-26 **CLARK'S LITTLE PILL** 41-34959 322BG, 451BS flew over 75 missions without an abort. L-R: T/Sgt. Melvin Mumbower, M/Sgt. Floyd Cunningham and Sgt. Peter Penrose. *1 May, 1944*

THE Fighters

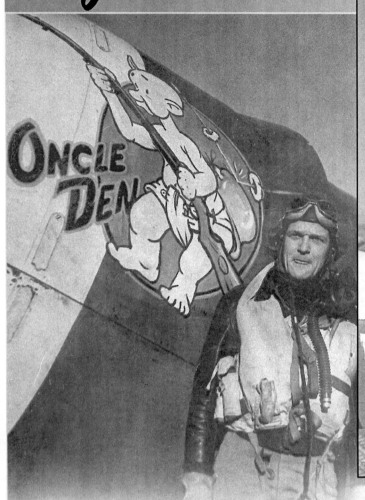

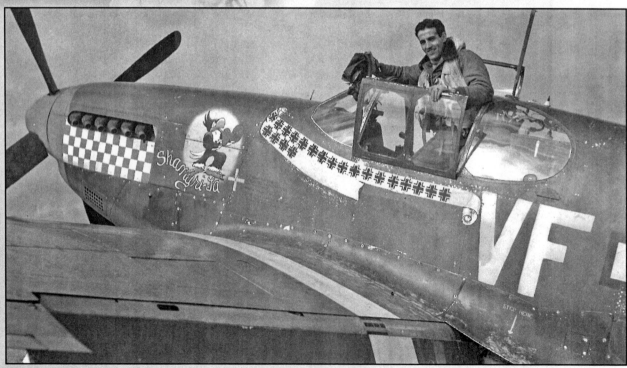

Even though space was far more limited for personal markings than their big counterparts, the nose art designs were just as creative as the bombers. The artists had to design their creations with a horizontal field in mind. In most cases, just using names was as effective. One would just paint the name as elaborate as he could. This is where an artist sign painting background skills would benefit.

Early on in support of the bombers in the ETO and MTO, the P-47, P-38 and P-51 arrived in combat with the standard OD finishes. Along with their pilots were the crews to maintain them. Among the crew there were several artists that unbeknownst to them, literally created an image for their groups and squadrons just by painting designs on the cowling. Some of the most colorful nose art groups were the Fourth FG, the 56FG, 57FG, 78FG, 352FG, 357FG and the 405FG. Among these groups were the aces that flew the artifices in combat on their cowling. Again, like the bombers, as their score rose, so did the media's attention to promote and exploit for morale purposes back home. Often, these aces already had some sort of nose art that helped in creating the larger-than-life persona all while feeding ones egocentric personality and aiding in a sense of confidence, all of which is needed to be successful as a fighter jock. Oh, and of course throw in some dexterous flying in the mix.

Unlike bomber crews, the fighter pilot was alone to make his own calls. The nose art on his plane usually was a direct reference to or about the pilot. A statement, message or perhaps a loved ones name. Without knowing the individual, it is quite entertaining trying to figure out what the nose art ment to the pilot or why.

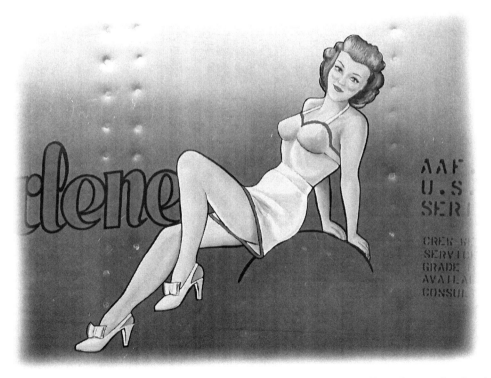

Top: Flight line of the 57th FG. Dwight Ormann **Inset:** A gun camera. **Bottom: SWEET ARLENE** panel re-creation done by the author depicts a design by Don Allen from the Fourth FG. **Opposite top:** A ground crewman crudely paints invasion stripes on a P-51B the day before D-Day. Reddie Archives **Opposite bottom:** Fourth FG ace Don Gentile and P-51 **SHANGRI-LA.** *Popper photo, England via John Campbell.*

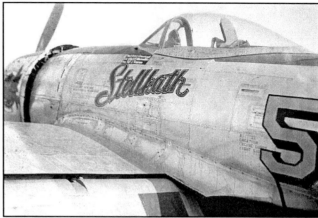

Left: A 65FS cowling panel being outlined in black. Stencils were used for each color sprayed.

Above: P-47D **STELLKATH** flown by Harry Cavenaugh. *D. Orman*

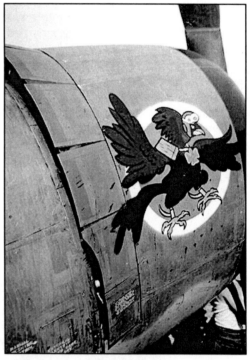

Middle left: P-47D **BERNICE** being serviced.

Above middle: The insignia of the 65FS, 57FG was called **"UNCLE BUD"**. Colors are; Green background with a white border behind a red fighting cock with leather helmet, Green clover charm with a yellow board, yellow feet with grey ankle pitches, grey goggles and white lenses.

Left: P47 **WICKED WABBIT** piloted by 1st. Lt. Jim C. Hare. *Photos Dwight Orman*

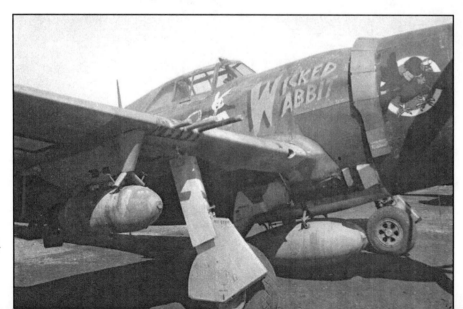

104

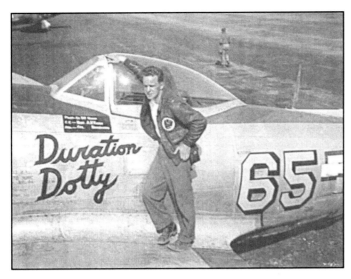

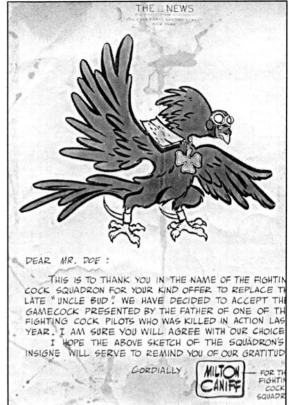

THE NEWS

DEAR MR. DOE :

THIS IS TO THANK YOU IN THE NAME OF THE FIGHTIN
COCK SQUADRON FOR YOUR KIND OFFER TO REPLACE TH
LATE "UNCLE BUD". WE HAVE DECIDED TO ACCEPT TH
GAMECOCK PRESENTED BY THE FATHER OF ONE OF TH
FIGHTING COCK PILOTS WHO WAS KILLED IN ACTION LAS
YEAR. I AM SURE YOU WILL AGREE WITH OUR CHOICE
I HOPE THE ABOVE SKETCH OF THE SQUADRON'S
INSIGNE WILL SERVE TO REMIND YOU OF OUR GRATITUD

CORDIALLY MILTON CANIFF FOR TH
FIGHTIN
COCK
SQUADR

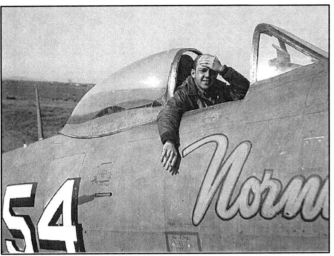

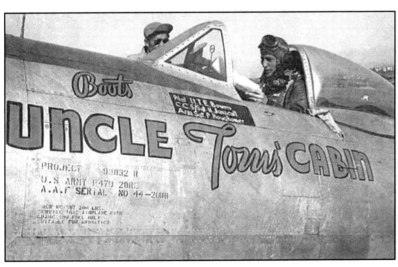

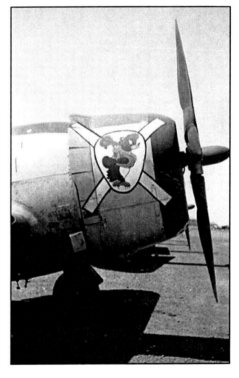

Top: P-47D **DURATION DOTTY** painted in red with black outline flown by Dwight Orman.

Top right: Renowned cartoonist Milt Caniff known for his "*Terry and the Pirates*" series, re-designed the insignia for the squadron and this is what was copied and painted on the cowls.

Middle: P-47 **NORMA** flown by Lyke. The name is painted light blue/grey with a possible second color and outlined in black.

Bottom left: P-47 **UNCLE TOM'S CABIN** was flown by Lt. Tom "Shady" Bowers.

Bottom right: A P-47 with the 66FS insignia. *Photos Dwight Orman*

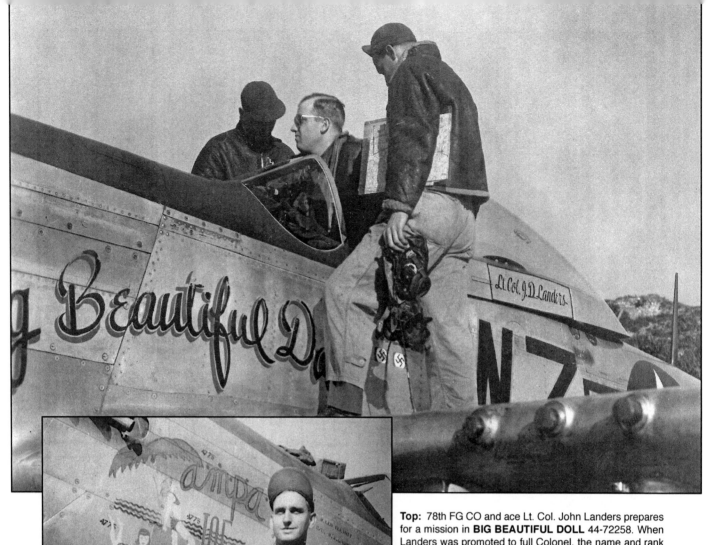

Top: 78th FG CO and ace Lt. Col. John Landers prepares for a mission in **BIG BEAUTIFUL DOLL** 44-72258. When Landers was promoted to full Colonel, the name and rank was re-painted from yellow to a red background with white lettering. The black and white checkers were also added to the wing tips.

Left: TAMPA JOE is an F-6 from the 12th Recon Squadron piloted by Leo Elliott.

Below: P-51D-5-NA **FEROCIOUS FRANKIE** flown by Wallace Hopkins from the 374FS, 361FG. *USAF*

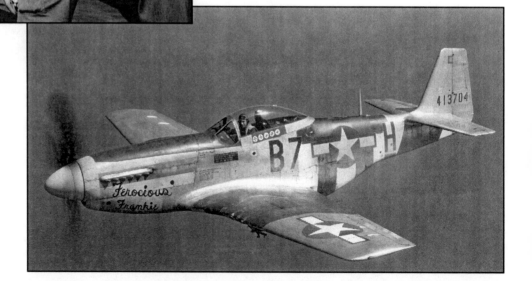

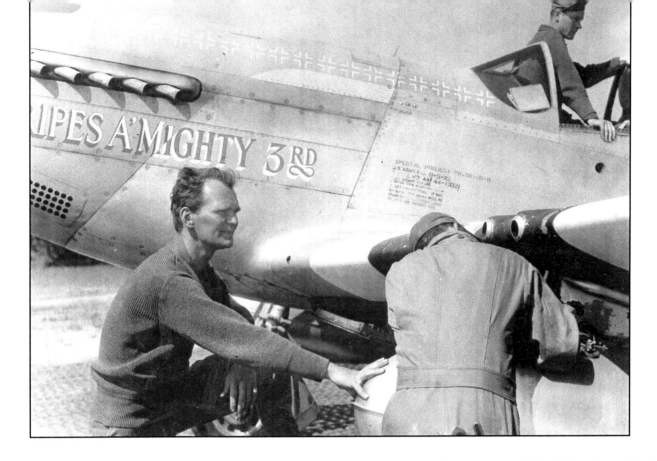

Above: Top P-51 Mustang ace, Major George Preddy's crew chief, S/Sgt. Lew Lunn assists Sgt. Kuhaneck and Cpl. McVay with servicing the plane. Notice that the **CRIPES A'MIGHTY 3RD** lettering is outlined in black with red and white alternating shadowing. The score of crosses are in white. The 352FG artists liked to use red, white and blue whenever possible as a patriotic statement. The alternative contrasting color to the "Blue Nosed Bastards" was yellow. *Darrell Crosby*

Below: P-51 **BEAUTIFUL BETTY** from the 352FG, 486FS 44-14877 piloted by Lt. Alex A. Karan, adds finishing touch to his name. A sergeant possibly his C/C, is mixing paint and may have done the name. Note the paint kit below the right external fuel tank. *Darrell Crosby*

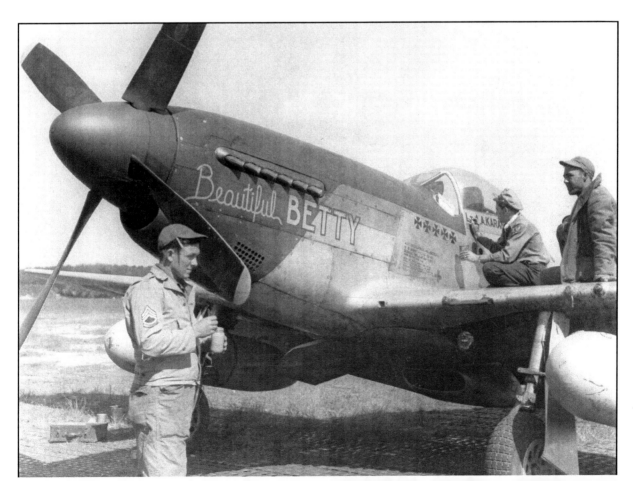

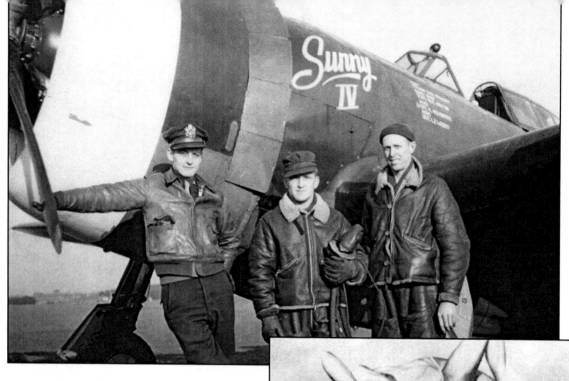

Right: Artist W. Nilan Jones from the 352 FG. *Berlow*

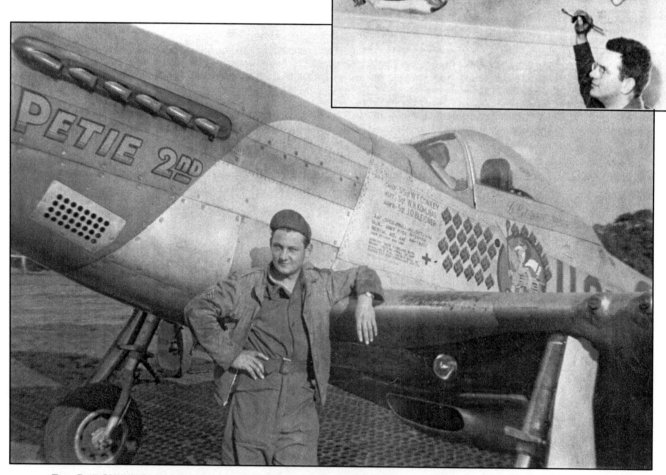

Top: P-47 **SUNNY IV** 42-8437 from the 328FS flown by Maj. Everett Stewart. Art appeared on both sides. *352nd FG Assn. via Sam Sox, Jr, Photography Archivist*

Above: P-51 **PETIE 2ND** seen here with Sgt. John Slabe in front of 487 FS CO. John Meyer's plane. The name and swastikas by this time has been painted in orange as per Meryer's request to "brighten up" the markings. Red lines were added for a blending effect. *Darrell Crosby*

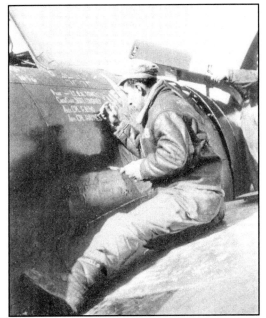

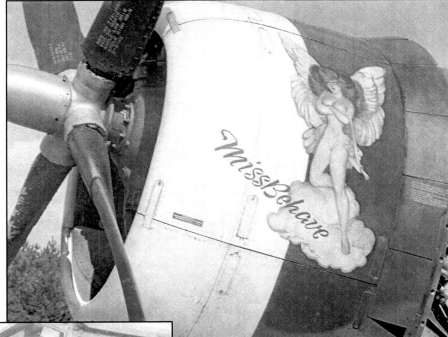

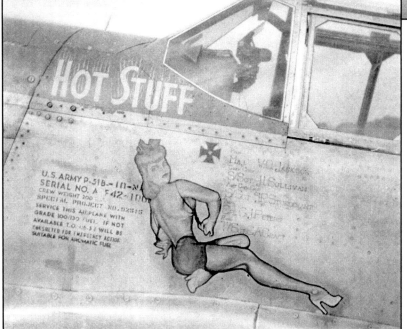

Top left: Crew Chief Sgt. Iggy Marinello paints names on Lt. Robert "Punchy" Powell's P-47 **THE WEST "BY GAWD" VIRGINIAN** s/n 42-8617. This a/c is also shared with Jamie Laing.

Top right: P-47 **MISS BEHAVE** 42-8434 was originally assigned to the 355FG and was transferred to the 487FS, 352FG, early March, 1944. The nose art was applied to both sides by 355FG artist Sgt. DeCosta. After the transfer, CO Lt. Col. J.C. Meyer did not approve of the art work and ordered it removed.

Left: P-51 **HOT STUFF** 42-106661 flown by Maj. Willie O. Jackson in the 486FS.

Bottom: P-47 **JEAN LOUISE** 42-8660 328FS flown by Lt. Harry L. Miller, Jr. Photos; 352nd FG *Assn. via Sam Sox, Jr, Photography Archivist.*

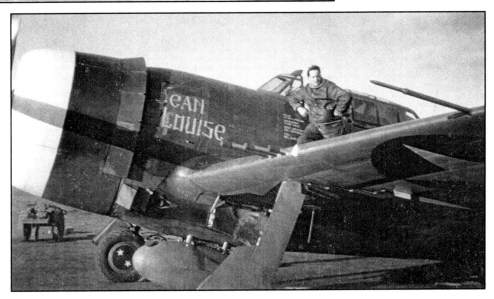

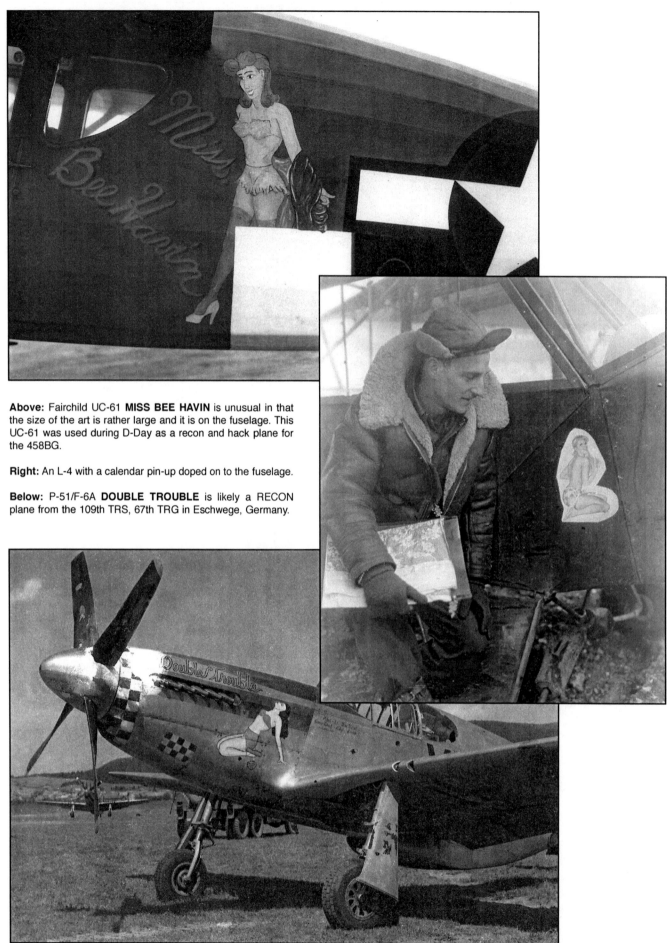

Above: Fairchild UC-61 **MISS BEE HAVIN** is unusual in that the size of the art is rather large and it is on the fuselage. This UC-61 was used during D-Day as a recon and hack plane for the 458BG.

Right: An L-4 with a calendar pin-up doped on to the fuselage.

Below: P-51/F-6A **DOUBLE TROUBLE** is likely a RECON plane from the 109th TRS, 67th TRG in Eschwege, Germany.

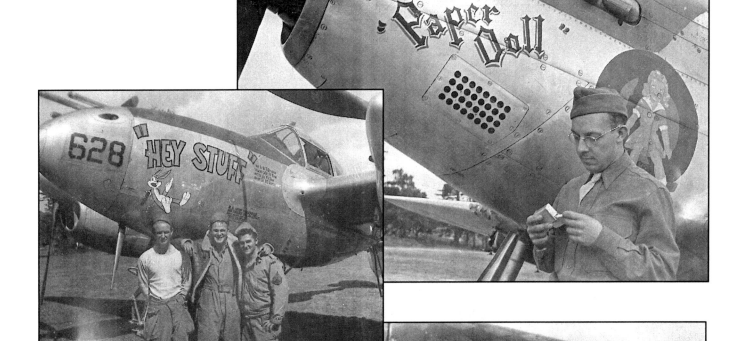

Above right: P-51D **PAPER DOLL** 44-63283 356FG, 360FS flown by Lt. Ernest W. Corner. This a/c was also assigned to Lt, George Schalk. Coded PI•X.

Above left: P-38 **HEY STUFF** 44-23626 367FG, 394FS.

Right: P-51D **TIM-MIT-ELL** 44-15354 356FG, 361FS flown by Capt. Raymond H. Campbell.

A close-up of **DOUBLE TROUBLE**. The pilot's first name was Mac.

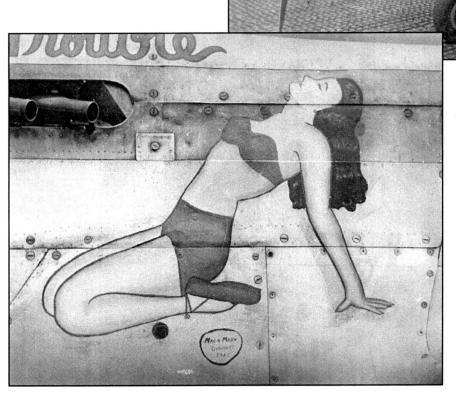

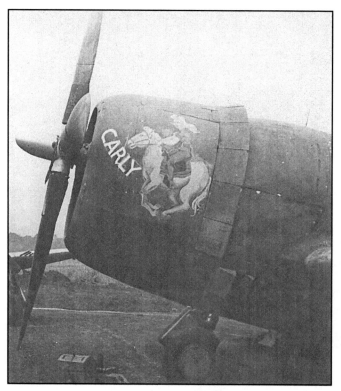

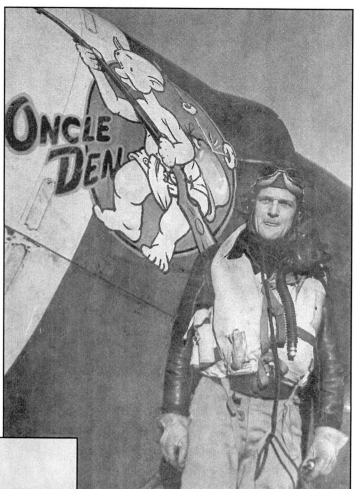

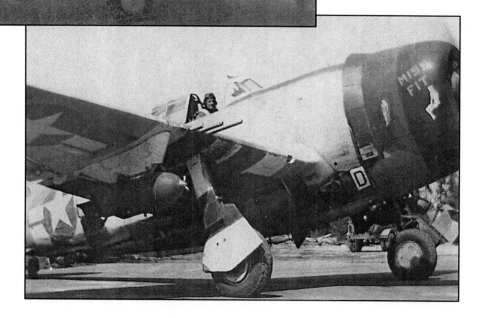

Top left: P-47 **CARLY.**

Top right: P-47 **UNCLE DEN** 41-6187 4FG, 334FS flown by Lt. Herb J. Blanchfield. Coded QP•E.

Middle left: P-47 **JOKER** 371FG.

Bottom Left: P-47 **MISS FIT** 83rd Adrm. Sqd., August, 1944. Calendar pinups appear to have been doped on.

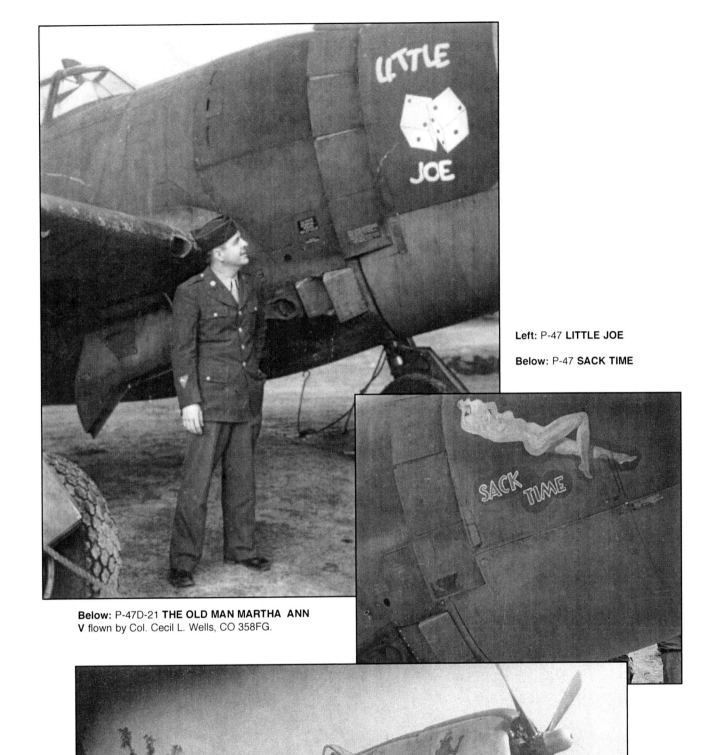

Left: P-47 **LITTLE JOE**

Below: P-47 **SACK TIME**

Below: P-47D-21 **THE OLD MAN MARTHA ANN V** flown by Col. Cecil L. Wells, CO 358FG.

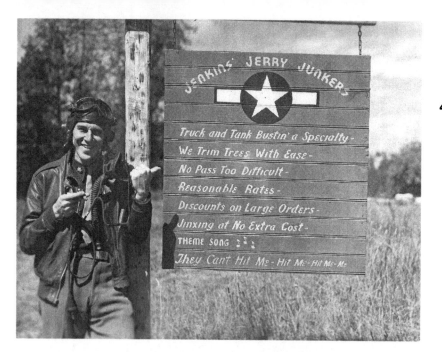

The 510th Fighter Squadron was originally comprised as the 625th Bombardment Squadron (Dive) on 4 February 1943. It was activated on 1 Mar 1943 at Dew Field, FL, and assigned to the 405th Bombardment (later, 405th Fighter-Bomber; 405th Fighter) Group. It was redesignated as the 510th Fighter-Bomber Squadron on 10 August 1943; as the 510th Fighter-Bomber Squadron, Single Engine, on 20 August 1943; and as the 510th Fighter Squadron, Single Engine, on 30 May 1944. Stationed in England, France and Germany, the squadron saw combat in ETO, from 11 April 1944-1 May 1945 before returning to the United States and inactivating on 27 October 1945 at Camp Kilmer, NJ.

Redesignated as the 510th Fighter Squadron on 23 March 1994, it activated on 1 July 1994 at Aviano AB, Italy, and was assigned to the 31st Fighter Wing's Operations Group, flying F-16CG/DG aircraft.

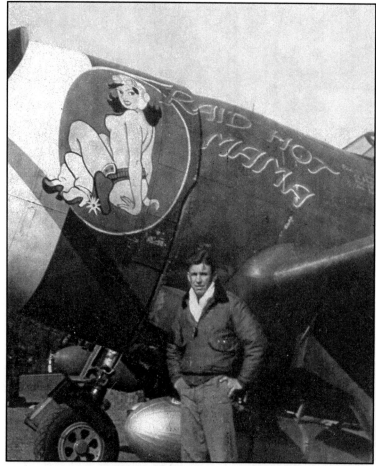

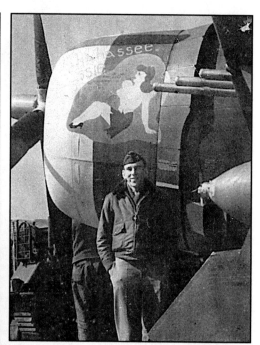

Top: Major Ralph C. Jenkins showing off the "Call" sign.

Above: P-47 **TALLAHASSEE LASSEE**

Left: P-47 **RAID HOT MAMA** and pilot Lt. John Drummond.

All 510FS photos courtesy of Adam Dintenfass

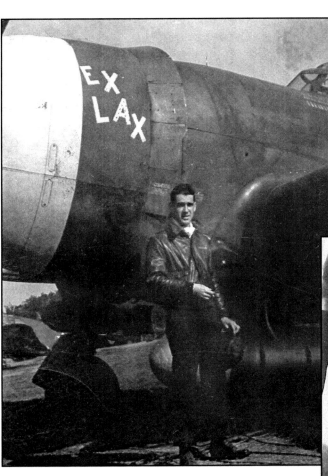

Left: P-47 **EX LAX**

Below: P-47 **"K" KID**
Flown by Lt. Kociencki

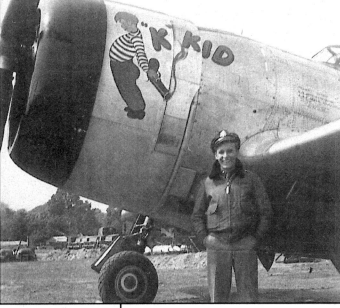

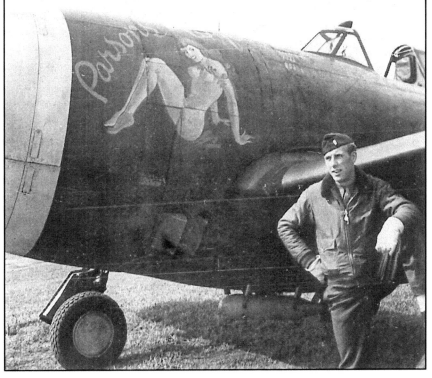

Left: P-47 **PARSON'S WIFE.**

The only known nose artist for the squadron was Sgt. Lynn Trank and most likely did all of these examples.

115

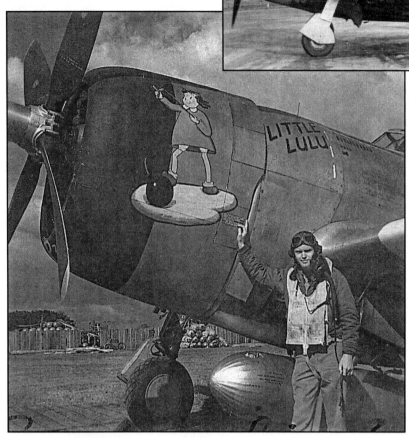

Top: P-47 Possibly **MISS GREGAR.**

Left: P-47 **LITTLE LULU.**

Below: P-47 **TIPSY**

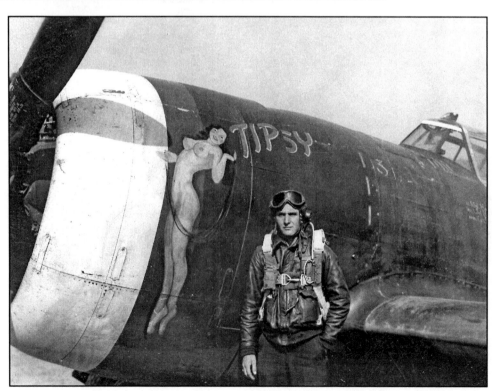

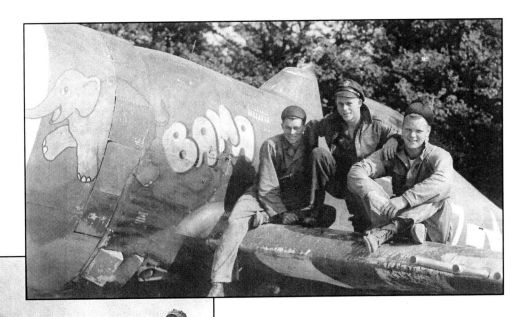

Top: P-47 **BAMA** flown by Lt. Bill James.

Left: P-47 **NANCY**

Below: P-47 **PEGGY DARLIN'** 44-33200 flown by Lt. Col. Bender.

405FG

Below: P-47 **THE SCARAB II**

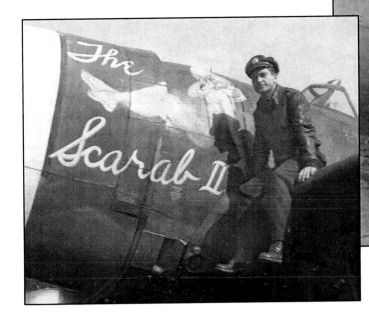

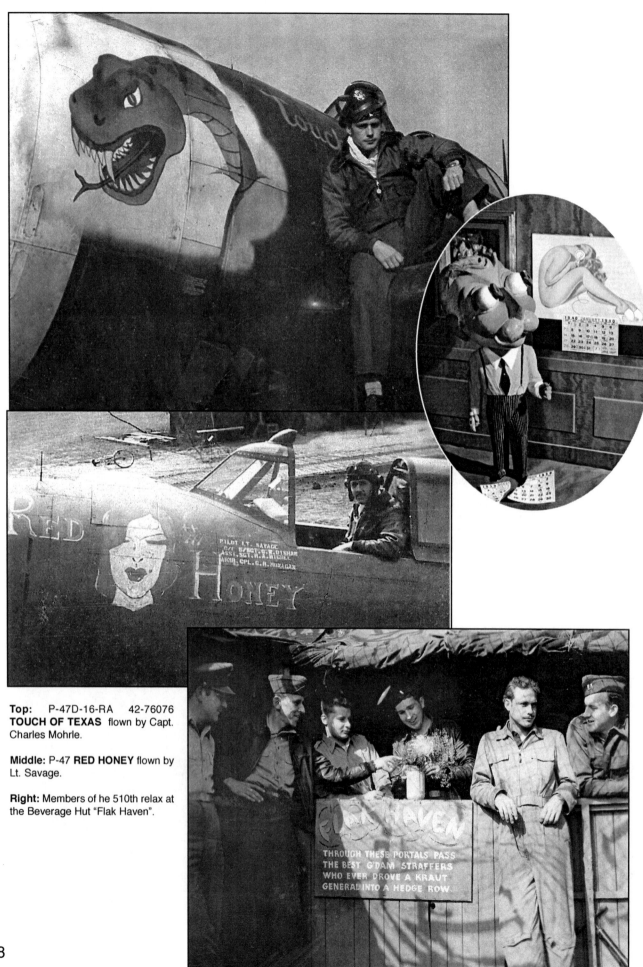

Top: P-47D-16-RA 42-76076 **TOUCH OF TEXAS** flown by Capt. Charles Mohrle.

Middle: P-47 **RED HONEY** flown by Lt. Savage.

Right: Members of he 510th relax at the Beverage Hut "Flak Haven".

405FG

Right and below: P-47D-22 42-25742 **KANSAS TORNADO II** flown by Lt. Howard J. Curran was shot down 12 September 1944 after scoring his third and final aerial victory. He evaded capture and made it back. Curran was also credited with two ground victories.

Bottom: P-47 **GEORGIA PEACH** flown by Lt. E.G. Powell.

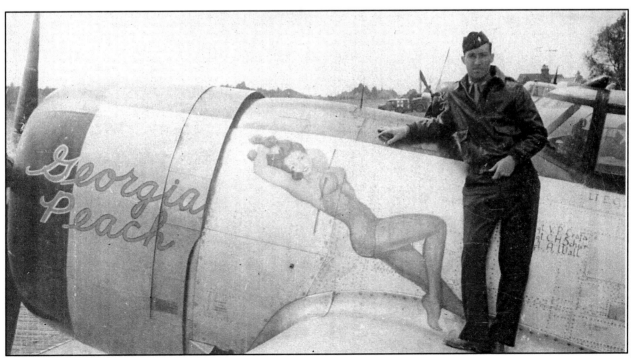

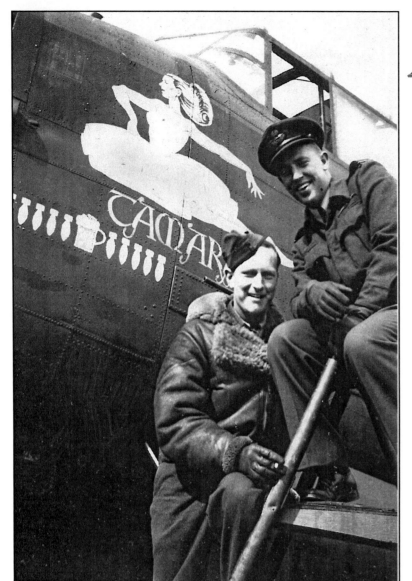

RAF

Our British allies also practiced the painting of nose art on aircraft. Among these aircraft primarily were the Lancaster, Halifax and Wellington. These aircraft were coded with a letter that usually determined the name from that letter. While the US Army Air Corps flew dar raids, the RAF bombers flew missions at night and were painted in night camo schemes - overall black with the top sides in Dark Green and Dark Earth. The fighters like the Spitfire and Hurricane also participated in the personal decor. Although over all, the designs were not as elaborate as the americans, they did possess a different feel for design. Illustrated here are but a few examples.

Lancaster Mk X **TAMARA** KB849 434 Squadron coded WL•T, T for Tommy. Note the V-1 in the sawastika mission and two pints of beer possibly for a beer run, toasting wounded or killed crew.

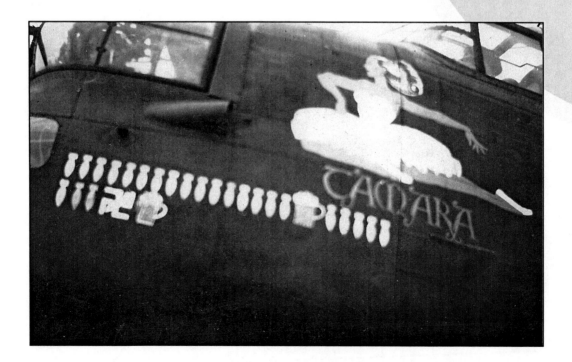

120

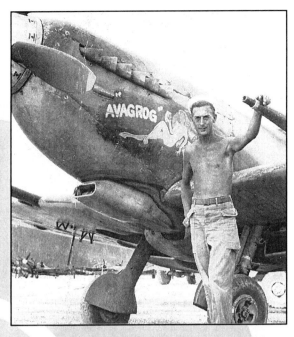

RAF Spitfire **AVAGROG** in Australia.

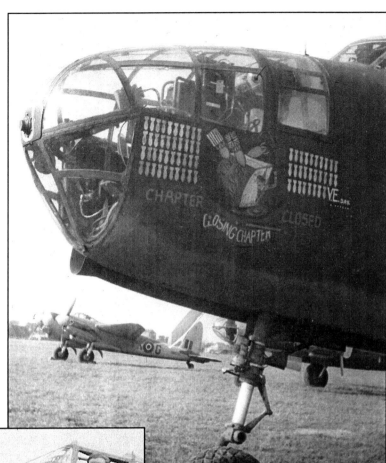

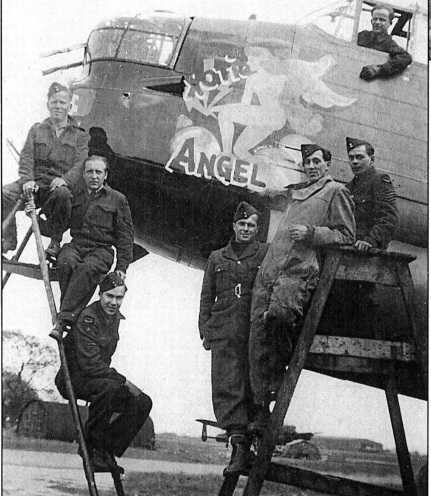

Top: CHAPTER CLOSED An unidentified Mitchell II showing the sentiment of the RAF towards the end of the war. The RAF equipped six squadrons of Bomber Command and the 2nd Tactical Air Force with Mitchells.

Left: RCAF Lancaster B Mk I PA226 **XOTIC ANGEL** from the 434 Squadron.

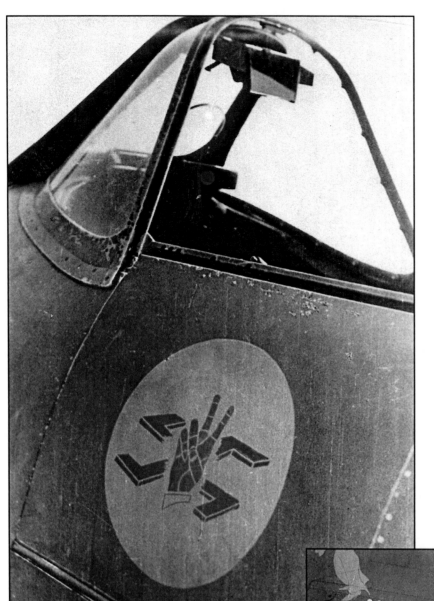

Left: Spitfire Mk Ia, N3277 displays the personal emblem of P/O R. Hardy of 234 Squadron. Receiving minor combat damage, Hardy was forced to land and subsequently taken prisoner on 15 August, 1940. The Germans experimented with this a/c and had it fitted with a Daimler-Benz engine. The emblem consisted of a yellow circle, red hand and black swastica.

Middle: Halifax B MkII 428 Squadron G for George depicts a yellow ghost while the mission markings are Skull and Crossbones. The name Ghost (not shown) is made up in white bones.

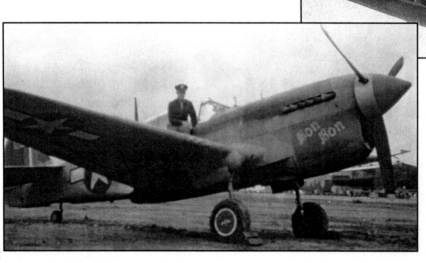

Left: P-40N **BON BON** 343BS and Major R.C. Harris, Lecce, Italy. 3/11-1944.

122

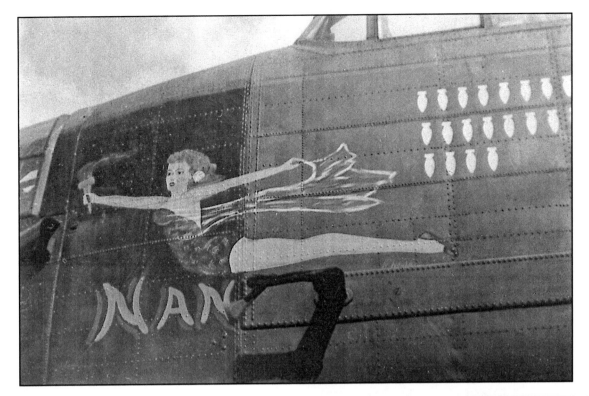

Lancaster Mk X **NAN** KB-890 434 Squadron depicts slightly modified art from the December 1943 Esquire Calendar.

Above: A Macchi 202 at the Aeroporto Fortunato Cesareo, Leece, Italy on 28 April, 1944.

Left: A Macchi 200 at the same aerodrome.

Below: A Russian YAK 9 Yugoslav Partizan Guard Bari, Italy 3 March, 1944.

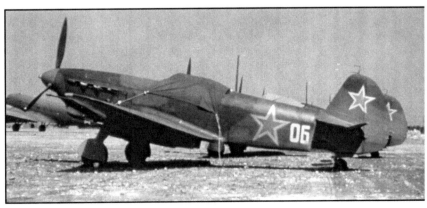

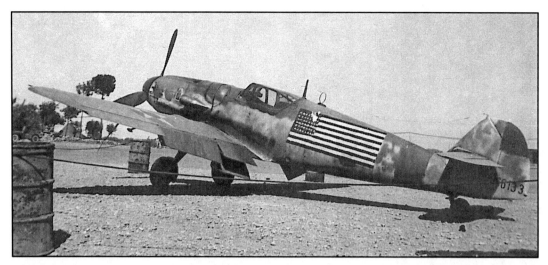

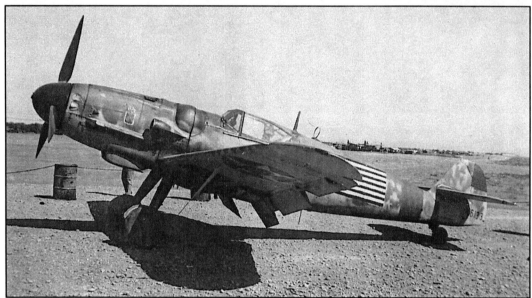

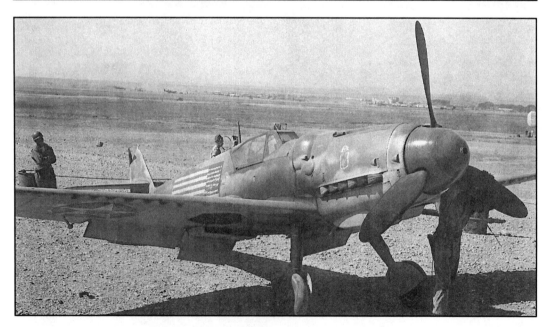

Above: An unidentified unit insignia on the nose may be a Rumanian Bf 109G Werke No. 166133 after switching sides later in the war. Early G models appeared late in 1943 and were assigned to the Mediterranean sector. Puzzling is the older style US insignia painted under the wings while its national insignia has been painted over with an American flag to avoid being shot down by allied pilots.

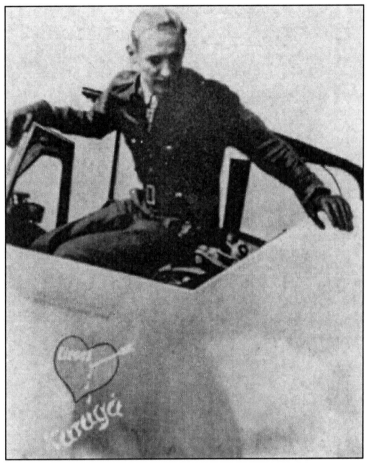

The Luftwaffe's markings were for the most, contemporary with unit insignia and on occasion, personal emblem were used. Undoubtedly the greatest scoring ace ever was Erich Hartmann who amassed 352 aerial victories. Pictured above in one of his G model Bf 190s, is the squadron emblem of 9./JG52 with his then girlfriend Ursel painted white in the red heart. In the following pages are but a few examples of such personal embellishments.

Below: A Bf 110 of ZG 1 depicting a very colorful bumble bee on its nose that was shared by all in this squadron.

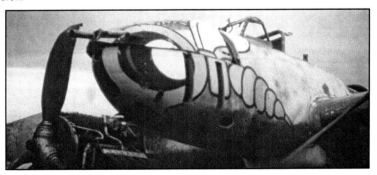

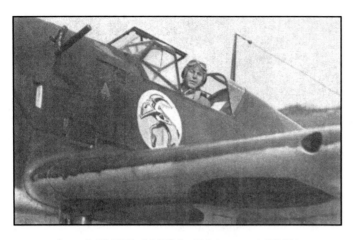

An early Bf 109B of 1./ZG 2 which became 1./JG 231.

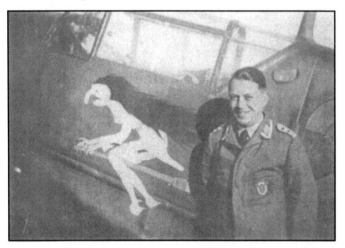

Ofw. Georg Seckel in Red 2 from 2. (J) Trägergruppe 186.

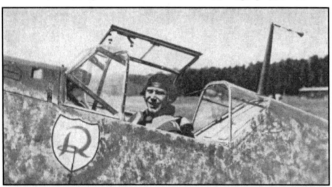

This unusual "stipple" camo on this 8./ JG 2 is RLM 71 over RLM 65.

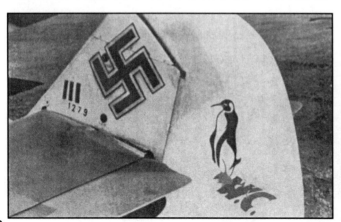

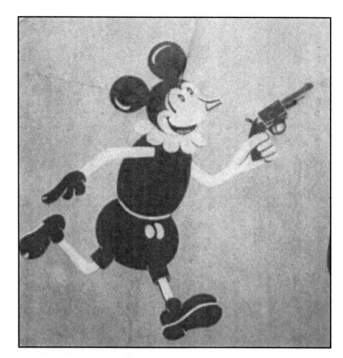

A variation of Micky-Maus from the 3 Staffel J/88.

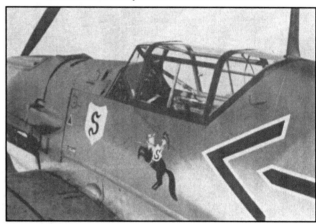

Above: Bf 109E-2 flown by Maj. Hans Hugo Witt of Stab/ JG 26

Below left: A rare example of tail art other than a score board is this personal markings of a penguin with possible initials W.C. This belongs to JG 26 and the Werke No. is 1279.

Below right: A crewman paints the 1./ JG 27 emblem on the cowl of a Bf 109E-4 with RLM 79/80/78 camo. Some of the 109Es in this group also had yellow cowling.

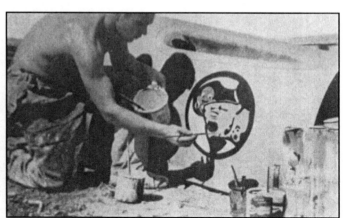

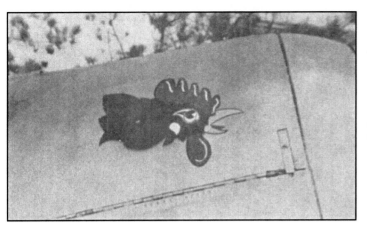

An FW 190 emblem of the III./ JG 2.

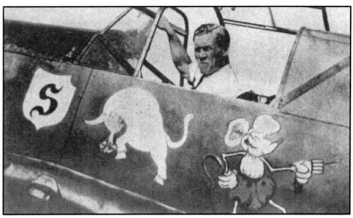

Kommodore of JG 26, Maj. Gotthardt Handrick August 1940.

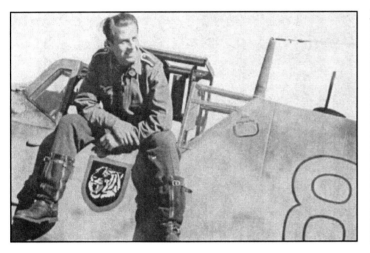

Yellow 8 of Uffz. Leo Demetz of III./ JG 11. 1944

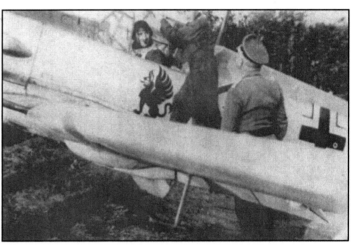

A rare photo of Maj. Adolf Galland Kommander of III./ JG 26 in a Bf 109 other than one of his personal planes.

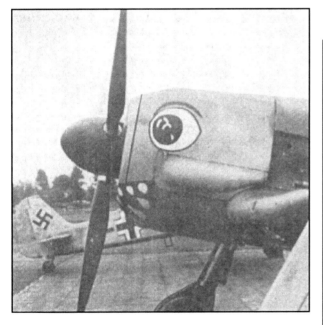

Above: An FW 190A of JG 1 with a stylized shark-type mouth.

Right: Obl. Hannes Trautloft in his FW 190 of JG 54. *Reddie Archives*

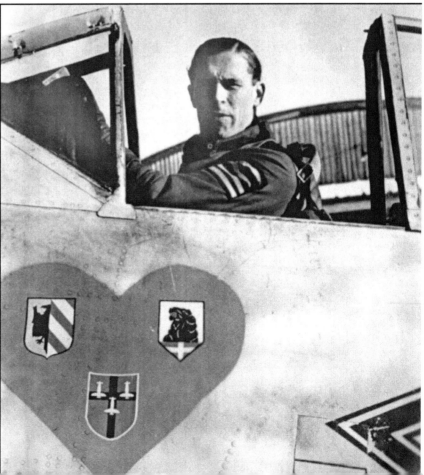

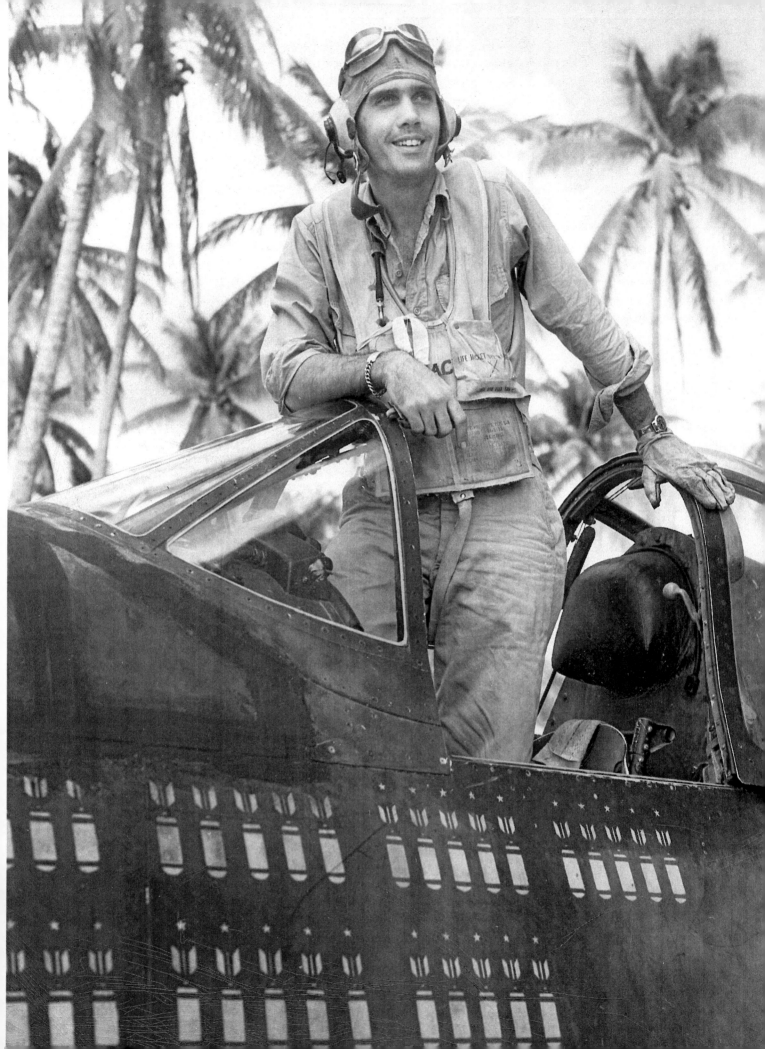

P.T.O.
PACIFIC THEATER OF OPERATIONS

War in the Pacific came swiftly on Sunday morning, 7 December 1941, when the Japanese attacked Pearl Harbor. In light of the impending hostilities in Europe and Japan's land grabbing of China, the US involvement in war was immanent. The Military was aware of this and had already been developing new war machines. In the Aircraft industry, Curtis, Grumman and Boeing had their early respective designs in use with the US Army Air Corps, Naval and Marine services. They were primarily the P-40, F4F and B-17. During the next two years, designers caught up to our counterparts and emerged with the P-47, P-51, P-38, F4U, F6F, P-61, B-25, B-26, B-24/PB4Y and ultimately the B-29.

As crews learned the characteristics of their machines, names were being painted on the noses which led to more elaborate and provocative art work. In contrast to the brashness of the designs compared to their European comrades, was simply the fact that in the Pacific, where island hopping and isolated airstrips did not require top brass to be present and therefore were not restricted to censor the nose art being applied. As the larger B-24s and PB4Ys (the Naval/ Marine variant of the Liberator in VB and VPB groups) became the backbone of the fifth, seventh and thirteenth Air Forces, nose art of some sort adorned the forward fuselages of the bombers. They presented a billboard-like canvas to which larger than life female forms were the choice IF the squadron had a talented artist to execute the task.

That was fine and dandy for the bomber squadrons, but on the Naval carriers and Marine held island-based fields, had a strict adherence policy to keep the aircraft clean and devoid of and such "graffiti" nose art. While this applied to the majority of the pilots, exceptions were the aces and heroes of the moment. As long as it was kept simple small and tasteful, the CO would look the other way. Squadron insignias and scoreboards were allowed albeit approved by the upper echelon. The Navy's leading ace Cmdr. David McCampbell, CO of Air Group 15 aboard USS ESSEX, had the name MINSI painted on all his F6Fs. Lieutenant Richard Stambook of VF-27 flew his F6F-3 with a stylized shark mouth and blood-shot eyes on the cowl. Junior Grade (Jg) Alexander Vraciu of VF-6 aboard USS INTREPID had two small insignias, the name GADGET and his scoreboard just forward of the cockpit. There were even fewer examples of F4F Corsair carrier based aircraft nose art.

Later in the war when the even larger B-29 arrived, artists were challenged to paint the surfaces with clever nose art. With the advent of air superiority, bombers were stripped of camouflage or got brand spanking' natural finished aluminum aircraft. This presented a problem with certain colors not showing up against the shiny finish. So the dominant color for names used was red with a black outline. From a distance, this color "popped" from the glare.

An analysis for the colors used by the artist will be given when applicable to further understand the artistic thought in the design factor. In my opinion that the creative license in nose art peaked at the end of the Pacific campaigns in 1945. Since then, none has matched the look of this unique record of American folk art.

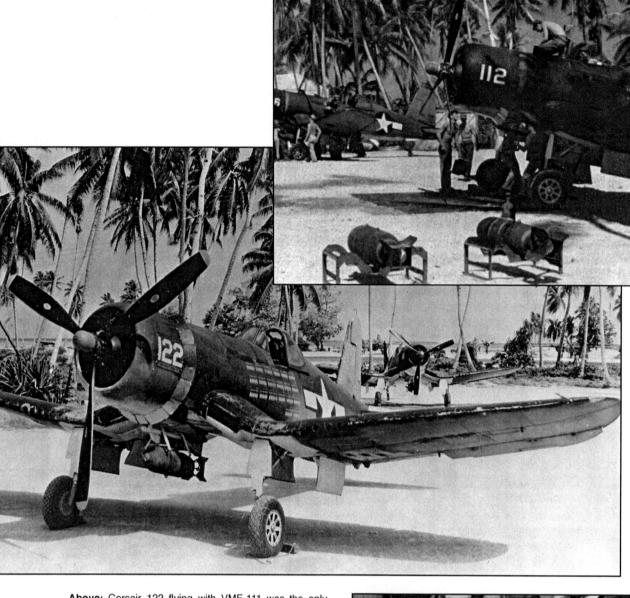

Above: Corsair 122 flying with VMF-111 was the only plane to receive an official citation in WWII. In 100 missions, the F4U-1D logged more than 400 hours flying time without any mechanical problems or aborts. These photos were taken in the Gilberts.

Inset: A rare color photo of the same group with ground crews at work.

Right: Lucy Malcolmson, Greg Boyington and Frank Walton at a Football game in the fall of 1945.
Bruce Gamble archives

Opposite: Boyington in the prepared F4U Corsair named LUCYBELLE. *Bruce Gamble archives*

Inset Left: A close-up of the name although partially covered, illustrates the letter "y". *Bruce Gamble archives*

Inset Right: Robert McClurg in the cocpit of the same a/c after the press leave. The name LUCYBELLE is clearly visible. *MAC053 McClurg Collection*

Previous page: 2nd Lt. William H. Magill in Corsair #122, VMF-111.
Inset: B-29 **The CAJUN QUEEN** 444BG, ,678BS

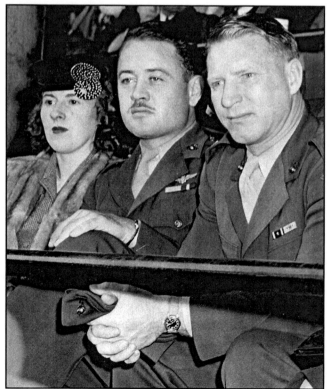

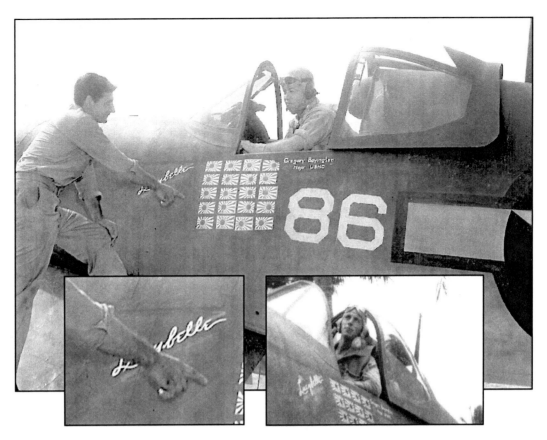

For years famed VMF-214 Black Sheep CO Major Gregory "Pappy" Boyington has been thought to have flown Corsair #86 when in fact he never did. The only known Corsairs Greg flew were BuNos 17740 and 17883. Because of the popularity given by the media press for his score coming close to that of Rickenbacker's, Boyington was called back for a publicity photo shoot. On 26 November, 1943, Squadron Intelligence Officer Major Frank Walton accompanied Boyington to Turtle Bay with several other Black Sheep, literally hundreds of miles from the combat zone. A Corsair was prepared with the name **LUCYBELLE** and 20 rising sun decals hastily trimmed and applied next to his name and rank. When an excellent copy was obtained for study, it was conclusively determined that when enlarged though slightly obstructed, the 'y' is clearly separated from the 'b'. Chalk guide lines are now seen for the name.

Boyington after his fall out with the AVG, had a torrid affair with a then married Lucy Malcolmson. They met aboard SS BRAZIL on return from Bombay to the states. It took six weeks to complete the trip back to New York and in doing so, the couple got to know each other quite well and she agreed to help manage Boyington's financial affairs while he was in combat. Naturally, the press became interested as a USMC pilot neared that of Rickenbacker's and in doing so, the press sought after Lucy also. The relationship became common knowledge although taboo. At some point waiting for Boyington to arrive for the now famous staged photo shoot, it was decided to paint the name *Lucybelle* on a Corsair along with the current score. When Boyington returned as a POW, the relationship soured and by January 8, 1946, Greg married the former Frances Baker. Needless to say that the scornful Lucy still withheld Boyington's back pay and subsequently never got it, hence the hostility which led to Boyington dispelling the name **LUCYBELLE** from the now famous photo. The partial name worked as a great cover and aided in the controversial name change to **LULUBELLE**. Usually, photographers take multiple photos of such an occasion. Why no other photos of this day as significant as this have surfaced still amazes me.

At the time of this publication, I contacted Robert McClurg who after 60 years, did have a photo that was taken with him seated in the cockpit of Corsair #86! The name is clearly visible although the decals have been re-arranged and placed backwards. McClurg could not recall the details surrounding the photo opportunity.

In lieu of Boyington's endorsement of the fictitious **LULUBELLE** name and decades of denial, no one questioned it. To further mask the truth, artists (myself included) have illustrated Boyington in combat flying #86. The fable even rubbed off on the late Japanese pilot Capt Masajiro "Mike" Kawato who claimed to have shot down Boyington while in #86. In his book, Kawato states having clearly seen the markings prior to the burning Corsair crashing into the sea. All said, this is how rumors, legends and conspiracies start.

Liberated on 29 August 1945, Boyington returned to the States and was "medically" retired as a colonel in 1946. He died from cancer on 11 January 1988 in Fresno, California. Boyington's official score came to 24 confirmed and 4 probables with a Medal of Honor and Navy Cross.

America's Ace of Aces, Major Richard Ira Bong scored all of his 40 kills in P-38s with another eight probable plus seven damaged. Amazingly, his eye sight was not as sharp as needed by pilots and his flying skill is what made up for his average sight. Bong has stated that the way he shot down his opponent was to "get in as close to his tail as possible, then let 'em have it".

A Poplar, Wisconsin native, Bong enlisted as an aviation cadet in the Army Air Forces on 29 May 1941 and received his wings on 9 January 1942. Assigned to the 9th Fighter Squadron, 49th Fighter Group in Australia, Lt. Bong took a small stint in Port Moresby, New Guinea. He was temporarily attached to 39th Fighter Squadron, 35th Fighter Group where two days after Christmas, scored his first two victories. Returning back to the 9th FG on 11 January 1943, he already had achieved ace status. After his first leave back from the States and his score at 20, Bong was assigned to HQ, Fifth Fighter Command in New Guinea. There between 11 February and 12 July 1944, he downed another seven Japanese aircraft surpassing Rickenbacker's record of 26. Sent back to the states a second time, he was an immediate celebrity along with his then girlfriend Marge Vattendahl, whose name was painted in red with white shadow. Rather than opting for nose art which he considered to be vulgar, Bong had a collage graduation picture of Marge enlarged, hand color tinted and doped to the left gun access door of his P-38. The photo had been applied at least twice on account for it being torn off in flight.

In October, Bong returned yet again to combat and within the next 60 days, ran his score to 40, shooting down his last enemy aircraft, an Oscar, on 17 December. Too valuable an asset, Bong was taken out of combat and given Carte Blanche to any job he desired. Still wanting to fly, he took duties as a test pilot Chief of Flight Operations at the Lockheed plant in Burbank, California. He finally married Marge on 10 February 1945. While testing a new P-80 Jet fighter, Bong had his engine flame out on take-off and did not have the height to bail out, subsequently crashing on 6 August 1945.

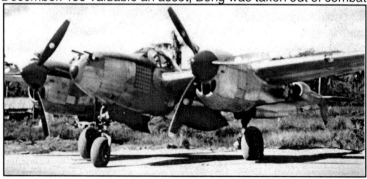

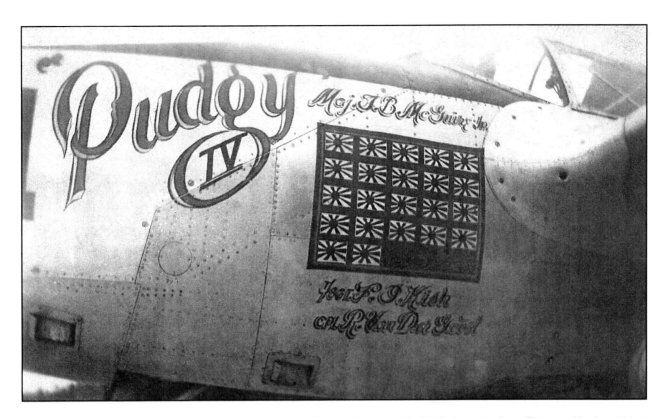

Bong's rival and second highest scoring ace, Major Thomas B. McGuire, Jr., flew P-38s with the 431st Fighter Squadron, 475th Fighter Group. The New Jersey native enlisted in the Army Air Forces on 12 July 1941 and trained at Key Field, Mississippi. McGuire's first assignment was to the 54th Pursuit Group in Nome, Alaska, where he served until 16 October 1942. On 14 March 1943 he departed for the Pacific, initially assigned to the 49th Fighter Group, he was subsequently transferred to the 431st Fighter Squadron, 475th Fighter Group on 20 July.

This being his fourth out of five P-38 nick-named **PUDGY IY**, after his new bride, also had red and white as squadron colors. McGuire was in **PUDGY V** when attacking a Zeke at tree-top level where he entered high-speed stall and crashed into the jungle. His final score came to 38 confirmed, three damaged and two probable.

The score box is in black with red and white rising sun flags. A thin red stripe surrounds the kill flags. The names and ranks are in black with a red shadow. The crew listed are; T/Sgt. F.J. Kish and Cpl. R. Van Der Geest. In other b/w published photos, the name is slightly lighter in shade than the a/c #131. This is most likely due to markings freshly re-painted or a different type of red paint was used where the pigment varied. This is often a common mistake taken when interpreting colors compounding the fact that there were two types of b/w film used in WWII that when developed would have the gray tones darker for certain colors (see last chapter for more details). The name and # 131 are outlined in black.

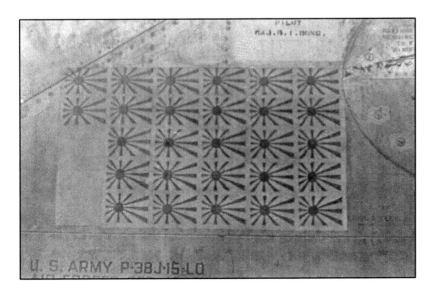

Left: P-38J-15-LO **MARGE** 42-103993 is shown here and opposite page. Although the photo of Marge, name and nose ID #993 has been removed for unknown reasons, the kill tally score board has also been changed to a white background with red rising sun flags stenciled along with his name. In the photo opposite page, the ground crew is added. This box was in black with names in white or yellow stenciling earlier on.

Opposite top: A 3/4 front shot of #993.

Opposite bottom: This being Bong's last P-38L-1-LO s/n 44-23964 was lost two weeks after this photo was taken on 28 November, 1944. It was piloted by Capt. John Davis and crashed killing its pilot during an aborted take-off.

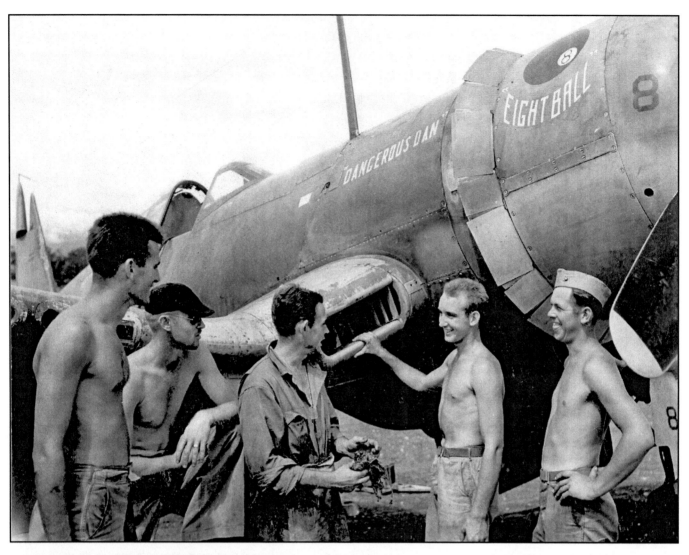

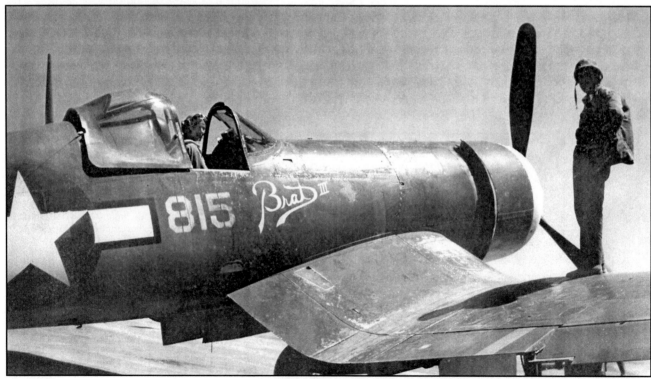

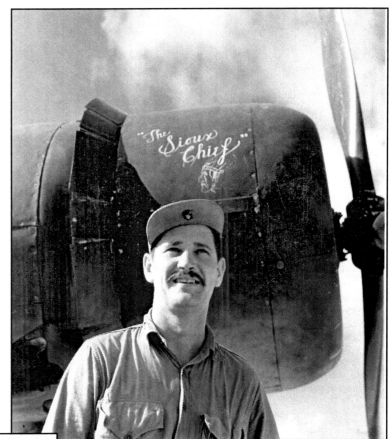

Opposite Top: F4U-1 **DANGEROUS DAN EIGHT BALL**.
NARA via Reddie Archives

Opposite Bottom: F4U-1A **BRATT III** on Iwo Jima.
NARA via Reddie Archives

Right: F4U The **SIOUX CHIEF** flown by Major Joe Foss the USMC highest scoring ace with 26 confirmed. All of his kills were from his F4Fs and in June 1943, Foss took Command of VMF-115 in Bougainville which by then transitioned into Corsairs. *NARA via Reddie Archives*

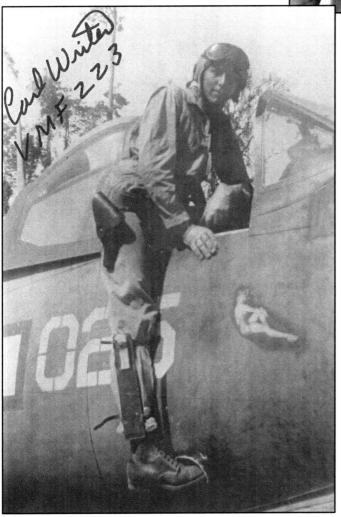

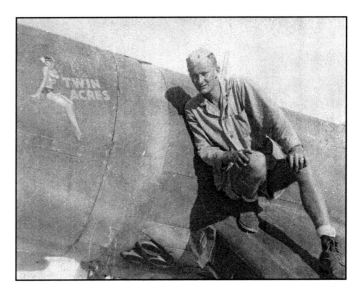

Above: F4U **TWIN ACRES** with unidentified marine.

Left: 2nd Lt. Carl Winter of VMF-223 steps into his F4U Corsair adorned with a doped on calendar pin-up.

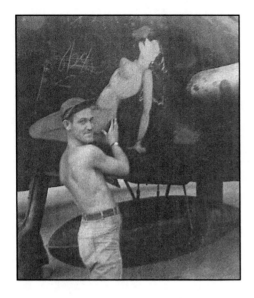

Above: A rather large example of pin-up art on a F6F-5N cowl.

Below: F6F-5N **1 O'CLOCK JUMP** VMF (N)-541 Two ground crew members admire art on this night fighting Hellcat. The name has not yet been painted. These F6Fs were based on Falalop Island 30 May, 1945.

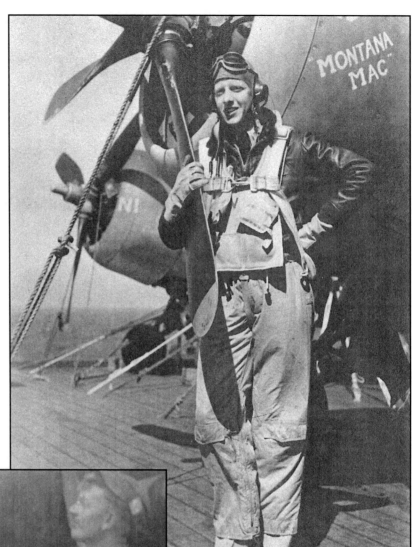

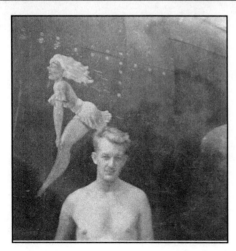

Above: F4F **MONTANA MAC** VC-21 Ensign William M. McLemore was killed offshore of Guadalcanal Island 1 September 1944.

Below: Three F6Fs from the same squadron, VMF (N)-541 with similar pin-up art presumably by the same artist.

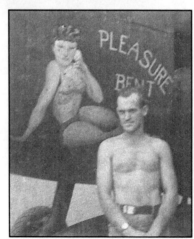

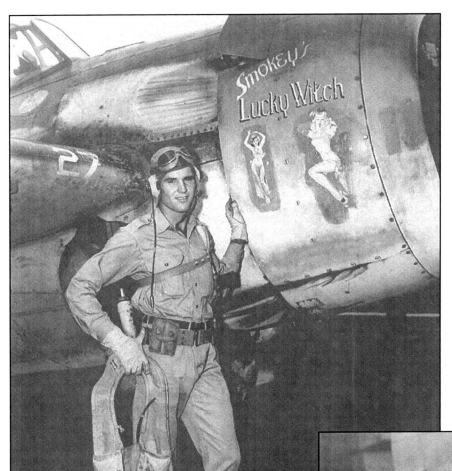

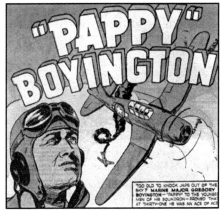

Top left: F4F **SMOKEY'S LUCKY WITCH** has actual calendar pin-ups doped on to the cowl which in all is highly unusual for a carrier based plane. A squadron insignia is visible but not identifiable.

Above: F6F **MID NITE MOOD** in line with other island based Hellcats that share similar pin-up art and may be F6F-5Ns from VMF (N)-541 equipped with radar based on Falalop Island.

Left: An unnamed F6F-5N with Elvgren inspired art. These are few known examples of pin-up nose art on Marine aircraft. Either the COs were lenient or they were not aware of the embellishments for this far exceeds the standard squadron insignia.

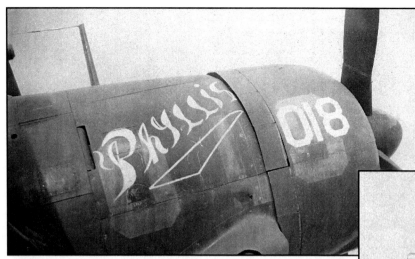

Left: SB2C-1 **PHYLLIS**

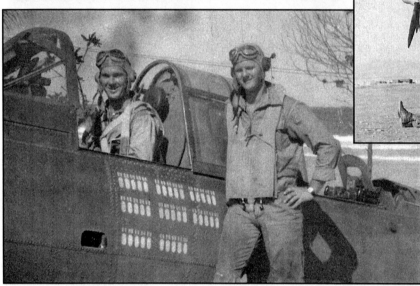

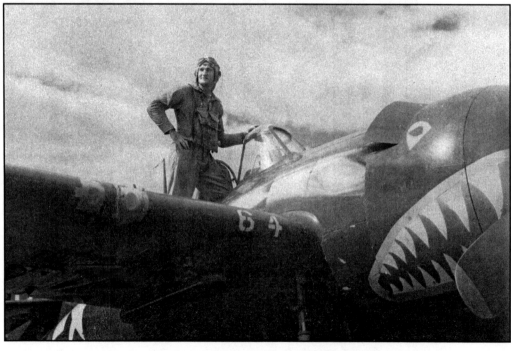

Above: A rare nose art photo of an A-35 Vultee Vengeance **JEZABELLE** in training. These were eventually used for target towing and never saw combat.

Left: SBD Dauntless of VMSB-231 crew pose by their mission score of 40.

Above: A rare color photo of an unidentified pilot and his F4F with shark teeth markings.

Right: P-39 from the 35FS, 8FG being prepped for another mission.

Middle: P-39 from the 40FS, 35FG signing off. Note the 37mm cannon which replaced the 20mm hispano.

Bottom: P-39 **LEURA** 41-38359 35FS, 8FG flown by Lt. Irving A. Erickson with crew chief C. A. Matteo at Milne Bay.

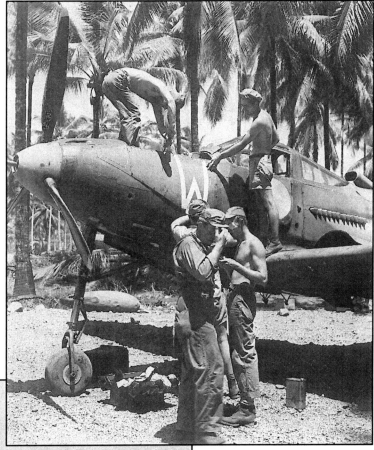

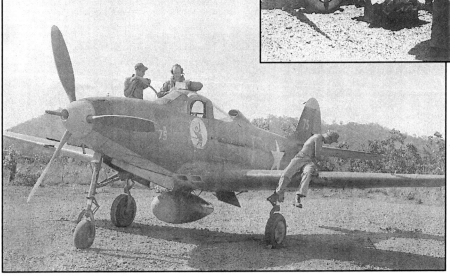

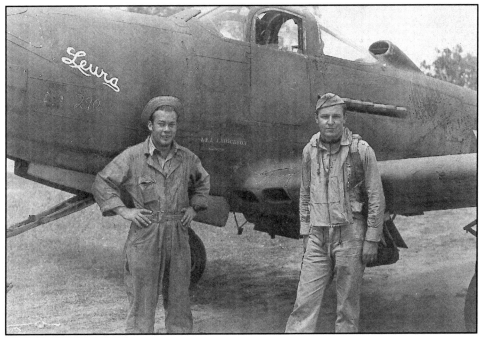

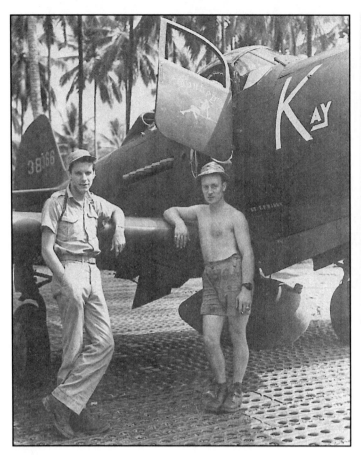

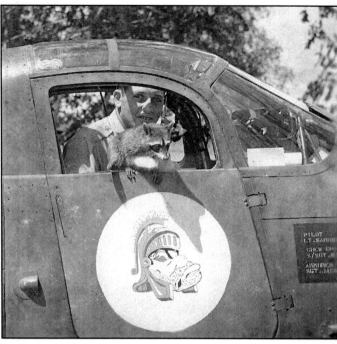

Above: P-39 flown by Lt. Lou Sarone displays his pet raccoon and his personal insignia rendition of Disney's "Peg Leg Pete".

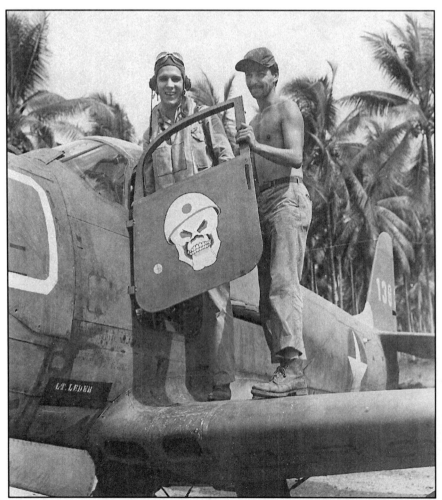

Top left: P-39D "**MONKEY**" (KAY) 35FS, 8FG 41-38336 flown by Lt. Leonard P. Marks with his crew chief. Note the name and pin-up on the door.

Left: P-39D 41-38352 35FS, 8FG flown by Lt. Leder. Note the personal emblem Leder has chosen to honor the Marine "Grunt".

These photos were taken at Port Moresby, New Guinea 1942 early before transition into P-40s and ultimately P-38s.

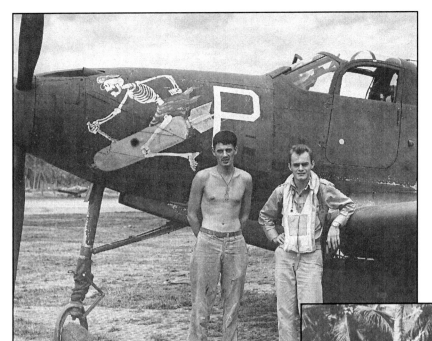

Left: P-39D 41-38350 35FS, 8FG Lt. Pankyo with his crew chief Sgt. Parsells.

Middle: P-39D **LIL ELSIE** 35FS, 8FG 41-38367 Lt. Jerry Quandt with crew chief.

Below: P-39D **UNCLE DUD** 35FS, 8FG flown by Lt. Clifton Troxell with crew chief Sgt. Pete Gino. Troxell is credited with 2 confirmed and one probable in this a/c. Later in a P-40N, one victory is recorded. Two more victories in a P-38G on 15 September 1943.

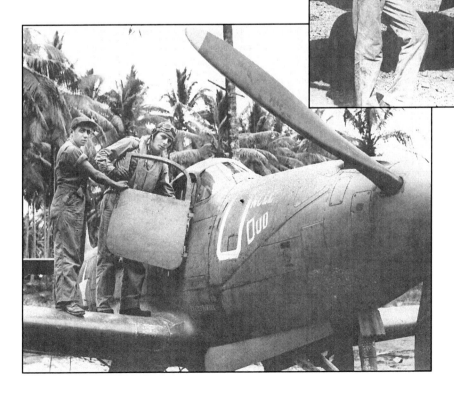

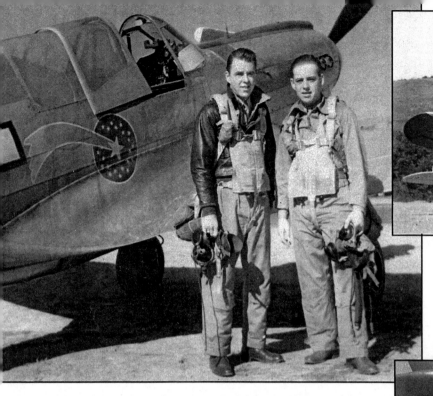

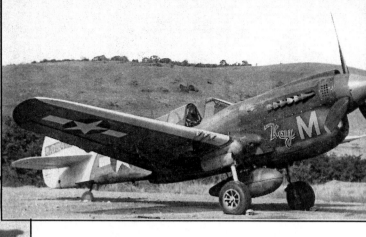

Above: P-40N **KAY** from the 8FG, 35FS piloted by Walter Posvistak and was credited with 1 kill on 22 September 1943.

Left: Pilots stop to pose with a P-40N from the 22nd Aero squadron in training.

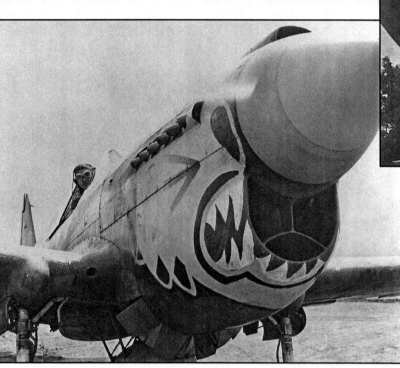

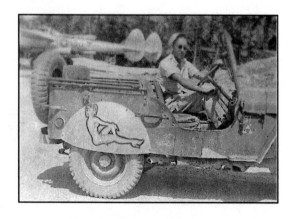

Above: P-40N-1 **COME IN SUCKERS!** 42-104827 was shipped to Australia under the lend lease program and assigned to the RAAF 78th Squadron. The serial number redesignated A29-414 and flown by Jim Harvey. It was written off in a landing accident upon arrival at Tadji (Aitape) off the northern coast of New Guinea. This a/c was recently re-discovered and is currently being restored in New Zealand.

Above: Curtis P-40E from the 11FS, 343FG, Alaska with the "Aleution Tiger" marking on the nose in Yellow and black. The markings were added to honor Squadron Commander Capt. John S. Chennault (later promoted to Lt. Col.) and his father Claire who commanded the AVG Flying Tigers.

Bottom Right: Somewhere in the Pacific is this novel wheel cover decorated with a lovely Varga pin-up.

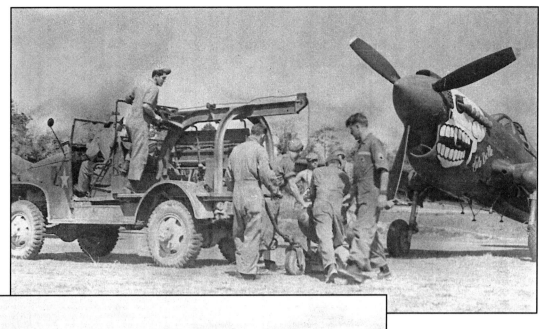

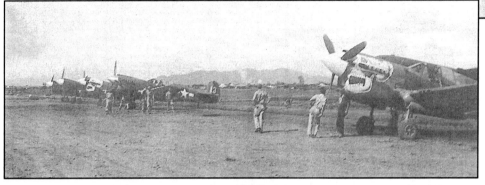

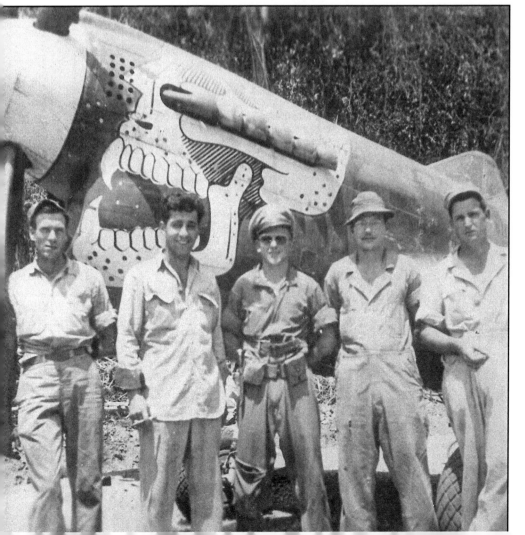

Top: P-40N **LULU BELLE** 80FG flown by 2Lt. Phil Adair is being prepared for another mission. This is Adair's 2nd P-40 with the same name. The prop spinner is red and had painted his tire walls white.

Middle: P-40Ns from the 80FG on the flight line.

Bottom: A close up of the Skull designed by Lt. Freeling "Dixie" Clower of the 89FS.

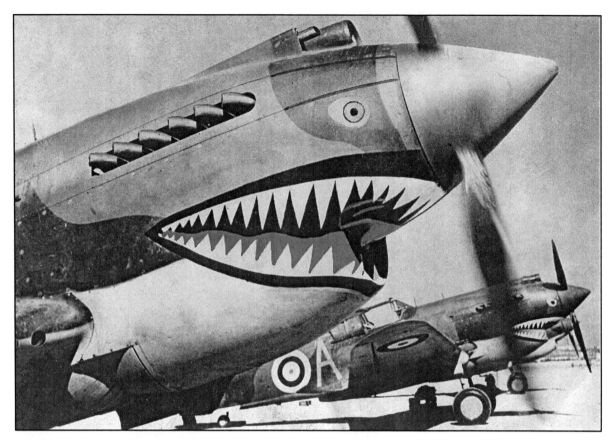

Top: RAF Tomahawk IIAs from the 112 Squadron originally wore the distinctive shark mouths on the noses August-September, 1941. The AVG followed suit soon after by Charles Bond who was the first to paint the distinctive markings on an AVG P-40. With Claire Chennault's approval, by 15 December 1941, all the AVG's P-40s ensued and carried the shark mouth which made it forever tied to the Flying Tiger history.

Left: P-40K **PREGNANTS MAGNIFICENT ABORTION** may be from the 75FS, 23FG.

Bottom: P-40E-1 flown by Capt. Dallas Clinger was first assigned to the 16FS, 51FG and later to the 74FS, 23FG. The art appeared on at least two P-40s and was painted to both sides of the rudder. The rising sun red detail has not yet been painted to #38.

Clinger is credited with 5 confirmed and 3 probable earning a DFC and Purple Heart.

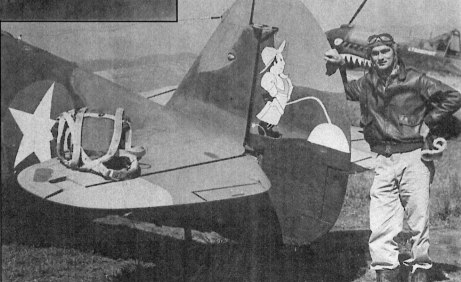

144

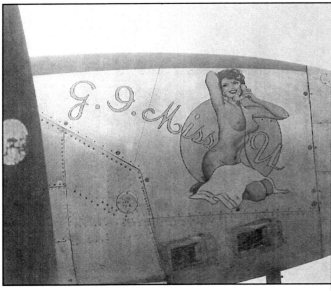

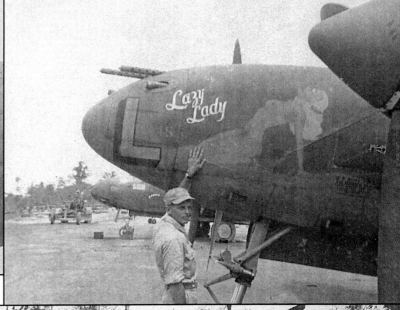

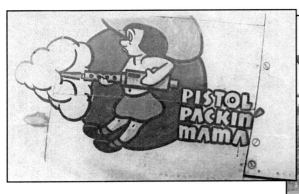

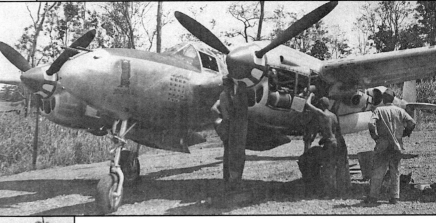

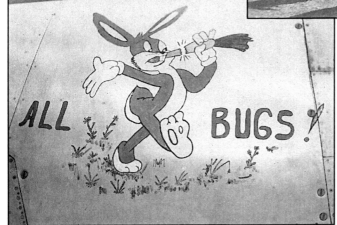

Above: P-38J-15 **JANDINA III** 42-103988 flown by Capt. Jay T. Robbins, CO of the "Headhunters" 80FS, 8FG. Robbins crash landed this P-38 in bad weather without hydrolics to lower the nose gear at Saidor on 7 May 1944. Notice the unusual red and white spinners. Robbins is credited with 22 confirmed, six probable and four damaged. Robbin rose to lieutenant general CO of the 12th AF and vice-commander of Tactical Air Command prior to retiring as vice-commander of Military Airlift Command on 1 September 1974.

Top: P-38 **G. I. MISS U** from the 35FS, 8FG. The 35th fighter squadron panther insignia was later added to the right of the pin-up.

Top Right: P-38J-10 **LAZY LADY** 35FS, 8FG flown by Lt. Glen Holder with 4 confirmed victories and 2 probable. The L is yellow with a black shadow. The name is in white. Red hair tie and shoes.

Middle Top: P-38 **PISTOL PACKIN' MAMA**.

Middle Bottom: P-38 **ALL BUGS!**

Left: P-38 **STRICTLY SEX** from the 347FG.

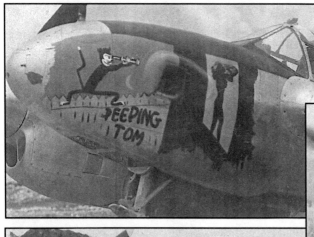

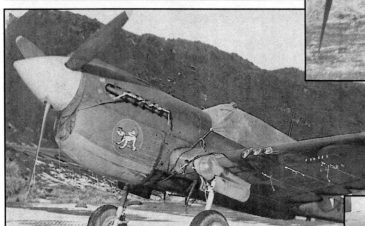

Top left: F-5 **PEEPING TOM**.

Above: P-51 **THE DEACON**.

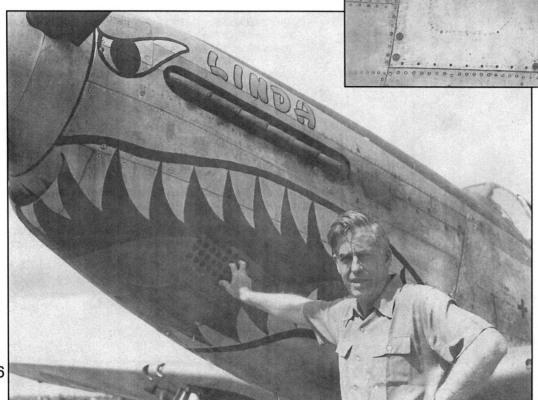

Above: P-40 from the 18FS. 343FG in the Aleutians.

Right: P-38 **PIGGY BACK**.

Below: P-51B **LINDA** 26FS, 51FG with Henry A. Wallace during a tour of China in September 1944. Wallace was FDR's second Vice President.

146

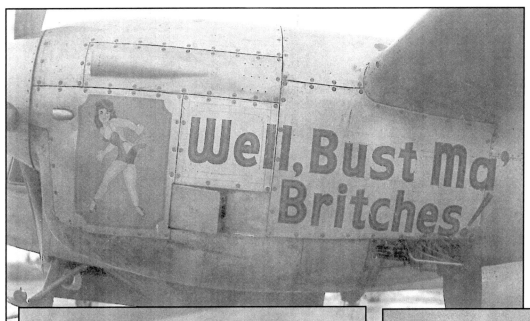

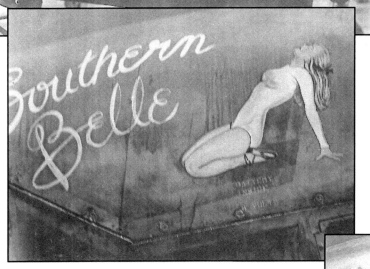

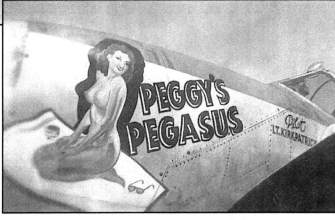

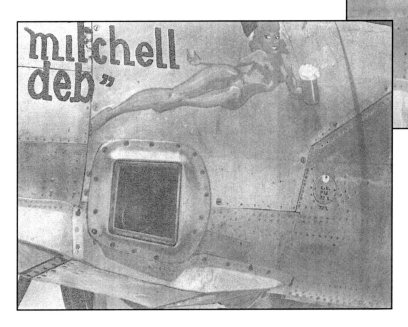

Top: F-5 **WELL, BUST MA' BRITCHES!**.

Middle left: P-38 **SOUTHERN BELLE**.

Middle right: P-38 **PEGGY'S PEGASUS** flown by Lt. Kirkpatrick.

Above: F-5 **THE COMELY COOLIE** 28PRS, 7PRG was named after the crew chief Leslie Coolie.

Left: F-5 **MITCHELL DEB** 44-25175 28 Photo Recon Squadron, 7 Photo Recon Group was named by crew chief James Schuhl.

147

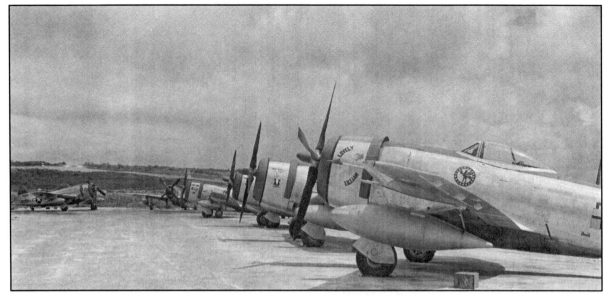

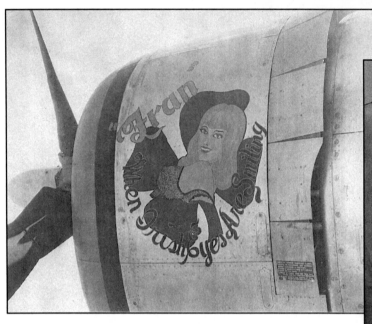

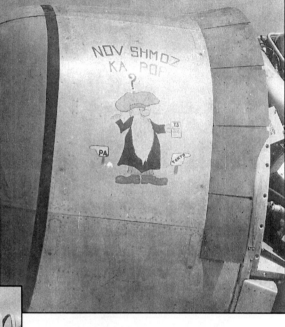

Top: P-47Ns of the 19FS, 318FG on flight line with **LOVELY LILLIAN** in the foreground.

Middle left: P-47N "**FRAN**" **WHEN IRISH EYES ARE SMILING** 19FS, 318FG.

Middle right: P-47N **NOV SHMOZ KA POP** 19FS, 318FG.

Left: P-47N 44-87962 **BOTTOMS' UP** 19FS, 318FG flown by Lt. William H. Mathis.

Right: P-47N-2-RE **HONOLULU TINA** 19FS, 318FG.

Below: P-47N **STANLEY'S STEAMER** 19FS, 318FG flown by Lt. Stanley J. Lustic. The name and hair is in black while the blanket is OD.

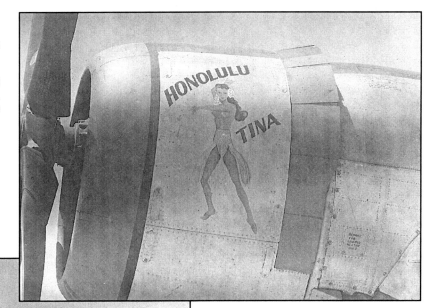

Above and left: Two unnamed P-47Ns from the 19FS, 318FG.

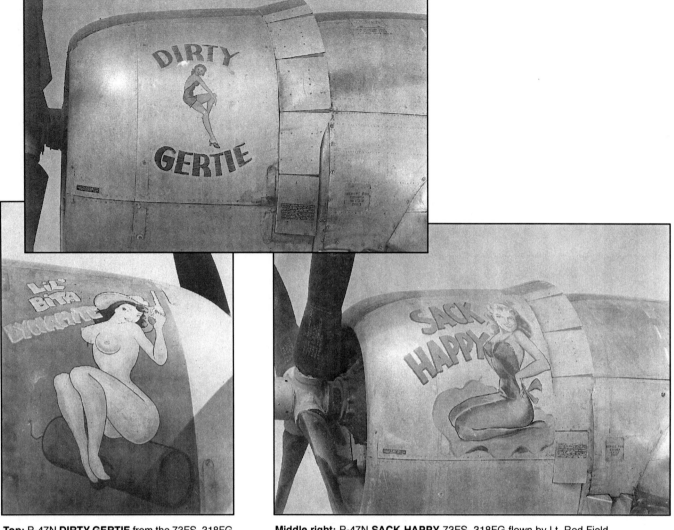

Top: P-47N **DIRTY GERTIE** from the 73FS, 318FG.

Middle left: P-47 **LIL' BITA DYNAMITE.**

Below left: P-47N **LADY SUSAN** 19FS, 318FG.

Middle right: P-47N **SACK HAPPY** 73FS, 318FG flown by Lt. Red Field.

Below right: P-47 N **MISS DAPHY** 19FS, 318FG.

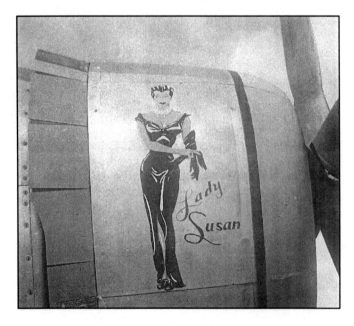

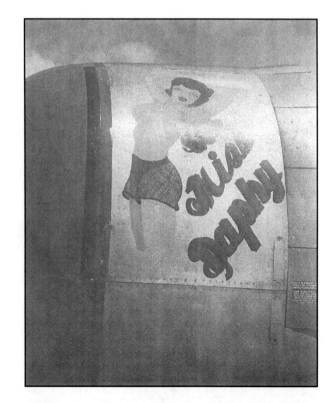

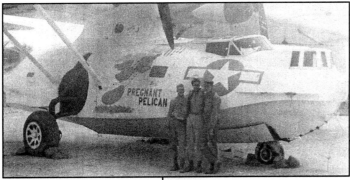

Top: OA-10A (PBY-5A) **PREGNANT PELICAN.**

Right: P-38J-10-LO **IRISH LASSIE** 459FS, 80FG flown by Lt. W. G.. Baumeister. *NARA via Reddie Archives*

Below left: P-47N **DRINK'N SISTER** 44-47319 flown by Capt. John E. Vogt. A five kile ace from the 19FS, 318FG.

Below right: P-47 possibly from the 27FG.

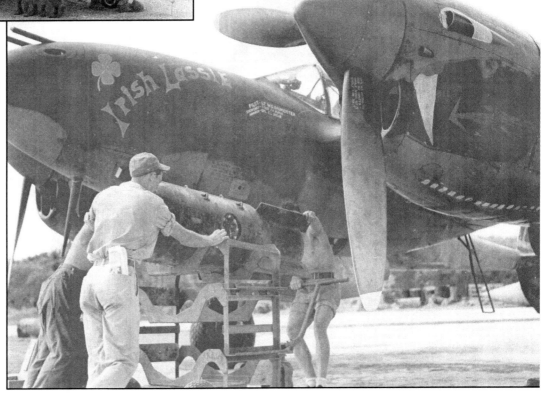

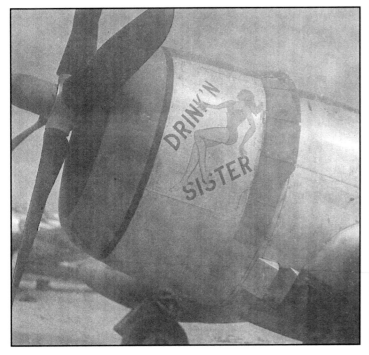

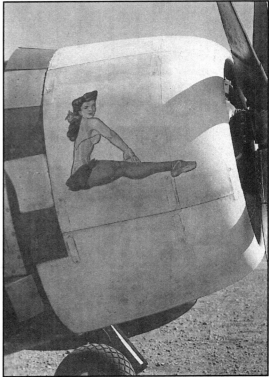

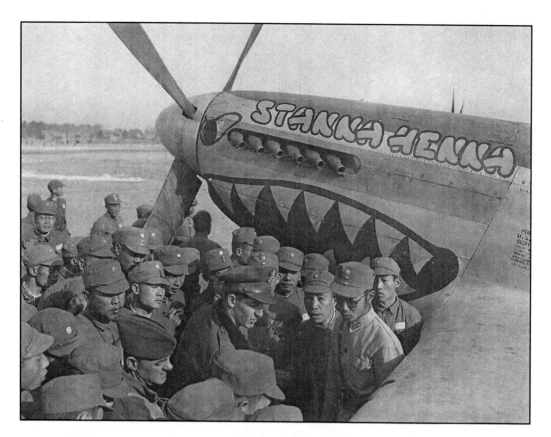

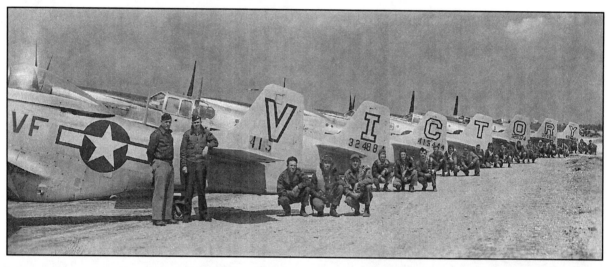

Three pilots take a moment to pose before a flight in a PT-19B.

Opposite top: A P-51B **STANNA HENNA** from the 51FG is used as students of the Chinese Class of the General Staff School listen to Capt. Joseph E. Hearn explain the workings of the a/c .

Opposite middle: V-E day 1945, yellow tailed P-51Ds from the 5FS, 52FG MTO sum it up with deputy CO Col. Woodeow B. Wilmot and squadron personnel in an elaborate publicity shot.

Below opposite and this page: Artful signage indicate the base location with a little boasting.

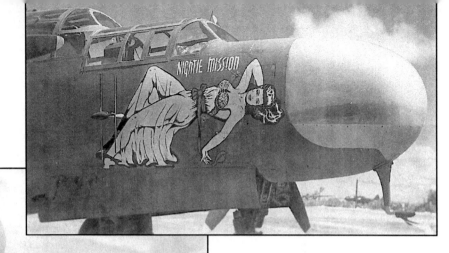

Top: P-61 **NIGHTIE MISSION** from the 6NFS.

Left: An F4F **RINGER** flown by Lt. Howard K. Winfield (center). At left is Donald Balch VMF-221 who became an ace with 5 confirmed, one probable and two damaged. Right is Lt. Wallace Hallmeyer. Tail art was very unusual in the USMC and would not have appeared aboard a carrier. *NARA via Reddie Archives*

Right: Douglas A-24 **ARISTOCRAT LADY**.

Below: Curtis A-24 **GALLOPIN GOOSE** were both Army variants of their Navy counterparts and both painted in OD/Neutral gray camouflage.

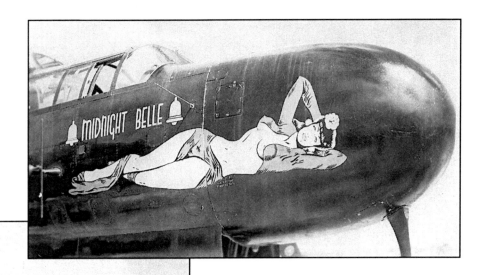

Top: P-61 **MIDNIGHT BELLE** 6NFS piloted by Capt. Mark E. Martin 1944. The artist was Eldon T. Gladden.

Left: P-61 **HUSSLIN' HUSSY** 6NFS. The artist was Eldon T. Gladden and his trademark was to incorporate a clever graphic image before and after the name. Note the four examples on this page.

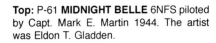

Navy Radar Wings

Right: P-61 **THE VIRGIN WIDOW** 6NFS. The artist was Eldon T. Gladden.

Bottom: P-61 **MOONHAPPY** 6NFS flown by Lt. Dale F. Haberman and named after its Radar operator, Ray Mooney. The artist was Eldon T. Gladden.

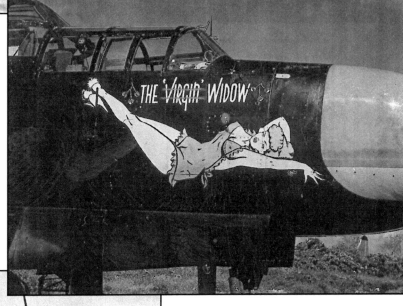

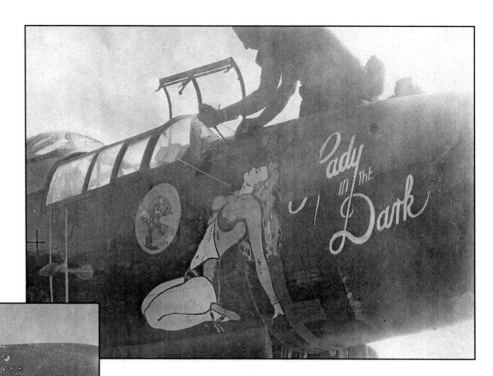

Above: P-61B-15 **LADY IN THE DARK** 42-39713 548NFS.

Left: P-61 **SLEEPY TIME GAL** 6NFS piloted by Capt. Ernest Thomas and R/O Lt. John Acre. The name was later changed and added the Roman number II.

Below: P-61A **JAP-BATTY** 42-5528 6NFS (in OD camo) flown by Lt. Jerome M. Hanson just after being awarded Air Medals for the destruction of an enemy aircraft by each of these P-61 crews.

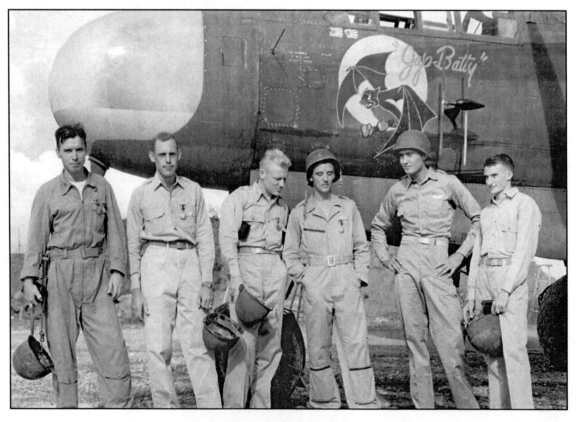

L-R: Ray Mooney-R/O, Jerome Hanson-Pilot, Dale Haberman-Pilot, William Wallace-R/O, Francis Eaton-Pilot, James Ketchum-R/O. *NARA via Reddie Archives*

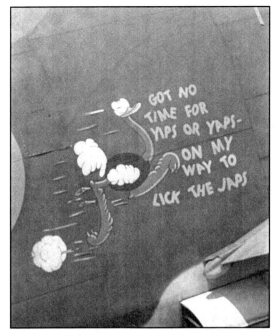

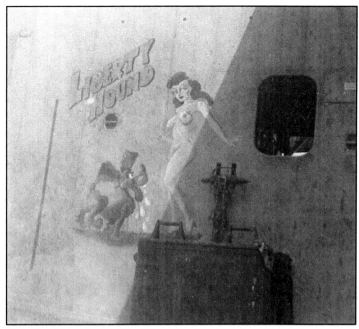

Top left: PV-1 RAF **VENTURA** from the NO. 21 Squadron.

Top right: PBM-3 **LIBERTY HOUND**.

Below: PV-1 **HEAVEN CAN WAIT** VPB-133 Tinian 1945 named all their aircraft art with titles of popular songs of the time.

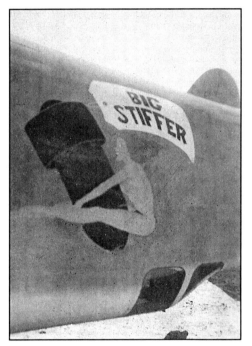

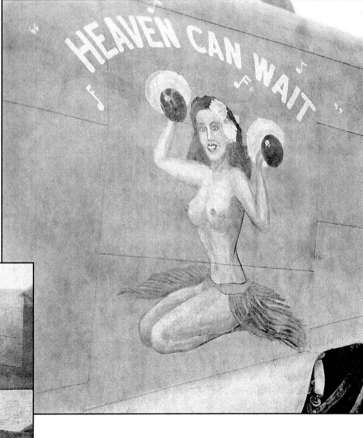

Above: PV-1 **BIG STIFFER**.

Below: PV-1 **THE SENTIMENTAL LADY**.

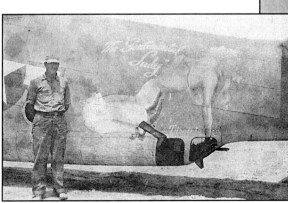

HOLLYWOOD
Goes to War

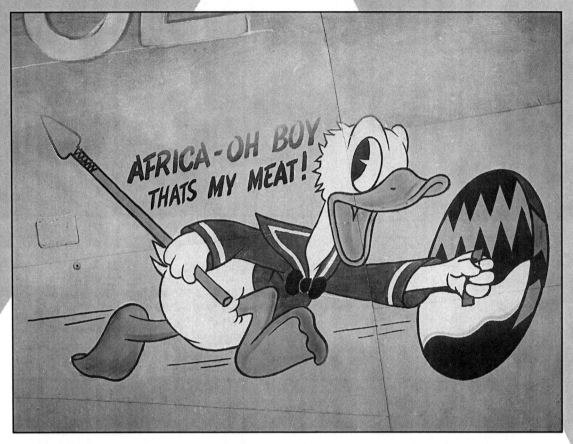

As war became imminent and a reality, the country as a whole came together in support of efforts in morality and in every aspect of sustaining material to the fronts. Walt Disney and company became one of the greatest contributors of WWII. With the help of his artists utilizing his familiar cartoon creations, Disney produced war training films, insignia, movie trailer shorts in support of the war and poster ad campaigns to name a few. This led to the hiring of a full time staff devoted to creating insignia for the war department.

Among the famous was the creation of the AVG Flying Tiger insignia. The China Defense Supplies in Washington, D.C., contacted the Walt Disney office and put in a special request to design an insignia for the AVG. The tiger replaced the dragon as China's national symbol and a final design was rendered by Roy Williams and Hank Porter at the Disney studios. The design was made into large decals with left and right images that were ment to be affixed to the fuselages of their P-40s. It wasn't until after Christmas 1941 that the "Tiger" decals started to appear on the Shark-mouthed Tomahawks.

Another famous design was the RAF Eagle Squadron insignia designed in 1940. there were many adaptations of this design that is still in use today in a variety of media.

Fortunately for the Lockheed Vega plant, the Disney studios was right next door in Burbank and whenever the artist had free time, he would stop by and paint cartoon characters on the noses and fuselages of various planes that came off the assembly line. In this case, PV-1 Venturas were being built and in the following pages are many examples of the fine art that appeared on these instruments of war. The bulk of the characters were Donald Duck and friends.

Occasionally a new character was created. One such Toon was Strato-Sam, a Lockheed worker that always had a pithy slogan against the axis. Soon after came Kid Vega, an eager young naval ensign. Several of the known PV-1 squadrons that had Disney art were VP-131, VP-45, VP-17 and VP-30. Some of the Venturas went to the RAF in a lend-lease program.

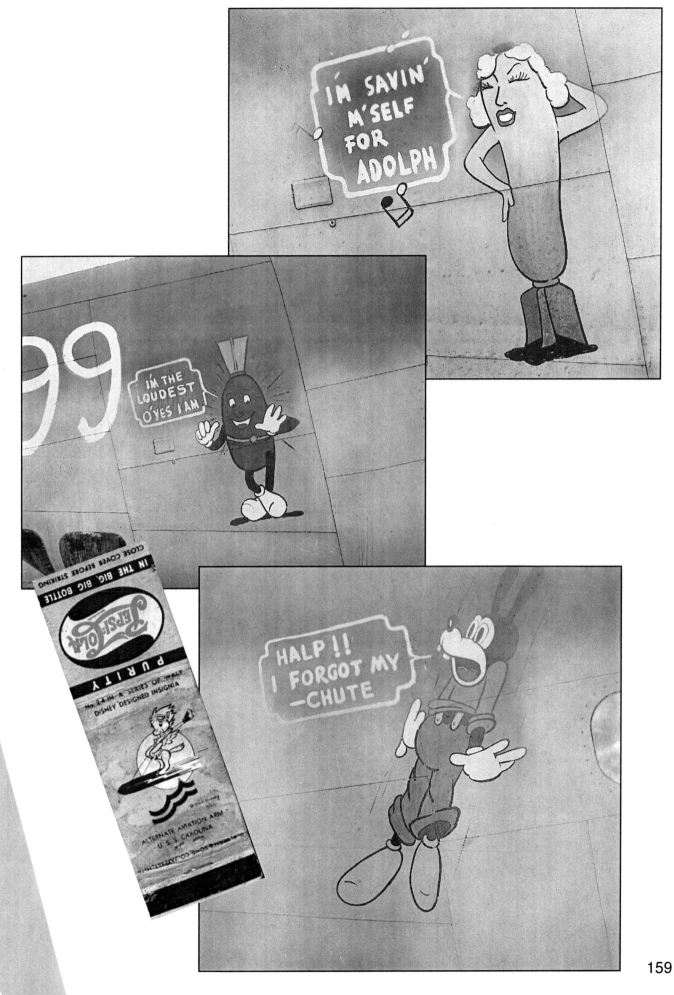

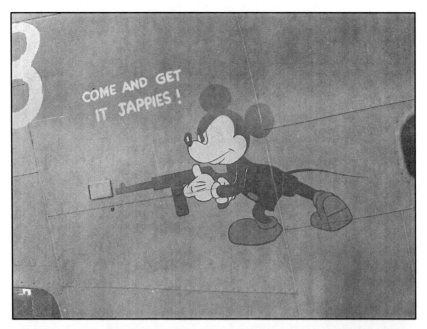

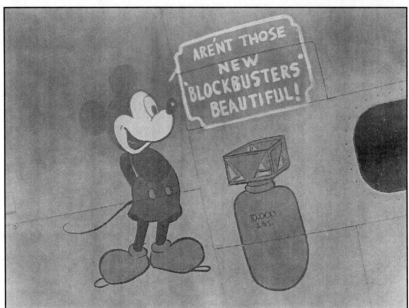

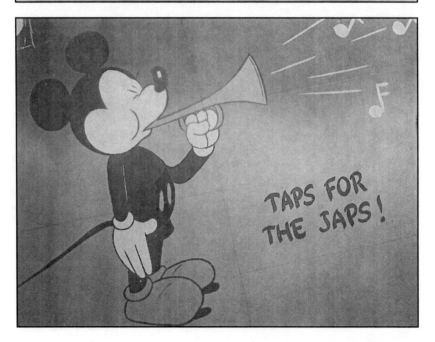

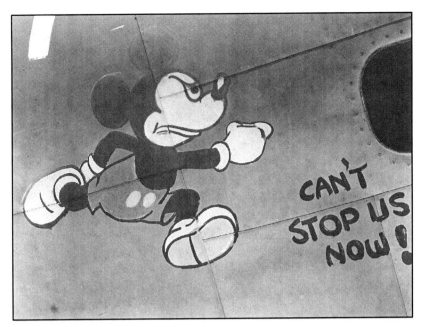

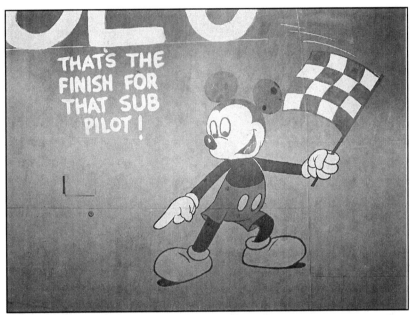

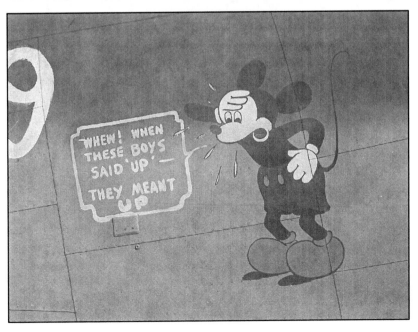

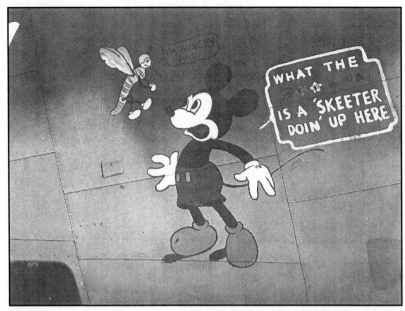

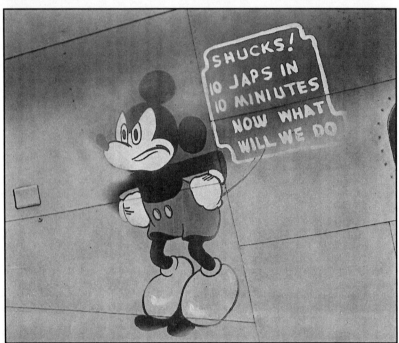

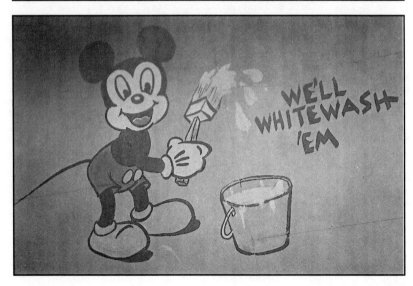

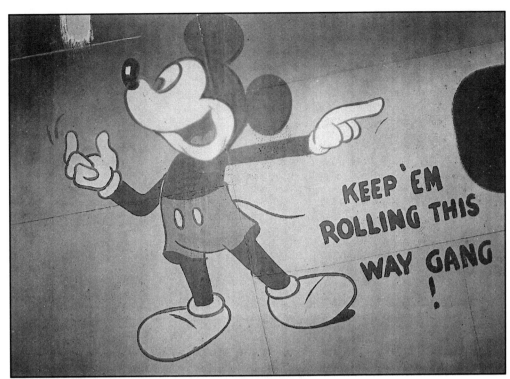

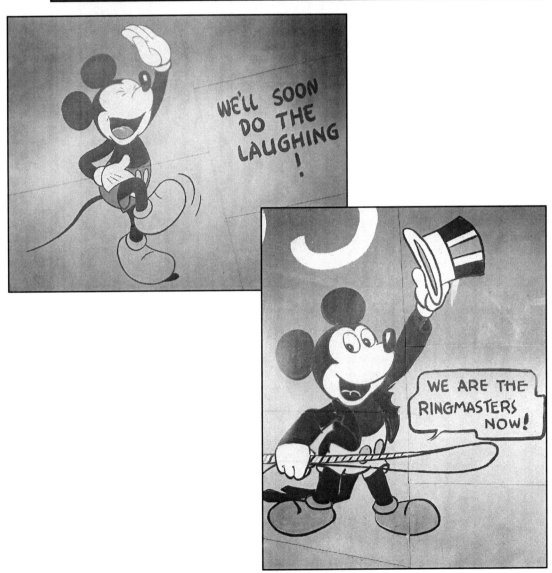

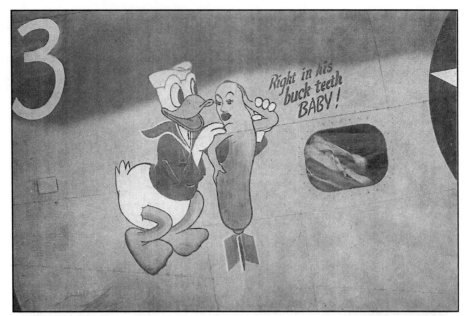

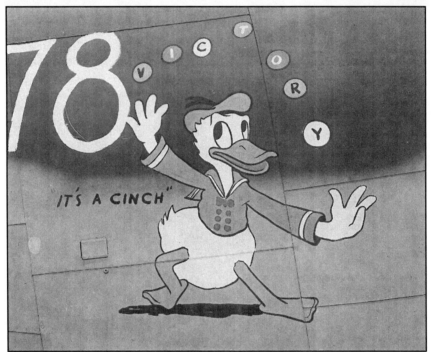

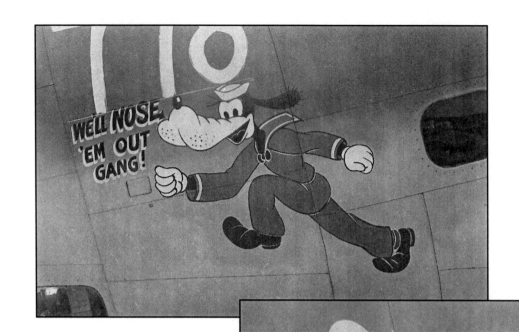

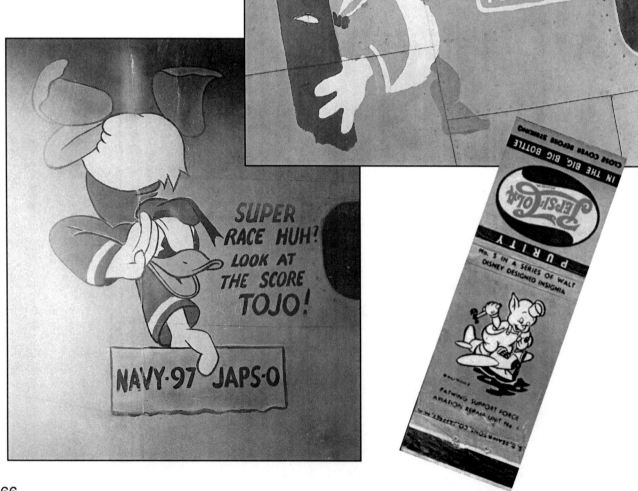

166

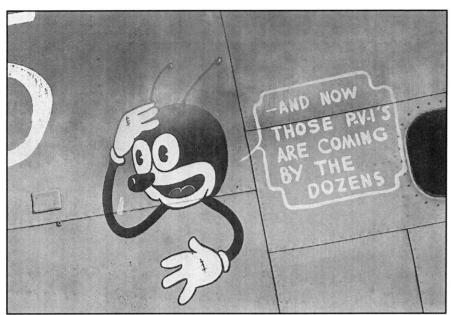

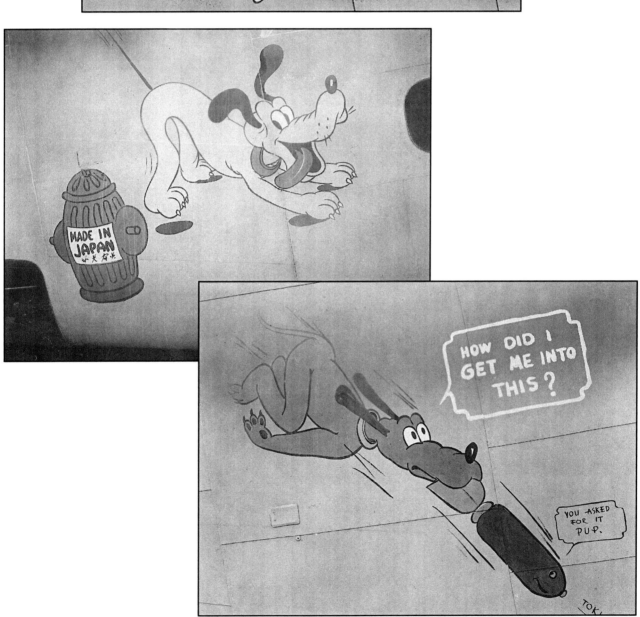

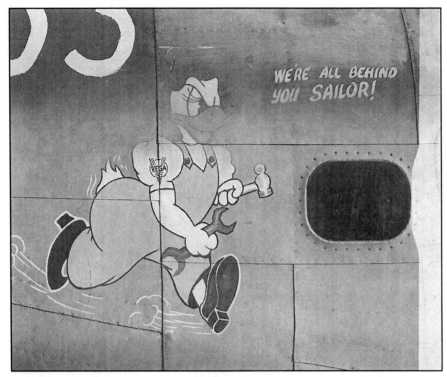

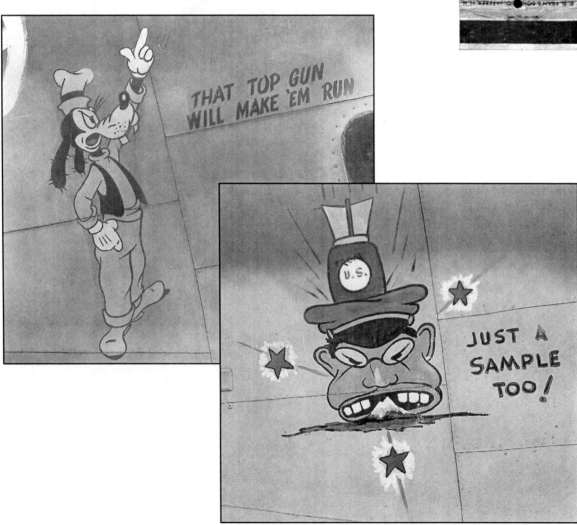

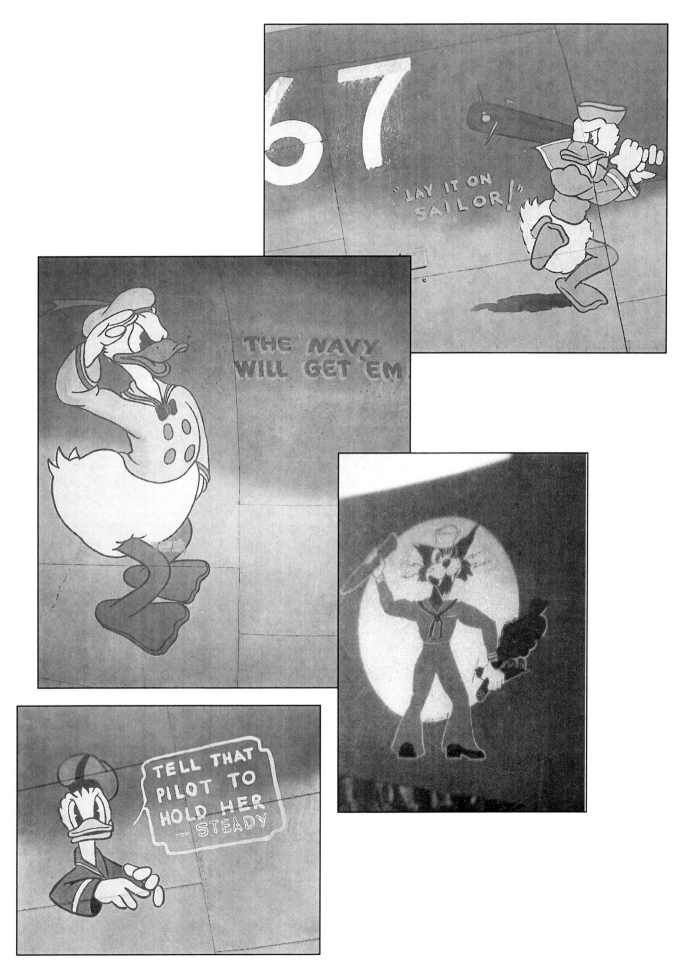

S.W.P.
LIBERATORS

The majority of the bombers in the pacific and CBI were comprised within eight air forces. These were; 5th AF in New Guinea and Australia, 7th AF originally based in Hawaii covered central pacific but also supported other theaters; the 10th AF went to cover China- Burma-India (CBI); 11th AF defended the Aleutains and Alaska, 13th AF went to the South Pacific islands including the Solomons; the 14th AF under General Claire Chennault also operated in the CBI; 20th AF in January 1944, mainly B-29s pushed toward the Japanese homeland from island based groups; finally, the 6th AF, although not in the Pacific, controlled the Panama Canal and Caribbean territories.

In the last two years of the war, nose art designs peaked. Some of the best nose art came from the Pacific Theater as illustrated in these pages. Many of these artists were not known because they simply did not sign their name by the finished art work and first hand accounts of the personnel who knew the artists are too few. It seems that when the camouflage was finally stripped and shiny new bomber aircraft arrived in natural aluminum finish, the artists were faced with a new challenge to use colors that would not get lost from the glare when viewed from a distance. Since the natural metal finish is basically black and white tones that make up many shades of gray, the dominant color that stood out the best was red. So this became the widely used color for lettering on aluminum finishes usually outlined in black. To add difficulty in color coordinating, the aluminum surface reflected light much like a mirror which would clash with the art and make it difficult to see from certain angles.

With regards to Naval and Marine aircraft, the camouflage colors remained as; Top surfaces - Non-Specular Sea Blue ANA 607 or Semi-Gloss Sea Blue ANA 606, Fuselage sides - Intermediate Blue ANA 608 and Under surfaces - Non-Specular White ANA 511. These aircraft ranged from the PBJ, a B-25 variant, the PB4Y which is a B-24 and later the PB4Y-2 Privateer which was a B-24 lengthened by seven feet and with a single tail.

It is also noted that in the last few months of the war, some B-24Ms and B-29s had their under surfaces painted in gloss black. The purpose for this was conducting night missions and anti-submarine/mine missions.

B-24J-170-CO **MASK-A-RAIDER** 44-40597 5BG.

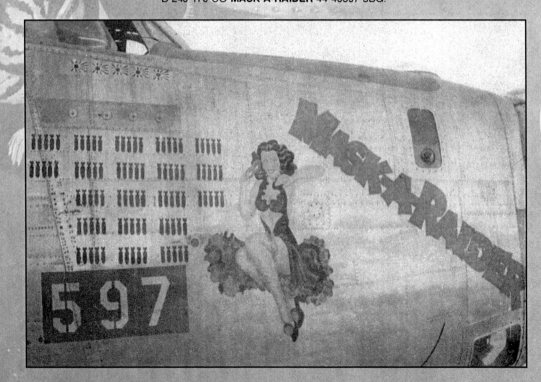

5TH

Bomb Group

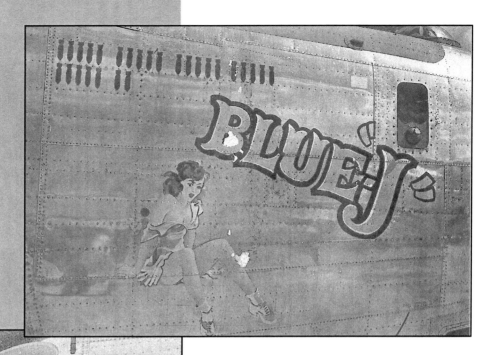

Top: B-24J-170-CO **BLUE-"J"** 44-40607 5BG, 31BS.

Left and bottom: B-24L-10-CO **MAIDEN MONTANA** 5BG, 23BS named after the ship's officers who came from Montana. The artist was Radioman Donald G. Graf. This a/c was MIA on 12 March.

The name, bombs are red as is the a/c number in the black box. The outline of the state is black.

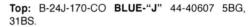

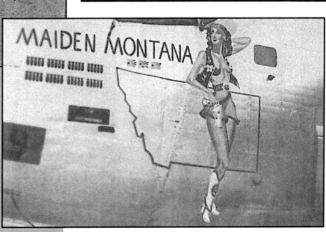

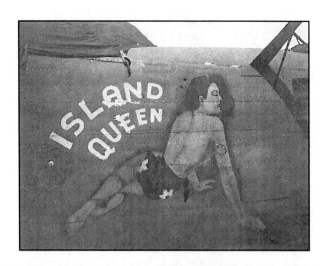

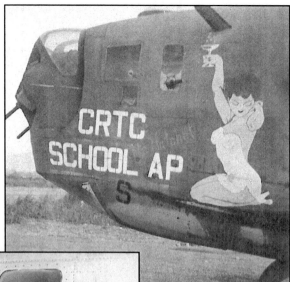

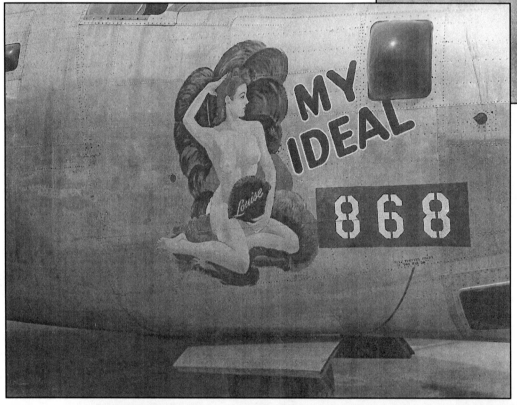

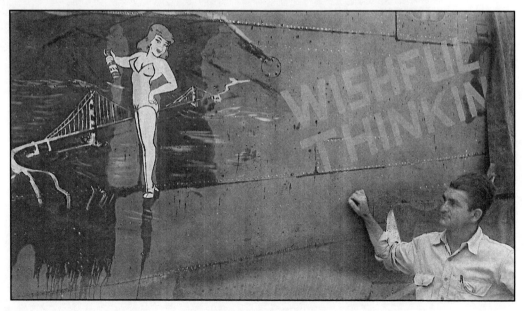

172

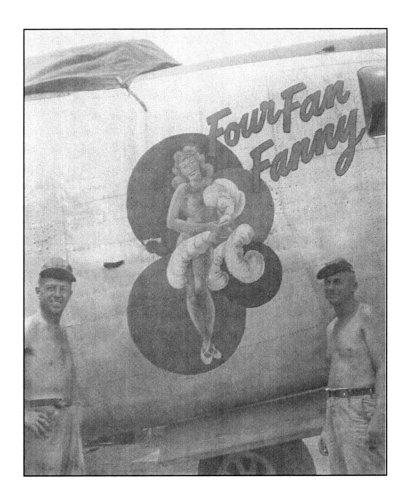

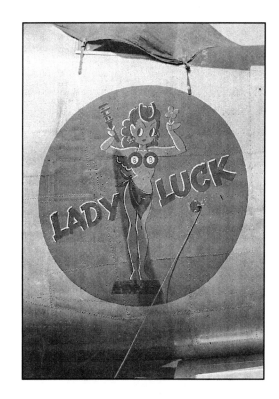

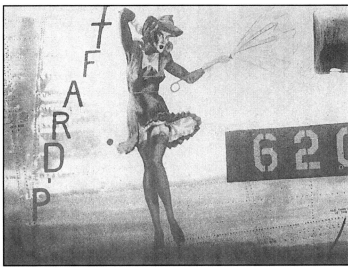

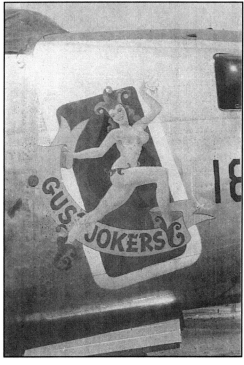

Top left: B-24L-15-CO **FOUR FAN FANNY** 44-41669 5BG, 31BS piloted by Marshall Smith who later became Base Commander.
Top right: B-24L-15-CO **LADY LUCK** 44-49845 5BG, 31BS.
Above left: B-24J-170-CO **UPDRAFT** 44-40620 5BG, 72BS.
Above right: B-24M-1-CO **GUS' JOKERS** 44-41848 5BG, 31BS.

Opposite page:
Top left: B-24J-60-CO **ISLAND QUEEN** 42-100022 5BG, 31BS.
Top right: B-24D-1 **THE LITTLE HATCHET** (CRTC SCHOOL APP) bombs were painted above the fire extinguisher door.
Middle: B-24M-5-CO **MY IDEAL** 44-41868 5BG, 31BS.
Bottom: B-24D-1 **WISHFUL THINKIN'** 5BG, 23BS. The nam only with bomb mission symbols appeared on the left side.

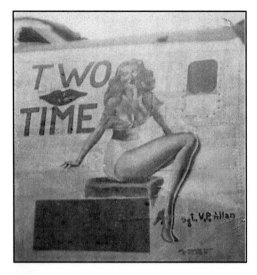

Top left: B-24 **IRON BIRD** 44-41850 5BG, 31BS.

Top right: B-24J-165-CO **TWO TIME** 44-40546 5BG, 72BS. Art done by Sgt. V.P. Allan.

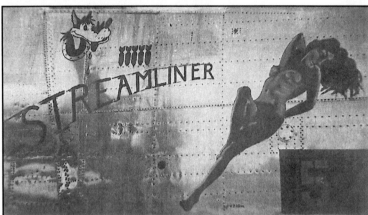

Middle: B-24J-165-CO **STREAMLINER** 44-40543 5BG, 23BS.

Bottom left: B-24J-165-CO **LITTLE QUEEN MARY** 44-40536 5BG, 394BS.

Bottom right: Douglas B-18 from the 5th BG Composite in Hawaii.

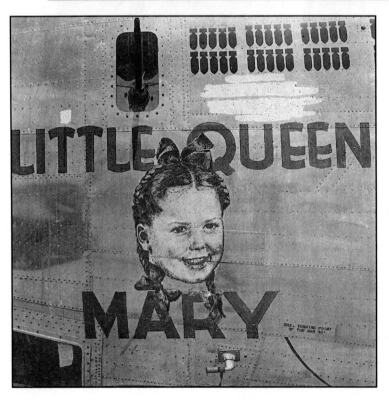

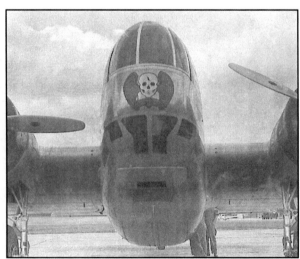

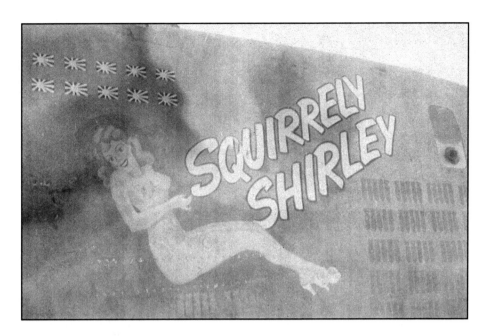

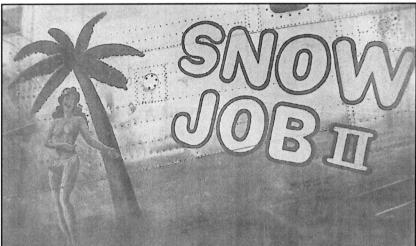

Top: B-24J-135-CO **SQUIRRELY SHIRLEY** 42-110092 5BG, 31BS.

Middle: B-24 J-170-CO **SNOW JOB** 44-40572 5BG, 31BS.

Bottom left: B-24 **PRETTY PRAIRIE SPECIAL** 5BG.

Bottom right: B-24 M-30-CO **SWEET THING** 44-42366 5BG, 72BS.

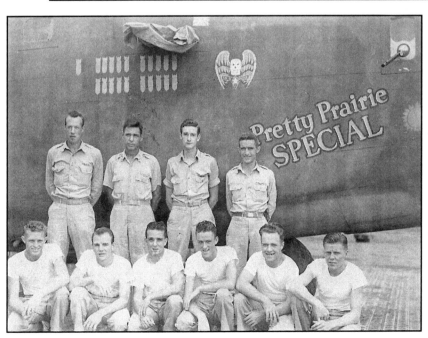

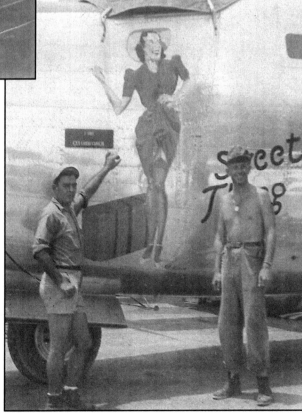

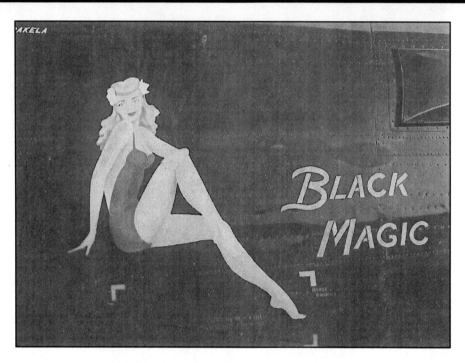

Above: B-24 **BLACK MAGIC** 7BG, 493BS art done by Vernon Drake.

Below: B-24 **DANGEROUS DANCE** 7BG art done by Vernon Drake.

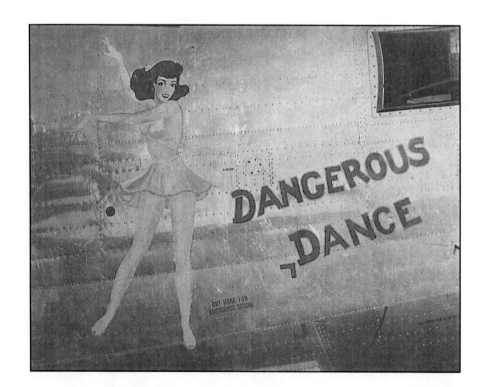

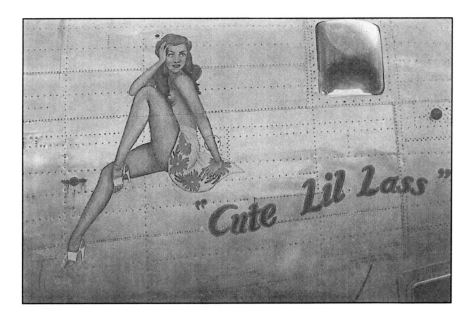

B-24J-195-CO **CUTE LIL LASS** 44-41085 7BG, 9BS. art by Vernon Drake.

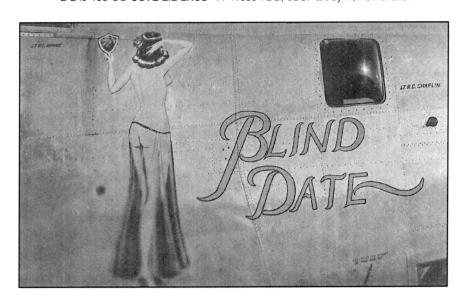

Above: B-24 **BLIND DATE** 7BG, 493BS. art by Vernon Drake.

Below: B-24J-190-CO **DOUBLE TROUBLE** 44-40989 7BG, 492BS.

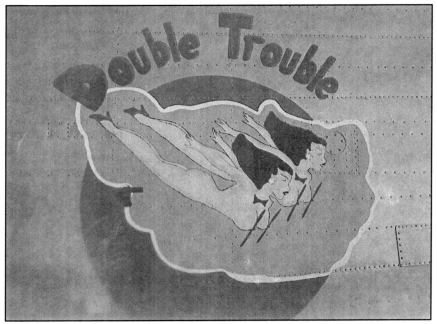

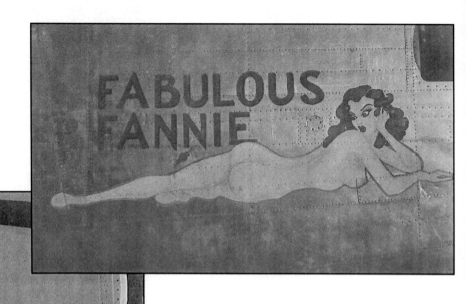

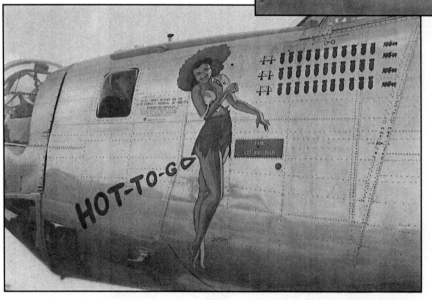

Top right: B-24 **FABULOUS FANNIE** 7BG, 492BS.

Top left: B-24M-15-FO **HOME STRETCH** 44-50857 7BG, 436BS also served with the 308BG.

Above: B-24 **SO ROUND SO FIRM SO FULLY STACKED.**

Left: B24M-25-CO **HOT-TO-GO** 44-42273 7BG, 9BS also flew in the 308BG.

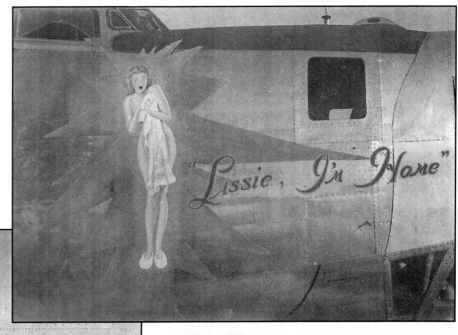

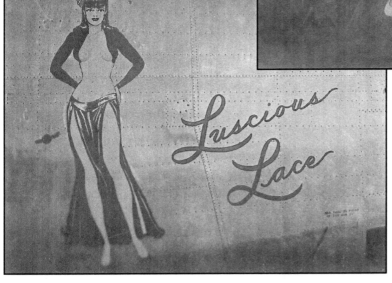

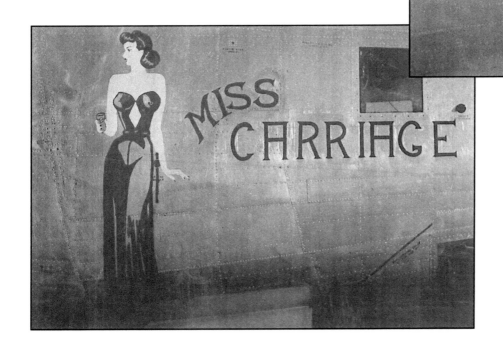

Top right: B-24 **LASSIE, I'M HOME** 7BG, 436BS also served with the 308BG.

Above: B-24 **LUSCIOUS LACE** 7BG, 493BS art done by Vernon Drake.

Right: B-24 **SHY ANN** 7BG, 492BS.

Below: B-24 **MISS CARRIAGE** 42-40624, 7BG also with the 308BG, 374BS.

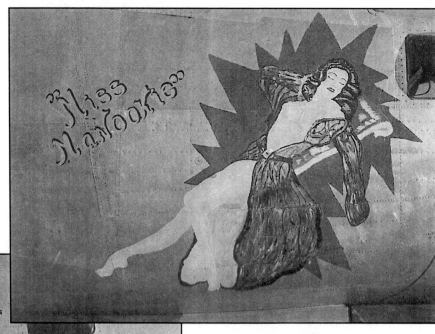

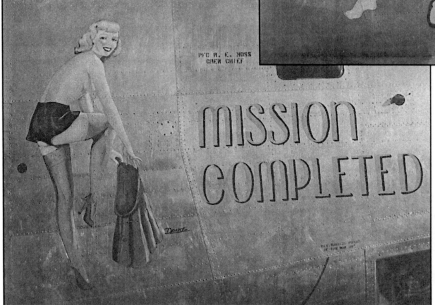

Top: B-24 **MISS MANOOKIE** 7BG.

Left: B-24 **MISSION COMPLETED** 7BG, 9BS art by Vernon Drake.

Below: B-24J-15-CO **PECKER RED** 42-73158 7BG, 493BS. August 1944

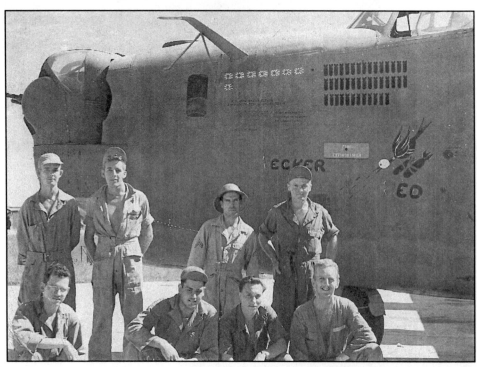

180

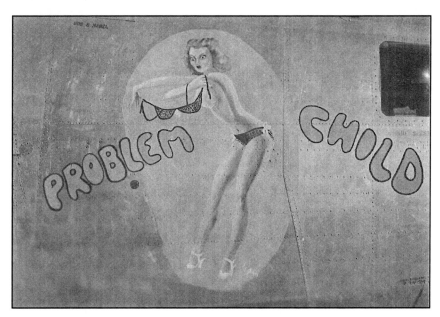

Top: B-24 **PROBLEM CHILD** 42-41164 7BG also served with the 308BG, 374BS.

Right: B-24 **REDDY TEDDY** 7BG also with the 308BG.

Below: B-24 **SOUTHERN COMFORT.**

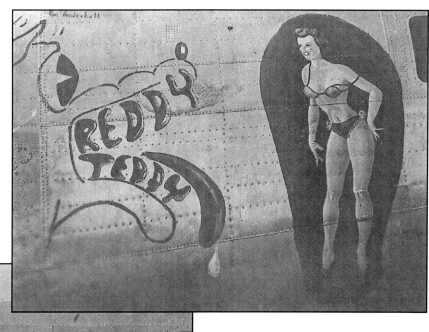

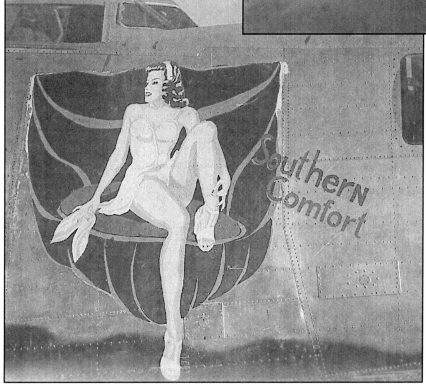

11th Bomb Group

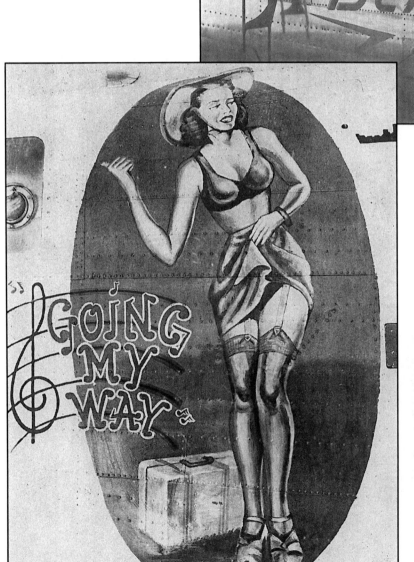

Top: B-24 **BEAUFORT BELLE** 44-49528 11BG.

Below: B-24J-175-CO **GOIN MY WAY** 44-40674 11BG, 431BS named after a Bing Crosby song and also served in th 30BG, 819BS. Its last mission was flown on 8 August 1945.

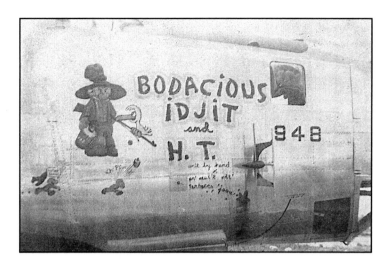

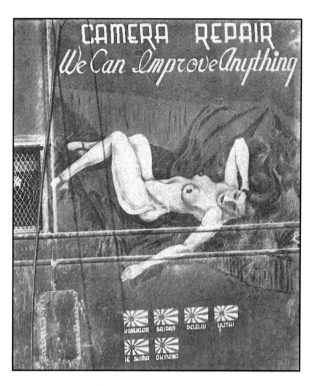

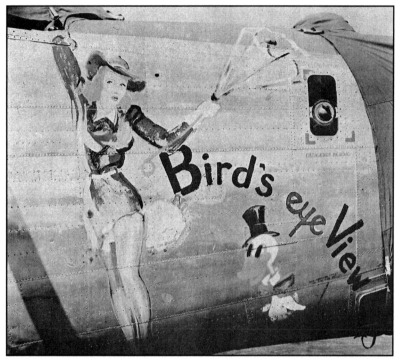

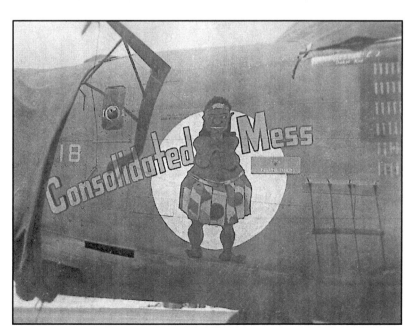

Top left: B-24M-5-CO **BODATIOUS IDJIT AND H.T.** 44-41948 11BG, 98BS.

Top right: It appears its business as usual based on the advertisement on the mobile unit with an impressive locale score.

Left: B-24J **BIRD'S EYE VIEW** 11BG, 431BS.

Below left: B-24J-25-CO **CONSOLIDATED MESS** 42-73218 11BG, 98BS.

183

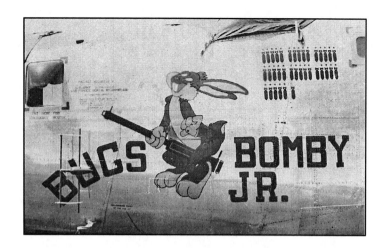

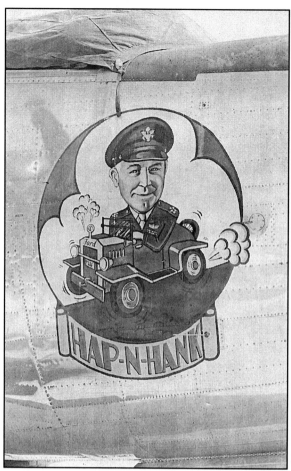

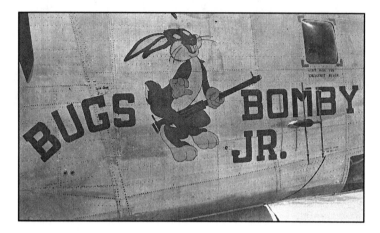

Left: B-24L-5-CO **BUGS BOMBY JR.** 44-41466 11BG, 42BS illustrates the art on both sides most likely traced to some extent.

Right: B-24L-20-FO **HAP-N-HANK** 44-50145 11BG, 431BS in honor of Gen. Henry H. Arnold.

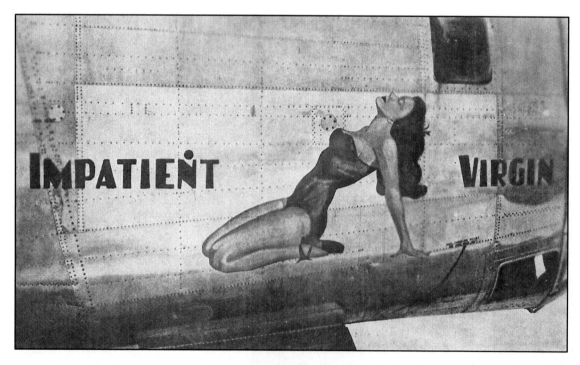

B-24 **IMPATIENT VIRGIN** 11BG.

Right: B-24J-160-CO **DANGEROUS CRITTER** 44-40382 11BG, 26BS black background and red lettering with a black outline.

Middle left: B-24 **LUCKY DOG** 44-40679 11BG.

Middle right: B-24J-110-CO **K LUCY** 42-109869 11BG, 26BS.

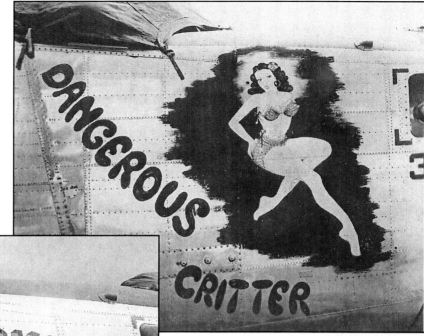

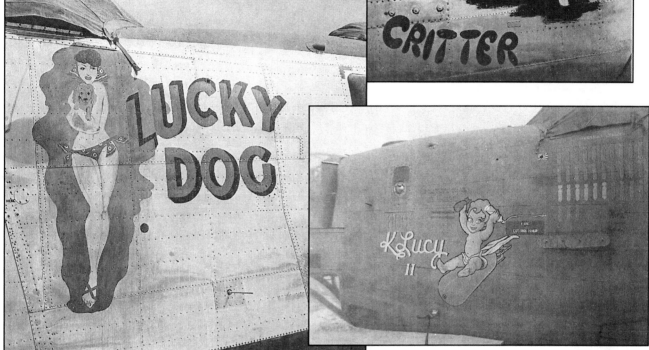

Right: B-24J-5-CO **LIL AUDREY** 42-73016 11BG, 431BS was the first bomber in the group to complete 100 missions as illustrated in this staged media photo.

L-R: (rear) M/Sgt. Lloyd Whyrick, Lt. Bernard Breiter, Lt. Stephen Coffey, Lt. Thomas Page, Lt. Francis Pouls.

L-R: (front) S/Sgt. Richard Martin, T/Sgt. Alexander Shinsky, S/Sgt. William Gannon, T/Sgt. Lloyd Rainbolt, S/Sgt. Harold Kilpatrick and S/Sgt. Don Hallmann. This crew just completed 40 missions. 3 August 1945

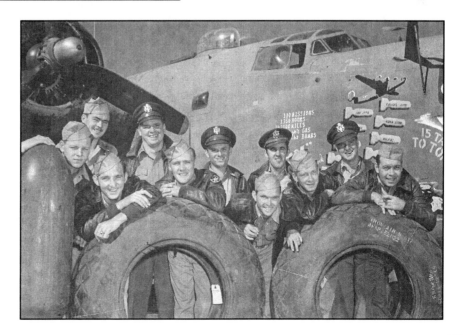

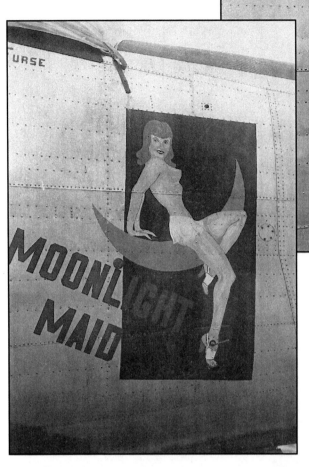

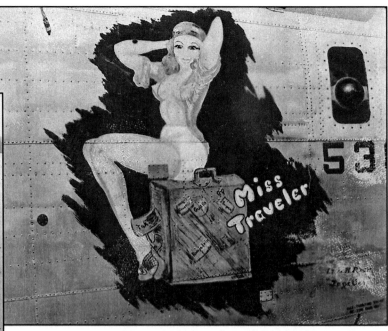

Top left: B-24M-25-CO **MOONLIGHT MAID** 44-42331 11BG, 431BS artist Co-pilot Lt. Ben Furse used the grid system to accomplish the rendering and tinted his colors from crushed island rock.

Top right: B-24J-165-CO **MISS TRAVELER** 44-40530 11BG, 98BS.

Below left: B-24J-175-CO **MISS SHERRY** 44-40710 11BG, 42BS.

Below right: B-24J-170-CO **WONDROUS WANDA** 44-40562 11BG, 431BS.

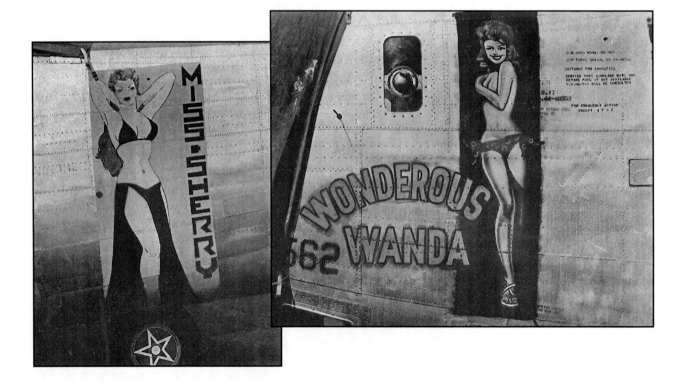

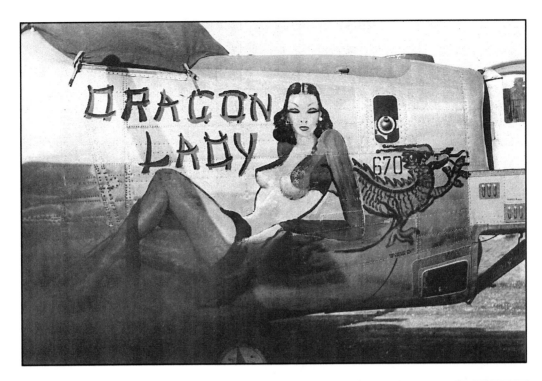

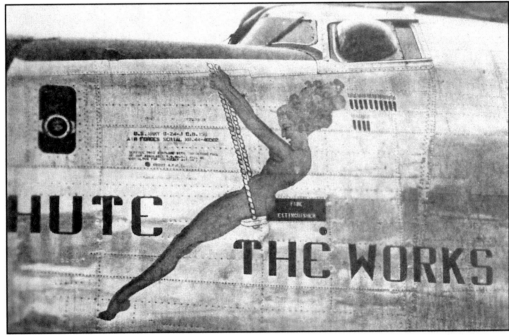

Top: B-24J-175-CO **DRAGON LADY** 44-40670 11BG, 42BS a Milt Caniff inspired piece from "Terry and the Pirates". This a/c also served with the 98BS.

Above: B-24J-155-CO **CHUTE THE WORKS** 44-403-2 11BG, 431BS.

The model at right is Hollywood actress Susanna Foster known for her roles in "The Phantom of the Opera", "The Climax" and "Frisco Sal". This was a common pin-up pose that was illustrated by pin-up artists George Petty and Varga.

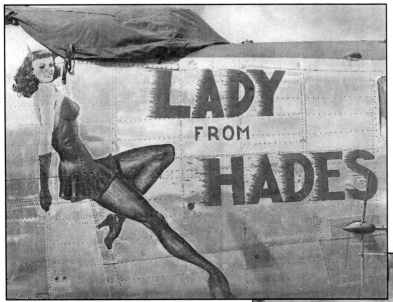

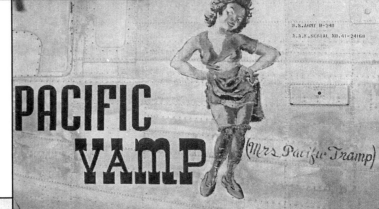

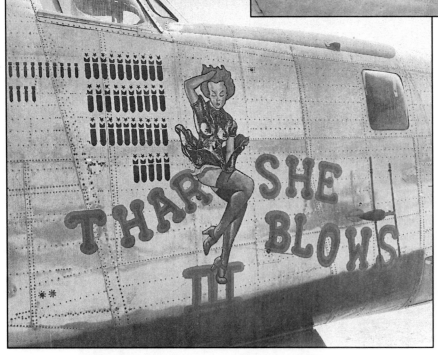

Top: B-24L-10-CO **LADY FROM HADES** 44-41613 11BG, 26BS.

Middle: B-24D **PACIFIC VAMP** 41-24168 11BG, 98BS.

Left: B-24J-150-CO **THAR SHE BLOWS III** 44-41468 11BG, 42BS.

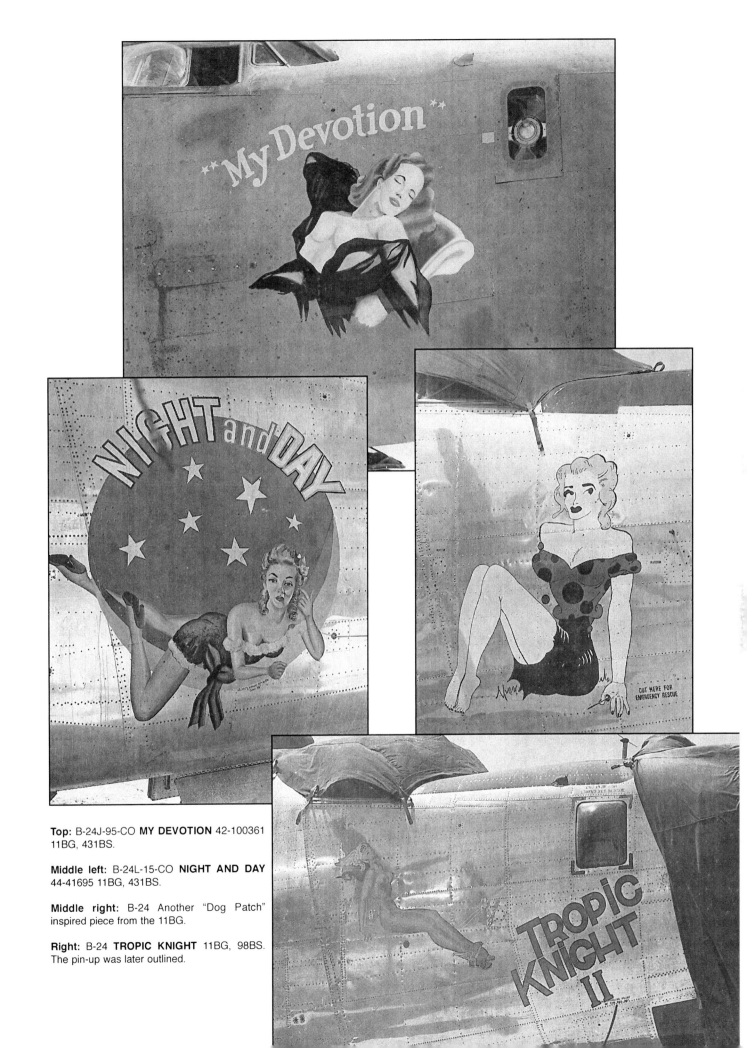

Top: B-24J-95-CO **MY DEVOTION** 42-100361 11BG, 431BS.

Middle left: B-24L-15-CO **NIGHT AND DAY** 44-41695 11BG, 431BS.

Middle right: B-24 Another "Dog Patch" inspired piece from the 11BG.

Right: B-24 **TROPIC KNIGHT** 11BG, 98BS. The pin-up was later outlined.

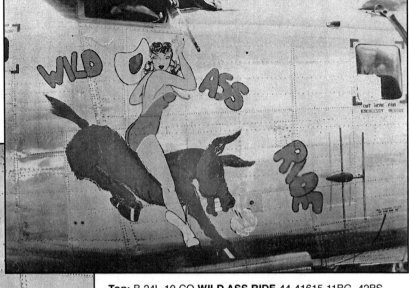

Top: B-24L-10-CO **WILD ASS RIDE** 44-41615 11BG, 42BS.

Left: B-24 **WISHFUL THINKIN'** unknown 11BG a/c.

Below: B-24J-17-CO **RUFF KNIGHTS** 44-40550 11BG, 42BS.

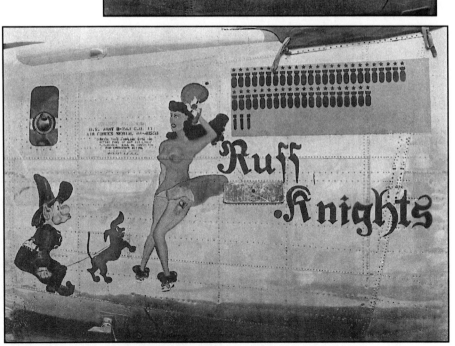

190

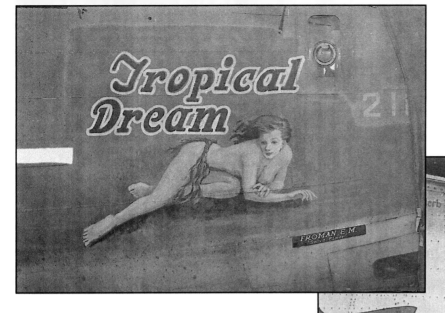

Top: B-24 **TROPICAL DREAM** 42-100218 11BG. December 1945

Right: B-24M-15-FO **TRICKY MICKY** 44-50960 11BG, 98BS.

Below: B-24 **VINEGAR JOE** is another 11BG ship in honor of Gen Joseph W. Stillwell.

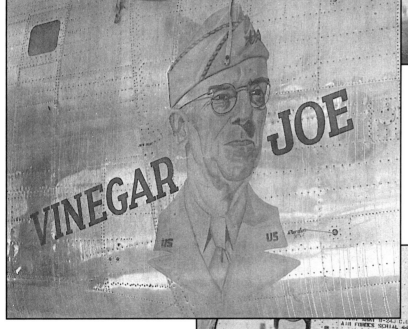

Below right: B-24J-165-CO **SWEET ROUTINE** 44-40527 11BG, 26BS. Art color consists of; Blue circle, blonde pin-up wearing sheer black panties/bra, red lettering with yellow center and black shadow, bombs and stars-black with a red outline. The name to the right are in black. Aircraft markings to the left are all red except for the data stencil which is always in black for natural aluminum a/c.

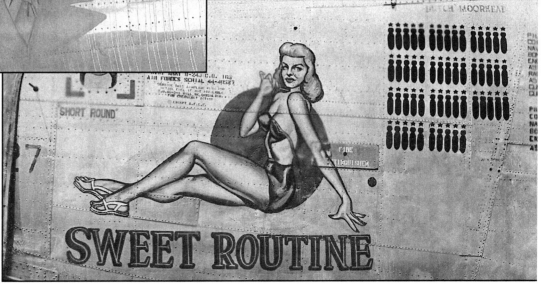

RED RAIDERS

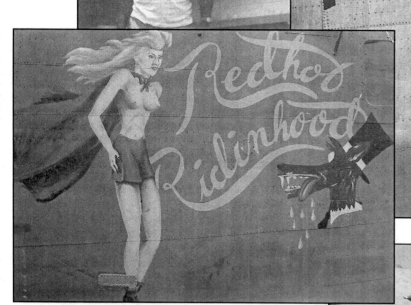

Top: B-24 **ROUND TRIP TICKET** 44-100202 22BG, 33BS.

Middle right: B-24J-150-CO **RED-HOT RIDEN-HOOD II** 44-40202 22BG, 2BS Art by Sgt. Charles R. Chestnut.

Above: B-24J-80-CO **RED-HOT RIDINHOOD** 42-100212.

Right: B-24J-90-CO **SANDY** 42-100324 22BG, 408BS lost on 14 October 1944.

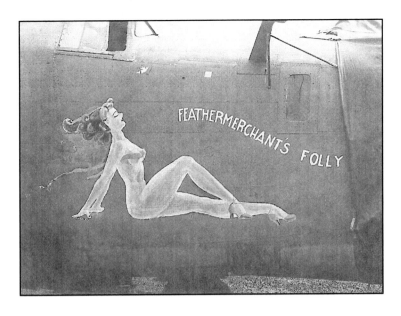

Top left: B-24J-90-CO **FEATHER MERCHANT'S FOLLY** 42-100293 22BG, 2BS the name is slang for civilian.

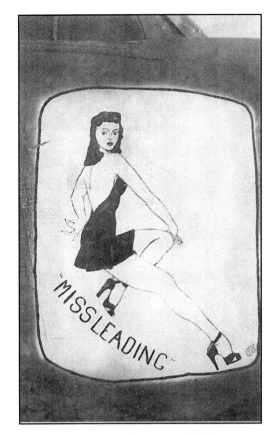

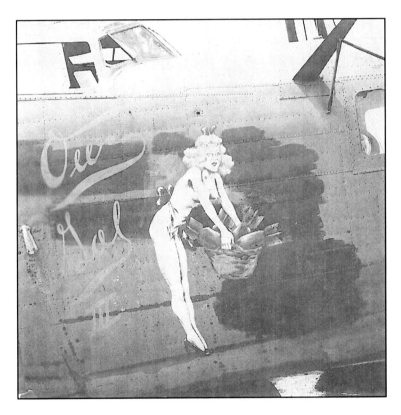

Above: B-24J-90-CO **OUR GAL III** 42-100313 22BG, 33BS art by Sgt Chestnut.

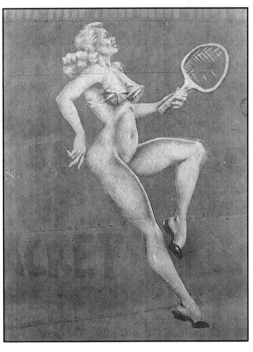

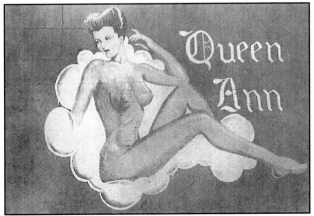

Top right: B-24J **MISLEADING** 42-100204 left side had the Red Raiders insignia along with its mission symbols.

Above: B-24J-80-CO **SWEET RACKET** 42-100188 22BG, 33BS.

Left: B-24J-135-CO **QUEEN ANN** 42-110119 22BG, 33BS four rows of red bombs totaling 100 just right of pin-ups foot.

193

RED RAIDERS

WE LEAD

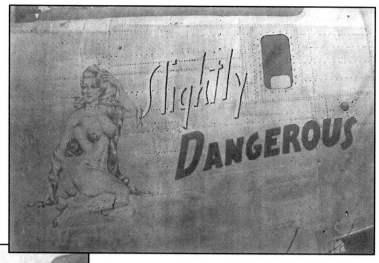

Above: B-24 **SLIGHTLY DANGEROUS** 44-40366 22BG, 33BS flown by Lt. W. L. Goodrich and accumulated over 100 missions.

Left: B-24J-160-CO **STAR EYES** 44-40397 22BG, 408BS Completed 100 missions.

Below left: B-24J-75-CO **YANKEE GAL** 42-100173 22BG, 33BS salvaged 10 August 1944.

Below: B-24J-120-CO **SHOO-SHOO BABY** 42-109984 22BG, 408BS made a forced landing on 6 May 1945 in a dry rice paddy near Clark Field after a strike on Kiirun, Formosa. She was said to have been the longest serving and the last in the Group of the camouflaged B-24s with 80 plus combat missions at the time of her crash.

Note the patch work due to flak damage.

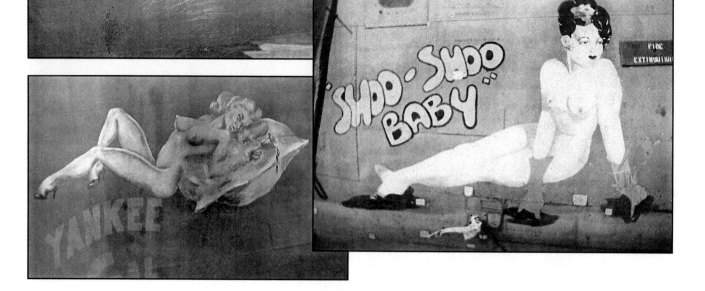

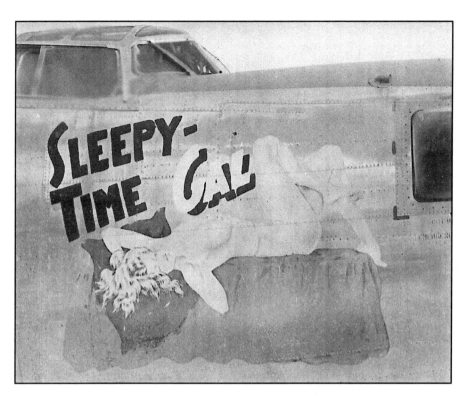

B-24J **SLEEPY TIME GAL** 44-41311 22BG, 33BS art by Sgt. Chestnut.

The popular 1942 movie hit SLEEPYTIME GAL movie poster.

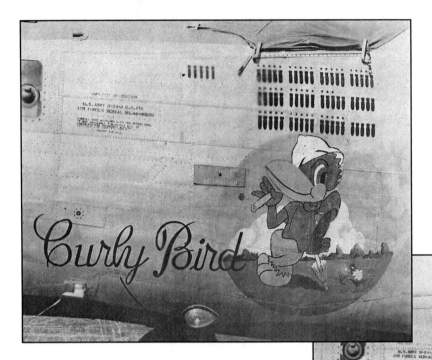

Left: B-24J-175-CO **CURLY BIRD** 44-40683 30BG, 819BS.

Below: B-24J-175-CO **JEETER BUG** 44-40661 30BG, 819BS.

Below: B-24J-165-CO **NIGHT MISSION** 44-40532 30BG, 819BS.

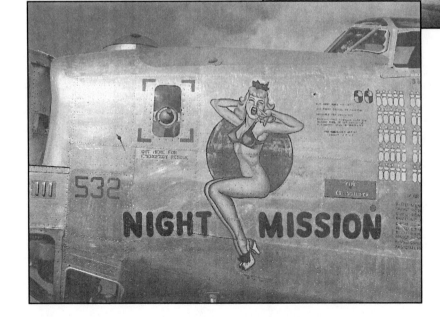

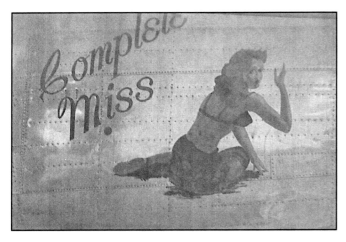

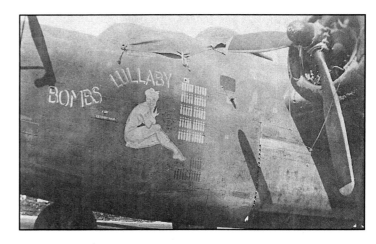

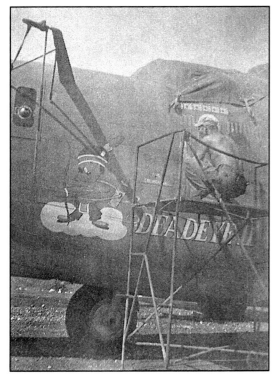

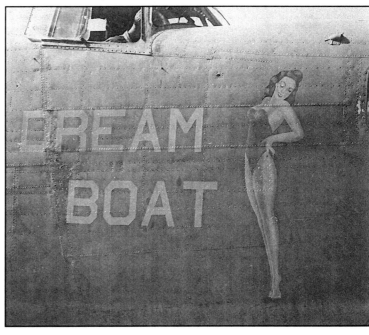

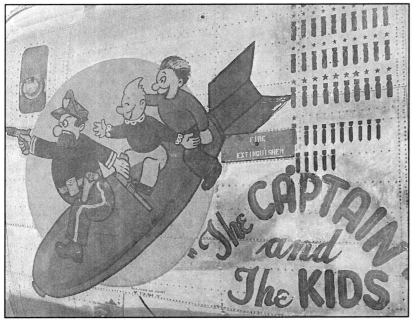

Top left: B-24J-180-CO **COMPLETE MISS** 44-40810 30BG, 27BS.

Top right: B-24J-1-C0 **BOMBS LULLABY** 42-72988 30BG, 392BS.

Middle left: B-24J-45-CO **DEADEYE II** 42-73415 30BG, 392BS.

Middle right: B-24J **DREAM BOAT** 30BG, 392BS.

Left: B-24J-165-CO **THE CAPTAIN AND THE KIDS** 44-40518 30BG, 819BS.

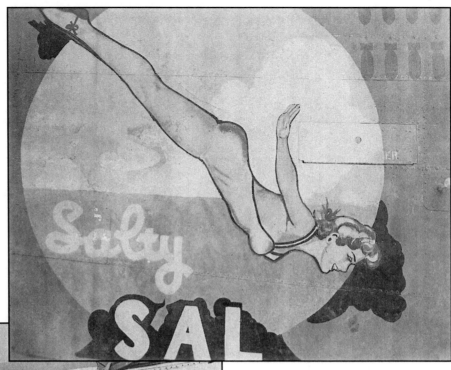

Above: B-24J-80-CO **SALTY SAL** 42-100219 30BG, 392BS.

Left: B-24J-155-CO **UMBRIAGO!** 44-40327 30BG, 392BS.

Below: B-24J-120-CO **UPSTAIRS MAID** 42-109941 30BG, 819BS.

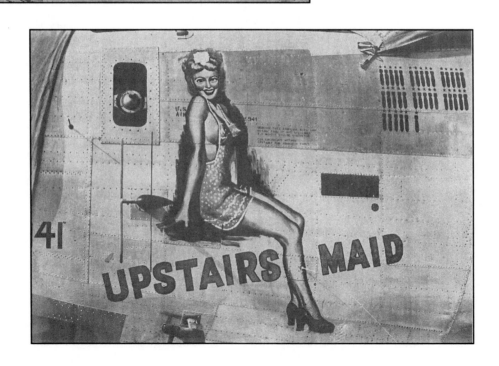

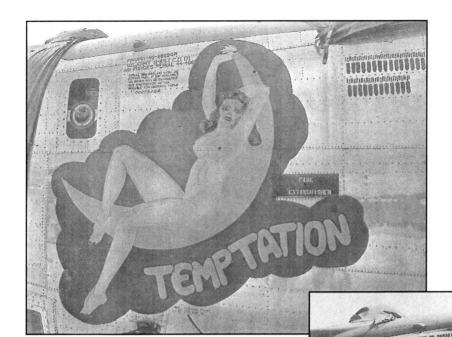

Above: B-24J-171-CO **TEMPTATION** 44-40617 30BG, 38BS

Right: B-24M-5-CO **PUDDLE JUMPER II** 44-41946 30BG, 819BS.

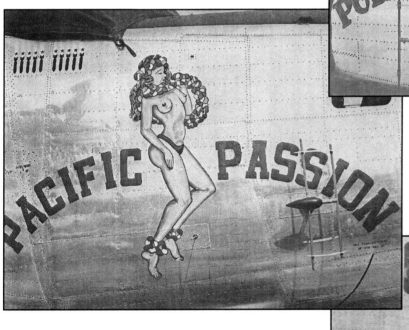

Above: B-24L-5-CO **PACIFIC PASSION** 44-41500 30BG, 392BS.

Right: B-24J-160-CO **TEXAS KATE** 44-40358 30BG, 392BS.

43rd Bomb Group

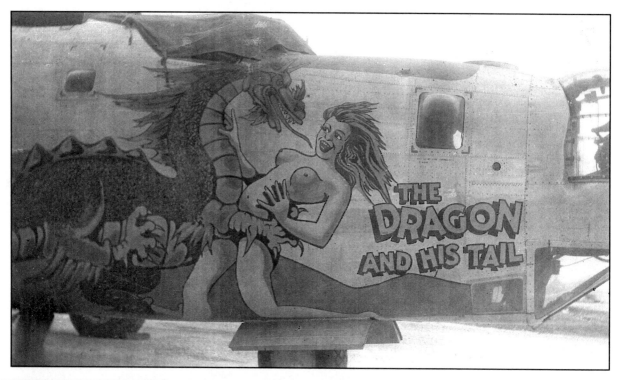

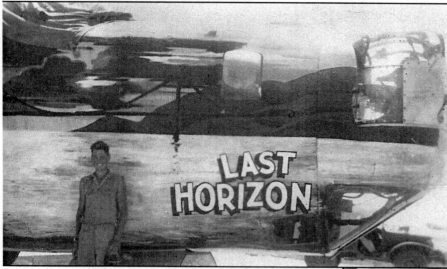

Opposite top left: B-24J-65-CO **I'LL BE AROUND** 42-100042 43BG, 63BS.

Opposite top right: B-24D-155-CO **FLYING FANNIE** 42-72780 43BG, 403BS.

Opposite middle left: B-24J-160-CO **HIP PARADE** 44-40430 43BG, 64BS.

Middle: B-24D1-130-CO **FLAMIN' MAMIE** 42-41062 43BG, 403BS.

Middle right: B-24D-145-CO *TWO BOB TILLIE* 42-41215 43BG, 65BS.

Top: B-24J-190-CO **THE DRAGON AND HIS TAIL** 44-40973 43BG, 64BS art by Sarkis Bartigan.

Above: B-24J-185-CO **LAST HORIZON** 44-40865 43BG, 64BS. A mural of San Francisco Bay takes up the complete nose area.

Right: B-24J-161-CO **MICHIGAN** 44-40429 43BG.

200

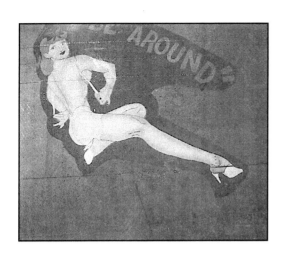

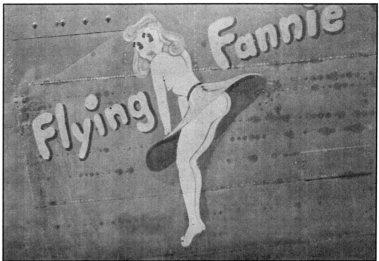

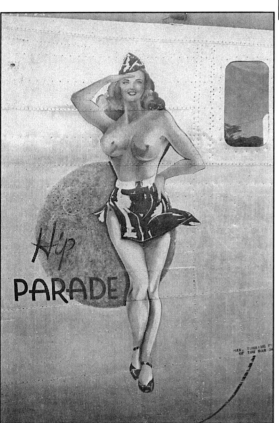

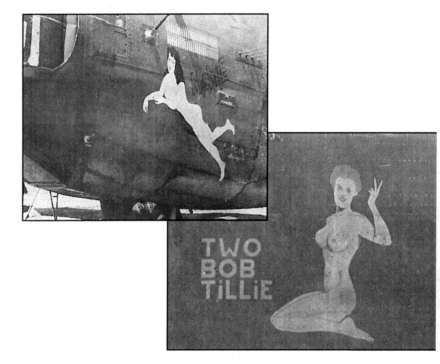

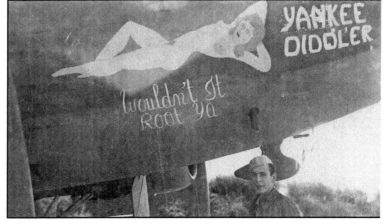

Bottom left: B-17F **THE OLD MAN** 41-24403 transferred to 43BG, 65BS from the 19BG, 30BS.

Bottom right: B-17F **YANKEE DIDDLER** 41-2458 damaged in air action and crash landed at Pariran 8 February 1942.

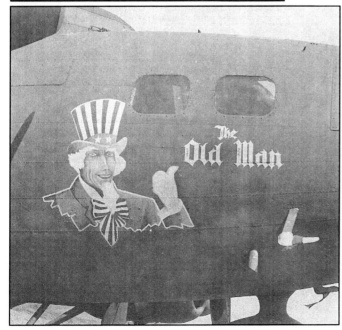

201

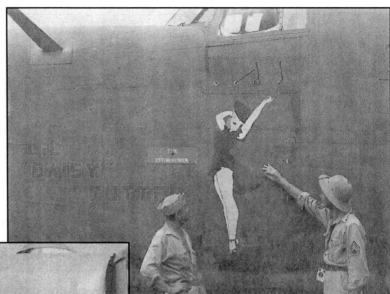

Top: B-24D-85-CO **LIL DAISY CUTTER** 42-40666 43BG, 63BS.

Left: B-24J-160-CO **PETTY GAL** 44-40373 43BG, 65BS last mission flown by Jim Cherkauer who landed on two engines. Another B-24 flying on wing exploded and fragmentation bombs threw debris into both port engines. Scrapped 18 May 1945.

Below: B-24J-50-CO **WOLF PACK** 42-73476 43BG, 403BS. The wolves are black and gray with orange pants. The girl is a brunette wearing black shoes and bra. The lettering is in white with a black outline. The bombs are yellow.

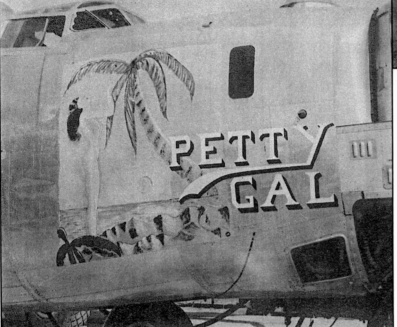

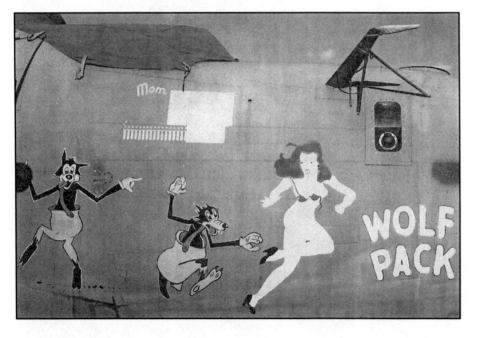

Opposite top right and middle: B-24D1-115-CO **MARIE** 42-40922 43BG, 64BS. The tally was painted over after a transfer.

Opposite top left: B-24J-160-CO **MISSIN' YOU** 44-40399 43BG, 65BS.

Opposite bottom left: B-24 from the 43BG and possibly 90BG. The OD camouflage has been removed carefully preserving the art.

Opposite bottom right: B-24J-155-CO **MILLION $ BABY** 44-40335 43BG, 403BS.

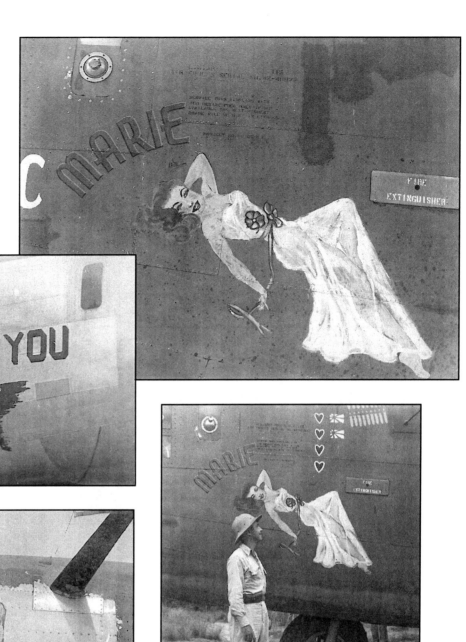

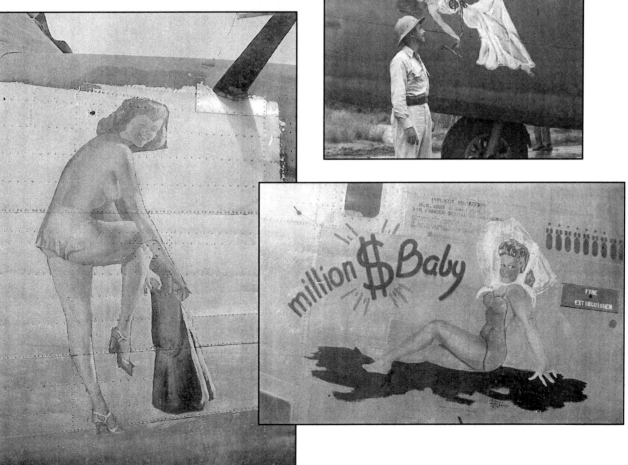

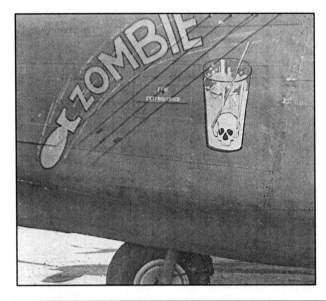

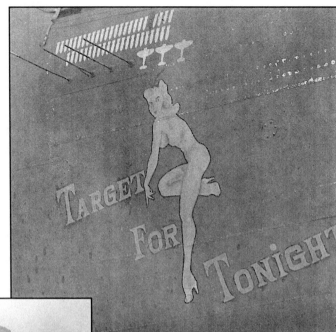

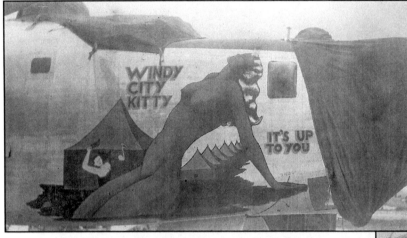

Top left: B-24D1-110-CO **ZOMBIE** 42-40913 43BG, 64BS may also have served with the 90BG.

Top right: B-24D-130-CO **TARGET FOR TONIGHT** 42-41060 43BG, 65BS had identical art on both sides.

Above: B-24 **WINDY CITY KITTY IT'S UP TO YOU** 43BG, 64BS. Lettering is black with red outline. The tents are OD

Right: B-24 J-40-CO **SWEET SIXTEEN** 42-73394 43BG, 63BS.

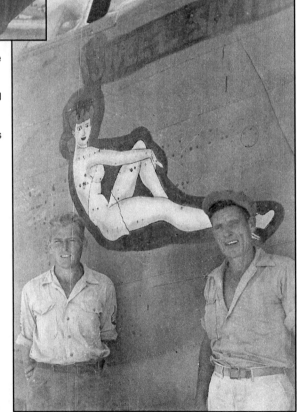

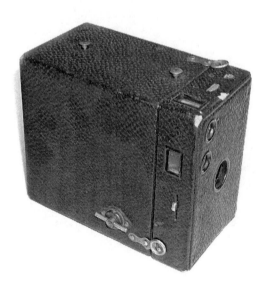

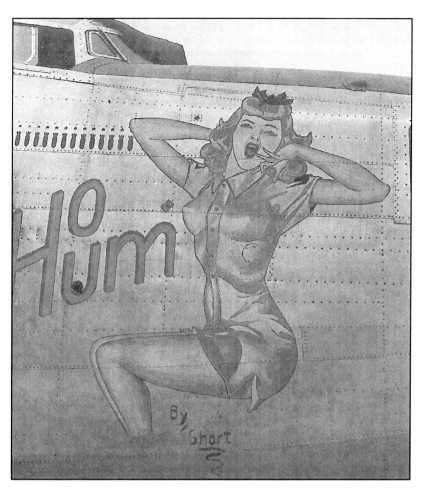

90th BG

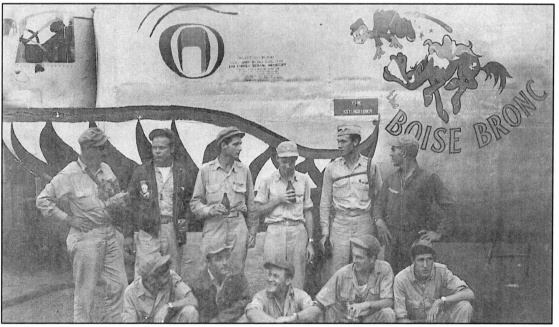

Top: B-24J-120-CO **HO-HUM** 42-109983 90BG, 400BS. The artist Sgt. Short, has signed his work. **Above:** B-24J-175-CO **BOISE BRONC** 44-40728 the crew enjoys a beverage after a mission and pose for this photo. **L-R** (standing); Lieutenants Arnold Martinson and Solmonson, Walter Keils, Noel, Lt. Col W.H. Banks and Maj. Lee Harter of Boise, Idaho. **L-R** (kneeling); Sergeants Leonard Mower, James Fisher, Glenn Reno, Herbert Coffin and Clarence Eno.

Note: In the final weeks of the war, the 43rd BG and 90th BG shared their base on Ie Shima and prior the 90th worked with the 380th BG in Java. Many of the B-24s were either transferred into these groups or commonly mistaken to be in them. The author has identified them to the best of his ability by using all available references at the time of this publication.

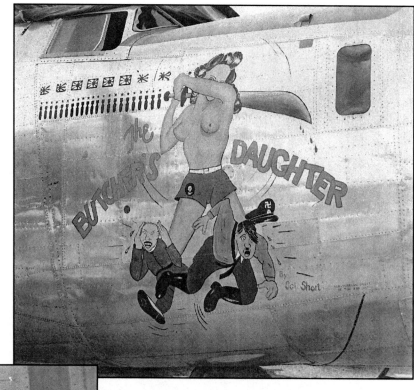

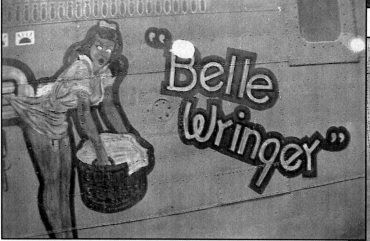

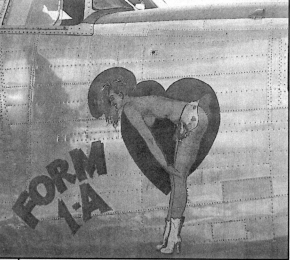

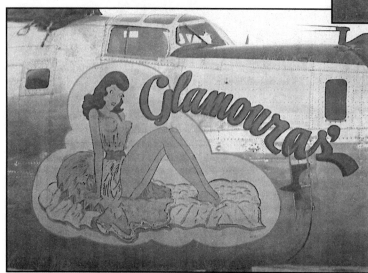

Top right: B-24J-150-CO **BUTCHER'S DAUGHTER** 44-40190 90BG, 319BS exploded after take-off 15 May 1945 en route to Formosa.

Middle: B-24M-10-FO **BELLE WRINGER** 44-50694 90BG, 400BS

Above: B-24J-150-CO **FORM 1-A** 44-40229 90BG, 321BS also known as "The Harry S. Truman".

Left: B-24J-170-CO **GLAMOURAS'** 44-40616 90BG, 321BS was later converted to an F-7.

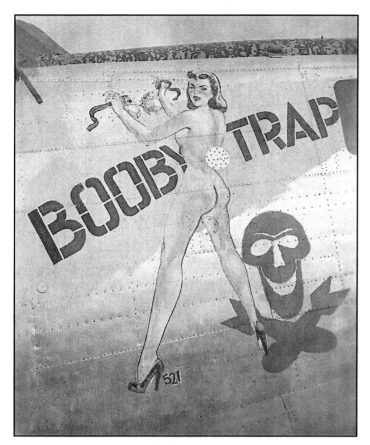

Top left: B-24J-150-CO **BOOBY TRAP** 44-40193 90BG, 321BS. The colors are; blue background, black lettering and green squadron insignia. Right side was **MISS JOLLY ROGER.**

Top right: B-24D1-CO **THE CORAL QUEEN** 41-11870 90BG, 320 and 400BS. MIA on 20 April 1943.

Above: B-24D-50-CO **DINKY** 42-40325 90BG, 320BS.

Left: B-24D-7-CO **COOKIE** 41-23839 90BG, 321BS. Same art on both sides and the rolling pin is not included (yet) but it is on the right side. This is one of the few aircraft that were painted black.

Right: B-24D1-145-CO **HEAVEN CAN WAIT** 42-41216 90BG, 320BS.

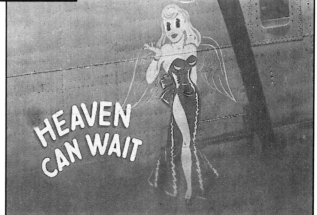

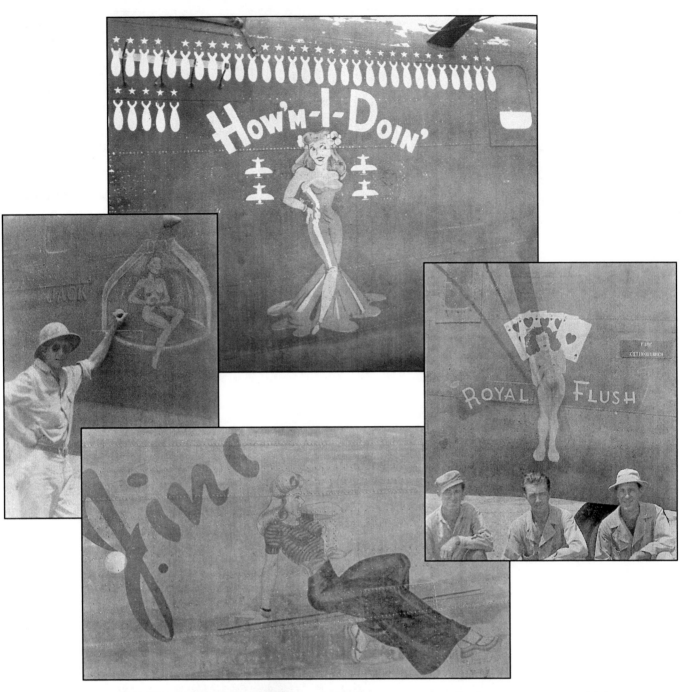

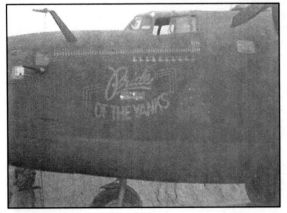

Top: B-24D1-150-CO **HOW'M-I-DOIN'** 42-41223 90BG, 319BS. The red "meatball" insignia has not yet been added to the planes.

Middle left: B-24D1-45-CO **JACK POT** 42-40280 90BG, 321BS.

Middle right: B-24J-15-CO **ROYAL FLUSH** 42-73131 90BG, 320BS.

Middle: B-24J-180-CO **JINI** 44-40804 90BG, 319BS was originally named **GLADYS**.

Left: B-24D **PRIDE OF THE YANKS** 41-11904 90BG, 400BS seen here at Port Moresby, New Guinea October 1943. The same art appeared on both sides. Later in February 1944 it was transferred to the RAAF.

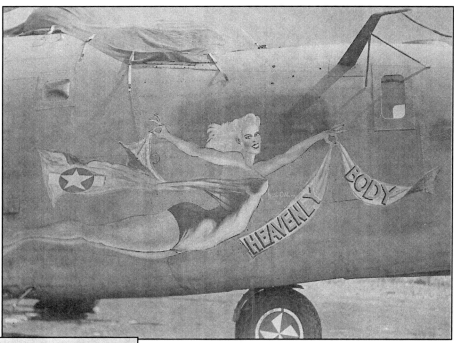

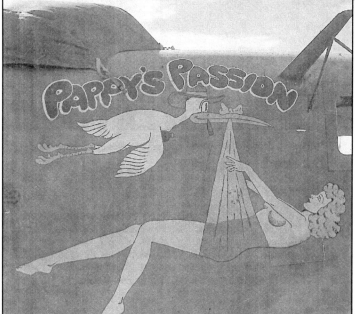

Top left: B-24D-15-CO **MARGIE** 41-24018 90BG, 320BS.

Top right: B-24J-50-CO **HEAVENLY BODY** 42-73484 90BG, 400BS. also served in the 43BG. Art by Sgt. Joe DiMauro.

Left: B-24J-80-CO **PAPPY'S PASSION** 42-100222 90BG, 319BS.

Below left: B-24J-155-CO **MISS KIWANIS** 44-40314 90BG, 319BS. The artist was Jack Eipper.

Below right: B-24J-150-CO **MISS JOLLY ROGER** 44-40193 90BG, 321BS. The right side art is **BOOBY TRAP.**

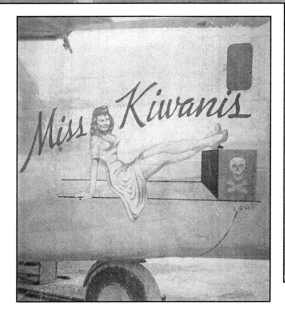

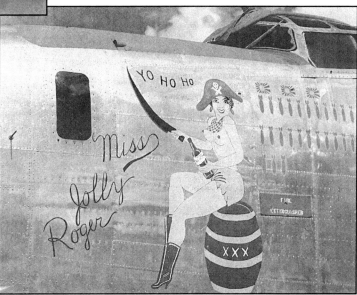

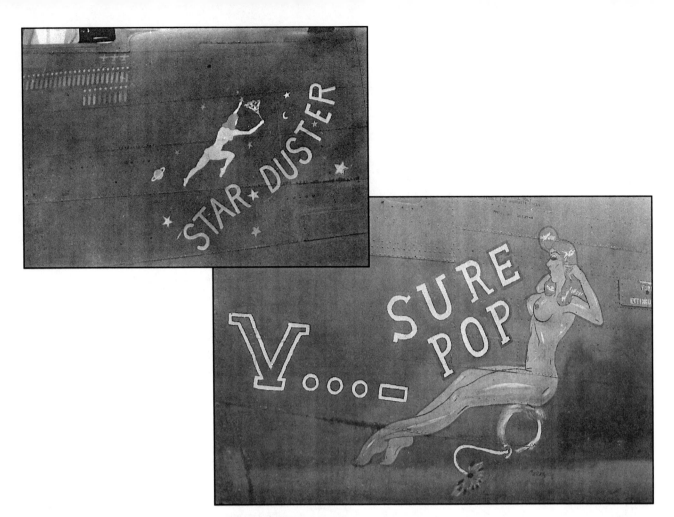

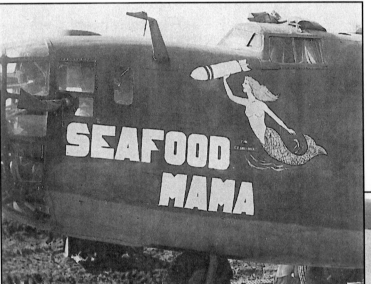

Top: B-24D-10-CO **STAR DUSTER** 41-23869 90BG, 321BS.

Above: B-24D-130-CO **V...-SURE POP** 42-41073 90BG, 319BS.

Left: B-24D-20-CO **SEAFOOD MAMA** 41-24219 90BG, 371BS. Shot down off Gazelle peninsula PNG 12 July 1943.

Below: B-24D-53-CO **MISSION BELLE** 42-40389 90BG, 400BS. The lettering was changed after the OD was stripped off. Shot down over Rabaul 18 October 1943.

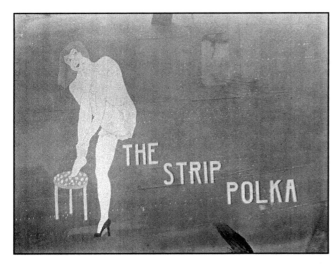 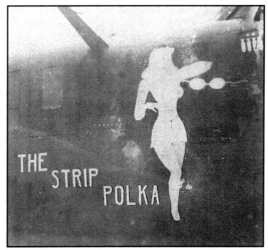

Above: B-24D1-120-CO **THE STRIP POLKA** 42-40970 90BG, 319BS. Right side art depicts the beginning of the "strip".

Below left: B-24 **WINDY CITY KITTY** 90BG.

Below right: B-24D-1-CO **ROARIN ROSIE** 41-23698 90BG, 319BS.

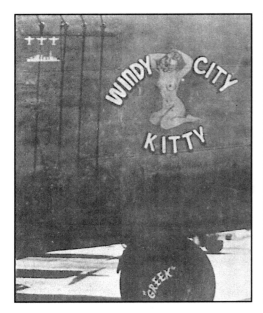 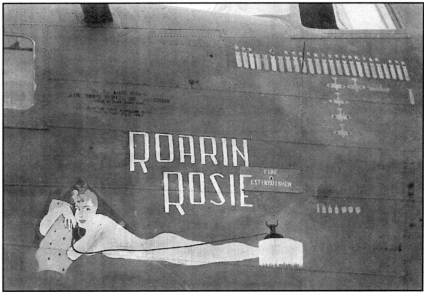

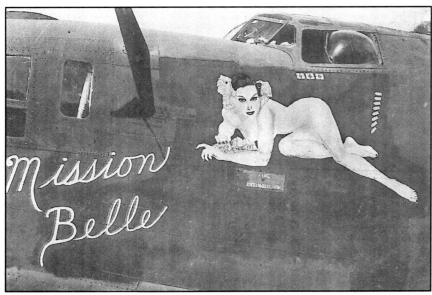

B-24D-53-CO **MISSION BELLE** 42-40389 90BG, 400BS. The lettering was changed after the OD was stripped off. Shot down over Rabaul 18 October 1943.

211

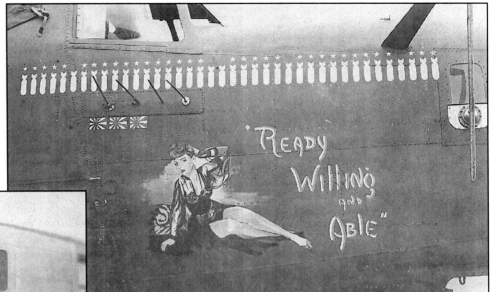

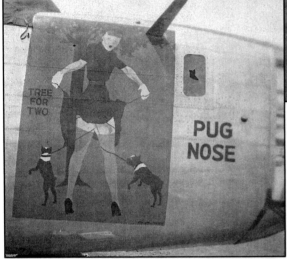

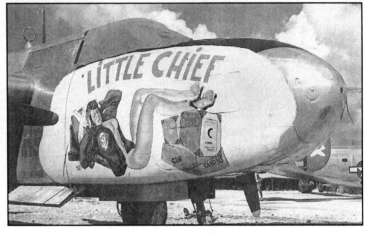

Top right: B-24D1-130-CO **READY WILLING AND ABLE** 42-41078 90BG, 319BS.

Top left: B-24D-5-CO **PUG NOSE** 41-23823 90BG, 321BS.

Above: A-20G **LITTLE CHIEF** Stripped of its armor and used as hack and for "supply" runs.

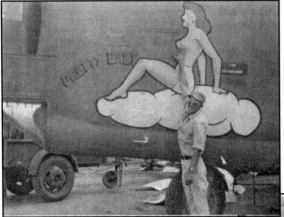

Above and right: B-24J-120-CO **PRETTY BABY** 42-109987 90BG, 319BS. The photo at right shows the camouflage removed with the art intact but the name was re-painted.

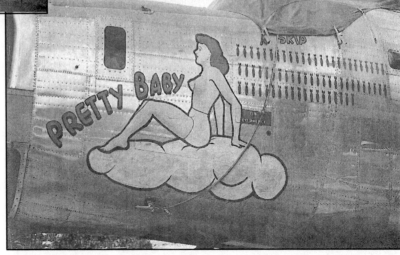

212

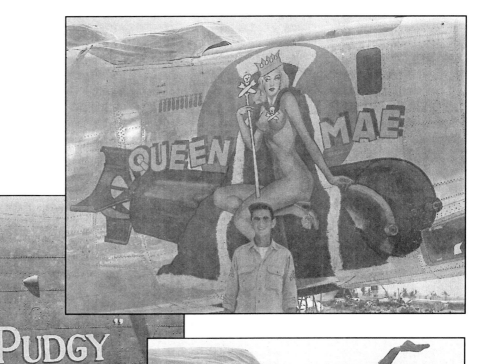

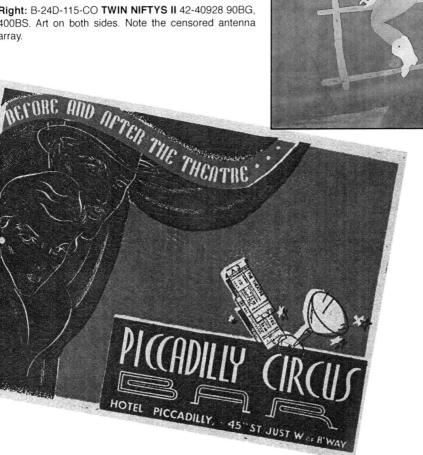

Top right: B-24J-155-CO **QUEEN MAE** 44-40337 90BG, 319BS. Man in photo is Leo Smith.

Above: B-24D-7-CO **PUDGY** 41-23830 90BG, 320BS.

Right: B-24D-115-CO **TWIN NIFTYS II** 42-40928 90BG, 400BS. Art on both sides. Note the censored antenna array.

The naming of aircraft has its own little story. Some are obvious anecdotes and others need some explanation as in the case of B-24D-110-CO 42-40914, **GOLDEN LADY**. Originally assigned to the 43rd BG, piloted by the then Flight Officer Madison L. Shaddox. Known as "Shad" by his crew made acceptance checks at Herington Army Base 23-24 June 1943. At the same time, Shaddox was approached by his Nose Gunner S/Sgt. Joe DiMauro for permission to paint a nose art design modeled after his new bride Anne, for the ship. As an accomplished artist, Joe and Flight Engineer T/Sgt. Vince LaMorge found some paint and with the approval of the crew, proceeded to transfer the image of a nude pin-up that Joe had earlier sketched. Soon after, they began their trek towards the Pacific theater. On the way at Hickam Field, the modification of a nose turret was added which required some touching up on the art by Joe. Maddox was impressed with the flight characteristics from the modification increasing its length by 3 feet. Upon arrival to Townsville, Australia on 18 July, the aircraft was put into a pool, where it was subsequently assigned to the 319th BS, 90th BG. The name **GOLDEN LADY** was added and reached ninety-seven missions and six Japanese Zeros credited. Five of the Zeros were downed on a daylight mission over Rabul.

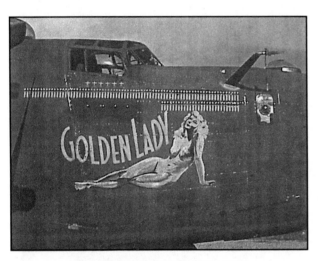

Above Photo John Campbell Archives

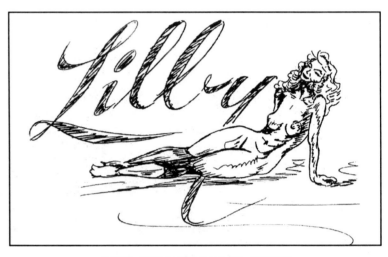

Sketch: Anne LaMorge via M.L. Shaddox

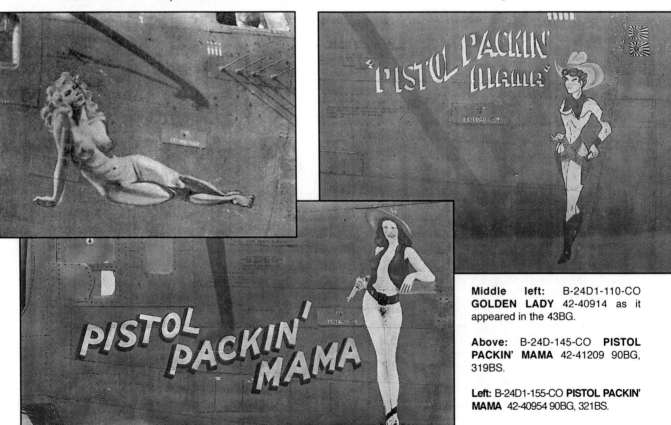

Middle left: B-24D1-110-CO **GOLDEN LADY** 42-40914 as it appeared in the 43BG.

Above: B-24D-145-CO **PISTOL PACKIN' MAMA** 42-41209 90BG, 319BS.

Left: B-24D1-155-CO **PISTOL PACKIN' MAMA** 42-40954 90BG, 321BS.

307th Bomb Group

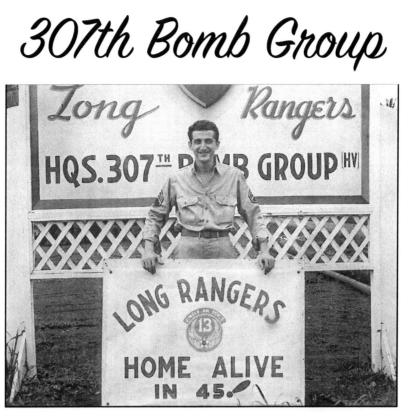

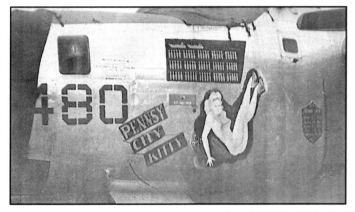

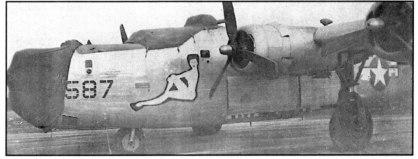

Middle left: B-24L-5-CO **PENNSY CITY KITTY** 44-41480 307BG. *Adam Dintenfass.*

Middle right: B-24J-195-CO **ROSE MARIE** 44-41132 307BG. *Adam Dintenfass.*

Left: A close-up of the elaborate signage honoring the ground crew for **PENNSY CITY KITTY**.

Above: B-24J-170-CO 44-40587 307BG. *Adam Dintenfass.*

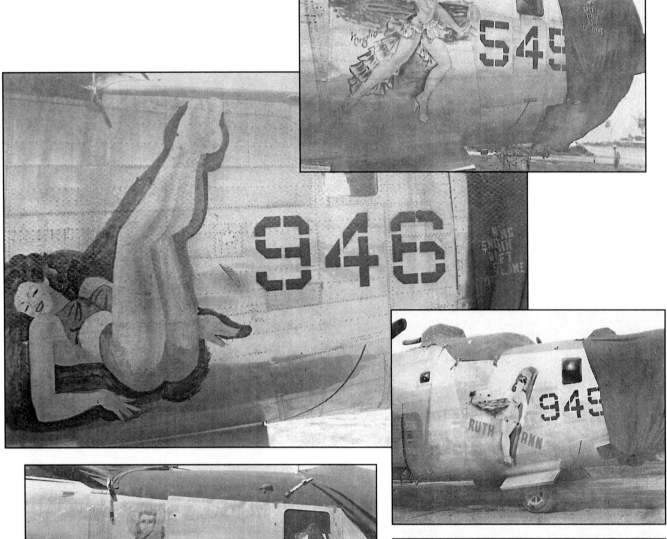

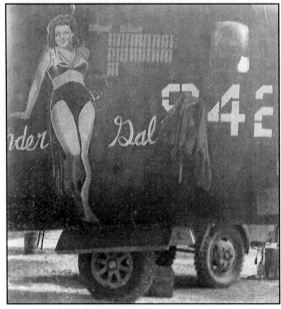

Top right: B-24J-165-CO 44-40545 art done by Joe Origlio. *Adam Dintenfass.*

Top left: B-24J-185-CO 44-40946. *Adam Dintenfass.*

Middle right: B-24J-185-CO **RUTH ANN** 4440945. *Adam Dintenfass.*

Above: B-24L-10-FO **BOBBIE LOU** 44-49617. *Adam Dintenfass.*

Right: B-24J-185-CO **WONDER GAL** 44-40942 transferred from the 43BG, 63BS. *Adam Dintenfass.*

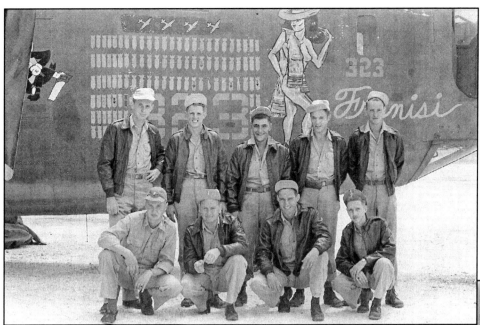

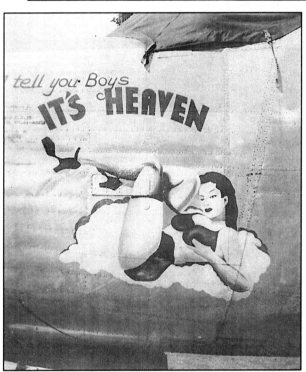

Top left: B-24D1-50-CO **FRENISI** 42-40323 307BG, 371BS was the first B-24 in the group to complete 100 missions. *Adam Dintenfass.*

Above: B-24J-10-CO **I TELL YOUR BOYS IT'S HEAVEN** 44-40959 307BG artist is Walter "Zoot" Bauer and his fee was four bottles of scotch.

Top right: B-24D-7-CO **GREMLIN'S DELIGHT** 42-23858 307BG. *Adam Dintenfass.*

Middle right: B-24 **DINAH MIGHT II** 307BG.

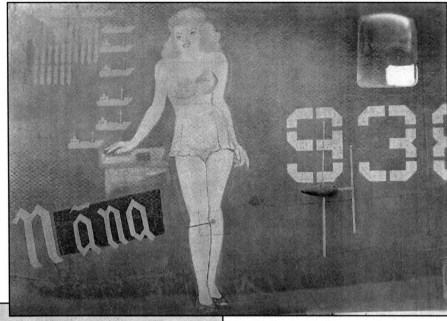

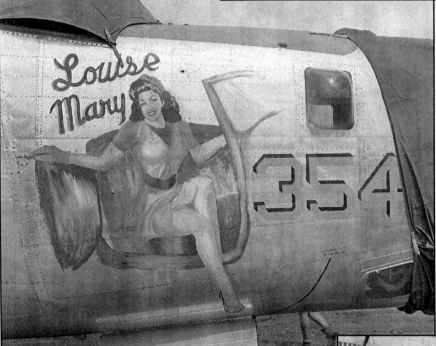

Above: B-24J-185-CO **NANA** 44-40938 307BG, 371BS and with the 868BS. *Adam Dintenfass*

Left: B-24J-210-CO **LOUISE MARY** 44-41354 307BG, 372BS. The name is black with a blue and white shadow. The exterior car color is blue and interior is red. The pin-up is wearing a yellow dress and hat that match the a/c numbers which is shadowed in black. Her belt and inner shirt is also red. *Adam Dintenfass*

Below right: B-24 **POLLY** may be 44-41548 307BG. *Adam Dintenfass*

Below left: B-24J-210-CO **SHADY LADY** 44-41370 370BG. *Adam Dintenfass*

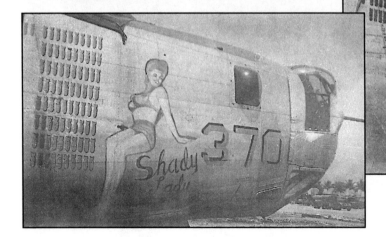

218

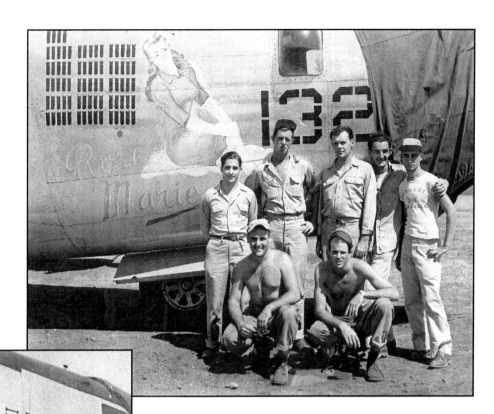

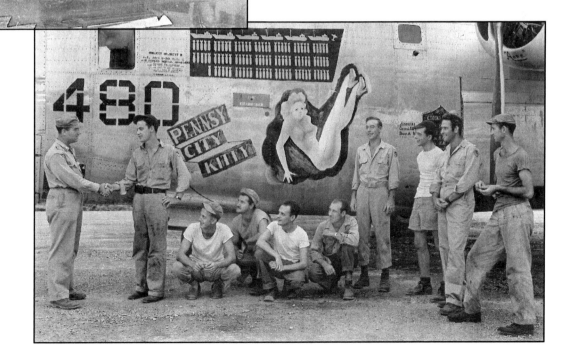

Above: Another shot of B-24J-195-CO **ROSE MARIE** 44-41132 307BG. *Adam Dintenfass.*

Left: B-24L-5-FO **INDIAN THUMMER** 44-49442 307BG. *Adam Dintenfass.*

Below: Another photo after 101 missions in B-24L-5-CO **PENNSY CITY KITTY** 44-41480 307BG. *Adam Dintenfass*

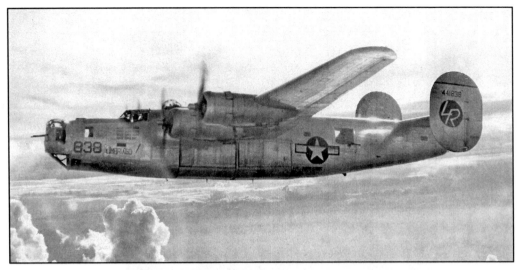

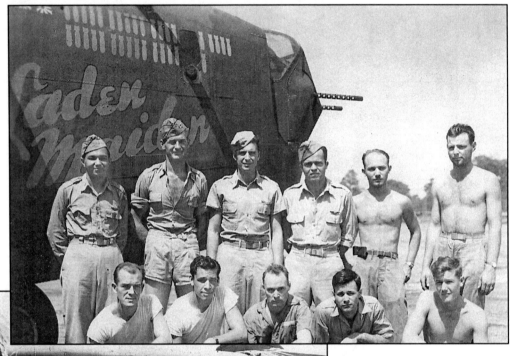

Top: B-24J-210-CO **UMBRIAGO** 44-41838 307BG in flight. *Adam Dintenfass*

Above: B-24D-160-CO **LADEN MAIDEN** 42-72819 307BG, 424BS.

Left: B-24L-15-CO **MY HEART BELONGS TO DADDY** 44-41696 307BG the mission bombs were later changed to hearts.

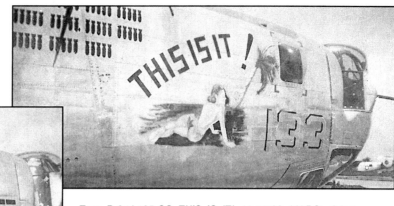

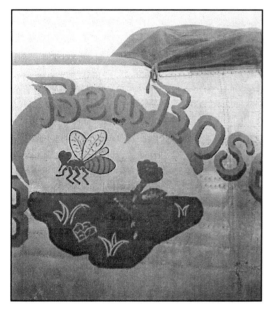

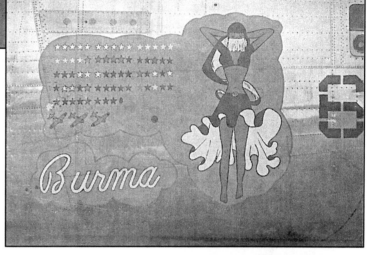

Top: B-24J-195-CO **THIS IS IT!** 44-41133 307BG. *Adam Dintenfass.*

Left: B-24L-5-CO **JANIE** 44-41535 307BG, 424BS. *Adam Dintenfass.*

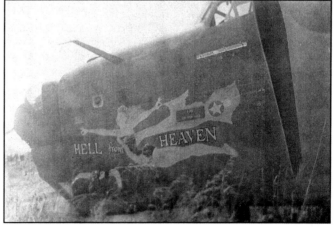

Middle left: B-24M-30-CO **BEA ROSE** 44-42363 307BG.

Middle right: B-24J-170-CO **BURMA** 44-40601 307BG, 424BS. 12 February 1945.

Above: B-24D-160-CO **HELL FROM HEAVEN** 42-72829 307BG.

308TH BOMB GROUP

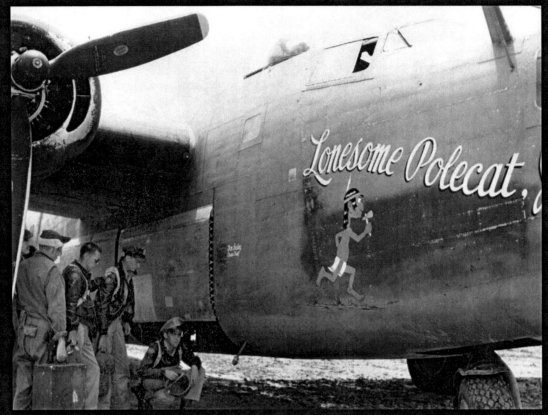

B-24J-80-CO **LONESOME POLECAT, JR.** 42-100235 308BG, 425BS

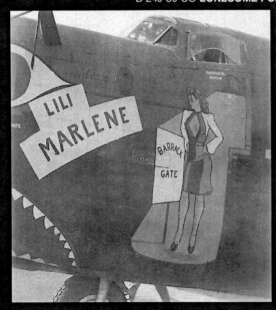

B-24J-50-CO **LILI MARLENE** 42-73494 308BG, 374BS.

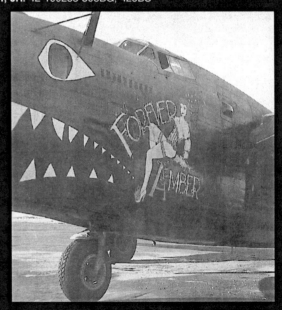

B-24J-20-CO **FOREVER AMBER** 42-73188 308BG, 374BS

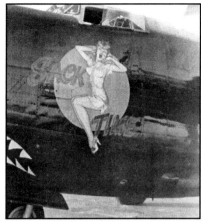

The 308th Bomb Group along with several other groups adopted the stylized shark mouth motif and painted them on the noses of their B-24s. Activated on 15 April 1942 at Gowen Field, Idaho but not fully manned until November, after receiving personnel from the 18th Replacement Wing. As part of the 14th Air Force, they flew many "Hump" supply missions along with supporting Chinese ground forces and bombing missions in French Indochina, Rangoon and Burma. The 308th Bomb Group consisted of the 373rd, 374th, 375th and 425th Bombardment Squadrons. The 308th also mined rivers and ports at the East China Sea, Formosa Strait, South China Sea and Gulf of Tonkin.

Of all the nose art in this group, one stands out that is somewhat controversial in that the colors depicted in the "restored" artifact hull section cut from the B-24M **SACK TIME**, are not correct. The surviving panel and numerous others are displayed in a well known museum in Texas. As they are currently undergoing restoration, questions arise as to the validity of the art work on some of the panels.

The panels were originally salvaged and cut from the aircraft in 1946 at Walnut Ridge, Arkansas, a salvage company owned by Brown and Root under the name Aircraft Conversion Company (ACC). The GM of the company, Minot Pratt kept the panels in storage and he eventually moved to Texas to start a cattle company. The panels were then "given" to the then Confederate Air Force (CAF) in Harlingen, Texas in the mid-1960s. At that time a CAF employee and acquaintance of mine also worked there from 1965-1975 recently revealed to me that he personally witnessed art being applied with model paints to some of the panels. I contacted the director of the museum for further answers and offered assistance in the matter and at that time touched upon a nerve encountering hostile resistance. This sent up red flags and begs the questioning whether their intentions regarding the only surviving nose art panels are honorable.

The photos herein are the only known examples depicting the nose art of **SACK TIME**. While the highly published "restored" panel lettering is in yellow with a dark blue shadow, the photos clearly suggest that they are in red with possibly an orange shadow. The circle background appears to be yellow suggesting sun down and would be logical. This is the correct shade for the color yellow in b/w film. Further supporting this is that the larger photo above is of *Orthochromatic* film which processes red tones very dark, almost black as is the red tongue in the mouth and the slightly visible a/c data in the upper left. The Fire Extinguisher door was also painted black when it was re-painted in the night camouflage. The two smaller photos are *Panchromatic* film which also show the lettering as a dark tone. Comparisons of yellow, orange and red can be seen in the following photos. After attending a reunion in 2004, surviving crew members of the 308th and **SACK TIME** unfortunately do not recall the color scheme or who did the the art on the planes in the group. Further examples of **SACK TIME** are on the following pages.

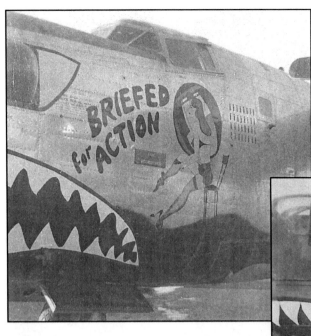

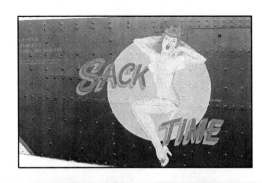

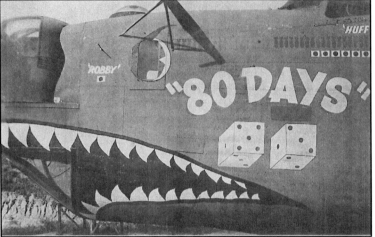

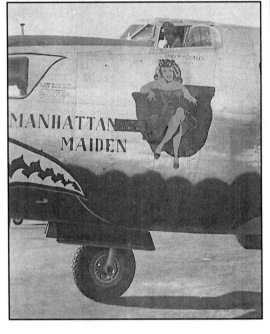

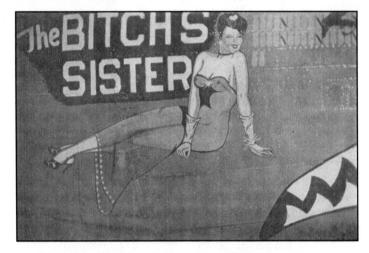

Top left: B-24L-1-CO **BRIEFED FOR ACTION** 44-41443 308BG, 374BS.

Top right: B-24J-85-CO **"80 DAYS"** 42-100267 308BG, 425BS.

Above: B-24M-15-CO **MANHATTAN MAIDEN** 44-42142 380BG, 374BS.

Middle right: B-24J-35-CO **THE BITCH'S SISTER** 42-73319 308BG, 374BS is a reference to the first B-24 **THE BITCH**.

Right: B-24M-10-CO **CALAMITY JANE** 44-42019 308BG, 375BS.

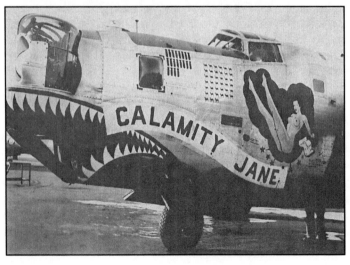

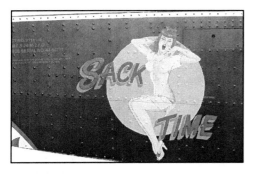

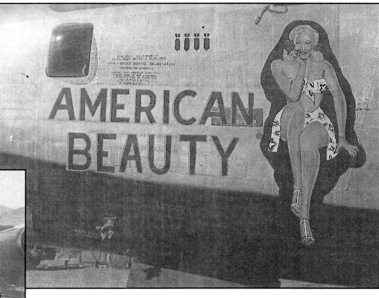

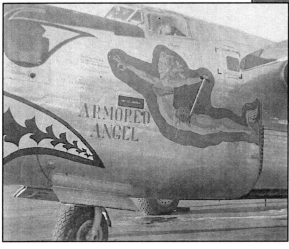

Above: B-24J-205-CO **AMERICAN BEAUTY** 44-41251 308BG, 375BS.

Left: B-24L-10-FO **ARMORED ANGEL** 44-49624 308BG, 374BS.

Below: B-24J-180-CO **MISS BERYL** 44-40832 308BG, 374BS.

Top left: The author's panel of **SACK TIME** illustrating the colors most likely as it appeared on the original B-24M.

Opposite top right: The same panel in black & white that corresponds and is consistent with the original photos on the previous page.

Below left: B-24L-1-FO **BACK AGAIN TO USA BOOMERANG** 44-49504 308BG may have also served with the 7BG, 493BS.

Below right: B-24J-35-CO **BUZZ-Z BUGGY** 42-73327 308BG, 374BS.

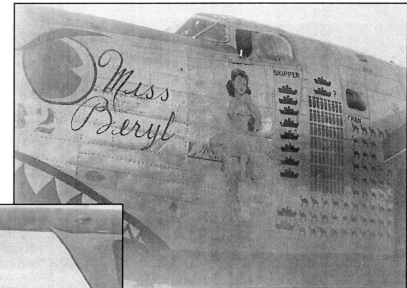

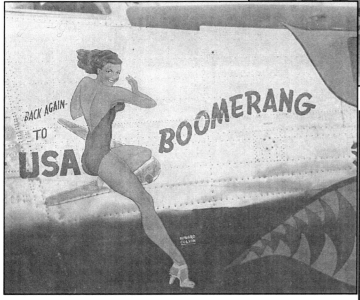

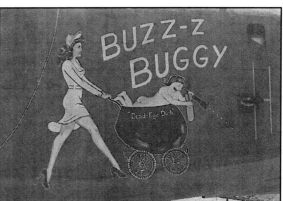

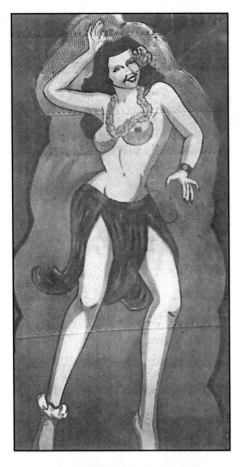

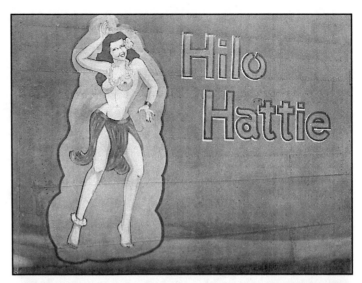

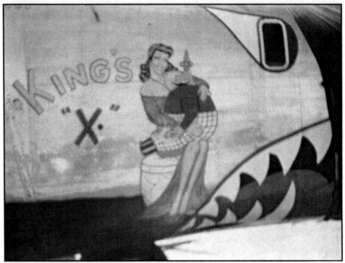

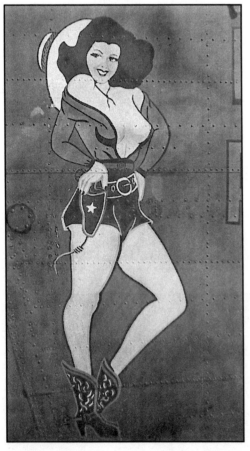

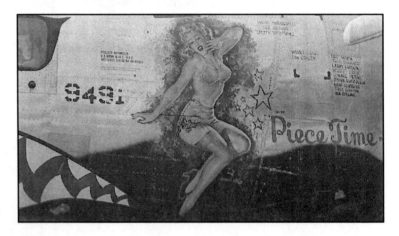

Top left and right: B-24D-7-CO **HILO HATTIE** 41-23844 308BG also served in the 11BG, 431BS.

Middle right: B-24J-170-CO **KING'S X** 44-40584 308BG, 375BS. *Ernest Kitterman.*

Left: B-24 **PISTOL PACKIN' MAMA** 308BG, 375BS close-up of the right side art. The left side is the exact mirror image. Pilot was Jack Keene.

Above: B-24L-5-FO **PIECE TIME** 44-49491 308BG, 373BS also served with the 7BG, 9BS.

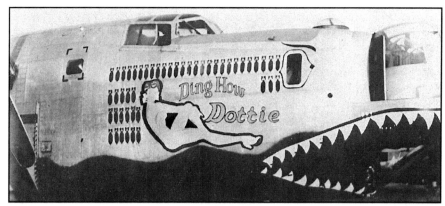

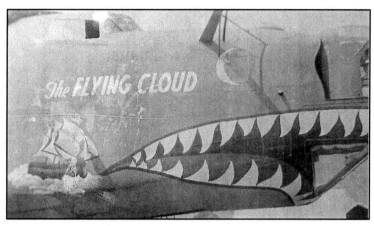

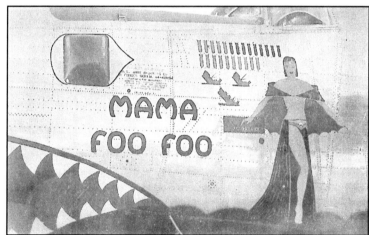

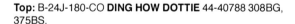

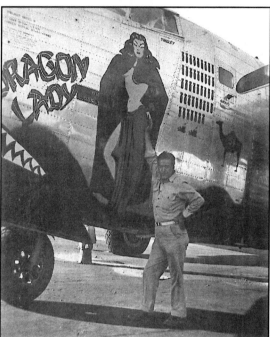

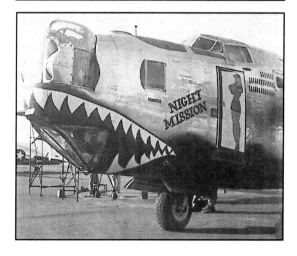

Top: B-24J-180-CO **DING HOW DOTTIE** 44-40788 308BG, 375BS.

Middle left: B-24J-35-CO **THE FLYING CLOUD** 42-73324 308BG, 375BS flown by 2Lt. Warren H. Smith Jr. The art appeared on both sides.

Middle right: B-24L-1-CO **DRAGON LADY** 44-41446 308BG, 425BS. Inspired by the Milt Caniff comics.

Above: B-24M-15-CO **MAMA FOO FOO** 44-42094 308BG, 374BS. The cape is red and black as is the name with a thin black outline. This contradicts the "restored" panel. The bombs were part yellow and black. The ships also are red.

Below right: B-24J-1-NT **NIGHT MISSION** 42-78680308BG, 374BS.

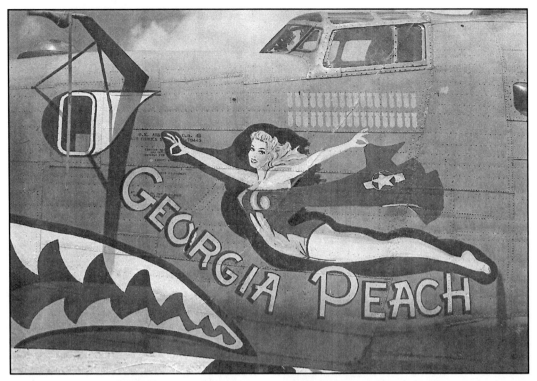

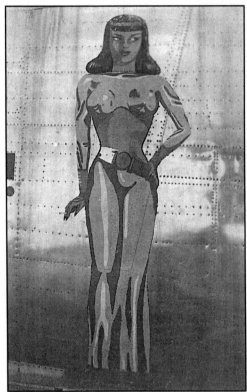

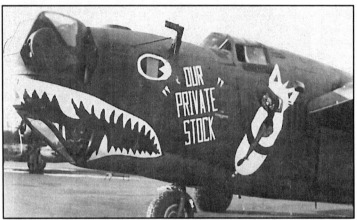

Top: B-24J-45-CO **GEORGIA PEACH** 42-73445 308BG, 374BS. Here is an excellent example of the colors in comparison to each other. The name and bombs are yellow with a black shadow for the lettering. The girl's outfit is red and matches the red tongue. On the original Varga illustration, the cape is blue and it may not have been done here. The entire pin-up is heavily outlined in black.

Above: B-24J-25-CO **OUR PRIVATE STOCK** 42-73247 308BG, 373BS.

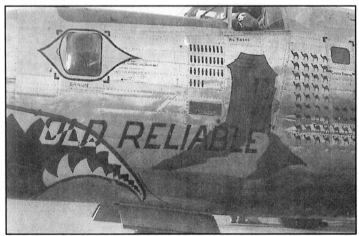

Above: B-24J-1-CO **CHINA GAL** 44-41436 308BG, 425BS.Co-pilot John Chesley painted the head and shark mouth only for unknown reasons and may have done other nose art for the group. The name was later added. Also served in the 7BG.

Right: B-24L-1-CO **OLD RELIABLE** 44-41437 308BG shows and impressive record of hump missions.

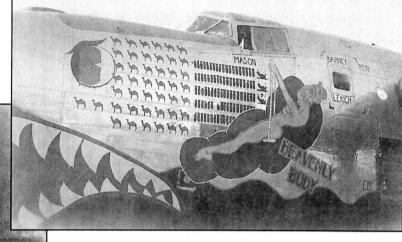

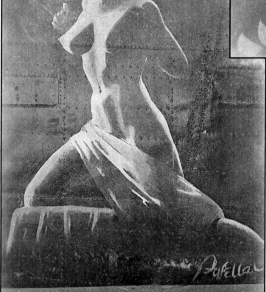

Top: B-24J-15-CO **HEAVENLY BODY** 42-73116 308BG, 425BS. Lost 14 March 1945.

Top left: A B-24 possibly with the 308th BG. Art signed by Pafellar.

Above: B-24L-10-FO **INNOCENT INFANT** 44-49649 308BG, 375BS. *Ernest Kitterman.*

Left: B-24J-5-CO **AVAILABLE** 42-100269 308BG, 374BS. The name was later added.

Below left: B-24D-20-CO **LAKANOOKI** 41-24188 308BG, 374BS.

Below right: B-24 **PISTOL PACKIN' MAMA** 308BG, 375BS The right side is the exact mirror image. Pilot was Jack Keene.

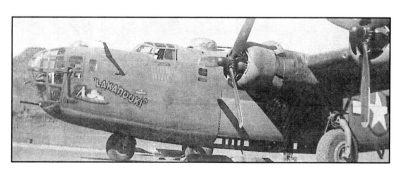

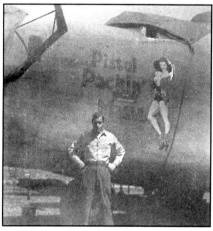

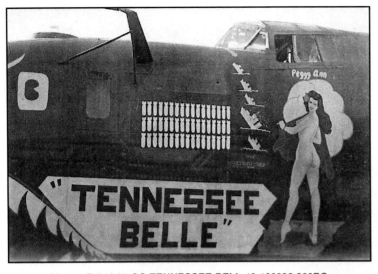

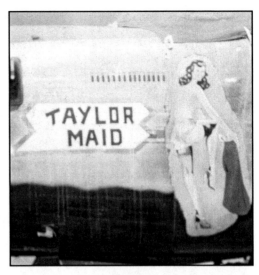

Above: B-24J-65-CO **TENNESSEE BELL** 42-100036 308BG.

Ernest Kitterman

Right and below: B-24J-200-CO **TAYLOR MAID** 44-41204 308BG, 374BS. Another example of the two film types. The sign is white with black thin outline and lettering. The 2" border around the sign is actually where the masking tape was and there is some slight overspray noticeable. The background is a medium blue while her panties has been changed from white to a lighter shade of blue. The slip and bombs are red. Note the stockings have not yet been added in the photo below. The eye around the window is also white although now yellowed slightly from the heat and age, and black outlined. The photo at right is panchromatic film and the below is orthochromatic.

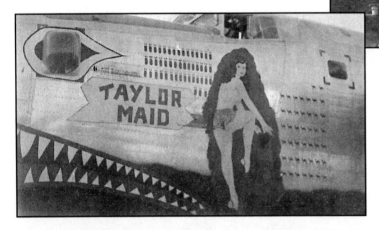

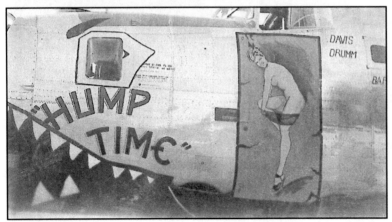

"I chose this bomb group to analyze the study of colors because the schemes were consistent throughout enough to do so. This process will be discussed more thoroughly in the last chapter. I do not claim to know for certain that the colors described are exact, but to the best of my ability from studying hundreds of photos from various sources and comparing them to known color examples of the same subject. From an artistic point of view and logical to MAC computer enhancement analysis, the utmost scrutiny was undertaken."

Left: B-24M-15-CO **HUMP TIME** 44-42117 308BG, 374BS. The background is yellow with blue shadows behind and below the pin-up. The lettering is red with a black outline and most likely yellow shadowing since it matches the tone of the rectangular background.

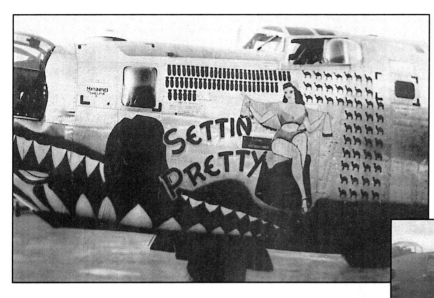

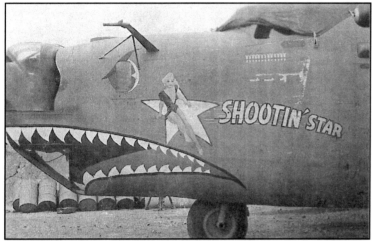

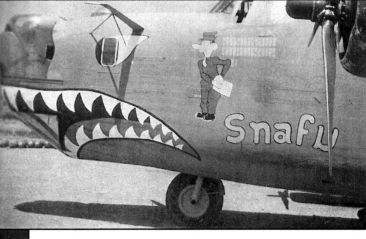

Top: B-24L-1-CO **SETTIN' PRETTY** 44-41429 308BG, 374BS.

Left and above: B-24J-25-CO **SHOOTIN' STAR** 42-73249 308BG, 374BS depict the left and right sides of the a/c. The star and lettering all yellow and the tones are not as dark as the background in **HUMP TIME** and suggest that the film above is panchromatic.

Below left: B-24M-10-CO **SQUEEZE** 44-42020 308BG, 374BS.

Below: B-24J-25-CO **SNAFU** 42-73246 308BG, 374BS. the art appeared on both sides. **SNAFU** is an acronym for; Situation Normal All Fouled Up.

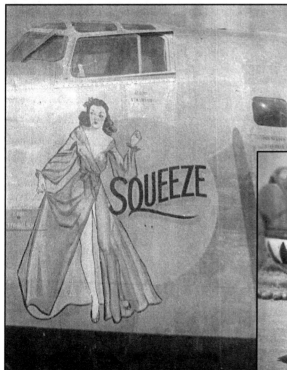

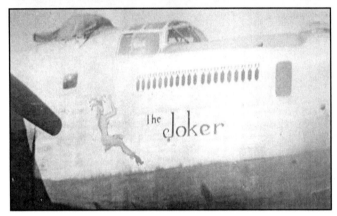

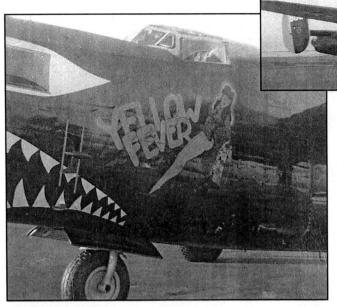

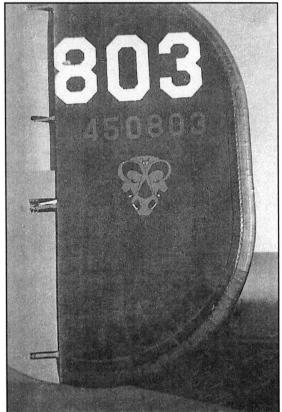

Top left, top right, middel right: B-24M-10-FO **YELLOW FEVER** 44-50803 308BG, 374BS the tail shows the serial and insignia in yellow.
The a/c #803 is white.

Middle: B-24 **THE JOKER** 308BG, 372BS.

Right: B-24 **TAIL HEAVY** B-24D-20-CO 41-24125 308BG, 373BS. *Ernest Kitterman.*

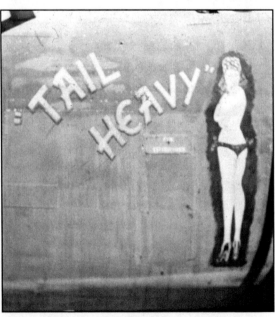

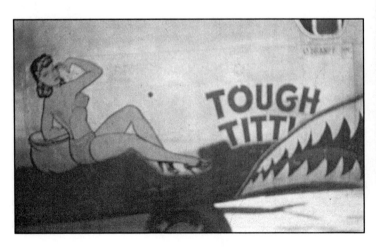

Left: B-24J-155-CO **TOUGH TITTY** 44-40296 308BG, 375BS. *Ernest Kitterman.*

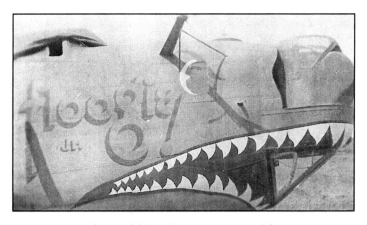

B-24J-45-CO **FLOOGIE! JR.** 42-73444 308BG, 374BS flown by Lt. D.T. Francis. *Adam Dintenfass.*

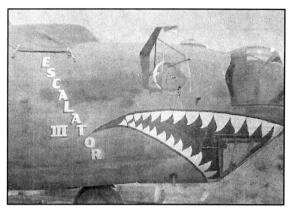

B24J-45-CO **ESCALATOR III** 42-73438 308BG, 375BS lost 21 November 1944. *Adam Dintenfass.*

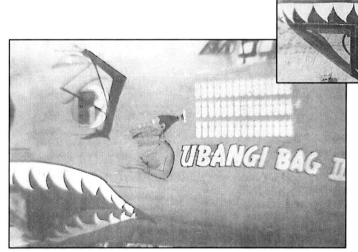

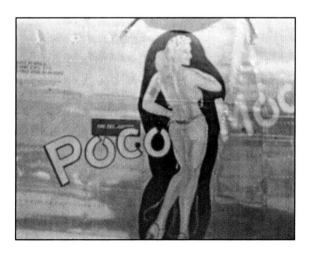

Above: B-24J-30-CO **ESKY** 42-73286 308BG, 373BS. *Adam Dintenfass.*

Left: B-24J-45-CO **UBANGI BAG III** 42-73436 308BG, 374BS lost on 8 May 1945. *Adam Dintenfass.*

Below: B-24 **MY ACHIN' BACK** 308BG. *Adam Dintenfass.*

Another known 308th Bomb Group artist was B. Krawczyk who did cartoon type characters early on when the B-24s were still camouflaged.

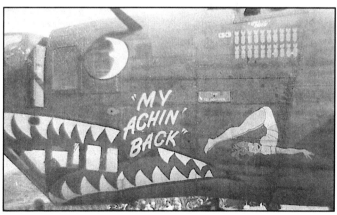

Left: POCO MOCO B-24L-5-FO 44-49451 308BG. *Ernest Kitterman.*

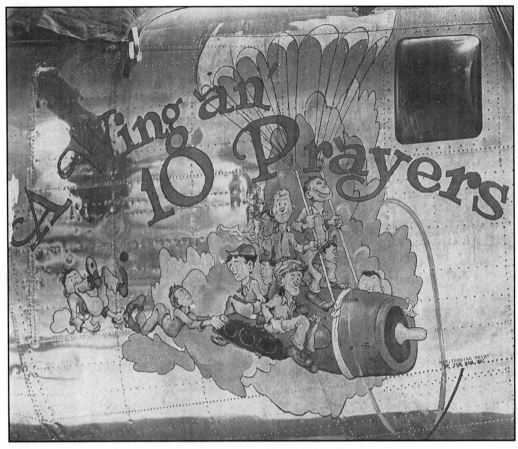

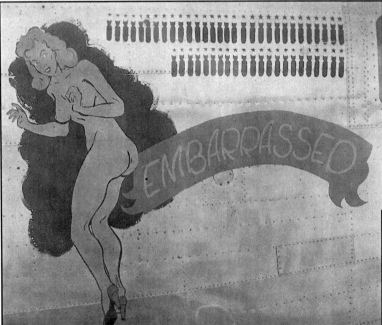

Top: B-24M-30-CO **A WING AN' 10 PRAYERS** 44-42378 380BG, 528BS.

Left and below: B-24J-15-CO **EMBARRASSED** 380BG, 531BS was also named **THE SCREAMER** on the left side. The 5th AF insignia was later added with the mission tally extended. The banner and is red with yellow lettering. The background and bombs are black while the "**108 MISSIONS** " is red and black shadowed.

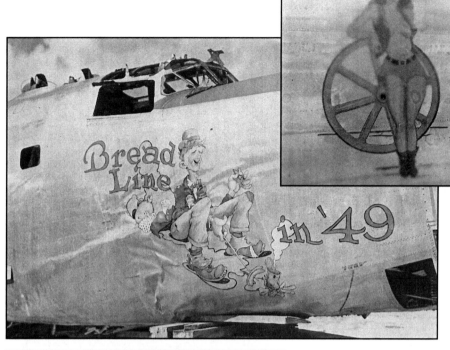

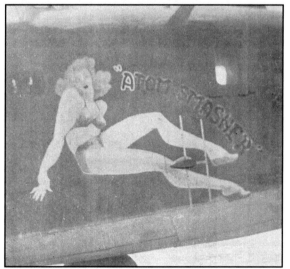

Top: B-24D1-65-CO **DAUNTLESS DOTTIE** 42-40495 380BG, 530BS.

Left: B-24M-20-CO **BREAD LINE IN '49** 44-42201 380BG, 528BS.

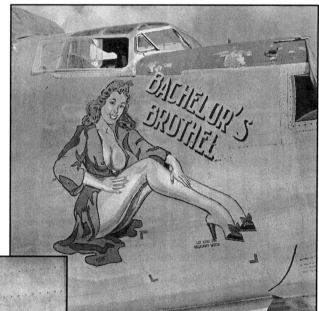

Middle left: B-24D-20-CF **ATOM SMASHER** 42-64045 380BG, 530BS. The left side has a different pin-up.

Above: B-24M-15-FO **BACHLOR'S BROTHEL** 44-51005 380BG. 531. The letters, dress and shoes are red with a black shadow.

Left: B-24M-5-FO **DOUBLE TROUBLE** 44-50602 380BG, 530BS.

235

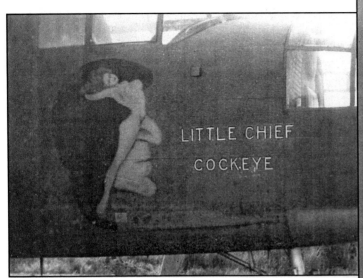

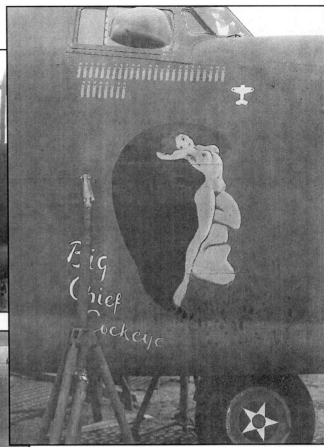

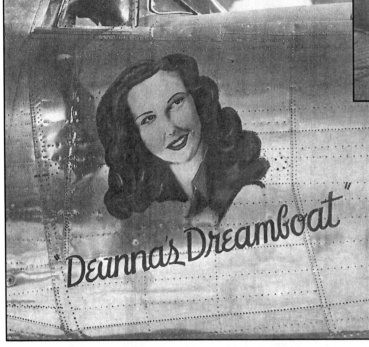

Top left: B-25 **LITTLE CHIEF COCKEYE** was a stripped down hack ship for the 380BG.

Top right: B-24D-53-CO **BIG CHIEF COCKEYE** 42-40351 380BG, 529BS.

Above: B-24M-20-CO **DEANNA'S DREAMBOAT** 44-42244 380BG, 530BS.

Right: B-24J-10-CO **HEAVENLY BODY** 42-73116 380BG, 528BS.

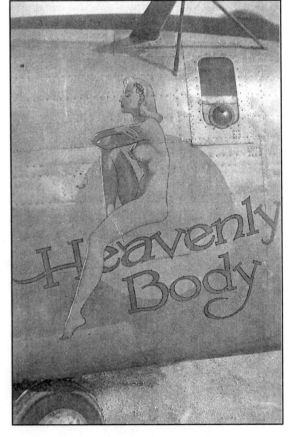

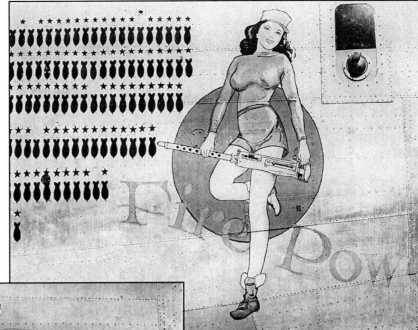

Right: B-24J-120-CO **FIRE POWER** 42-109986 380BG, 528 was re-named **ROBERTA AND SON**. The outfit and name are red and black outlined. The bombs are black and the circle is yellow. Panchromatic.

Below: B-24J-160-CO **FLAK FLED FLAPPER** 44-40434 380BG, 528BS.

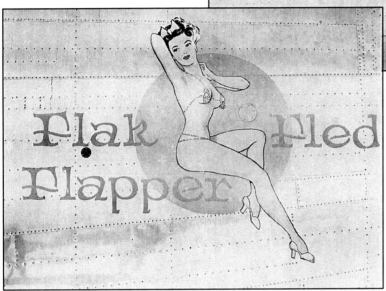

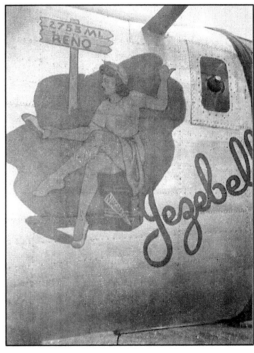

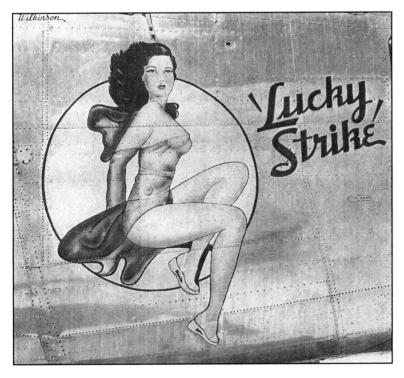

Above: B-24D1-170-CO **JEZEBELLE** 42-72953 380BG, 529BS. There was different art on the left side.

Left: B-24M-5-CO **LUCKY STRIKE** 44-41876 380BG, 530BS.

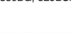

Right: B-24M-15-FO **LIBERTY BELLE** 44-50894 380BG, 529BS.

Below: B-24M-25-CO **LUVABLASS** 44-42263 380BG, 529BS.

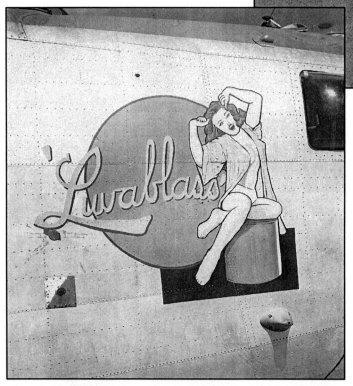

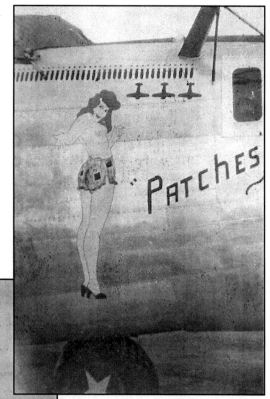

Above: B-24J-50-CO **PATCHES** 42-73474 380BG, 531BS.

Left: B-24M-10-FO **PEACE OFFERING** 44-50811 380BG, 529BS.

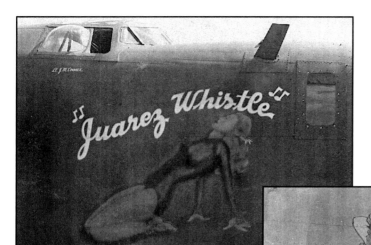

Left: B-24D1-65-CO **JUAREZ WHISTLE** 42-40496 380BG, 530BS.

Below: B-24J-125-CO M**ADAME QUEEN** 42-109999 380BG, 529BS. The lettering is black with a yellow outline. The rectangular is red.

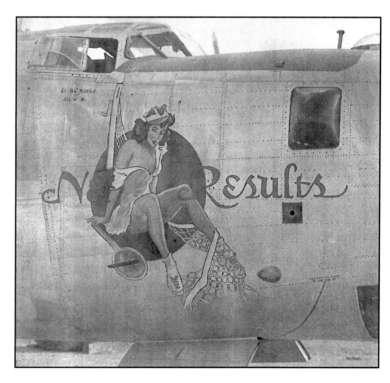

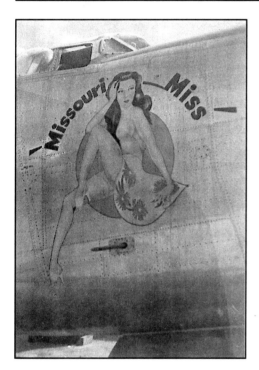

Middle left: B-24M-1-CO **MISSOURI MISS** 44-41811 380BG, 530BS also served in the 434BG.

Above: B-24M-5-CO **NET RESULTS** 44-41875 380BG, 528.

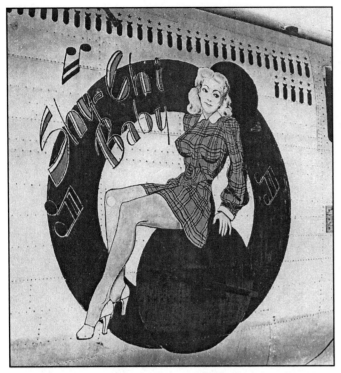

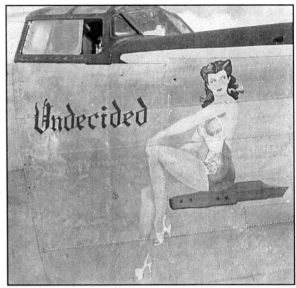

Top left: B-24J-185-CO **SHY-CHI BABY** 44-40920 380BG, 531BS.

Above: B-24L-120-CO **UNDECIDED** 42-109990 380BG, 530BS.

Left: B-24J-80-CO **SIX BITTS** 42-100214 380BG, 529BS. Art on both sides with a scoreboard on the left side.

Below left: B-24J-160-CO **QUEEN HI** 44-40432 380BG, 529BS.

Below right: B-24J-185-CO **LIL' NILMERG** 44-40861 380BG, 529BS.

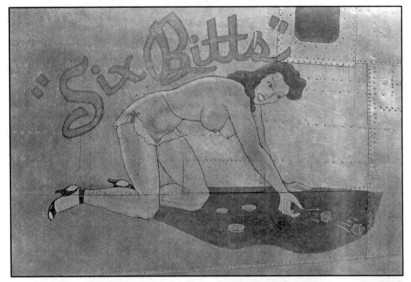

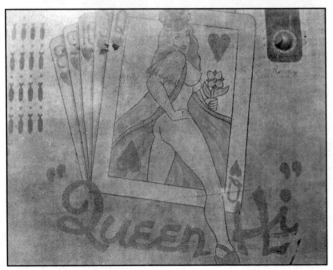

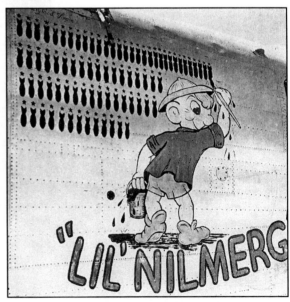

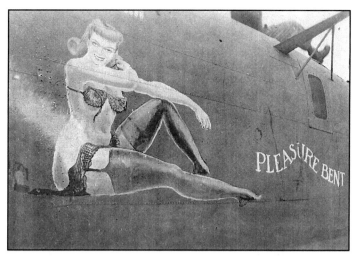

Left: B-24J-45-CO **PLEASURE BENT** 42-73440 380BG.

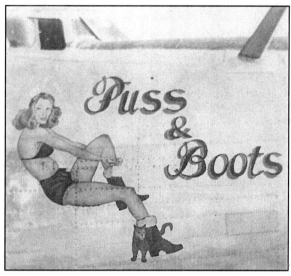

B-24D-170-CO **PUSS & BOOTS** 42-72942 380BG, 528BS.

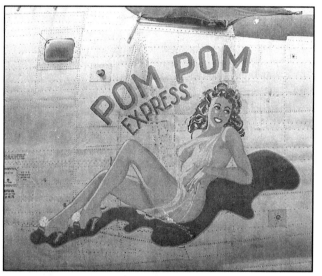

B-24M-1-FO **POM POM EXPRESS** 44-50396 380BG, 531BS.

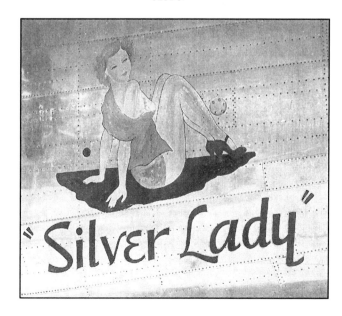

B-24J-160-CO **SILVER LADY** 44-40371 380BG, 530BS.

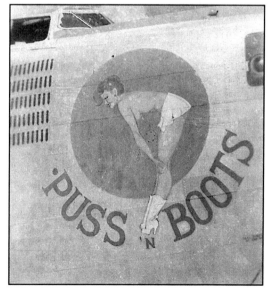

B-24D-170-CO **PUSS 'N BOOTS** 42-72942 380B also served in the 434BG.

494TH BOMB GROUP

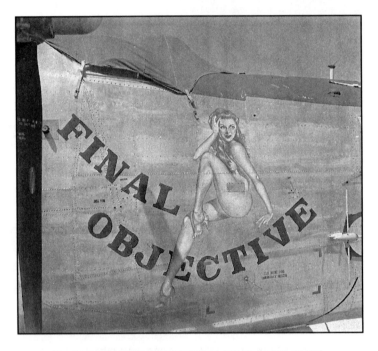

B-24M-5-CO **FINAL OBJECTIVE** 44-41945 494BG, 864BS.

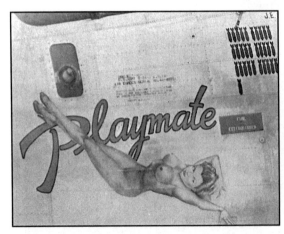

B-24J-180-CO **PLAYMATE** 44-40791 494BG, 867BS also served with the 11BG. The right side had the name **PLAYBOY**.

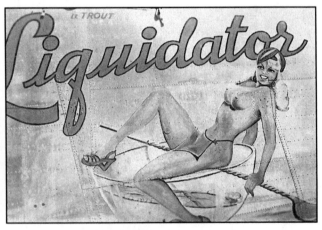

B-24M-15-CO **LIQUIDATOR** 44-42052 494BG, 866BS.

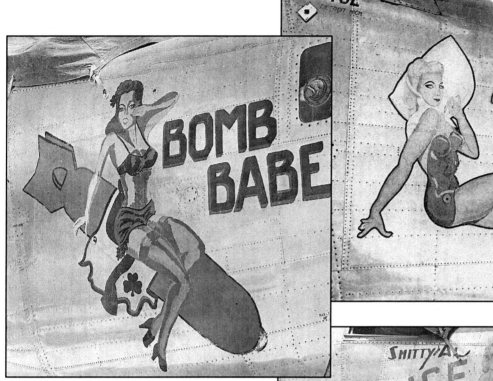

Top left: B-24J-175-CO **BOMB BABE** 44-40709 494BG, 866BS.

Top right: B-24L-175-CO **CONTRARY MARY** 44-40739 494BG, 864BS.

Right: B-24J-175-CO **INNOCENCE A-BROAD** 44-40733 494BG, 865BS also served in the 11BG.

Below: B-24J-175-CO **PLUNDERBUS** 44-40712 494BG, 864BS.

Below right: B-24J-180-CO **THE DUCHESS** 44-40754 494BG, 867BS.

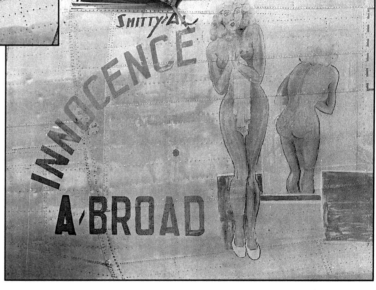

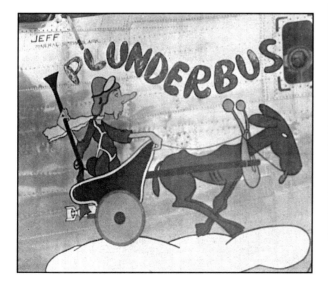

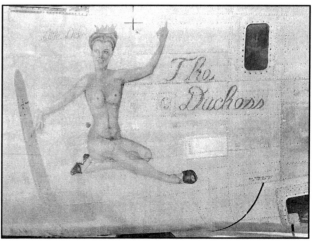

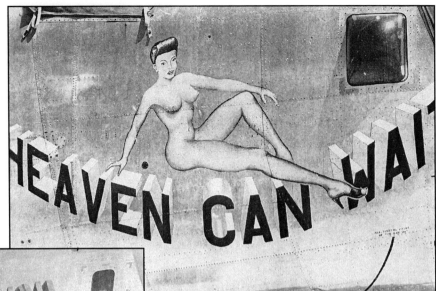

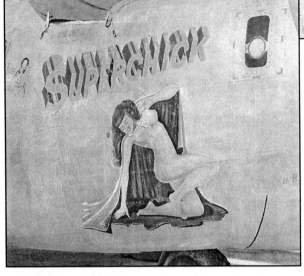

Top right: B-24M-15 **HEAVEN CAN WAIT** 44-42061 494BG, 866BS flew 26 combat missions and the artist was Ball Turret Gunner William J. Gatz.

Above: B-24J-170-CO J -170 **SUPERCHICK** 44-40645 494BG, 865BS.

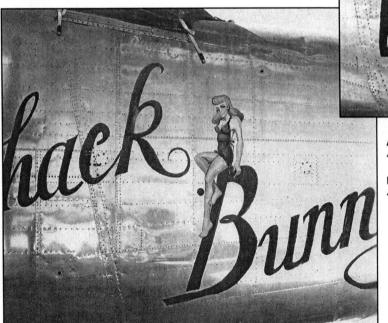

Above: B-24L-10-CO **STAR DUST** 44-41610 494BG, 867BS was originally with the 30th BG.

Left: B-24J-180-CO **SHACK BUNNY** 44-40759 494BG, 867BS.

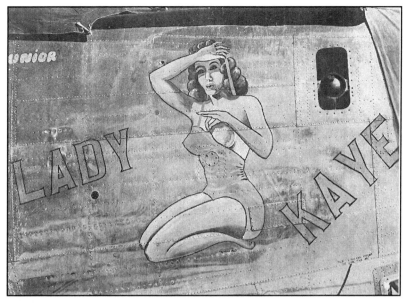

B-24J-170-CO **LADY KAYE** 44-40647 494BG, 867BS. The artist was T/Sgt. Al Restuccia.

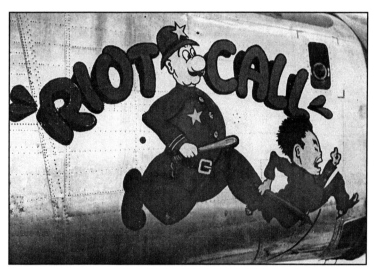

Right: B-24J-180-CO **RIOT CALL** 44-40755 494BG, 864BS.

Below: B-24J-17-CO **THE SNIFFIN GRIFFIN** 494BG, 865BS.

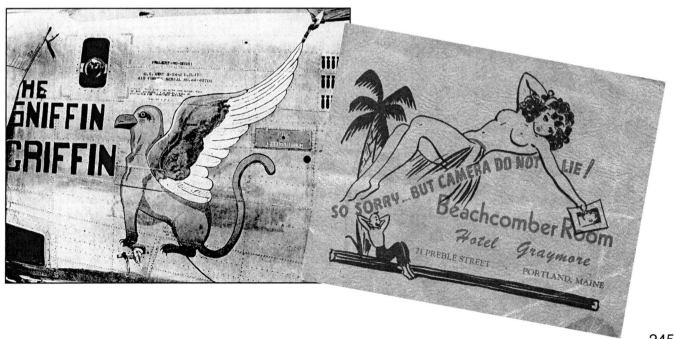

20th Combat Mapping Squadron

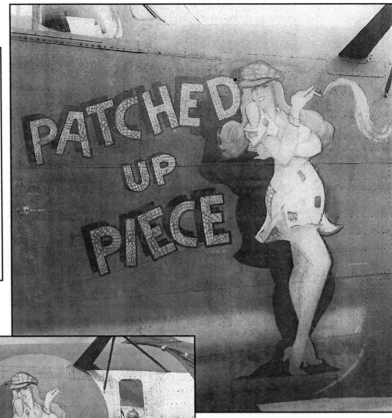

Top: F-7 (B-24-1-CF) **PATCHED UP PIECE** 42-64047 6th Photo Reconnaissance, 20th CMS. Art done by Al Merkling over OD and his first nose art design.

Left: The same a/c with the camouflage stripped and the name re-done.

Below: F-7A (B-24J-1-CF) **LITTLE JOE** 42-64054 20CMS is another Merkling design.

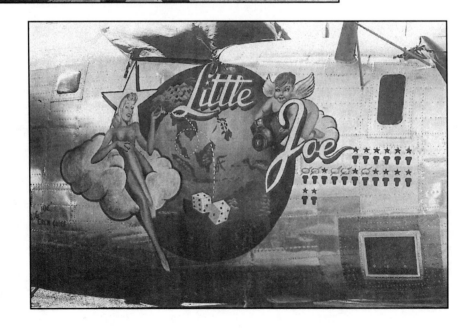

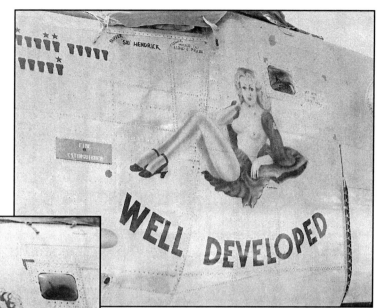

Above: F-7B (B-24J-150-CO) **WELL DEVELOPED** 44-40209 served in the 494BG and 4PCS.

Left: F-7A (B-24J-190-CO) **HI-PRIORITY STUFF** 44-40967 served with the 2PCS.

Right: F-7A (B-24J-5-CO) **UNDER EXPOSED** 42-73052 20CMS, 6PR. Nose art by Merkling

Below: F-7A (B-24J-5-CO) **THE RIP SNORTER** 42-73047 20CMS, 6PR art by Al Merkling.

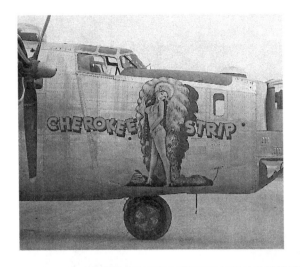

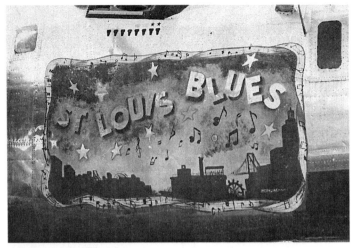

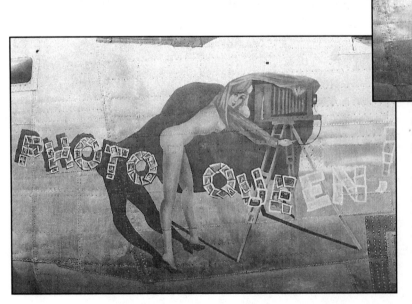

Top left: F-7B (B-24J-150-CO) **CHEROKEE STRIP** 44-40198 20CMS, 6PR. Art by Al Merkling.

Top right: F-7A (B-24J-5-CF) **ST. LOUIS BLUES** 42-64172 20CMS. Yet another Merkling design.

Left: F-7 (B-24J-15-CO) **PHOTO FANNY** 42-73157 2PC.

Above and left: F-7A (B-24J-5-CO) **PHOTO QUEEN!** 42-73049 20CMS is a work in progress by Al Merkling.

At the time this was done in New Guinea, Merkling did some 12 F-7s, an A-20 and a C-47. Prior to his draft in 1942, Merkling was a toy designer. His assigned job in the military was as a lab technician. His first F-7 was **PATCHED UP PIECE** and he never copied calendar pin-up for reference. They were his own creations.

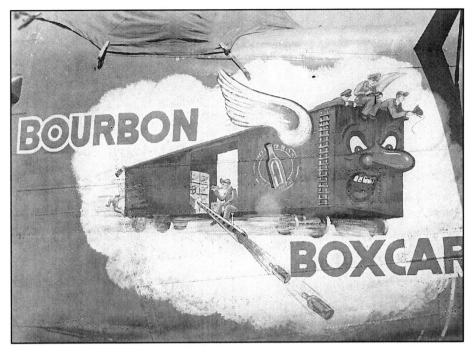

F-7A (B-24J-5-CO) **BOURBON BOXCAR** 42-73048 20CMS, 6PR.

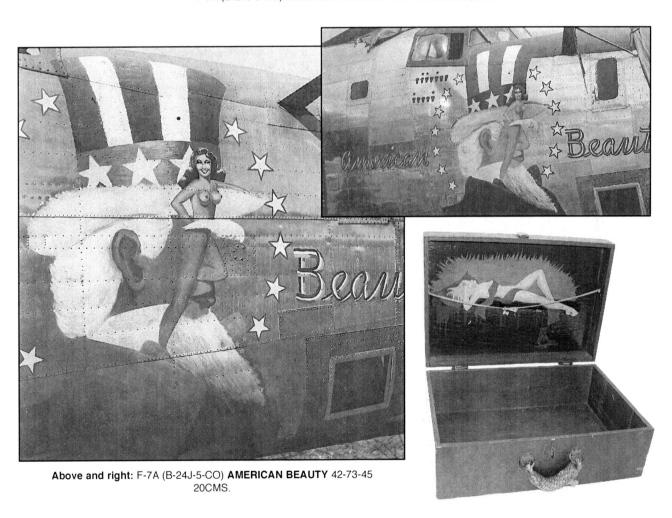

Above and right: F-7A (B-24J-5-CO) **AMERICAN BEAUTY** 42-73-45 20CMS.

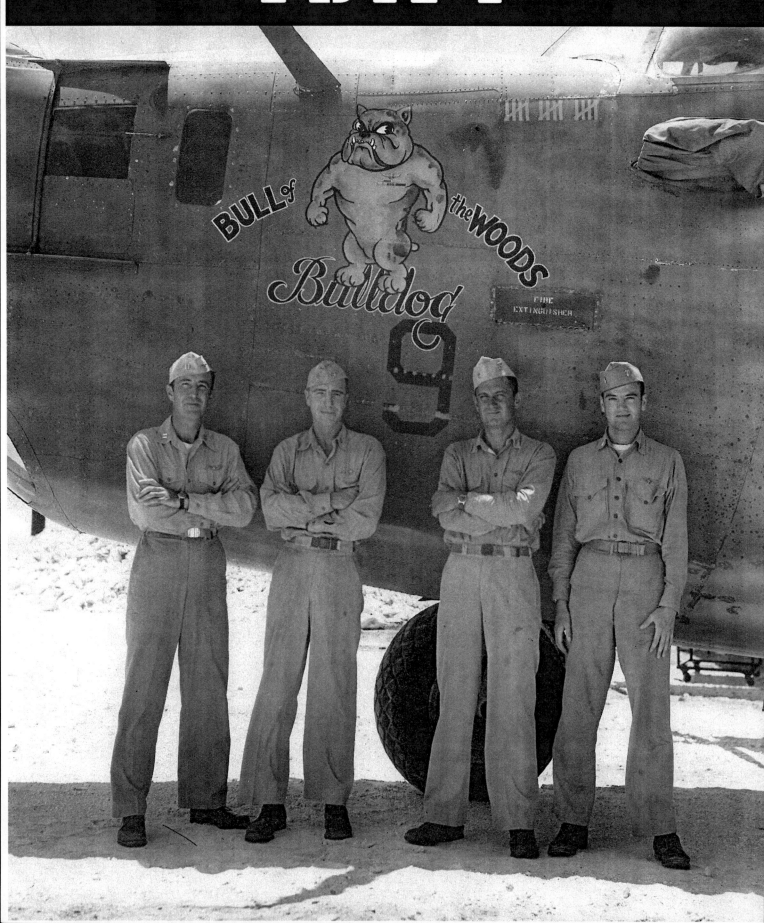

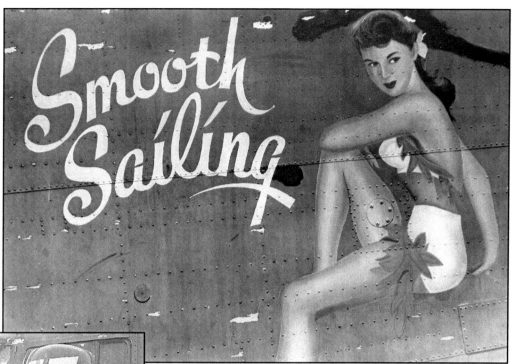

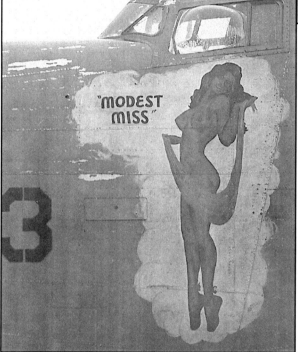

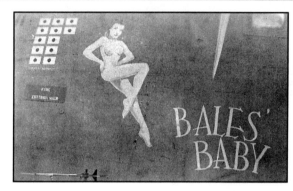

Top: PB4Y-1 **SMOOTH SAILING**

Middle left: PB4Y-1 **MODEST MISS** BuNo 38733 (B-24J-150-CO 44-40215) VPB-111 PPC Lt. J.A. Tvedt and VPB-116.

Middle right: PB4Y-1 **BALES' BABY** VPB-119 PPC Lt Cdr. Raymond C. Bales. Lost on 1 April 1945.

Left: PB4Y-1 **LOOSE LIVIN II.**

Right: PB4Y-1 **DOC'S DELIGHT** BuNo 38746 (B-24J-155-CO 44-40258) VPB-111 PPC Lt. R.L. Fleming and VPB-117.

Opposite page: PB4Y-1 **BULL OF THE WOODS BULLDOG** VD-1 (PRS). L-R; Lt. Cross, Cmdr. Stroh, Lt. (jg) Larson and an unknown officer.

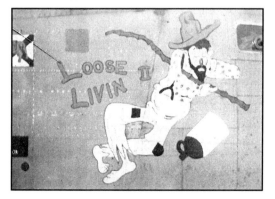

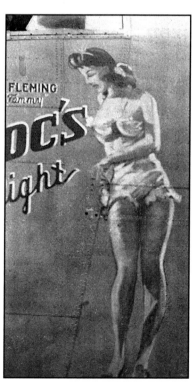

Right: PB4Y-1 **CUNTRY CUZIN** B-24L-10-CO 44-41570

Below: PB4Y-1 **EASY MAID** BuNo 38923 (B-24J-205-CO 44-41328) VPB-116 was a Hal Olsen design. This panel was saved from salvage and currently on display at the American Airpower Heritage Museum.

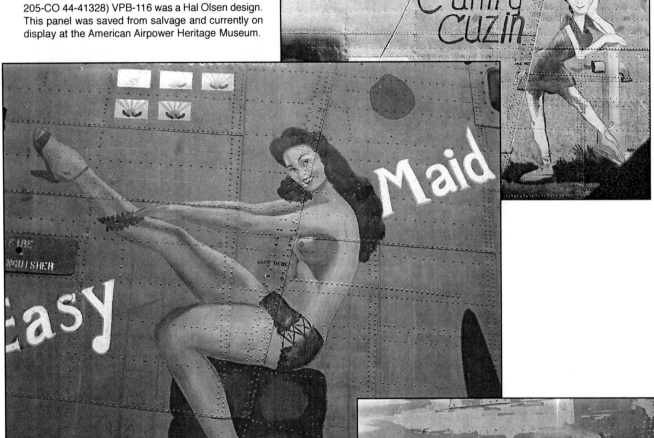

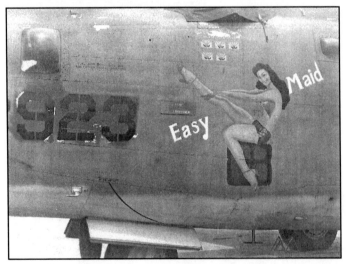

Right: PB4Y-1 **IMPATIENT VIRGIN** BuNo 38920 (B-24J-205-CO) VPB-102. Nose art by Hal Olsen.

Hal Olsen - AMM-2c, ITG-31, CASU-44 Tinian, Marianas

Hailing from New Hampshire, Olsen worked in a machine shop as a tool maker for a sub-contractor suppling tooling for Pratt & Whitney. The day after his 23rd birthday, he joined the Navy in 1943. After his training in Indiana, the last stop in the continental USA was California where he bought $50 worth of artist paint supplies so that he could paint landscapes in his free time. Olsen's role in the Navy was to repair aircraft auto-pilot instruments on Tinian. Soon after his arrival, the island was attacked by the Japanese and a supply hut was hit where a resident artist had kept his supplies. This essentially put the nose artist out of business, leaving Olsen to take over the potential demand for nose art designs the new crews wanted. Having seen existing examples on the islands aircraft, Olsen thought he could easily do this utilizing the grid system. Gathering his

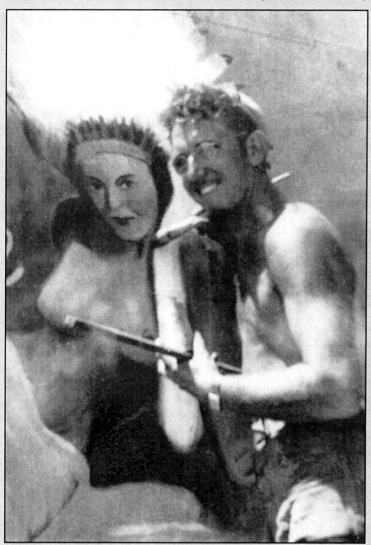

supplies, he mixed the fine oils with stock military paints thinned with turpentine to acquire the required colors needed, also applying the grids and design in chalk. The demand was overwhelming and he had to prepare the flesh tones by the gallon.

The fee for a nose art design averaged $50 or trading whisky as currency when applicable and preferred since his margin of profit would be extended when re-selling the alcohol to the sea-bees. The designs would include an aircraft name as well as smaller personal names and stencilled mission markings. Olsen sent most of his earnings home from the success of this enterprise and aroused suspicion within the military post office. This led to his friends sending funds on his behalf. Since his duties didn't start until noon through midnight, the only time to paint was in the mornings, which worked out fine when the weather was cooler. The designs on average took about four hours, completing some 100 PB4Y-1s and dash 2s for VPB-102, 108, 116 and 121. A single C-47 and a B-29 **UP-AN-ATOM** was done by Olsen prior to his departure.

After the war Olsen studied at the Boston School of Fine Arts and became a technical illustrator for the Los Alamos Laboratory. Today at age 84, residing in New Mexico, he continues to paint in acrylics, re-creating his original designs from contributed photos of his PB4Y nose art.

Above: Hal Olsen poses during the painting of **INDIAN MADE** which was later re-named as **REDWING.**

Right: PB4Y-1 **SLEEPYTIME GAL** BuNo 38977 (B-24L-10-CO 44-41566) VPB-116 and VD-5. Nose art by Hal Olsen.

Left: PB4Y-1 **BOSS BURTON'S NITEMARE** VPB-102.

Botton left: PB4Y-1 **COMAIR WOLFPACK "II"** BuNo 32276 (B-24J-125-CO 42-110012) VB-115.

Below: PB4Y-1 **NO STRAIN-II** BuNo 65293 (B-24L-1-CO 44-41708) VPB-102 Patrol Plane Captain (PPC.) Lt. Don Strange.

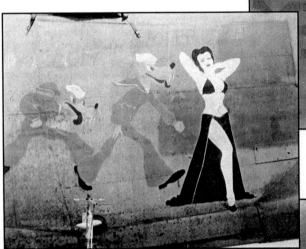

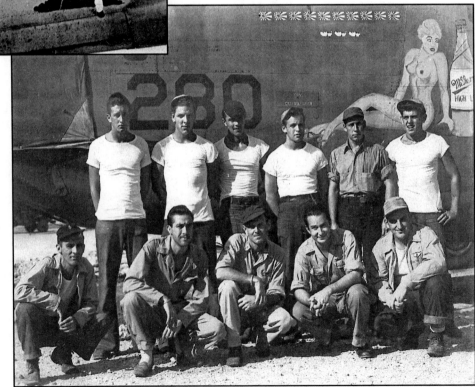

Right: PB4Y-2 **MILLER'S HIGH LIFE** BuNo 32280 (B-24D-120-CO 42-41006) VPB-101 Cdr. Justin A. Miller and crew on the morning of 18 October 1944 before they were shot down at sea near Puluwat. Seven found their way back two months later. The crew is credited with two cargo ships sunk, 10 planes destroyed, three probable and 15 damaged.

Right: PB4Y-1 **CALL HOUSE MADAM** art by Olsen.

Below: PB4Y-1 **SLIDIN' HOME** BuNo 38901 (B-24J-205-CO 44-41288) VPB-117 PPC Lt. G. Forbes whose name was painted yellow in Arabic under the cockpit window. The art was done by Olsen.

Bottom left: PB4Y-1 **LADY LUCK** BuNo 38892 (B-24J) VPB-111 PPC Cmdr J.V. Berry.

Middle right: PB4Y-1 **BEACHCOMBER** BuNo 38943 VPB-102.

Bottom right: PB4Y-1 **CHICK'S CHICK** BuNo 32238 VPB-106 and 115.

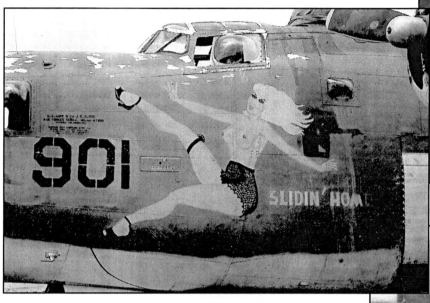

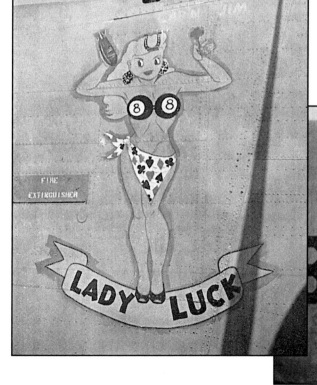

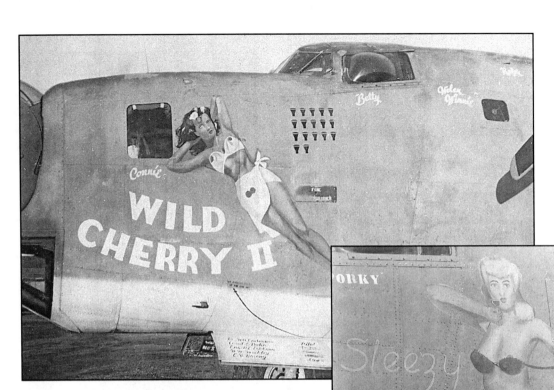

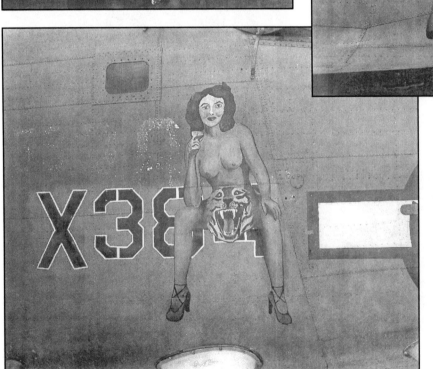

Top left: PB4Y-1 **WILD CHERRY II** VPB-123 PPC Lt. H.O. Anderson.

Middle left: PB4Y-1 **SITTING PRETTY.**

Above: PB4Y-1 **SLEEZY BEAS**T unknown and appears to be the work of Olsen.

Left: PB4Y-1 BuNo 59384 VPB-106.

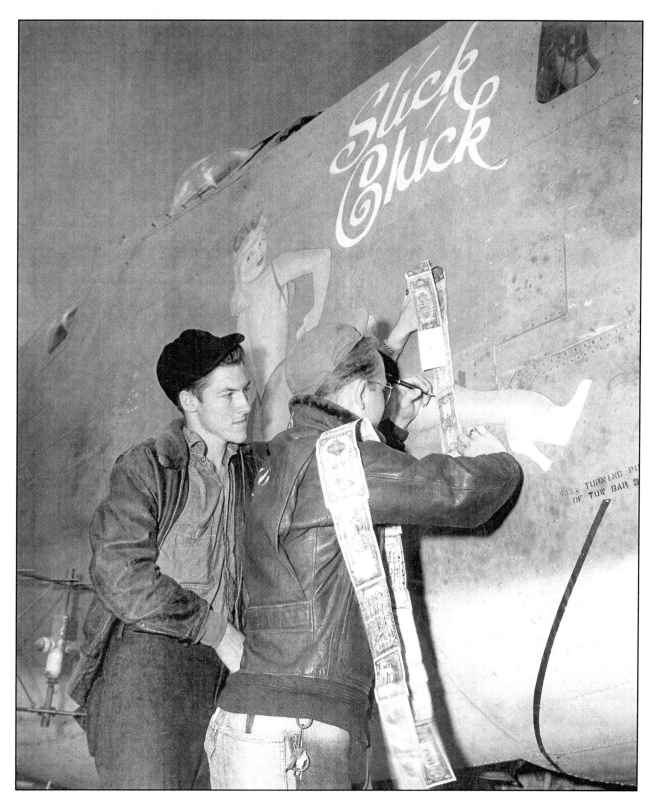

A PB4Y-1 **SLICK CHICK** from VD-5 with two crew members demonstrating the "Short Snorter" tradition. The story and its rules vary in the different theaters but its origin is traced to the British having started this custom. Generally, one would start by having a bill signed by friends until there is no more room on the currency. He would then tape another bill on end and so on. When among a gathering, usually in a bar setting, one could "challenge" another by demanding to see their short snorter within a two minute period. If the opponent produced an unsatisfactory specimen compared to the challenger, he would have to buy him or the entire players involved a round of "shots", usually not a full glass hence the term "Short Snorter". In any case, the one who had the most impressive "snorter" would win. This might include signatures from famous actors, top brass officers or the quantity of bills from various countries. It was imperative to carry the rolled up "snorters" at all times as to not lose in the event of a challenge.

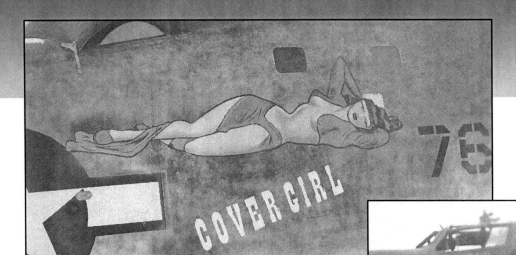

Top: PB4Y-2 **COVER GIRL** BuNo 59760 VPB-116 art by Olsen.

Right: PB4Y-2 **BLUE DIAMOND** BuNo 59396 VPB-106 art by Olsen.

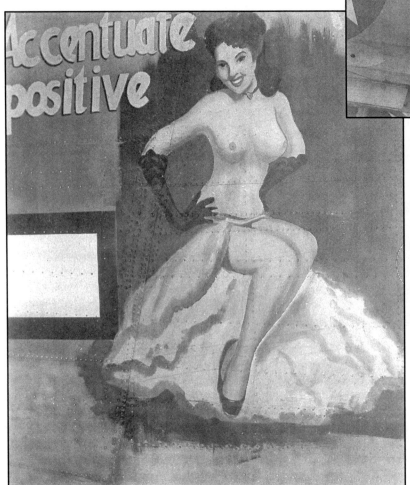

Left: PB4Y-2 **ACCENTUATE THE POSITIVE** BuNo 59441 VPB-108 art by Olsen.

Above: PB4Y-2 **LADY LUCK III** BuNo 59459 VPB-108 art by Olsen.

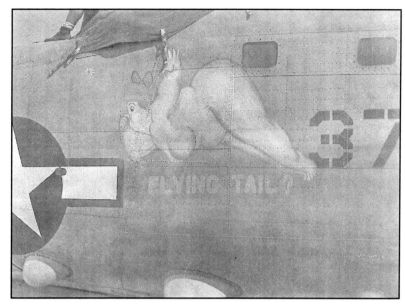

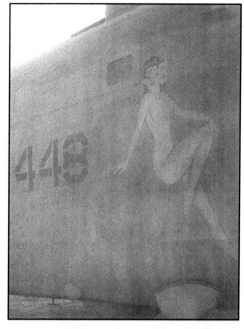

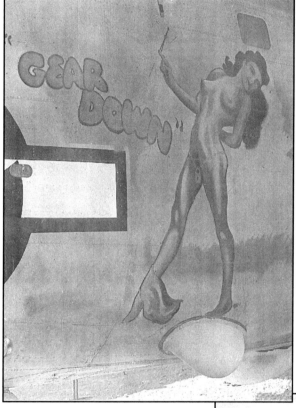

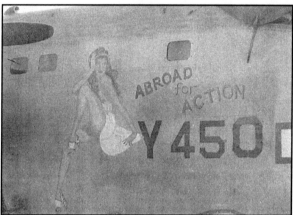

Top left: PB4Y-2 **FLYING TAIL?** BuNo 59379 VPB-118 PPC Lt. Michael Keiser (crew #12), Lt. Henry Thompson (crew #17)

Top right: PB4Y-2 **MADE IN OASIS** BuNo 59448 VPB-118.

Above: PB4Y-2 **ABROAD FOR ACTION** BuNo 59450 VPB-121

Above: PB4Y-2 **GEAR DOWN** VPB-124 PPC Lt. J.E. Ramsey.

Right: PB4Y-2 unknown, all art on this page was done by Hal Olsen.

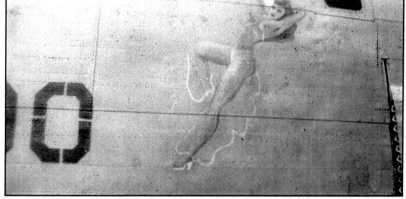

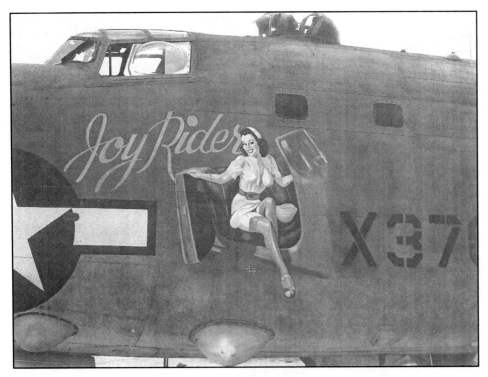

Left: PB4Y-2 **JOY RIDER** BuNo 59370 VPB-106 a shadow was later added to the a/c numbers and the name "Princess Beth" below the cockpit window. An artist other than Olsen did this piece.

Below: PB4Y-2 **REDWING** BuNo 59505 VPB-123 name later changed from **INDIAN MADE.** Olsen did the nose art.

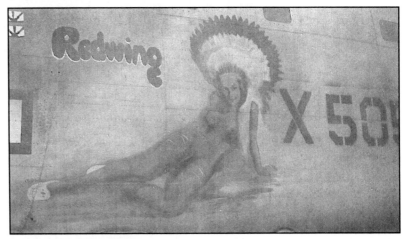

Below left: PB4Y-2 59390 of VPB-106 appears to have had other nose art painted over.

Below right: PB4Y-2 **PIRATE PRINCESS** BuNo 59404 VPB-118 PPC Cdr. K. Harper. This a/c was hit by a stray bomb at Okinawa 28, July 1945.

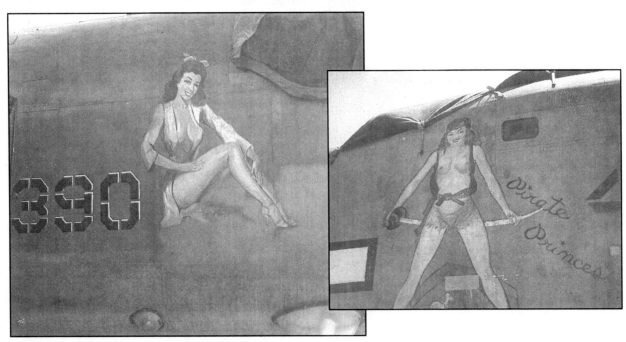

260

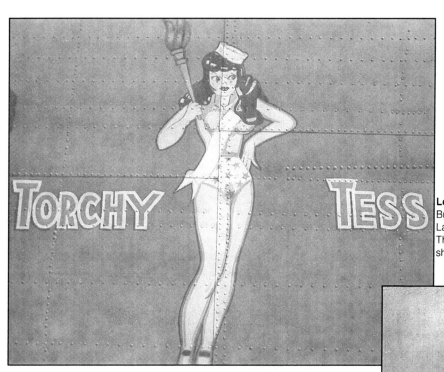

Left: PB4Y-2 **NAVY'S TORCHY TESS** BuNo 59383 VPB-118 PPC Lt. J.A. "Tex" Lasater (crew #3) was lost on 6 May 1945. The lettering is red with a white outline shadowed in black.

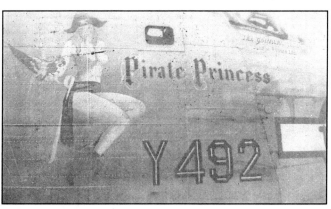

Middle left: PB4Y-2 **PIRATE PRINCESS** BuNo 59492 VPB-121. This a/c hit PB4Y-1 38933 which was parked while landing at Clark Field, Luzon Mar 2, 1945. Both were damaged beyond repair.

Above: PB4Y-2 **LA CHERI** BuNo 59489 VPB-108 Olsen nose art.

Left: PB4Y-2 **COME 'N GET IT** BuNo 59409 VPB-121/118 and VJ-19.

261

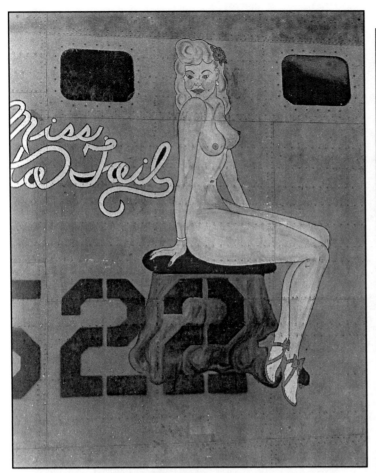
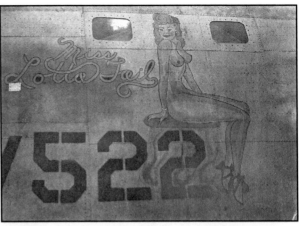
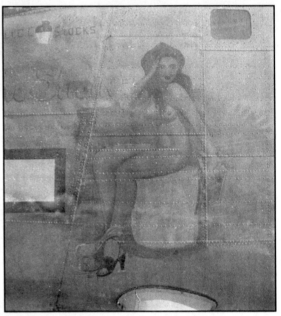
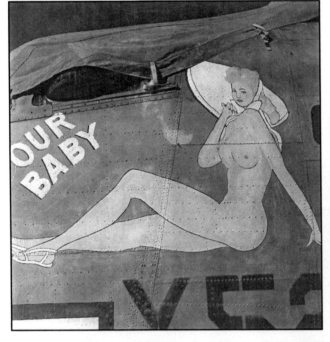
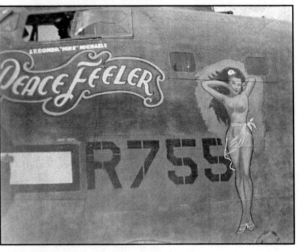

Top left and right: PB4Y-2 **MISS LOTTA TAIL** BuNo 59522 VPB-109 PPC Lt. Joe Jadin (crew #5).

Middle: PB4Y-2 **NO STRAIN** VPB-123 on Okinawa 1945 appears to have been done by Olsen.

Above left: PB4Y-2 **OUR BABY** BuNo 59525 VPB-106 and VPB-121.

Above right: PB4Y-2 **PEACE FEELER** BuNo 59755 VPB-104/VPB-116 PPC Lt. Cdr. "Mike" Michaels.

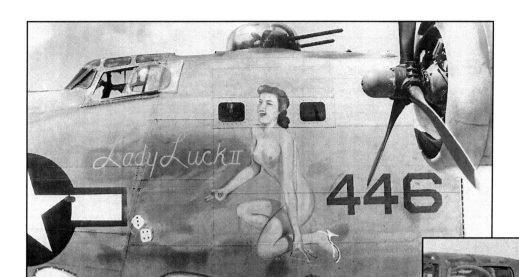

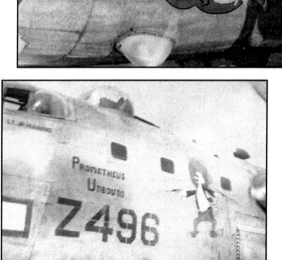

Above: PB4Y-2 **LADY LUCK II** BuNo 59446 VPB-108. Nose art by Olsen.

Right: PB4Y-2 **LUCKY-"LEVEN"** VPB-106.

Middle right: PB4Y-2 **PROMETHEUS UNBOUND** BuNo 59496 PPC Lt. J.R. Hubbard.

Below left: PB4Y-2 **MISS MILOVIN** BuNo 59617 VPB-121.

Below right: PB4Y-2 **LETS MAKE MERRIE** VPB-123.

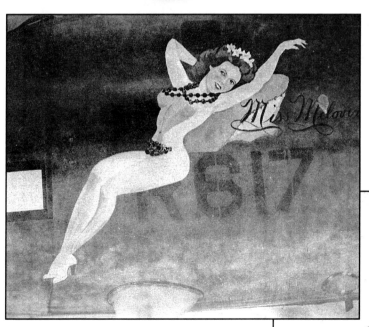

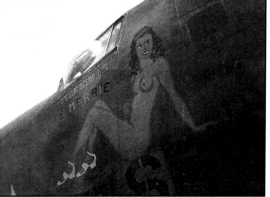

263

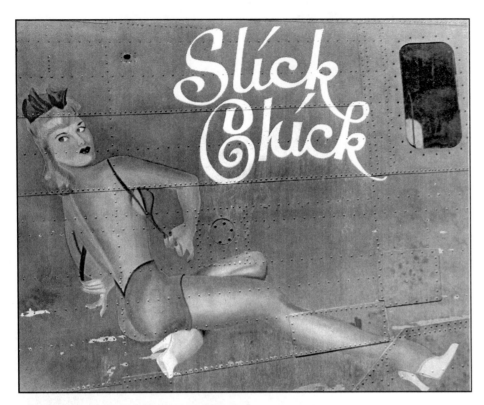

Left: A better shot of PB4Y-1 **SLICK CHICK** from VD-5 and may be the work of Hal Olsen.

Middle left: PB4Y-2 **PISTOL PACKIN' MAMA** BuNo 59562 VPB-121 nose art by Olsen.

Middle right: PB4Y-2 **SLEEPY TIME GAL** BuNo 59605 VPB-123.

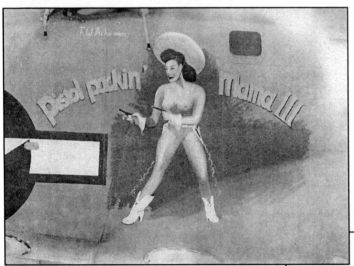

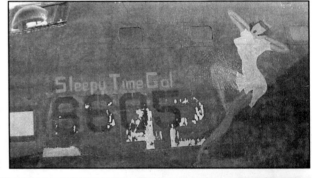

Right: PB4Y-2 **UMBRIAGO/ SLEEPY TIME GAL** BuNo 59390 VPB-105.

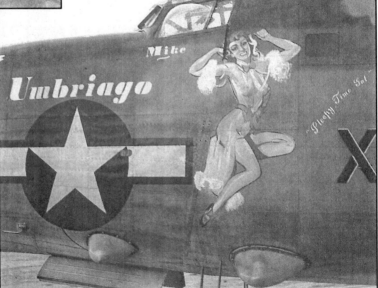

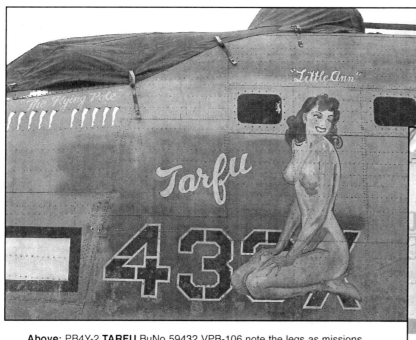

Above: PB4Y-2 **TARFU** BuNo 59432 VPB-106 note the legs as missions.

Right: PB4Y-2 **VAGRANT VIRAGO** BuNo 59487 VPB-109 nose art by Olsen.

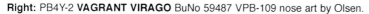

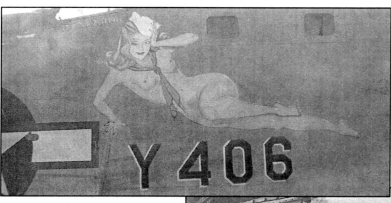

Above: PB4Y-2 BuNo 59406 VPB-121 referred to as **NAVAL BODY** but a photo with the name (if painted) has not yet surfaced.

Right: PB4Y-2 BuNo 59382 VPB-118 with similar art. Returned to the USA

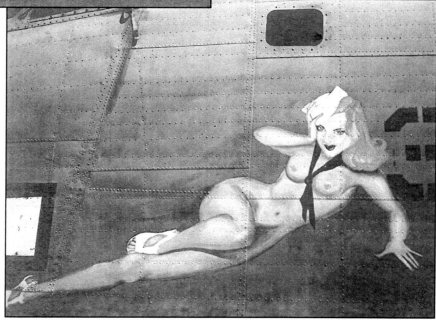

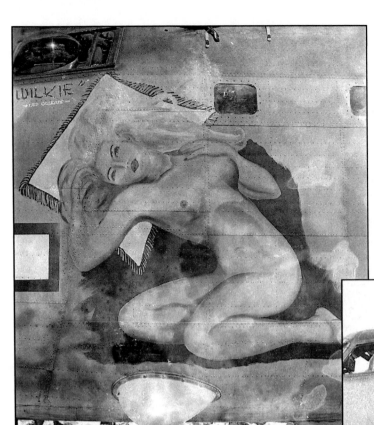

Above: PB4Y-2 **PUNKIE** BuNo 59501 VB/VPB-109 PPC Lt. Hugh Wilkinson (crew #15) nose art by Hal Olsen. The pilot's home town of New Orleans is painted below his nickname "Wilkie".

Above: PB4Y-2 **MISS PANDEMONIUM** VPB-123 nose art by Olsen.

Left: PB4Y-2 **ELS NOTCHO** BuNo 59460 VPB-108 nose art by Olsen.

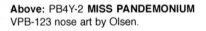

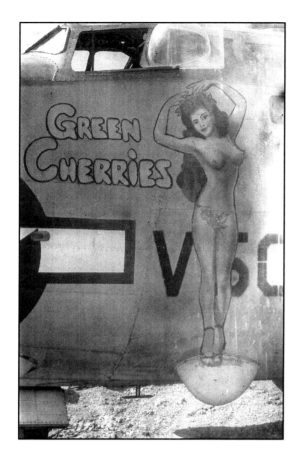

Left: Pb4y-2 **GREEN CHERRIES** buNo 59502 VPB-109 PPC Lt. Thomas Challis (crew #14). Nose art by Olsen.

Below: B-24 **BOUNCIN' BETTE** and her Teddy VJ-19.

Bottom: PB4Y-2 **LOTTA TAYLE** BuNo 59484 VPB-121 may have been painted by Olsen. It is not signed but has all the characteristics of Olsen's work.

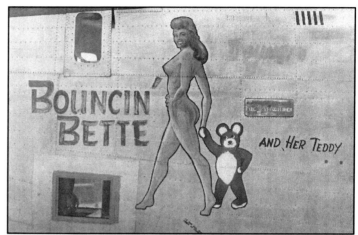

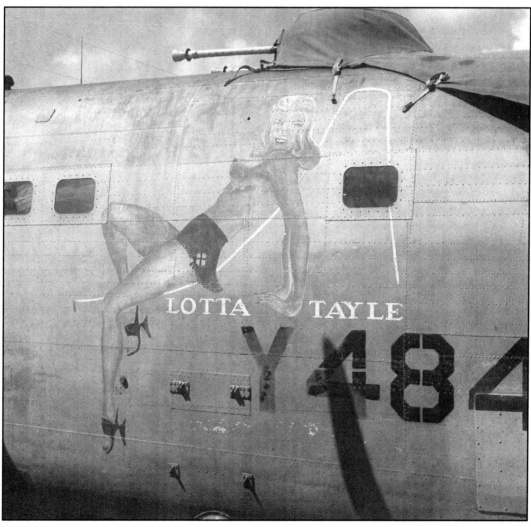

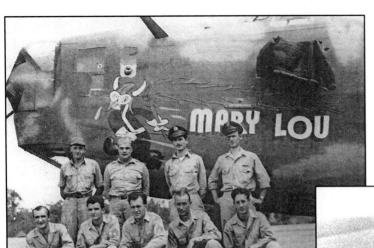

LB-30

F-7

The Panama Canal zone was patrolled and defended by the small lesser known 397th Bomb Squadron, 6th Bomb Group which later became 6th bomber Command. The Army Air Corps requisitioned 75 LB-30s from RAF production. Of these, 46 saw active service, 26 were returned to the RAF and six were lost due to accidents.

Photo variants of the B-24 were designated as F-7s which carried six cameras, three in the nose and three in the bomb bay. F-7A /B conversions totaled 214 aircraft and operated in the pacific campaigns.

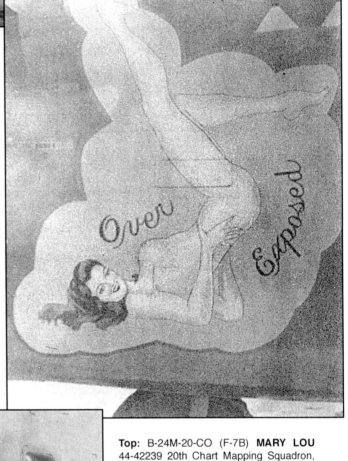

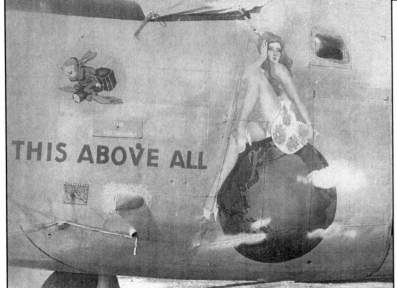

Top: B-24M-20-CO (F-7B) **MARY LOU** 44-42239 20th Chart Mapping Squadron, 6th Photo Recon.

Middle: B-24J-10-CF (F-7A) **OVER EXPOSED** 42-64331 2PMS.

Left: B-24J-155-CO (F-7) **THIS ABOVE ALL** 44-40316 4PCS.

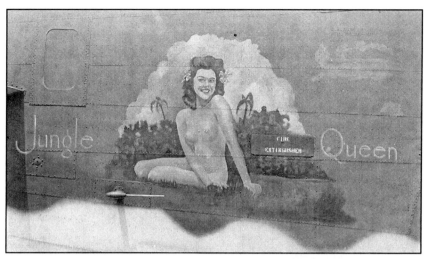

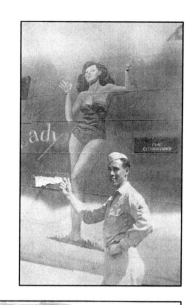

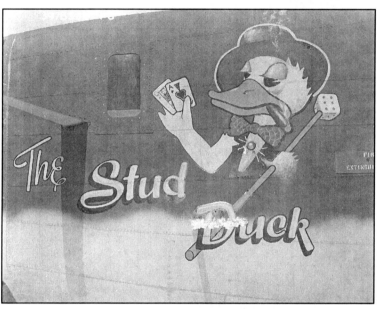

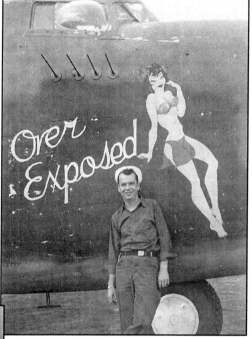

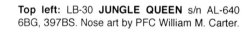

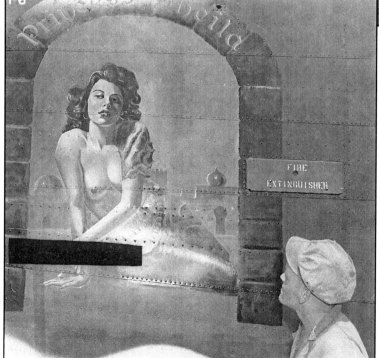

Top left: LB-30 **JUNGLE QUEEN** s/n AL-640 6BG, 397BS. Nose art by PFC William M. Carter.

Top right: LB-30 **TIGER LADY** s/n AL-641 6BG, 397BS. Art on both sides.

Middle left: LB-30 **THE STUD DUCK** s/n AL-634 (B-24 42-40372) 6BG, 397BS

Middle right: B-24J-5-CO (F-7A) **OVER EXPOSED** 42-73020 2PC.

Left: LB-30 **PRINCESS SHEILA** s/n AL-640 6BG, 397BS nose art by PFC William M. Carter. Note the censored antenna array.

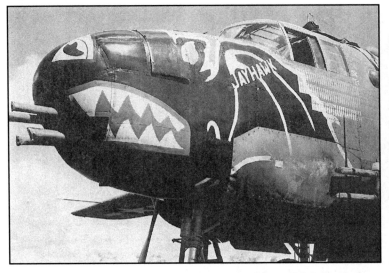

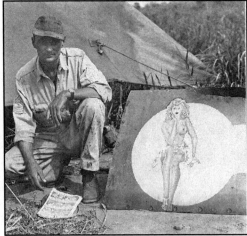

Above: B-25D-5 **JAYHAWK** 41-30014 345BG, 499BS flown by Capt George Cooper and completed 121 missions with two Japanese a/c downed. The bat is painted black with a red mouth

Right: B-25D-1 **QUITCH** 41-30518 345BG, 501BS flown by 1/Lt. Milford H. Symens.

Top right: A sergeant displays his finished panel art work.

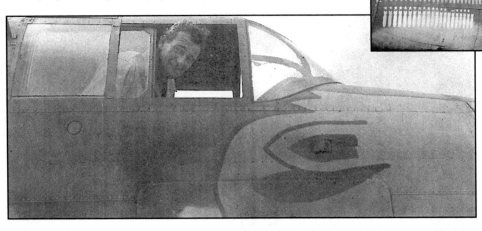

Above: B-25G from the 38BG, 823BS. John Wayne pokes his head out before a demo flight during his visit with Miss Montana on January 1945.

Right: B-25 **GRUMPY** from the 38BG, 823BS.

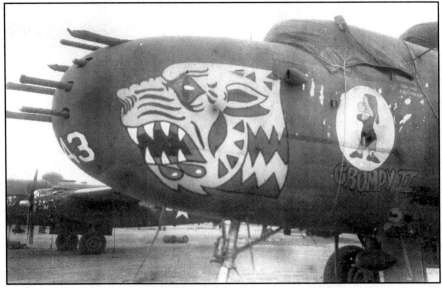

270

Right: B-25C-1 **DIRTY DORA** 41-12971 345BG, 499BS was transferred from the 38BG. The pilot was Capt. Vic Tatelman. The wings were a medium blue outlined in white, red mouth and ears. The bomb missions markings are yellow.

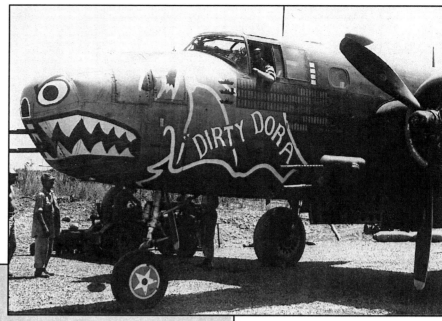

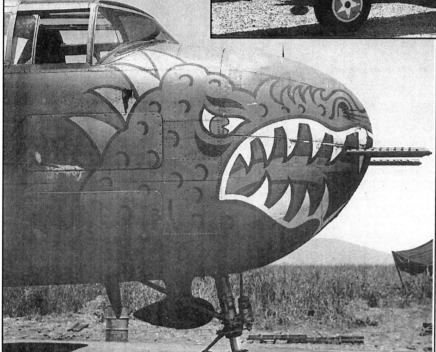

Left: A B-25 from the 38BG, 405BS.

Below left: B-25J **LADY LIL** 345BG, 498BS. The parrot head appears to have been re-painted cutting off part of the pin-up and name.

Below right: The left side a 405th BS B-25.

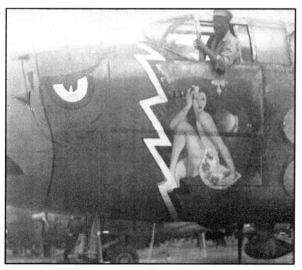

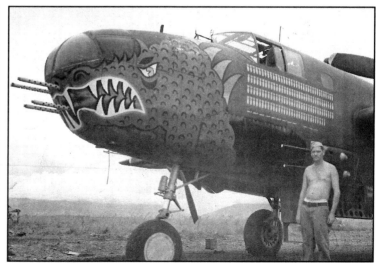

271

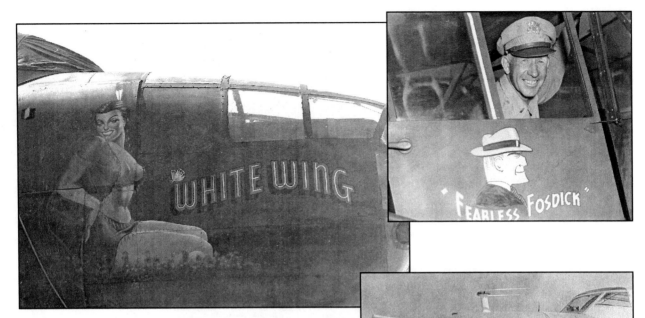

Above left: B-25J-10-NC **WHITE WING** 43-36172 345BG, 501BS.

Above right: An L-4 nose art that bears a resemblance to the Lieutenant.

Right: B-25J-1-NC Workin' for the **YANKEE DOLLAR** at Sydney Island Air Base.

Below: B-25D-10 **HELL'S FIRE** 41-30278 345BG, 500BS flown by 2Lt. Allan W. Lay. On its last mission while circling and protecting another downed ship, this a/c was attacked and shot down by two Japanese fighters. **HELL'S FIRE** crashed into the base of Mt. Tongkoko. All were lost.

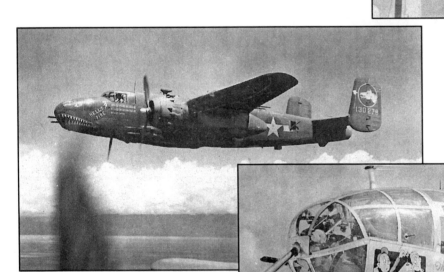

Right: B-25J-1-NC **THE INK SQUIRTS** at Sydney Island Air Base.

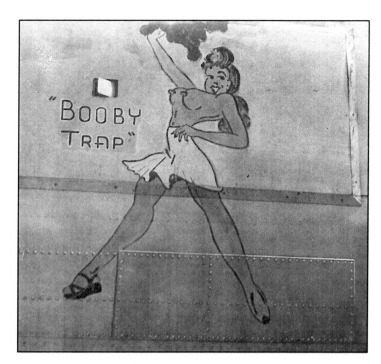

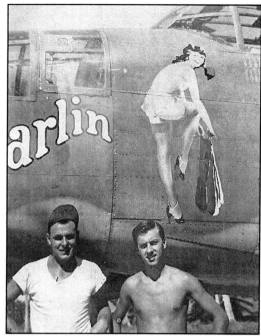

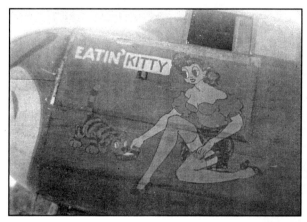

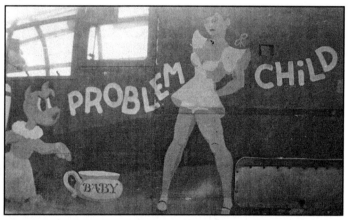

Top left: B-25 **BOOBY TRAP**.

Top right: **DARLIN** 42BG, 75BS.

Middle left: B-25 **EATIN' KITTY** 12BG, 82BS.

Middle right: B-25 **PROBLEM CHILD** 12BG, 82BS.

Right: B-25 **FAT CAT** 3rd Attack Group 5AF was built from three different wrecked air frames and did not carry an ID. The welded bomb-bay doors and stripped down B-25 was used for R & R runs between New Guinea and Australia. The primary pilot was John "Jock" Henebry. The art appeared on both sides.

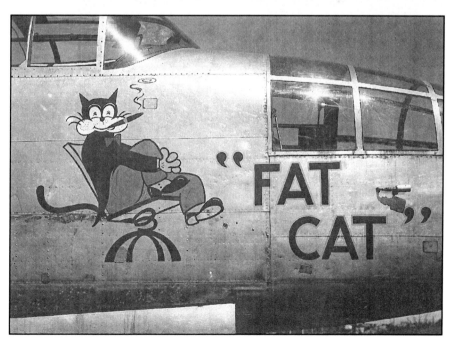

273

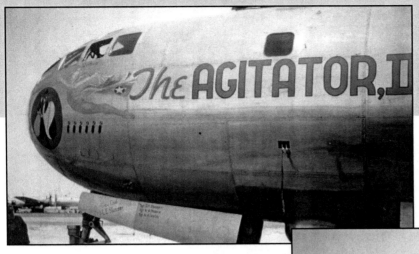

Above: B-29 **THE AGITATOR II** 42-24899 444BG, 678BS reclaimed on 11 August 1950. *C. Harper*

Right: B-29 **BATCHELOR QUARTERS** 42-24507 444BG, 678BS. A pin-up was later added to the nose and moved the mission marks below the name. Three confirmed Japanese planes shot down. Reclaimed 4 April 1949. *Charles Harper*

Below: B-29-16-BA **BLACK JACK TOO** 42-63451 444BG, 678BS flown by 1/Lt. Woodrow B. Palmer. Shot down 5 June 1945 on a mission to Kobe, Japan.
Charles Harper

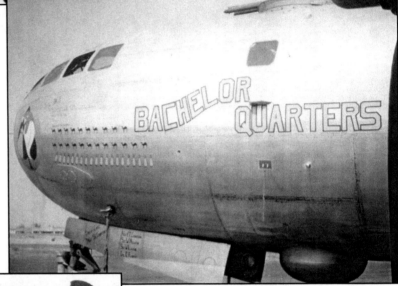

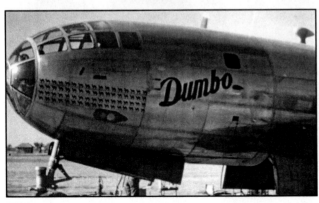

Below left: B-29 **DUMBO** 42-6257 42-6257 444BG, 678BS. *Charles Harper*

Below right: B-29 **BLACK JACK** 42-6292 444BG, 678BS. *Charles Harper*

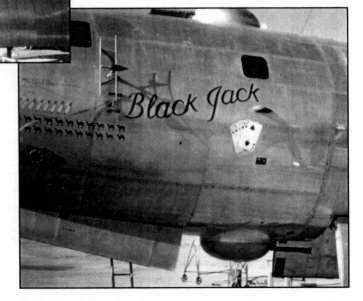

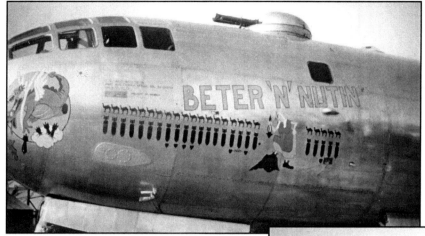

Top: B-29 **BETER 'N' NUTIN'** 42-24538 444BG, 676BS. *Charles Harper.*

Right: B-29 **BIG POISON** Second Dose 42-65270 444BG, 677BS flown by 'Shorty' Arnoult. Lost over Osaka 1 June 1945. *Charles Harper.*

Below: B-29 **FU-KEMAL** 42-6352 444BG, 676BS. *Charles Harper.*

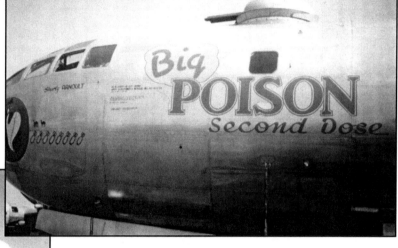

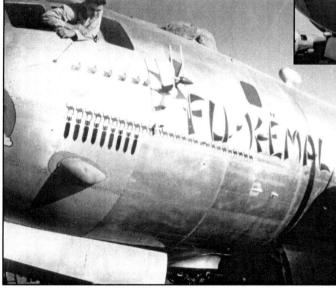

Below left: B-29 **LASSIE TOO** 42-93894 462BG, 768BS.

Below right: B-29 **LI'L HERBERT** 444BG, 679BS. *Charles Harper.*

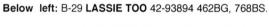

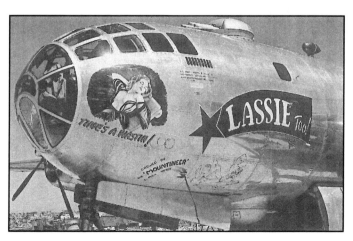

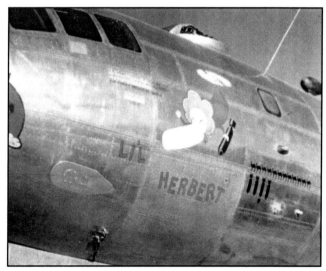

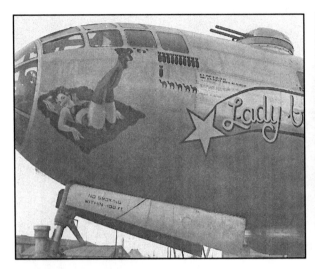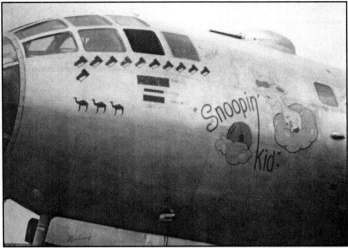

Top left: B-29 **LADY BE GOOD** 42-65227468BG, 792BS.

Top right: B-29 (F-13) **SNOOPIN' KID**. Photo Recon. *Charles Harper.*

Below: B-29 **MONSOON GOON** 42-93828 468BG, 794BS. Reclaimed 20 November 1948. *Charles Harper.*

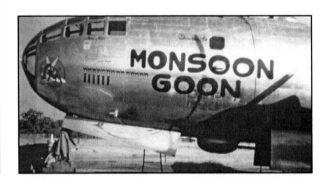

Above left: B-29 (F-13) **SHUTTER BUG** 42-93864 Photo Recon. *Charles Harper.*

Below: B-29 **LES'S BEST** 42-93900 3rd PRC flown by Lt. Les Langhans, Jr.

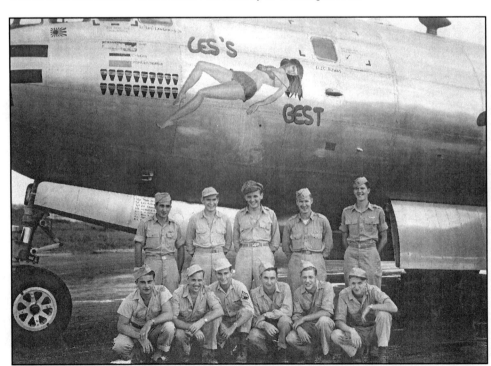

276

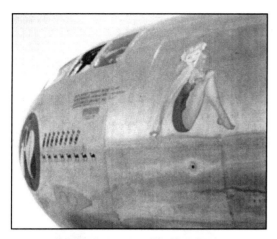
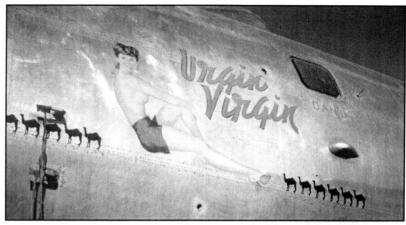

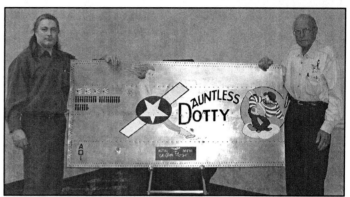

The author and Col. Morgan display a recreation of Morgan's '**DOTTY**' painted on actual B-29 skin. This is part of a series of panels that will tour museums as a traveling exhibit.

Top left: An unnamed B-29 42-63446 from the 444BG, 678BS. *Charles Harper.*

Top right: B-29 **URGIN' VIRGIN** 42-6423 444BG, 676BS. *Charles Harper..*

Middle left: The 1935 pin-up that served as the reference for Robert Morgan's B-29 **DAUNTLESS DOTTY's** nose art, although modified.

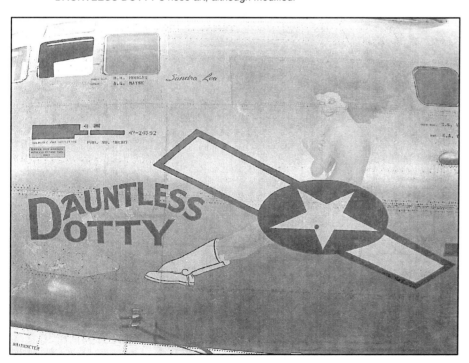

B-29 **DAUNTLESS DOTTY** 42-24592 497BG, 869BS, 73BW flown by Robert K. Morgan. After having toured the country with the B-17 **MEMPHIS BELLE**, Morgan took on another tour of duty in the pacific. Having led the first fire raids in Tokyo, the crew of **DAUNTLESS DOTTY** was credited with 26 missions flown and shot down four Japanese fighters. The B-29's last flight flown by another pilot and crew, it crashed on take-off from Kwajalein on 6 June 1945. The art appeared on both sides.

At this time of publication, the '**DOTTY**' has been located and an ongoing process is underway to recover the B-29.

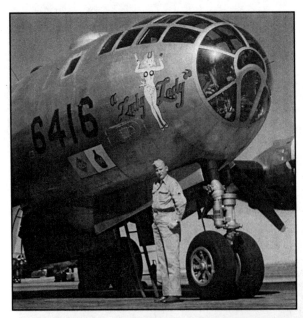

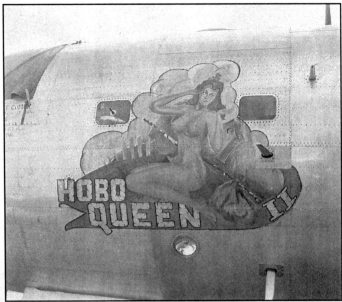

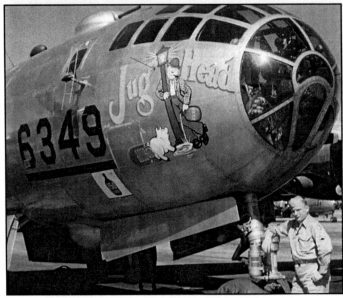

Top left: B-29 **LUCKY LADY** aka **MISS SHORTY** (left side) 42-65272 468BG, 793BS Reclaimed 16 August 1954. The 'Lucky' character also appeared on the left side.

Top right: B-32-CF **HOBO QUEEN II** 312BG, 386BS, 314BW.

Middle left: B-29 **JUG HEAD**.

Middle right: C-74 **GLOBEMASTER THE ROC III** 42-65409. This a/c retired from the USAF in 1956 and later appeared in the 1969 film "The Italian Job" starring Michael Caine. The C-74 was purchased by the Civil Aviation Airlines Corp. and painted in fictitious communist Chinese markings.

Right: B-25 being painted with a unit insignia from the Korean war era.

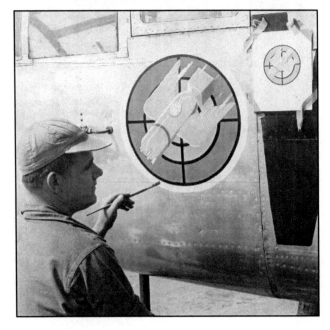

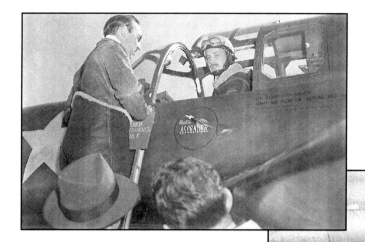

Left: A Curtis XP55 #2 **ASCENDER** being greeted by the press as pilot Bob Fausel poses for photos on 18 February 1944.

Below: P-59B **AIRACOMET RELUCTANT ROBOT** 44-22633 was used as drone directors. The overall color was International Orange. Currently this a/c sits on a pole next to the Edwards AFB Library.

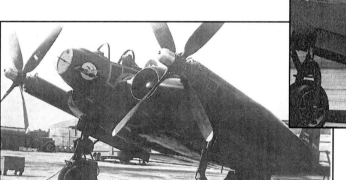

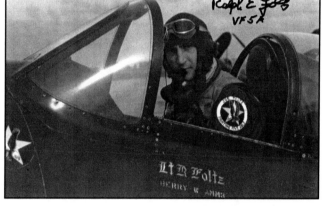

Middle: **CHANCE VOUGHT** XF5U-1 BuNo 33958 nicknamed 'Flying Flapjack' because of its shape was one of two prototypes. The nose art depicts Bugs Bunny riding a flying carpet.

Right: F4U-4 of Lt. Ralph Holtz VF-5A, served as Squadron Photo Officer and flew 49 combat missions in Korea from the USS Boxer. The insignia just forward of the wind screen may be a decal.

Below: F-94 **STARFIRE** from the 144 FIS 11AF. The a/c crew chief pictured is S/Sgt. Robert D. Oliver at Elmendorf AFB, Alaska. *Jeff Lester.*

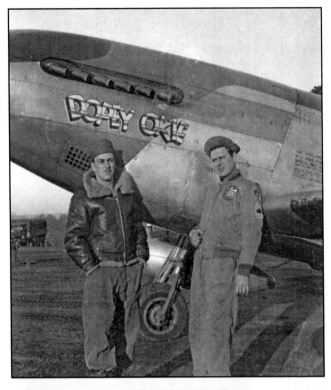

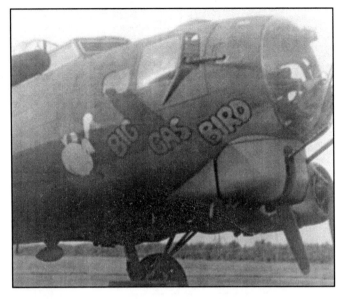

Top left: P-51D **DOPEY OKIE** 44-14955 352FG, 487FS flown by Karl K. Dittmer and was credited with downing an Me-109. *Karl Dittmer via Darrell Crosby.*

Top right: B-17G **BIG GAS BIRD** 42-31638 385BG, 548BS also flown by Dittmer. *Karl Dittmer via Darrell Crosby.*

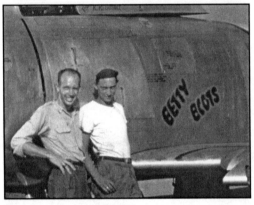

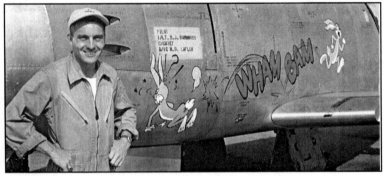

Middle left: F-86 **BETTY BOOTS** 335FIS, 4th FW flown by Karl Dittmer and credited with three MiG kills, two on one mission. Dittmer did several nose art designs in his squadron. His F-86 was named after his wife Betty. *Karl Dittmer via Darrell Crosby.*

Middle right: F-86 **WHAM BAM** 335FIS flown by Lt. Martin Bambrick and painted by Dittmer. *Karl Dittmer via Darrell Crosby.*

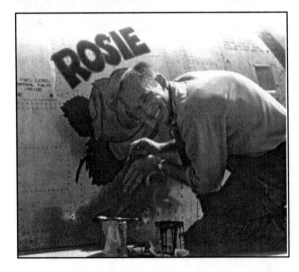

Left: Karl Dittmer glances over while he works on finishing Capt. Troy G. Cope's F-86 **ROSIE**. *Karl Dittmer via Darrell Crosby.*

Dittmer first flew B-17s in his first combat tour and after ferried B-24s to England. In the interim Dittmer managed to convince the CO in the 352FG to let him fly P-51s in the group. After the war he became a trim carpenter.

In Korea, Dittmer only had eight flights prior to going into combat and credits the F-86's ease of handling for learning to fly the Sabre.

Dittmer passed in 2003 and his two sons continued in his father's foot steps and flew in Desert Storm.

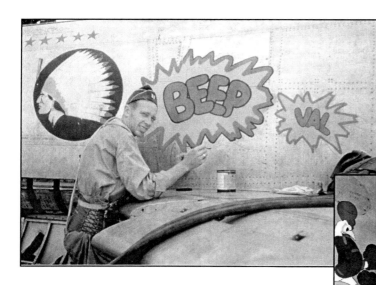

Left: Dittmer at work on Lt. John Nolli's F-86 **BEEP VAL**. *Karl Dittmer via Darrell Crosby.*

Below: S/Sgt. Sidney C. Parry demonstrates the fighting spirit of the 67th Squadron to Col. Frank Perego, CO, 18th FBW.

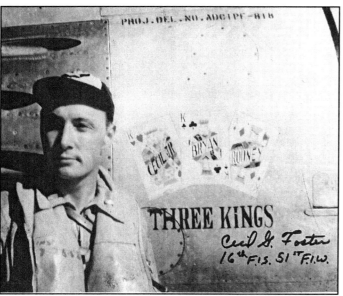

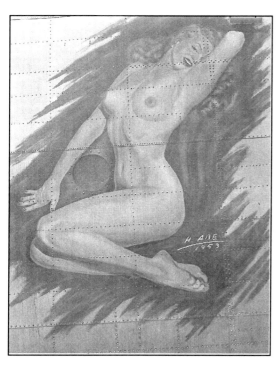

Left: F-86 **THREE KINGS** 16FIS, 51FIW flown by Cecil G. Foster.

Bottom left: C-119 with nose art in the likeness of Marylin Monroe.

Bottom right: A C-119 with an advertisement message name being applied along with its name **KAY'S KARAVAN**.

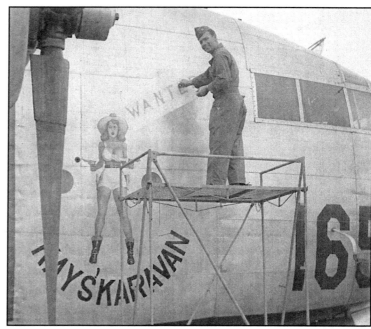

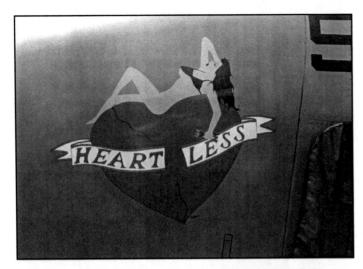

Top left: HEARTLESS is a rare example of modern day nose art on an A-6E Intruder. Usually Navy/Marine aircraft were devoid of such nose art and personal markings.

Top right: F-18 Hornet tail of VFA-87 aboard the USS Theodore Roosevelt.

Middle: Two examples of USAF F-4 Phantom tail art which was restricted to unit and squadron insignias.

Below left and right: Landing gear doors and other access doors were permitted to have "censored" art.

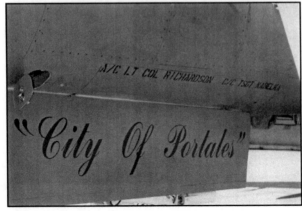

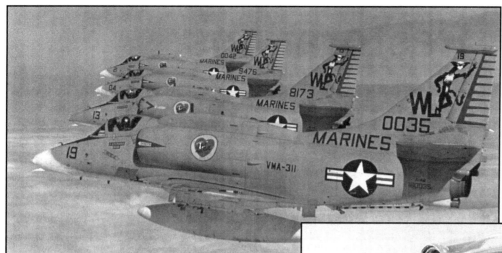

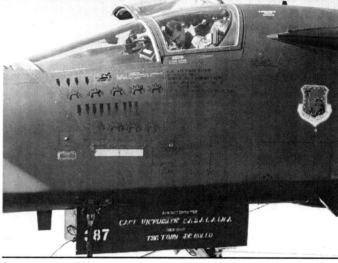

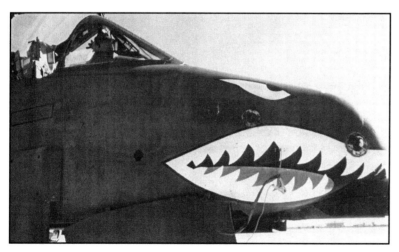

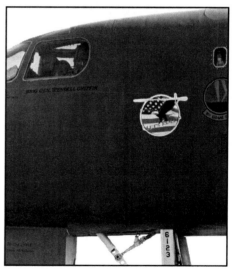

Top: A-4M Skyhawk's of VMA- 311 in formation adorning the cat themed insignia on the fuselage and tail fin. USAF

Middle left: The official nose art design created by Senior Airman Duane White, a journeyman from Air Combat Command's multimedia center at Langley AFB, VA. In honor of 911 and passenger on flight 93 and Todd Beamer's last words.

A-10 Warthog of the 23FIS displaying its score in red stars next to the red profiled enemy vehicles.

Middle right: F-111F of Capt. Vic "Finster" Casalaina prepares for flight. This F-111 has combat sorties from Operation Desert Storm recorded on its nose.

Above: B-1B 86-0123 6th Bomb Squadron being checked for pre-flight by Brig. Gen. Wendell Griffin at Dyess AFB during Operation Iraqi Freedom in 2003. It displays the **"LET'S ROLL"** decal. USAF

Restorations

In this chapter I will discuss the process of how to apply nose art to restored warbirds in the traditional manner. The gloss showcase modern graphically "perfect" look is done with masking and friskets, much like airbrushing on illustration board. It is time consuming and the finished product, in my opinion, looks too good. Given the time, resources and finances involved put into these privately owned flyable antiques, I can understand the practical choice since the objective is for the airframe to last as long as possible in its "new" state. An overall top coat of clear IMRON lacquer or enamel seals the paint job and provides easy cleaning maintenance.

I am a stickler for detail when it comes to authenticity. The restored vintage warbirds in today's air shows never looked as good in WWII, proved by the photos in this volume, and that is exactly why I get called by commission to do a "traditional job" using brushes from start-to -finish. There is a certain quality and feel to the completed design that projects a human touch. I will admit that not all nose art was aesthetically pleasing from a design aspect and when I recreate a panel design for a customer, it is decided whether or not to re-create the original rendering versus embellishing the design for a more pleasing and attractive result. An example of this is evident when I did the Collings Foundation B-25 TONDELAYO project. The original pin-up does not look quite as nice as the restored version. It was a mutual agreement to enhance the pin-up slightly and give it more depth by blending the flesh tones for 3-D appearance as opposed to a 2-D flat monochromatic, almost cartoonish look.

Research

The first thing to do when a subject design has been chosen is to research all possible records of the aircraft. A lot of hours have been spent researching all available information regarding the plane, pilot, group, squadron and even the artists. Unfortunately, most original veterans are now gone or time has vailed the details forever. Cross-referencing is also important because sometimes there may be inconsistencies in the information from one source to another. I never rely on illustrations because you never know how much research went into it. The internet is a great source for information, a virtual world-class library at your fingertips. Photo images are the best key for reference, but are not always available. This brings us to the next step in the research.

Photos: Black & White = Color

Now that several black and white photos have been found on the plane and at least one good one of these is nose art, there still lies an important question. What are the colors? If you found a color photo, great, but it is rare that a color photo exists of your subject. Yes, there are a considerable amount of color photos of nose art out there, but take into consideration that of the hundreds of thousands of aircraft WWII produced, not even one percent of these may have been photographed in the new color film technology.

To make matters worse, there were two types of b/w film in use at that time, Panchromatic and Orthochromatic.

Orthochromatic film has a very low sensitivity to light in the visible red portion of the spectrum and will render red as a very dark shade. This film is also sensitive to green and blue light. Panchromatic film is more natural and records all colors in their proper tone relationships, giving them, in black and white, the same relative brightness which the eye assigns them. A K2 yellow filter was a common addition to the camera when using this film type.

A good example of the two film types in comparison is of the 308th BG SACK TIME in this volume. Keep this in mind when reviewing the photos. It is not easy, but if there is a color photo of the same subject, it will make sense. Seasoned artists would likely comprehend this analogy because of experience in mixing colors and how to achieve them.

If that were not enough, the plane's paint may have already faded prior to being photographed and the lighting may not have been right. Was there a filter used? Was it over or under exposed? How about the developing? Were the correct chemicals used or did Corporal Snafu dilute the formulas? If your reference photos were published in a book like the one in your hands, it was definitely manipulated.

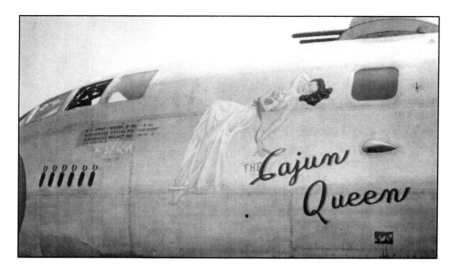

B-29 **THE CAJUN QUEEN** 42-63557 444BG, 678BS, 58BW. There were 5 versions of this a/c utilizing the same pin-up, later having the undersides painted black. *Charles Harper*

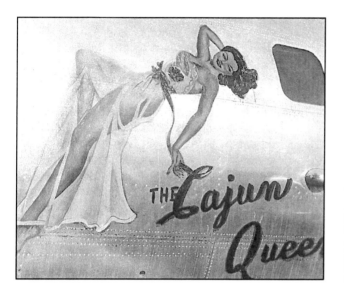

In the photo above, Orthochromatic film illustrates the red tones in the bow and flower very dark. The bow turns into yellow lettering shadow which also appears somewhat dark. The flesh tones are pronounced by red and brown pigments in the paint.

Here is Panchromatic film rendering the colors in various medium shades. Notice that the red bow and flower are similar in tone to the light blue bra. Also note the dark blue squadron insignia in the color photo compounded by shaded light.

Paints and Brushes

There are so many quality products nowadays to choose from. The way I see it is that nose art is a derivative from the advertising sign trade. The best nose artists were usually in that business prior to enlisting or drafted in the service and always had their brushes with them. This trade today is a dying art form given way to air brushing and computer graphics. The result is often a perfect illustration that lacks a human feel. That may be fine in a modern computer age but for a traditional look, brushes and actual paint are the only way to go.

Finding these supplies is not as simple as going down to the art store and picking them up. The sign painting trade has their own types of brushes and paints. To begin with, the brushes that sign painters use have longer bristles that serve two purposes. Longer bristles allow you to create straighter lines for lettering and they hold more paint that the conventional brush. These are generally called Quills and the best type of quills are hand-made from squirrel hair. For pin-ups and other types of elements where blending is needed other than lettering, a good quality sable brush is employed. Size of these brushes vary depending on the scale of the work. It is a good rule-of-thumb to start with a smaller brush and work your way up to one that suits you better to accomplish the task. If you

start with a larger one for the job, you will find out by having a heavy hand and re-doing it because it wasn't right. I know because I've done this.

If you want traditional, then you must use the paint type of the era. Well, because of environmental and health reasons, lead paint is all but done away with. The only leaded paint available is strictly used for marine and fortunately, sign painting. Problem is, you have to special order it or find a specialized art store that caters to the small but elite industry. Same goes for the lettering brushes. You can use oil based enamels, but you will not get the quality and leveling performance as you would from a leaded product.

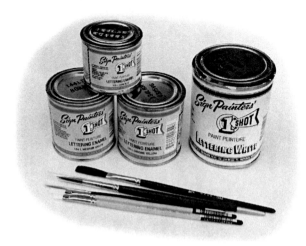

Collings Foundation
B-25 TONDELAYO 345th Bomb Group, 500th Bomb Squadron

This project was one of the most elaborate I've done in terms of elements, colors and names. When discussing the project with the client, it was agreed that enhancing the pin-up would add to the colorful appearance. There were several decent original photos I had of this a/c plus other published photos that I used as reference. The pin-up was supposed to be in the likeness of Hollywood's sultry film actress Hedy Lamar from the movie White Cargo. The pin-up that the artist used as reference to paint the original B-25D was the Esquire June 1943 calendar. Logically, I used it also. The reference photos show the a/c nose art at various stages implying that the art work was painted at least twice. The name also underwent a slight transformation. A black background was later added to the Japanese flags scoreboard.

A climate controlled hangar could not be secured and I had to do this project outside in weather reaching over 100 degrees. Though experiencing the extreme heat much like the original group did in the South Pacific,

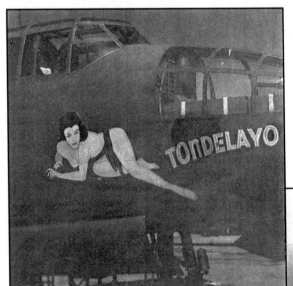

the finish of the nose art was affected by this in a way that the paints dried unevenly causing drag and wrinkling in some areas. This is typical in these conditions and was a constant battle to control using retardant. These imperfections are not visible in the photos and most nose art of the period would have had the same results. The painting was done in August 2002 appearing for the WINGS OF FREEDOM air show in Frederick, MD.

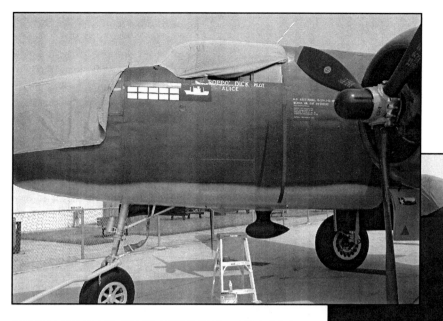

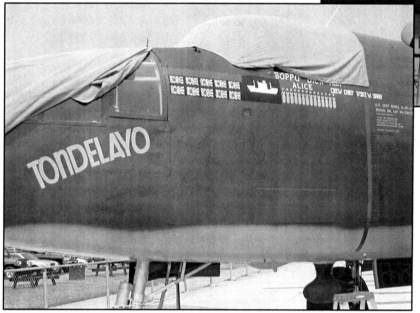

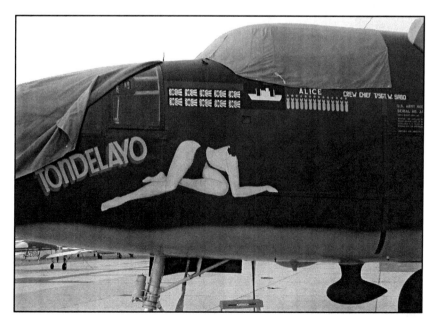

Top: Day 1 - After plotting where the elements would go according to the original, I decided to begin with the scoreboard and secondary names. This would help in later positioning the pin-up. Templates were made for the flags and bombs.

Middle: The red coloring in the japanese flags are completed as are the bombs and all the smaller names. I positioned and masked off the main title name. Using an alcohol-based marker, I then sketched in the name and roughed out the pin-up.

Above: Day 2 - The right side name was also measured, marked and painted in yellow.

Left: The red shadow was painted in on the title name and work begun on the pin-up, beginning with the feet and then the largest part on the pin-up, the right thigh and leg. As a rule, I paint background to foreground. This cleans up on the lines. This took up a good part of Day 3.

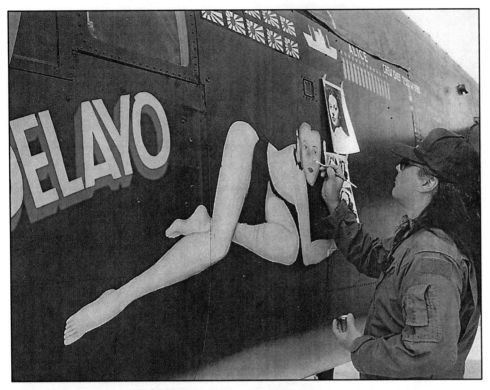

Left: Day 4 - Work Begins on the face. Six different photos of Hedy Lamar's face were used to come up with a likeness similar to the final rendition seen on the original **TONDELAYO**.

Below left: Detailing the eyes and face using a combination of all references. I broke-down the pin-up into several sections which proved to work nicely. Keeping a wet-edge was again difficult given the extreme heat. Note my sun burnt hands and face. I bugged the line men often and daily for them to position the plane out of direct sunlight for me. Still, the paint dried in minutes after applying.

At times I could not even touch the skin of the a/c. That is HOT. The right side of the pin-up was begun after carefully making a tracing of the left side and reversing the image. The B-25 was parked in front of the airport restaraunt where patrons got to see the work in progress albeit in air conditioning. They must have thought I was nuts working in the high temperatures in my nomex flight suit. This created a buzz among the locals and received some media press and these three photos appeared in the Frederick Post.

Below: The finished job - Cheese! Note the strategically posed shot censoring the photo for newsprint.

Day 5 - Completed the pin-up on the right side.
Skip Lawrence Frederick News-Post

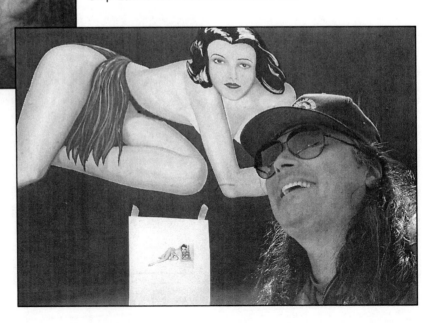

288

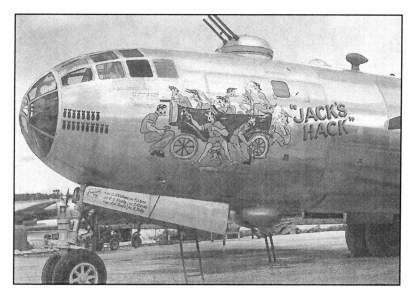

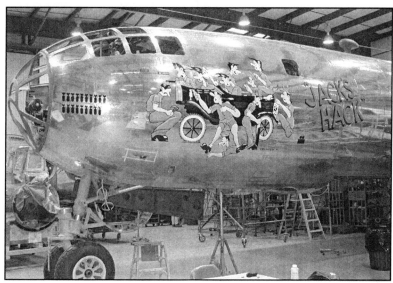

New England Air Museum
B-29 "JACK'S HACK" 468th Bomb Group, 794th Bomb Squadron, 58th Bomb Wing(VH)

Home of the 58th Bomb Wing, the NEAM is headed by director Mike Special and project coordinator Col. Dennis Savage, Ret., overlooked the massive task of restoring s/n 44-61975 to static display. I was commissioned to paint the nose art near the completion of the B-29, but the name and or nose art was not yet chosen and time was running out since I was involved in re-locating to Virginia from my native state of Connecticut. It was narrowed down to two choices, JACK'S HACK or FIRE BELLE. Finally word came to do JACK'S HACK for its political correctness and appeal to the younger generation. Another factor was that seven out of the eleven crew members were still alive to be reunited with the a/c.

At the time only one color photo and a grainy b/w photo were available for reference. The photo above was acquired a year after the completion of the work. The original JACK'S HACK s/n 44-61566 was piloted by Jack Volkert and flew 20 missions, including the last mission of WW II on 14 August 1945. The last flight of JACK'S HACK was on 9 July 1947, when it was transferred to Peyote AAF, Texas for storage and remained there until 15 September 1953, where it was scrapped.

The NEAM acquired B-29 44-61975 in 1973 from the US Army Proving Ground in Aberdeen, Maryland. The aft fuselage was badly damage and a deal was made to use the aft fuselage from 44-61739. Once in Connecticut, a fatal rare tornado nearly destroyed the B-29. After sitting for 20 years exposed to the elements, a restoration campaign had begun. Funds from a state grant helped restore the B-29 as it is seen today.

Day 1 - Using an alcohol based marker, I sketched a rough design carefully correcting the placements of all the characters along the way. This process took about three hours. Once this was done, I began on the name, painting it in red.

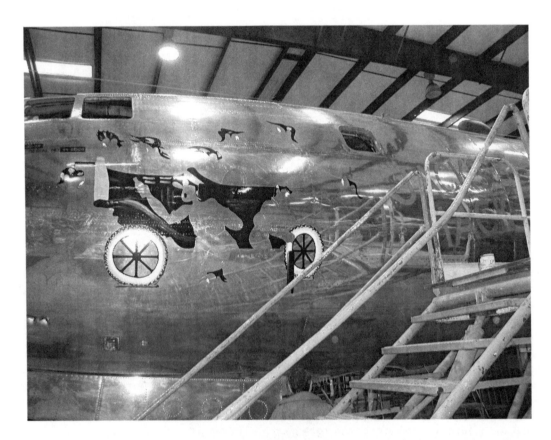

After the name, I continued to do the "Jalopy", staying with the black and white colors. The bombs were also painted using a template. I threw in the radiator before calling it a day.

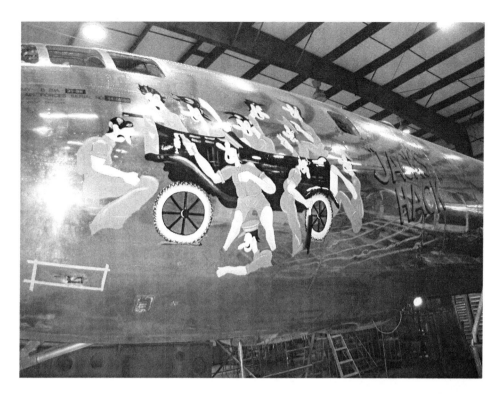

Day 2 - The black shadowing in the name was done next. I mixed up a batch of Khaki color for the uniformed characters.

Day 3 - I continued with the characters and did the flesh tones and detailed the "jalopy".

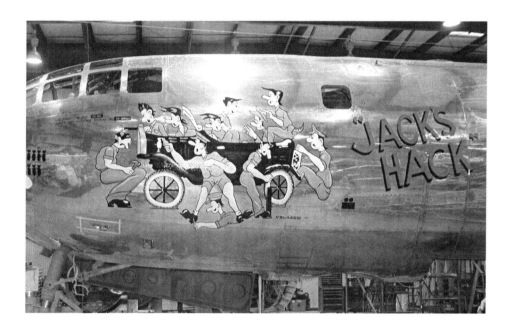

Day 4 - Finished up on the detailing and began lining the characters in black. This process made the whole design "pop".

The restoration team were made up of retiree's from Pratt & Whitney, Hamilton Standard and vets who maintained the B-29 while in service. These were a finest bunch of people I've had the pleasure of working with on a restoration project and made my job less stressful.

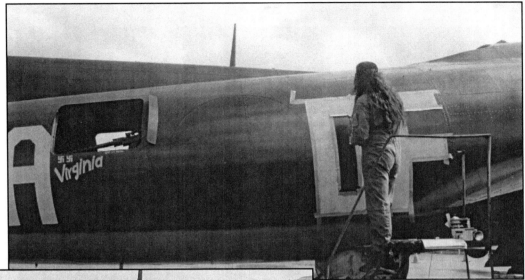

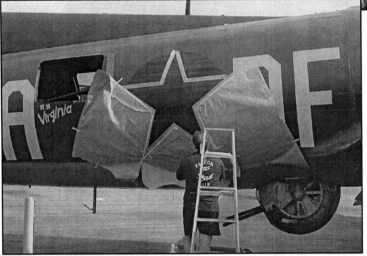

Above: Day 1 - Utilizing a cherry picker, I did the tail serial numbers in yellow. Counting rivets and using photos as reference, I taped the fuselage codes in their historically accurate positions. I first painted the name Virginia and swastikas. The coded letters were applied with a 3" brush. The paint leveled out nicely. The blue circles for the early national insignia was masked and painted in IMRON. There are four all together, top left main wing, lower right wing and both sides of the fuselage.

Left: Day 2 - The star was plotted using a numerical formula and sprayed with white IMRON by assistant Mark Scott. Luckily, the wind was to a minimum for this!

Right: Day 3 - Left side fuselage codes added with the name Sally and another two swastikas.

David Tallichet
B-17 MEMPHIS BELLE 91st Bomb
Group, 324th Bomb Squadron

Perhaps the most famous B-17 of the 8th AF is the MEMPHIS BELLE. I met the owner of this a/c David Tallichet in 1998 at an air show I was involved in CT. He was impressed by my work and was in need of a paint job for his B-17, which still had its Hollywood "BELLE" markings that appeared in the 1991 movie MEMPHIS BELLE. After negotiations, I was contracted for the

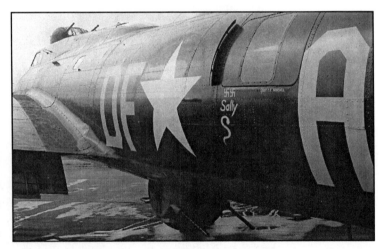

markings only and the pin-up nose art was done by fellow artist Ron Kaplan, who simply out bid me for this and did an excellent job with the art.

I wanted to do the dark green camo spotting to complete the authentic scheme but it somehow never got done due to logistics. Perhaps I can get Tallichet to schedule this minor detail in the future. Over all, this is a nice clean job that was done in a traditional "field" paint applique. The a/c markings were painted on August 1999 at Lawrence Municipal Airport, North Andover, MA.

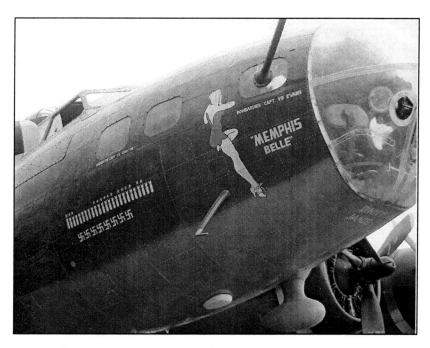

Day 4 - The bomb missions, swastikas and all other names that appear on the B-17 were done. Again a master template was made for the bombs and swastikas.

INDEX
AIRCRAFT

CPSIA information can be obtained at www.ICGtesting.com
Printed in the USA
BVOW050512260412

288747BV00005B/1/P